THE IMAGERY OF SURREALISM

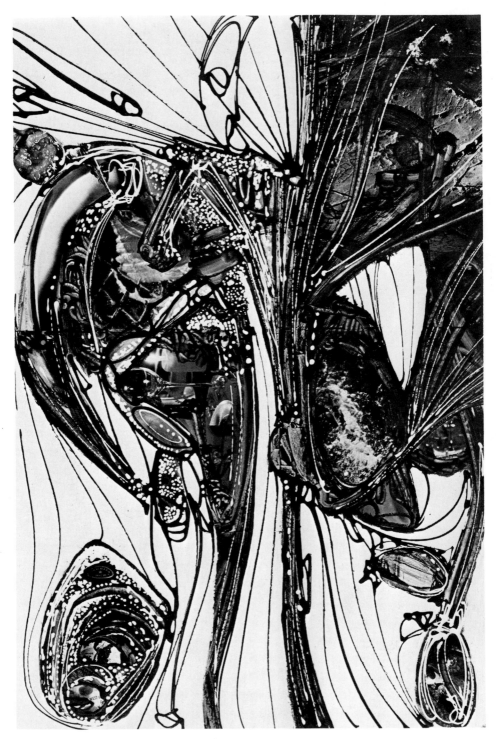

Adrien Dax, Untitled Painting. 1977. Acrylic on wood. Collection of the artist.

THE IMAGERY
OF SURREALISM

J. H. Matthews

SYRACUSE UNIVERSITY PRESS 1977

Library of Congress Cataloging in Publication Data

Matthews, J H
 The imagery of surrealism.
 Bibliography: p.
 Includes index.
 1. Surrealism. 2. Arts, Modern—20th century.
I. Title.
NX600.S9M37 700'.9'04 77-7927
ISBN 0-8156-2183-3

To the memory of
Jehan Mayoux

J. H. MATTHEWS is a member of the committee appointed by the French government's Centre National de la Recherche scientifique to establish a center in Paris for documenting world-wide surrealism. He is American correspondent for *Edda* and *Gradiva* (Brussels), *Phases* (Paris), and *Sud* (Marseilles), magazines devoted to vanguard poetry and art. Professor Matthews is a member of the faculty of Syracuse University and is the author of seventeen books, most of them about surrealism. In 1977 the University of Wales conferred upon him its D.Litt., in recognition of his work on surrealism.

CONTENTS

Preface xiii

Acknowledgments xxv

Introduction 1

The Inner Model 37

Collage 65

Chance 117

Object Lessons 165

Interpretation 225

Conclusion 255

Works Cited 277

Index 287

ILLUSTRATIONS

Adrien Dax, Untitled Painting ii

Yves Tanguy, *Proteus' Armoire.* xviii

Jean Terrossian, *Midnight Spermission.* xix

Ragnar von Holten, collage for a Swedish edition of
 Lautréamont's *Les Chants de Maldoror.* xxi

Karol Baron, *Mutants, Gryphones, Skyles and
 Palcelogoides.* 3

Martin Stejskal, Contourage. 3

John Banting, *The Quarrel in the Lavatory.* 6

Giuseppe Gallizioli, *Closed-Circuit Habitation.* 6

Pierre Molinier, *The Great Combat No. 2.* 12

Pierre Molinier, *Women in Love.* 12

František Janoušek, *The May Evening.* 18

Jan Švankmajer, *Cabinet of Natural Sciences.* 18

Jules Perahim, *Love Letter.* 19

Ronald L. Papp, *My Pet Ophelia.* 19

Wilhelm Freddie, *Sex-Paralysappeal.* 22

Thom Burns, *Island of Uncertain Hours.* 24

Jean-Jacques Jack Dauben, *Sade's Juliette.* 24

Adrien Dax, Automatic Drawing. 33

Yves Tanguy, Automatic Drawing. 33

René Magritte, *Countryside III.* 35

Marcel Jean, *The Gulf Stream.* 35

Juhani Linnoraara, *What Has Happened Here?* 41

Paul Hammond, *My Country's Flag.* 41

Enrico Baj, *Little Child Playing with his Toys.* 44

Hans Henrik Lerfeldt, *Nature Comes to Reason.* 45

Wilhelm Freddie, *The Fountain.* 49

Ivan Tovar, *The Melancholy Fountain.* 50

Mikuláš Medek, *The Sleeping Woman.* 52
Renzo Margonari, *Fish and/or Woman.* 53
LEFT. Toyen, *The Huntress.* 56
RIGHT. Jindrich Styrsky, *The Somnambulist Muse.* 56
Ragnar von Holten, *Many to play the Diabolo.* 61
Brooke Rothwell, *The Heights of Candor.* 62
E. L. T. Mesens, *Landscape.* 67
E. L. T. Mesens, *Eternity Mama.* 67
Mario Cesariny, *To Rimbaud, the Invisible, the
 Untouchable, the Inaudible.* 73
Artur Cruzeiro Seixas, *The Alchemy of the Word.* 74
Jindrich Styrsky, *Statue of Liberty.* 81
Artur Cruzeiro Seixas, *The Basis of Language—
 I, You, He.* 82
Albert Marenčin, from the collage cycle *Returns to the
 Unknown.* 82
Sebastian Matta Echaurren, *The Unglimpsed.* 85
Enrico Baj, *Mary Augusta Arnold Ward, English Writer.* 86
Paul Delvaux, *The Woman with the Rose.* 89
Peter Weis, collage for *The Arabian Nights.* 89
Georges Hugnet, Untitled Photomontage. 93
Karel Teige, Untitled Collage. 93
Max Ernst, collage from *Rêve d'une Petite Fille qui
 voulut entrer au Carmel.* 102
Conroy Maddox, *The Invitation.* 107
Ladislav Novak, *Landscape-Face (The Giantess).* 107
Ludwig Zeller, two collages from the series "The 110
 Downfall of the Church." 111
Max Ernst, *The Forest.* 120
Suzana Wald, drawing from the series "Skinscapes." 124
Suzana Wald, Untitled Drawing. 124
Robert Lagarde, *The Shadow Goes on Moving.* 128
Jan Švankmajer, *Histoires naturelles.* 128
Adrien Dax, Impression de relief. 136
Wolfgang Paalen, *The Strangers.* 136
Oscar Dominguez, Decalcomania. 139
Oscar Dominguez, *Professor of Surrealism.* 139
António Pedro, Fernando de Azevedo, Vespeira, Joâo
 Moniz Pereira, António Dominguez, Exquisite
 Corpse. 144
André Breton, Frédéric Migret, Susanna Migret, Anon.,
 Exquisite Corpse. 144
Sebastian Matta Echaurren, Esteban Frances, Gordon
 Onslow-Ford, Exquisite Corpse. 147

Ronald L. Papp and Jean-Jacques Jack Dauben, *Conscious Asleep, Unconscious Awakened*. 148

Eva Švankmajerová, Karol Baron, Vratislav Effenberger, Albert Marenčin, Juraj Mojzis, Martin Stejskal, Ludvik Šváb, Andy Lass, Jan Švankmajer, *Security*. 148

Man Ray, Rayograph. 151

Karol Baron, Alena Nádvorníková, Eva Švankmajerová, Emila Medková, Vratislav Effenberger, Albert Marenčin, Martin Stejskal, Ludvik Šváb, Jan Švankmajer, *Phantom Karel Teige*. 152

Conroy Maddox, *Figure*. 159

Richard Oelze, *Burial Celebration*. 160

Marcel Mariën, *The Object*. 166

Tatsuo Ikeda, *The Eyeball of Vigilance*. 166

Georges Hugnet, Untitled Photomontage. 168

René Magritte, *Variant on Sadness*. 168

Augustin Cárdenas, *Girl*. 171

Alberto Giacometti, *The Hour of the Traces*. 172

Wilhelm Freddie, *Mrs Simpson's Pink Shoes*. 175

Micheline Bounoure, *Camera Obscura*. 177

Yves Tanguy, Untitled Gouache. 177

Jorge Camacho, *Sovereign*. 180

Her de Vries, *Without One Ever Knowing Why*. 180

André Breton, Poem-Object. 183

Arshile Gorky, *The Liver is the Cock's Comb*. 186

Jan Švankmajor, *Unforgettable Encounter*. 186

Václav Tikal, *Symbiosis*. 187

Robert Green, *The Drake*. 191

Carlos Revilla, *Devourer of Pearls*. 193

Konrad Klapheck, *The Face of Terror*. 194

Max Walter Svanberg, *Rich Woman Experiencing the Metamorphoses of the Day*. 200

Max Walter Svanberg, Untitled Drawing. 201

Hans Bellmer, *The Doll*. 204

Hans Bellmer, Untitled Drawing. 206

Hans Bellmer, engraving for Joyce Mansour's *Jules César*. 207

Hans Bellmer, *Little Anthology of the Ink-Well (Reversible Cephalopod)*. 209

Wilhelm Freddie, *Zola's Writing-Desk*. 213

Jean-Louis Bédouin, *The Algonquin Tango*. 214

Robert Lagarde, *Closed House [Brothel] on the Courtyard, We Visit the Garden* 222

René Magritte, *Painted on a Summer's Night.* 223
Emila Medková, *The Widows.* 229
Gabriel Der Kevorkian, *High Precision.* 229
Wilhelm Freddie, *Young Girl with Umbrella.* 232
Philip West, *The Lovers.* 232
Adrien Dax, Untitled Painting. 236
Eva Švankmajerová, *What needs to be added?* 236
Man Ray, *Fine Weather* (also called *The Adventure*). 239
Rik Lina, *Heart-Source.* 239
Jorge Camacho, "*The Dance of Death*" *Opus 18.*
 Self-Portrait. 244
Joseph Jablonski, *The Shores of Umor.* 244
E. F. Granell, *Teresa de Avila Wonders whether to*
 Return to Toledo. 248
E. F. Granell, *The Riding Master Congratulates the*
 Young Horsewoman. 249
Joan Miró, *Person, Birds, Stars.* 253
Joan Miró, Untitled. 253
Leonora Carrington, *Lepidoptera.* 257
Jacques Brunius, Found Object. 258
Marianne van Hirtum, *Lost Cat and Dog.* 259
Penelope Rosemont, *The Voyage of the Albatross.* 259
René Magritte, *Les Vases communicants.* 263
Alberto Martini, *The Three Altars.* 265
Marcel Mariën, *The Captive Caress.* 272
Roland Penrose, *Taeco–Mene.* 272

PREFACE

SURREALISM first found expression as an attempt to expand the capabilities of linguistic communication. Initially in France, where surrealism originated, its practitioners—Louis Aragon, André Breton, and Paul Eluard, notably—were young men who a few years earlier, before the outbreak of the 1914–18 war, already had felt drawn to poetry. None of those whose names are cited in the 1924 *Manifesto of Surrealism* as having "given proof of ABSOLUTE SURREALISM" were painters. Yet over the years surrealism has impressed the public at large primarily through painting. In the long run, a spirit of inquiry which originally seemed destined to leave its mark—if at all—upon literature, has gained wide recognition less through the work of writers it has impelled to experiment with words than through that of painters who have drawn inspiration from it.

Now it would be dangerous to attach undue importance to the fact that surrealism has become better known to the general public thanks to its painters than its poets. After all, painting comes much closer than the written text to being universally comprehensible. All the same, the surrealist poet Jean Schuster very rightly has stressed that the two best books on surrealist painting, André Breton's *Le Surréalisme et la peinture* and José Pierre's *Le Surréalisme,* "complement one another in saying that surrealist painting is contained in surrealism and not the reverse."[1]

[1] Jean Schuster, "Introduction," in José Pierre, *Le Surréalisme,* p. 7. Full details regarding all books cited appear below under the rubric "Works Cited."

Interviewed by Pierre Mazars, Victor Brauner once said of surrealism, "It is a movement that contributed much on the plane of rigor, of oneiric cognition. But

Considering those painters whose art, finding at least some im-
petus in surrealism, has received most acclaim outside the surrealist
movement, we notice they are the very ones whose work has been
evaluated most consistently in a manner conflicting with Schuster's
views. This, apparently, is because critics incline to share a tendency
to minimize their favorite painters' debt to surrealism. They often treat
participation in surrealism as an accessory activity on the artist's part,
something of a *péché de jeunesse,* even. Quite exceptionally, Patrick
Waldberg gives surrealism full credit for imposing on René Magritte's
work its distinctive characteristics.[2] Far more typical of critical com-
mentary is Carola Giedion-Welcker's dismissal of Jean Arp's associa-
tion with surrealism, in flagrant disregard of Arp's own declaration in
his *Jours effeuillés:* "It was during the surrealist period that my poetic
writing and my plastic writing came closest together" (p. 446).

We have the distinct impression that art critics who speak with
respect of Max Ernst, André Masson, and Joan Miró, for instance, aim
to detach these artists from the surrealist movement, as though af-
firmation of artistic merit as well as of respectability must presuppose
severance of all ties with the surrealists. We shall see that the sur-
realists' negative attitude toward esthetic preoccupations provides
critics with apparently good reasons for thinking it necessary to act
this way. Even before examining this attitude, however, we can de-
tect one immediate consequence of a widespread critical approach
that virtually eliminates surrealism from discussion, as if it were a
stigma to be erased by convenient forgetfulness. Some of the most
significant effects of surrealism upon the work of a number of painters
who have become famous in the twentieth century are either distorted
or ignored altogether. Thus Jacques Dupin, a poet who has nothing
to do with surrealism, feels it appropriate to refer to Miró's "dream
painting" (from 1925 onward) as "the very opposite of the 'painted
dreams' into which other [unnamed] Surrealist painters too often, and
too complacently, sank" (p. 162). The most Dupin is willing to grant,
when he cannot avoid admitting that Miró has acted upon occasion in

don't let anyone say I'm a surrealist painter. And there is no 'surrealist painting';
it doesn't exist! There was only a certain kind of painting that corresponded to
surrealist research." See Pierre Mazars, "Victor Brauner peintre surréaliste: 'la
peinture surréaliste ça n'existe pas!'" *Le Figaro littéraire,* January 21–27, 1965.
Brauner spoke of surrealism in the past tense, as painters so frequently do when
discussing it after they have left or been expelled from the movement.
[2] Patrick Waldberg, *René Magritte,* p. 228. Henceforth, where a parenthetical
page reference only appears in the text, it refers to a publication that can be
identified without difficulty among the "Works Cited."

conformity with surrealist directives, is that he has acted *like* a sur-
realist: "Like the Surrealists who had systematized inspiration, he tried
deliberately to provoke it by staring fixedly at the rough surface of a
floor, or the configurations of clouds, and then letting forms be sug-
gested to him" (p. 162). Dupin devotes a whole chapter to Miró's
Constellations without quoting from even one of André Breton's
proses parallèles which accompanied their first showing and later
publication, while James Thrall Soby conceals the very existence of
Breton's poetic commentary on Miró's graphics.

Quite a few surrealists have not stopped short of pronouncing
evidence of this kind proof of a "conspiracy of silence" (a phrase more
than one of them has used), surrounding surrealism and isolating it.
This, they say, has denied surrealism the attention it deserves from the
critics and the general public. There are a certain number of signs
that such a claim is not without its basis in truth: neglect of surrealism
in Waldberg's book on Ernst for instance, and also in John Russell's.
All the same, the willingness—not to say the eagerness—of former
surrealists to forget their origins, together with the active collaboration
of those whom they have assisted in their critical writings, does not
explain matters entirely. To complete the picture we have to listen to
other surrealist commentators whose objectivity assists us in identify-
ing the central problem with which surrealism confronts any outsider
proposing to evaluate its expression through painting. At times more
directly than others, these men and women have suggested that the
critics' reluctance to deal with the impact of surrealism on painting
usually points significantly in one direction. It demonstrates surreal-
ism's intractability to assessment by traditional evaluative methods,
and calls for a radically new approach which cannot be expected of
conventional art criticism.

This matter will receive fuller examination below. For the present,
it is enough to note one fact of fundamental importance. Studies of
serious proportions, focused on the work of major painters who have
made a significant contribution to surrealism, do little to advance our
understanding of surrealism itself. Meanwhile, surrealist word poems
have not been forgotten by any means in critical circles. Even so, the
question of quality and of fairness aside, books about surrealism gen-
erally fall into two studiously separated categories: those treating
surrealism as "art" and those that speak of it as "literature." Here and
there, now and again, a brief allusion to painting appears in a study
reserved for what is termed "surrealist literature," while, similarly, the
author of a book on "surrealist art" will refer in passing to "literary

texts." Nevertheless, the prevailing critical assumption, with which available evidence encourages the reading public to agree, is by and large that the value of a surrealist painting, sculpture, or object has really nothing to do with that of a surrealist poem. There is tacit agreement all around that painting and verbal poetry are to be treated as independent, if roughly parallel, ventures. Generally, what we read about surrealism leaves us free to conclude that nothing connects them organically and that there is no reason to search for a fundamental and necessary link between the things one surrealist commits to canvas and those another puts down on the printed page.

The present study questions such a conclusion, attempting to show it to be both hasty and inaccurate. This essay rests on quite a different hypothesis, therefore: that our understanding of surrealist creative activity—where it comes from and what it serves to accomplish—is enriched through simultaneous examination of pictorial and verbal expressions of the surrealist viewpoint. Testing this hypothesis calls for analysis of the theory underlying surrealist imagery, pictorial and verbal, conducted in such a way as to demonstrate the following. Full appreciation of surrealist painting cannot come until we have grasped the significance of surrealist word poems. By the same token, appraisal of the images we meet in surrealist writing must remain incomplete unless undertaken in light of surrealist pictorial imagery.

It might be argued that there is nothing essentially new here; that James Thrall Soby, for one, at least has implied comparisons of the kind to be drawn below. Speaking in his book on Yves Tanguy of an impressive canvas entitled *Multiplication des arcs,* Soby writes, "This picture is a sort of boneyard of the world, its inexplicable objects gathered in fantastic profusion before a soft and brooding sky. The close gradations of light, time and form are handled with such acumen that a pristine order evolves, whose poetic impact is more than likely to establish the picture as one of the master works in the art of our time" (p. 22). Yet we do not have to take a second glance to detect in Soby's reference to poetic impact an admission of defeat before the difficulties of describing Tanguy's painting adequately. Soby does not make any attempt to identify its poetic content, let alone its affinities with the poetry of surrealism. Designations like "poet," "poetry," and "poetic" are vague enough to be applied in relative safety, and to painters of varying persuasions. Hence, far more enlightening than

the description reproduced above is a comment in the preamble to former surrealist Alain Jouffroy's *Une Révolution du regard*. Alluding to his first sight of Tanguy's *L'Armoire de Protée*, Jouffroy explains:

> That picture in fact bowled me over at once: it was the sudden open-ing of a door on a world where everything is possible, and like awakening on the deck of a ship whose direction I shall never know: perhaps the assonance of Tanguy and *tanguer* [to pitch] had something to do with it. Learning that this painter had always been unaware of what his pictures "represented" I understood, ingenuously but fully, that painting could give *an image of the unknown*. Up to that moment I had believed poetry alone capable of exploring what remains inaccessible to man: Yves Tanguy convinced me on the contrary of the exploratory function of painting, and of the fundamental relation-ship that therefore links it with poetry. (p. 9)

Instead of seeking refuge in the kind of obscurantism for which many have set an example, I wish to follow the lead given by Jouffroy, facing the following question. To what extent, to what degree, is the imagery of certain pictorial artists comparable to that of certain poets who share ambitions accurately identifiable by the adjective "surrealist"?

Marcel Jean, of course, has referred to the surrealists as "painters who have revealed the various faces of a new plastic poetry" (p. 132). What he has not done, however, is show this *poésie plastique* to be fundamentally the same as the poetry defended and illustrated in surrealist creative writing. Certainly, his point is made far more per-suasively in the catalog of an Arp show held at the Galleria Schwarz in Milan during 1965. Uncluttered by introductory commentary, the catalog places side by side and on equal terms photographs of reliefs and sculptures executed by Arp and poems taken from his 1946 col-lection *Le Siège de l'air* (*The Air Seat*).

"Surrealism," observes José Pierre in his *Le Surréalisme*, "is that too: an adventure conducted in brotherhood by painters and poets" (p. 22). In contrast with critics who draw rough-and-ready distinc-tions between surrealism in verse and in painting, the surrealists themselves act in complete consistency with their adamant refusal to categorize modes of poetic expression. They have never hesitated to make comparisons between writing and painting. In surrealism, both are placed on an equal footing. Thus, looking back from a text written in 1947, André Breton, author of the surrealist manifestoes, was to

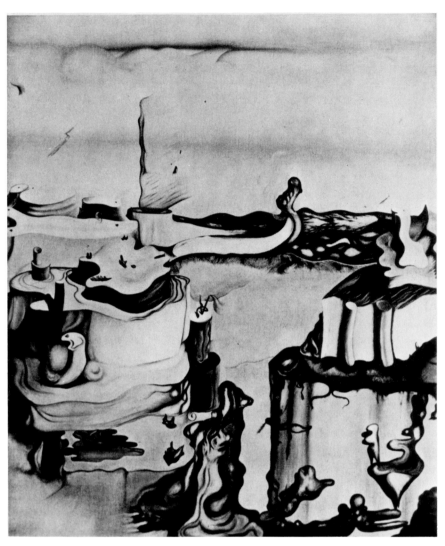

Yves Tanguy, *Proteus' Armoire*. 1931. Oil on canvas. Private Collection, Paris.

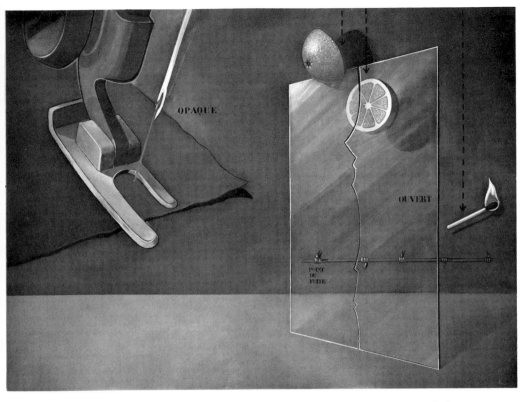

Jean Terrossian, *Midnight Spermission*. Oil on canvas. Collection of the artist. Photo Marcel Lannoy.

comment, "Also, for the first time no doubt with surrealism, poetry has not ceased to give plastic art its support. If such was the case with a few isolated works in the past—with those that, for this reason, surrealism brings to the fore: Uccello, Arcimbaldo, Bosch, Baldung, Goya, Blake, Meryon, Redon, Rousseau—at least never before as a whole had the two approaches shown themselves in this way to be voluntarily fused."[3]

Speaking of the situation of painting in 1954, Georges Goldfayn was to remark pertinently: "Not only do the problems of painting appear to be no different from those of poetry in general, but also I find quite incomprehensible the singular inflation of which they are the object in particular and have been for a long time now."[4] One image especially—"beautiful as the chance encounter on a dissecting table of a sewing machine and an umbrella," from a nineteenth-century text, Lautréamont's *Les Chants de Maldoror*—has never ceased to fascinate surrealists everywhere. Noting the preeminently visual quality of this verbal comparison, which has had a profound influence on the development of surrealist pictorial imagery, we experience no difficulty realizing that Goldfayn's was a conclusion anticipated by certain surrealists up to a third of a century before.

Examining the common sources of imagery in word poems, paintings, and surrealist objects will take us beyond mere identification of predictable points of contact between artistic media. It will lead into consideration of the essentials underlying surrealist endeavor. It will oblige us to concentrate on the very nature of an adventure for which verbal and pictorial elements, falling into suggestive patterns, serve really as no more than external signs. Concentrating upon the image, that prime manifestation of surrealist creative practice, we may hope to avoid some of the pitfalls into which so many have stumbled when seeking to interpret surrealism. At all events, doing so will help us deal more confidently than we could do otherwise with the effect upon surrealist language, in its pictorial as well as its verbal forms, of a "philosophy of immanence" that governed Breton's thinking for four decades. Then many of the objections and reservations formulated by critics in whom, over the years, surrealism recurrently has provoked the same frustration can be seen to reflect weaknesses in critical method, not in surrealism itself. Indeed, we begin to see things more clearly as soon as we understand that the following statement

[3] André Breton, "Comète surréaliste" (1947) in his *La Clé des champs*, p. 100.
[4] See Charles Estienne and José Pierre, "Situation de la peinture en 1954," *Médium: communication surréaliste*, Nouvelle Série, No. 4 (January 1955), p. 44.

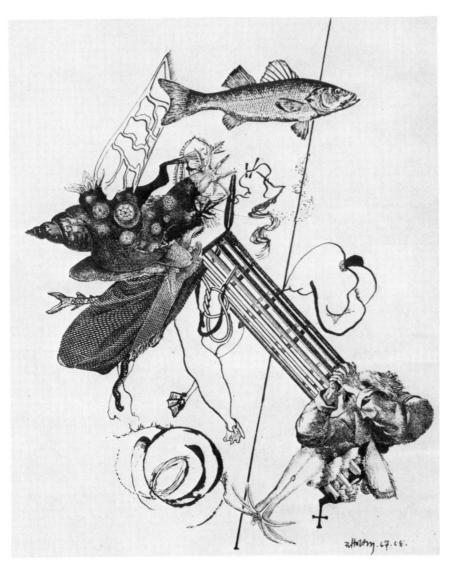

Ragnar von Holten, collage for a Swedish edition of Lautréamont's *Les
Chants de Maldoror* (Lund: Bo Cavefors Bokförlag Berlingska Boktryckeriet,
1972). 1968. Speaking in Canto IV of "this new species of amphibious man,"
Lautréamont writes, "I do not believe the reader has cause to be sorry,
if he grants my narrative less the detrimental obstacle of stupid credulity
than the supreme service of profound confidence, that discusses lawfully,
with secret sympathy, the poetic mysteries, too few in number, in his own
opinion, that I take it upon myself to reveal, when, each time, the occasion
presents itself." The point of departure for each of von Holten's collages, in
this edition, was an illustration from Bunyan's *The Pilgrim's Progress*.

in Paul Eluard's *Donner à voir* applies no less to surrealism in painting than in verse: "Poems always have big white margins, big white margins of silence in which ardent memory is consumed to create anew a delirium without a past" (p. 74). Similarly, we stand to learn much about surrealist writing from André Breton's confession at the beginning of his *Le Surréalisme et la peinture*: "So it is that I find it impossible to consider a painting other than as a window about which my first concern is knowing what *it looks out upon* . . ." (p. 2).

The reader will not find here a succession of parallels in which individual details drawn from surrealist texts are shown to be verbal transcriptions of pictorial images, or surrealist paintings are viewed as transcribing images to be found in surrealist writing. Parallels of this kind are not difficult to establish. Yet they could hardly be deemed conclusive proof of anything other than the proximity in which surrealist writers and painters have always lived. Much more important is a search for certain underlying principles from which creative activity among the surrealists draws strength and purpose.

To understand the significance of surrealist language—taken in its broadest sense and touching a variety of creative modes—we have to acknowledge the following. Surrealists grant precedence to evaluative criteria that depart radically from the norms of conventional literary and art criticism. From the very beginning, the surrealist position was one of opposition and denial. Hence, surrealist principles emerge with greatest clarity when we consider how and why they negate generally accepted esthetic values—those for which surrealists the world over have expressed as much scorn as for rationalism. In other words, surrealism's positive program takes on definition with least delay when, seeking to identify its salient features, we ask why and with what consequences it denies values on which our education in art and literature have taught us to place reliance.

The material assembled in this book was offered originally under circumstances that account for the way it is presented here. The following pages bring together remarks made within the framework of a summer seminar for college teachers, supported by the National Endowment for the Humanities, Division of Fellowships. This seminar was not designed to provide a critical appraisal of surrealism through analysis of its pictorial and verbal imagery, but to assist those who face the task of helping their students appreciate surrealism. My primary purpose remains now what it was then. So far as it is possible for someone who has not participated in the surrealist movement to

do this, I wish to give a glimpse of the insider's view of surrealism.

My ambition is to satisfy as far as I can the needs of readers whom curiosity prompts to ask what surrealist imagery is meant to accomplish, by what means, and for what purposes. How does a surrealist image look to a surrealist, and what does he demand of it? Because I address myself to this question before anything else, my study is essentially expository and explicative. It is evaluative only to the extent that it examines the relationship between surrealist images and the principles from which imagery derives the only meaning it can have in surrealism. In short, this study does not propound a theory of surrealism or offer a critique of its creative processes. It is, quite simply, an attempt to reach an understanding of surrealist imagery on the surrealists' own terms.

Through an examination of the principles lying behind a variety of expressive modes and of the ways they have been applied, the present inquiry aims at uncovering the fundamental unity of purpose characterizing surrealist experimentation with pictorial and verbal imagery. It seeks to show that only when we comprehend what—above and beyond disparate techniques—unifies surrealist artists in the creative act, and for what reasons, can we hope to trace the lines of force in the magnetic fields from which *Les Champs magnétiques* took its title as early as 1919.

ACKNOWLEDGMENTS

Grateful acknowledgment is made to the following for permission to reproduce the works indicated: Aarhus Kunstmuseum, Aarhus, for Freddie's *Fontænen;* Albright–Knox Art Gallery, Buffalo, N.Y., for Gorky's *Le Foie est la crête du coq;* Mme Doriane Bihl-Bellmer and the Galerie A.-F. Petit, Paris, for Bellmer's doll and drawings; Fyns Stifts Kunstmuseum, Odense, for Freddie's *Les Chaussures roses de Mrs Simpson;* Galerie Isy Brachot, Brussels, for Delvaux's *La Femme à la rose,* Ernst's *La Forêt,* and Magritte's *Campagne III, Peint sur nuit d'été,* and *Les Vases communicants;* Galerie Maeght, Paris, for Miró's *Huile et aquarelle sur papier* and *Personnage, oiseaux, étoiles;* Galerie Svend Hansen, Copenhagen, for Freddie's *Ung Pige med paraply;* Bruno Grossetti, Centro Italiano d'Arte Annunciata, Milan, for Martini's *I tre altari;* Louisiana Kunstmuseum, Humlebæk, for Freddie's *Zola's skrivebord;* Moderna Museet, Stockholm, for Freddie's *Sex-paralysappeal;* Museo d'Arte contemporanea, Sasseferrato, for Margonari's *Pesce e/o Donna.*

Special thanks are due the artists who made works available for reproduction, collectors who graciously authorized reproduction of works owned by them, and the following individuals who helped obtain photographs inaccessible to the author without their assistance: Timothy Baum (New York), Isy Brachot III (Brussels), Micheline and Vincent Bounoure (Paris), Steen Colding (Copenhagen,) Ragnar von Holten (Stockholm), Edouard Jaguer (Paris), Conroy Maddox (London), Joyce Mansour (Paris), José Pierre (Paris), Franklin Rosemont (Chicago), Jan Švankmajer (Prague), Her de Vries (Amsterdam).

INTRODUCTION

*L*ES CHAMPS MAGNÉTIQUES was written in collaboration by André Breton and Philippe Soupault during the summer of 1919. First serialized in the magazine *Littérature* from October 1919 onward, it appeared in book form under the imprint Au Sans Pareil in 1920. In his *Entretiens* (1952), Breton qualifies *Les Champs magnétiques* as "the first *surrealist* work," because it was "the fruit of the first systematic applications of automatic writing" (p. 56). An essay in Soupault's *Profils perdus* (1963) explains at greater length:

> At that period, while André Breton and myself had not yet baptised ourselves surrealists, we wanted at first to give ourselves up to experimentation. It led us to consider poetry as a liberation, as the possibility (perhaps the sole possibility) of granting the mind a liberty we had known only in our dreams and of delivering us from the apparatus of logic.
>
> In the course of our inquiry we had discovered indeed that the mind released from all critical pressures and from academic habits offered images and not logical propositions and that, if we agreed to adopt what the psychiatrist Pierre Janet called automatic writing, we noted down texts in which we discovered a "universe" unexplored up to then. (p. 166)

As Soupault points out in an *Essai sur la poésie* (1950), their experiments persuaded him and Breton to treat poetry not as a system, after the manner of Stéphane Mallarmé, but as a liberative experience (p. xx).

1

The consequences were manifest very soon. The very first sentence of *Les Champs magnétiques* brings us face to face with some essential characteristics of surrealist communication by images: "Prisonniers des gouttes d'eau, nous ne sommes que des animaux perpétuels" ("Prisoners of the drops of water, we are but perpetual animals"). The words we read are instantly recognizable as semantic units. Yet their arrangement in a sentence, grammatically impeccable though it is, has produced a statement to which reasonable logic can assign no satisfactory meaning. Surprise, disappointment, dissatisfaction, bemusement, mystification: these responses in the rational mind indicate how far surrealist language stands outside the norm of day-to-day verbal exchange. The imagery of surrealism—its "image-work," to avail ourselves of the dictionary definition—is not amenable to rational control or explanation. To this extent, it strikes many readers and listeners as being without purpose or justification.

It is perhaps the apparent gratuitousness of the surrealist verbal image that most offends rationality, aggravatingly defeating efforts to interpret its meaning. Quite obviously, the success of the image-making process cannot be evaluated by reference to coordinates upon which we rely habitually. It often seems, in fact, that poetry in surrealism is directed at producing effects common sense must judge pointless. The authors of *Les Champs magnétiques*, for example, evidently make no attempt to provide us with an opportunity to measure their skill at rendering things familiar to us all but now presented in a way distinctly their own. Hence the sibylline quality with which several of their images are invested: "Le silence obscur des métaux paissait leurs paroles" ("The obscure silence of metals was grazing on their words" [p. 92]). If we let common sense dictate our reaction, we are likely to conclude Breton and Soupault are rendering nothing, and so are not really communicating at all.

If this happens to be the case, then we can look for no advancement in our understanding of surrealism until we have acknowledged that the surrealist's approach to reality and to the relationship language bears to the real differs radically from our own. In an essay on the poetry of Benjamin Péret, edited for publication in his *Donner à voir*, Paul Eluard speaks for all surrealists when he asserts that imagination has no instinct for imitation: "It is the universe without association, the universe that does not belong to a larger universe, the universe without a god, since it never lies, since it never confuses what will be with what has been." In other words, the surrealist image takes flight in the imagination, from the very contradictions and in-

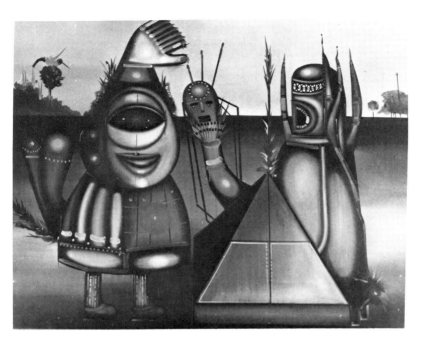

Karol Baron, *Mutants, Gryphones, Skyles and Palcelogoides*. 1972. Oil on canvas. Collection of the artist.

Martin Stejskal, Contourage. 1970. Collection of the artist.

congruities rendering it unassimilable by reason. This is the special characteristic of surrealist theories of image-making. They treat the image as viable only so long as it conflicts with reasonable presuppositions. The image displays most vitality, in the surrealist's eyes, where it provides a spectacle for which rational logic or past experience have not prepared us.

In *Les Champs magnétiques* the mental pictures conjured up by words—what they make us see—do not show something familiar enough to us, but presented this time in sharper focus or even in a new light altogether. The images rising before us offer glimpses of a world quite different from the one to which we are accustomed. Entry to that world is possible only for someone willing to accept surrealism as presenting us with a password to take us beyond frontiers rationalist thought has never been tempted to cross. Speaking of poetry—surrealist poetry, we understand—Eluard wrote in the *prière d'insérer* for Benjamin Péret's *De derrière les fagots*, "For it militates insolently in favor of a new *régime*, that of logic linked with life not like a shadow but like a star." In "Confronts," one of his *Poèmes militants*, René Char declares, "Worlds in transformation belong to the carnivorous poets" ("Les mondes en transformation appartiennent aux poètes carnassiers").

Surrealist precept and practice grow out of the conviction that there are other and more profitable ways of responding to an image than those accessible to reason. More than this, these are preferable ways, in the surrealist's estimation. They promise far more enjoyment and are capable of showing the kinds of imagery to which he is attracted above all to be more pertinent than reason can appreciate to some of our deepest and most urgent psychological needs. It is in the very nature of surrealist imagery to challenge us to take advantage of such means and to reap the benefits of doing so. Surrealists do not doubt for an instant that the poetic image will take us, as Eluard expresses it in "Sans Age," from his *Cours naturel*, "Out of all the caves / Out of ourselves" ("Hors de toutes les cavernes / Hors de nous-mêmes"). As interpreted by Jean-Louis Bédouin in the third issue of the second series of *Médium: communication surréaliste*, surrealism is a "passionate search for 'the powers of the mind,' an unprecedented attempt to restore them." Hence, in the domain of poetry, Bédouin goes on to stress, surrealism takes guidance from the idea that the limitations weighing on all forms of expression can be abolished thanks to the use of appropriate means (p. 17).

Unless we rise to its challenge, the surrealist image-work and its

fruits will appear no more than a hoax or a crazy impertinence, un-
deserving of attention, either way, and quite incapable of offering any
form of durable pleasure. Disputing the claims of rationality in *Les
Champs magnétiques*, Breton and Soupault do not act out of perverse-
ness or in response to an instinct for sensationalism. They see denial
of the demands imposed by reason as a prerequisite for broadening
and at the same time deepening experience outside the boundaries
set by rationality. We observe in this connection that memory is no
guarantee against the disorientation of thought from which exploration
of a new world takes its point of departure. A section of *Les Champs
magnétiques* presumably detailing recollections of childhood goes well
beyond sentimental embroidery of facts, to depict school desks as
three-masted vessels sailing over a failing grade for good behavior
with the astonishing dust of transoms that someone will succeed in
finding how to close ("les pupitres naviguent trois-mâts sur le zéro de
conduite avec l'étonnante poussière des vasistas qu'on trouvera moyen
de fermer" [p. 25]). Freed from the past and the limiting associations
it leaves behind, Breton and Soupault are at liberty to explore the
new.

At times, the prospect before them is frightening, like the endless
perspective of monstrous theories of nightmares, dancing ("A perte de
vue les théories monstrueuses des cauchemars dansaient sans suite"
[p. 35]). The narrator of *Les Champs magnétiques* in fact knows
moments of terror. He admits to being afraid of finding within him-
self some of those senile tricks that, he tells us, are confused with
rose-windows of noise ("J'ai peur de découvrir en moi de ces manèges
séniles que l'on confond avec des rosaces de bruit" [p. 28]). For the
world where he finds himself is not without menacing features. He
speaks, for instance, of clocks in despair reciting the Rosary ("Les
horloges désespérées égrenaient un chapelet" [p. 90]).

More typically, all the same, the narrator accepts without signs
of surprise or alarm strange and unprecedented sights on which he
reports matter-of-factly. This is the case with the soaring song of gold
leaves from an electroscope found in certain top hats ("la chanson
envolée des feuilles d'or d'électroscope qu'on trouve dans certains
chapeaux haut de forme" [p. 19]). The same is true of the beaches
full of those eyes without bodies one meets near dunes and distant
meadows, red with the blood of flocks in blossom ("Les plages sont
pleines de ces yeux sans corps que l'on rencontre près des dunes et
des prairies lointaines et rouges du sang des troupeaux fleuris" [p.
77]). The narrator informs us that of all the navigators we can sup-

John Banting, *The Quarrel in the Lavatory*. 1935. Ink and watercolor drawing. Former Collection E. L. T. Mesens.

Giuseppe Gallizioli, *Closed-Circuit Habitation*. 1974. Oil on canvas. Collection of the artist.

pose, the one who pleases him most is the one with a thorax in the form of a port of call ("De tous les navigateurs supposables, celui qui a la poitrine en forme d'escale me plaît le mieux" [p. 38]). Where the burden of narration is assumed by a voice speaking in the first-person plural, we learn of a window opening up over the heart to reveal an immense lake. Here reddish-brown dragonflies, sweet-smelling like peonies, settle at noon ("La fenêtre creusée dans notre chair s'ouvre sur notre cœur. On y voit un immense lac où viennent se poser à midi des libellules mordorées et odorantes comme des pivoines" [p. 20]). The passage from which this last image comes is taken from the section of *Les Champs magnétiques* that André Breton liked best. It was written by Philippe Soupault.

No special meaning is to be attached, apparently, to the use in *Les Champs magnétiques* of both a singular narrative voice and a plural one. It is explained, quite simply, by the fact that this book, which its coauthors chose to present over both their signatures, brings together texts written independently as well as passages where Breton's contribution and Soupault's alternate. There are even some sections, written by Soupault, in which a phrase by Breton has been intercalated. Notes on *Les Champs magnétiques* written by Breton and published for the first time by Marguerite Bonnet (p. 182) explain, apropos of one such phrase—"Gentilles sauterelles de vinaigre" ("Nice grasshoppers of vinegar" [p. 50])—"This addition by me (which I point out as being by me!) may seem puerile. It can bear witness however only to the very special interest I took and still take in a certain number of images whose hallucinatory value goes for me beyond all others." In the article "Le Message automatique," reprinted in his *Point du jour*, Breton was to point out, "Automatic writing, practiced with some fervor, leads directly to visual hallucination, I have experienced this personally . . ." (p. 248).

Les Champs magnétiques draws us into a world where anxiety and wonder are contradictory yet complementary forces. Making their magnetic influence felt upon the reader's sensibility, these forces find expression through imagery that brings him up against the following question. How does language lend itself to describing a universe that presents features without equivalent in the world about him and quite beyond the range of rational conjecture? To begin answering this question, we need to look more closely at certain of the images set down by Breton and Soupault. In doing so, let us limit ourselves, for now, to examining effect, without speculating upon cause.

Reduced to its simplest terms and functioning on the most elementary level, the verbal image takes the form of a simile, having the uncomplicated but practical purpose of comparing one thing to another. Conventionally, the simile establishes a comparison with which all can agree, even though it may take some people longer than others to reach agreement with the writer. Here the basis for comparison is underlying similarity, identified by reason. So far as the simile presents a degree of admirable adventurousness, and hence of originality, it does so when the writer has managed to detect a similarity where others have not seen it before and where they become responsive to its existence only after he has brought it to their attention. The boldness of his image is thus held in check. Everything depends on how far he can take us from the first element of his simile to the other before common sense intervenes to question whether, indeed, there can be a relationship between them.

The mechanism of the simile can be seen in operation in *Les Champs magnétiques*. The results it gives are noticeably different, though, from those to which we are accustomed. Here the simile does not round off significance in a manner reason can approve and in a way that confirms reason in its role of arbiter of acceptable meaning. Instead, denying reason the right to set terms to meaningful communication, it expands sense. The simile has not returned to its point of departure by telling us things are exactly what they appear to be. On the contrary, it has opened up a perspective in a direction where reason cannot guide us and, in fact, would have us believe there is no purpose in traveling. The word "like" has ceased to be reassuring proof of the immutability of habitual experience. It now marks the departure point for experiences generated by an entirely new associative scale: "Notre squelette transparaît comme un arbre à travers les aurores successives de la chair où les désirs d'enfant dorment à poings fermés" ("Our skeletons show through like a tree through the successive dawns of flesh in which the desires of children sleep soundly" [literally: "with clenched fists," p. 17]). Far from reaffirming the validity of the status quo, the surrealist simile rocks the supposedly solid base of the familiar. Where the first element of the simile takes us off guard and appears to call for some excuse, if not for an explanation, no reconciliation with reason's demands is forthcoming. Louis Aragon's poem "Serrure de sûreté," in *Le Mouvement perpétuel*, introduces us to a bolt that turns like a tongue ("Le verrou se remet à tourner comme une langue"). Here "like" opens the door on wonder. The same is true of the first line of a well-known poem from Eluard's

L'Amour la poésie: "La terre est bleue comme une orange" ("The earth is blue like an orange"), and also of a verse in "L'Armoire du soleil," from Jehan Mayoux's *Au Crible de la nuit:* "La mer riait comme une enclume" ("The sea was laughing like an anvil").

Where, to begin with, the simile apparently requires no explanation and therefore can pass without justification, it may well end, after all, in resistance to reasonable projection. In *Les Champs magnétiques* we read, "Entre les multiples splendeurs de la colère je regarde une porte claquer comme le corset d'une fleur ou la gomme des écoliers" ("Between the multiple splendors of wrath, I watch a door slam like the corset of a flower or the school children's eraser" [p. 83]). The surrealist simile precipitates us into situations where habit, routine, and educated response guarantee nothing but surprise.

The comparison established by way of conventional simile is no more than implied in metaphor. Consequently, the latter seems to betoken greater sophistication, on the plane of association as well as in linguistic terms. Given the liberty granted similes in surrealist writing, we can expect to see metaphors widening the gap between rational discourse and the language of surrealism. Numerous metaphors follow the pattern set by this one in *Les Champs magnétiques*, presenting words passing by as a triangular, furtive flight: "Des paroles passaient: c'était un vol triangulaire et furtif" (p. 53). The first verse of Jean Arp's "Les Pigeons quadrangulaires" in *Le Siège de l'air*, assures us that the hat is a square navel ("le chapeau est un nombril carré"). In the third chapter of Georges Schehadé's *Rodogune Sinne,* a flower is said to be a bird of salt ("Une fleur est un oiseau de sel").

In the example cited from *Les Champs magnétiques* words are not said to pass like flying birds; they *are* a flight, at once triangular and furtive. Through adjectives, one concrete visual impression is connected with another. Suggestively interpretive, the latter introduces human characteristics and motives into a situation where rational thought can detect no reason for their presence. The surrealist adjective removes the substantive it qualifies from the world of habitual experience: "Monte Carlo" in Arp's *Le Siège de l'air* speaks of "geometrical fire" and "vegetation of exhumed breath."

Where animism is a feature of the surrealist image, its function is not like that of literary anthropomorphism, to enliven the picture by means of figurative language. Instead, it introduces a dislocative factor for which there is no accounting on the level of rationality. In a poem of Arp's about an elephant in love with a millimeter ("l'éléphant est amoureux du millimètre," in *Poèmes sans prénoms*) a crayfish has the

bestial voice of a raspberry. In another, "Violettes rouges" ("Red Violets") from *Le Siège de l'air*, "the court of flowers wheedles and laughs in kneeling light" ("la cour des fleurs se cajole et rit dans une lumière agenouillée"). Among Georges Hugnet's *40 poésies de Stanislas Boutemer* is "L'Heure du berger," where we read of an evening dress running and crying out in a forest clearing ("Une robe de soirée courait et criait dans la clairière"). Eluard's "L'Univers-solitude," from *A Toute Epreuve*, has a flaming window where thunder shows its breasts ("Une fenêtre enflammée / Où la foudre montre ses seins"). An untitled poem in Mayoux's *Ma Tête à couper* refers to the intelligence of firedamp, described in Aragon's "Tant pis pour moi" (*Persécuté Persécuteur*) as jumping (or exploding) "with a long sound of broken luxury" ("Ainsi que le cœur qui se déchire au début de l'absence / le grisou sautera dans Paris / avec un long bruit de luxe brisé").

Aragon begins with a banality—his allusion to a heart broken by absence—only to move on quickly to a picture that owes nothing to literary commonplace: jumping or exploding firedamp. The movement of his poetic statement accords perfectly with the characteristic tendency of surrealist metaphoric language to take a direction divergent from that to which literary tradition and rational association and deduction have accustomed us. If a metaphor begins innocuously, it does so the better to depart from the predictable. In *Les Champs magnétiques* Breton and Soupault present avarice as a fine sin, but this is a sin covered with seaweed and sunny incrustations ("L'avarice est un beau péché recouvert d'algues et d'incrustations soleilleuses" [p. 28]). The world of the surrealist allows us to draw no firm distinction between the concrete and the abstract. Here they commingle disconcertingly in ways common sense would dismiss as unacceptable. The tangible and the intangible appear to contaminate one another in such a manner that reason cannot handle what comes before it. "They wrap their icy words in silver paper," we read in *Les Champs magnétiques* ("Ils enveloppent de papier d'argent leurs paroles glaciales" [p. 18]). Who are they who treat words like this? The cadavers of broken trees, of course. They inhabit the universe of *Les Champs magnétiques* next to the stupid rigging of the air that forms monkeys who soon understand they have been made fun of and uncoil their tails of hardened steel ("Les agrès stupides de l'air, avant d'arriver, forment des singes qui comprennent vite qu'on s'est moqué d'eux. Ils détendent leur queue d'acier trempé" [pp. 41–42]). This is a universe where, inhabitant of "the nubile space of love"—according to Char's

"Métaux refroidis" (*Poèmes militants*)—"the verdigris of spades is going to blossom" ("Habitant des espaces nubiles de l'amour / le vert-de-gris des bêches va fleurir"), where Joyce Mansour sees herself in "Pericoloso Sporghesi" (*Rapaces*) floating naked "between the flotsam with moustaches of steel / Rusted by dreams interrupted / By the soft ululation of the sea" ("Nue / Je flotte entre les épaves aux moustaches d'acier / Rouillées de rêves interrompus / Par le doux hululement de la mer").

We have seen enough for one thing to have become very clear. Imagery in surrealism takes on a very distinctive quality indeed. To the surrealist writer, treating the image as a mental picture does not mean simply provoking a mental representation that will recapture the familiar or even give an intimation of some unusual or strange aspect of life. Through his use of imagery, the surrealist ventures outside the boundaries of the real world, so called. He moves into zones of experience for which our waking life offers no precedent. Breton and Soupault were among the first to demonstrate how linking words in defiance of common sense can afford glimpses of a new reality.

What forms does that reality take? What authorizes considering it the higher reality to which the substantive "surreality" refers? These are among a number of fundamental questions to which no one would have found it easy to supply answers in 1919. Only when they looked back later on did Breton, Soupault, and the other surrealists find themselves in a position to appreciate the importance of *Les Champs magnétiques* as the first sustained piece of writing specifically surrealist in nature. Viewed from the vantage point provided by André Breton's *Manifeste du surréalisme,* published in 1924, *Les Champs magnétiques* emerged as a document of unquestionable importance in the history of surrealist activity. In other words, the primary value of the first surrealist manifesto is that it codified a theory of surrealism, formulating basic principles. The latter made sense of and gave positive direction to "five years of uninterrupted experimental activity" which, as Breton was to emphasize in *Entretiens* (p. 77), dated back to the text he had written in conjunction with Soupault.

The 1924 manifesto is a pivotal work for this very reason. Retrospectively, it *situated* experiments like *Les Champs magnétiques,* the first extended exploration of the realm of automatic writing. At the same time, it laid down a theoretical platform without which argu-

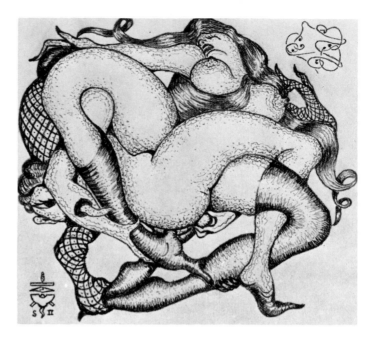

Pierre Molinier, *The Great Combat No. 2.* 1965–66.
Drawing. Collection of the artist.

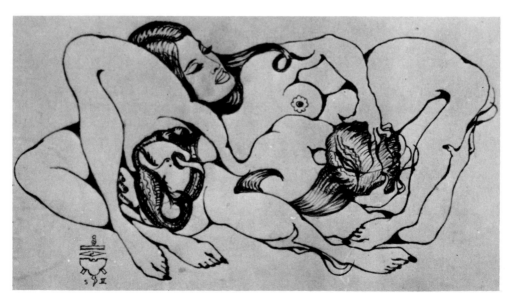

Pierre Molinier, *Women in Love.* 1965–66. Drawing. Collection of the
artist.

ments presented and defended, hypotheses advanced and tested, and avenues explored in the name of surrealism, through many years thereafter, would be less comprehensible than they are. The unity of purpose linking all vigorous modes of surrealist inquiry would be lacking. In short, Breton's manifesto casts light on the imagery of works like *Les Champs magnétiques* and others sometimes markedly different in character, in a way that helps us understand how much the ambitions pursued by surrealist writers have in common with those of surrealist painters. To understand even better, though, we have to turn to Breton's second manifesto.

The *Second Manifeste du surréalisme* came out in the twelfth and last number of the magazine *La Révolution surréaliste* on December 15, 1929, before separate publication in June of 1930. Opening it, we find here an emphasis apparently different from the one characterizing the first manifesto. True, Breton still speaks of the idea of surrealism as tending quite simply toward "a total recuperation of our psychic strength by a means none other than vertiginous descent into ourselves, systematic illumination of the hidden places and progressive darkening of the other places, a perpetual walk in the forbidden zone" (pp. 167–68). All the same, in his very first paragraph he presents surrealism as having tended to provoke a general and serious "*crisis of consciousness,*" perceived "from the intellectual and moral point of view" (p. 153). Historically, he argues, the success or failure of surrealism are to be measured by its success or failure in achieving that goal. The essential question, now, seems to be the following. "What indeed could be expected of the surrealist experience by those who retain some concern for the place they will occupy *in the world?*" (p. 154). The stress appears to have shifted somewhat. Breton stigmatizes "the baseness of western thought" as well as calling yet again for "insurrection against logic" (p. 158). We soon find an indisputable sign of his intolerance with respect to any "apparatus of social conservation" (p. 159)—his declaration that surrealists are devoted, totally and without any reservations, to the principle of dialectical materialism (p. 173).

Just when we have begun to suspect Breton intends to make his new manifesto a sociopolitical tract, we come upon this assertion: "The problem of social action is, I should like to return to this and insist upon it, but one of the forms of a more general problem surrealism has set about raising and which is that of *human expression in all its forms.* Whoever says expression says, to begin with, language. You must not

be surprised, then, to see surrealism situated first of all almost exclusively on the plane of language . . ." (p. 183). This statement redresses the balance, with respect to André Breton's remarks on sociopolitical matters. In addition, it places the surrealist use of language in a perspective from which we have not had occasion to consider it, up to now.

Because the surrealist revolution first began to make its effects felt upon the use of words, it seemed perfectly natural and altogether fitting to treat surrealism as a mode of literary experimentation, revolutionary so far as it exemplified revolt against established conventions of literary composition. The insistence with which surrealists referred to poetry, from the beginning, lent itself to interpretation in one light only: as indicative of ambitions that appeared accurately definable within the framework of literature. It seemed a minor detail that surrealists consistently spoke of poetry (as they understood it and wished to see it practiced) as being in conflict with literature, as it had been and was still being practiced. Perhaps it was too early, during the twenties, to see that real progress with surrealism is not merely slow but actually impossible, if surrealists are thought to have begun treating language as they did out of concern for literature, in the hope of doing something for literature, and with purposes encompassed by literature. It is no less fundamental an error to suppose they mounted their attack upon language simply because, in western Europe, literature is far more vulnerable than the products of social forces and of political theory.

To bring things into focus, we have to start by accepting the following. Surrealists have never ceased treating rational language as the outgrowth of a certain kind of oppressive civilization. Meanwhile, the language of myth and legend—so admired in surrealism—appears to them suggestively expressive of another culture entirely. The latter may be known, generally, as primitive. It is still altogether preferable, in their eyes. Michel Leiris' evolution from the surrealist author of *Glossaire, j'y serre mes gloses* and *Haut Mal* into the ethnographer who wrote the classic *L'Afrique fantôme* is not really a surprise. Nor is the fascination with folklore that led Benjamin Péret to assemble his bulky *Anthologie des Mythes, légendes et contes populaires d'Amérique,* or the interest in ritual masks to which we owe Jean-Louis Bédouin's *Les Masques.*

Commenting on *Glossaire, j'y serre mes gloses,* Antonin Artaud remarked, "Yes here now is the only use to which language can be put henceforth, a means for madness, for eliminating thought, for making

a break, the maze of unreason, and not a DICTIONARY in which certain ill-bred pedants from around the Seine [the French Academy] canalize their spiritual shrinkage." *Glossaire* and Artaud's comments on it appeared in the third number of *La Révolution surréaliste*. Put together by Artaud, that number of the French surrealists' first magazine carried an open letter to the chancellors of European universities, an open letter to the directors of insane asylums, an address to the Pope, and an introductory piece titled "A Table." All unsigned, these texts were written by Artaud, who castigated western thought and religion. On the same occasion he published an address, appealing to the Dalai Lama to send illumination "in a language that our contaminated Europeans' minds can understand" and confessed in a letter to the schools of Buddha, "we are suffering from rot, from the rot of Reason."

Rationality is the surrealists' *bête noire*. It is to be driven out for reasons that have nothing to do with the ambition of promoting a new literary mode or fashion. Rejection of rational sequence, whether by automatic writing or by any other method, constitutes a radical innovation that by far exceeds the narrow limits of literary communication. It represents defiance of the civilization all surrealists hold responsible for inculcating rational thought and for virtually discrediting everything with which rational thinking cannot cope and therefore refuses to accept. Poetry, to the surrealist, resides in challenging rationality and, with it, the society in which rational processes find encouragement. In consequence, poetry is revolutionary to the extent that departure from rational norms implies criticism of society's usages, laws, and regulations. Benjamin Péret vigorously develops an outline of the surrealist argument in the preface to his *Anthologie des Mythes* (originally published separately in New York as a pamphlet entitled *La Parole est à Péret*) and in his diatribe *Le Déshonneur des poètes*, directed against a collection of patriotic verse, *L'Honneur des poètes*, which had appeared clandestinely in France during the German occupation of the forties and in which Péret could not point to even one text that rose above "the lyrical level of pharmaceutical publicity."

Younger surrealists see no cause to disagree with Péret. Reviewing the history of surrealist activity from 1924 through 1975, Vratislav Effenberger and Vincent Bounoure comment in a volume edited by the latter under the title *La Civilisation surréaliste:*

> Duly taking into account the judgment passed by the founders
> of surrealism on the historical, geographical, sociological and especially

cultural circumstances that surrounded its birth, it is worth pausing over the general evolution of societies through aberrant formalization to observe that this evolution engenders a permanent malaise in the social edifice by rendering the satisfaction of primordial needs uncertain and that for this reason, it provokes the opposition of men who, first attacking the most painful symptoms of the malady, fairly soon reach the point of indicting more fundamentally the type of civilization in which they live. It becomes obvious to their mind that this civilization suffers from a truly congenital neurosis, as is shown by its language and the architecture according to which the civilization is constructed. (p. 25)

Surrealists everywhere associate confinement of language within the narrow framework of rational discourse with a form of civilization that has fostered language of this restrictive kind. An outsider reasonably might suppose from the evidence surrealists adduce that the best way to strike a blow for freedom would be to turn civilization's logical language back against it, through elaboration of texts developing political themes, utopian philosophy, or inflammatory ideas—in short, through propaganda. Surrealists have always preferred a different route altogether.

It was Benjamin Péret who set the purest example. Like Aragon, Breton, Eluard, and Pierre Unik, he joined the Communist Party during the twenties. Within days of the expulsion of Trotsky and Zinoviev from the Russian Communist Party in November 1927, the surrealists withdrew, Péret among them. Whereas their experiences were to leave Breton wary of direct participation in political causes, Péret, a Trotskyist, moving to Brazil in 1929, joined the Liga Communista (Oposicão) in 1932. The consequences were a term of inprisonment followed by expulsion from Brazil. Coauthor with G. Munis of *Pour un Second Manifeste communiste,* published under the auspices of a group called Fomento Obrero Revolucionario, Péret found himself recalled to military service in France in 1940. Within months he was in prison once again, for political activism.

The important thing to notice in all this is that few of the political subversives with whom Péret worked side by side knew he wrote poetry. Moreover, his lifelong dedication to the cause of social revolution did not influence in any perceptible way the kinds of poems and short stories he wrote. How many of his political friends would have recognized the man they knew in the author of *Dormir, dormir dans les pierres* (*To Sleep, to Sleep in the Stones*) or *Le Gigot, sa vie*

et son œuvre (*The Leg of Mutton, its Life and Works*)? All the same, Benjamin Péret was not two contradictory people in one. He went to Spain—where he was to serve on the Aragonese Front as an anarchist militiaman—the year he published a major collection of poems, *Je sublime*. His *Manifeste des exégètes*, confirming his break with the IVth International, came out in 1946, the same year as his story collection *Main forte*. His series of articles attacking the trade-union movement appeared in the newspaper *Le Libertaire* (July–September, 1952), the very year he brought out the long poem celebrating his period of residence in Mexico, *Air mexicain*. For Péret, political and poetic action were complementary. But this was far from meaning poetry must be placed at the service of politics. Poetic revolution, so Péret taught by example, has nothing to do with the dissemination of ideological precepts. Hence he did not seek to foment revolt by committing poetry to the cause of political ideology. Instead, he confided in *De derrière les fagots* (*Rank Outsider*):

> Je m'étonne de l'orthographe de *fois*
> qui ressemble tant à un champignon
> roulé dans la farine

> (I'm surprised at the spelling of *times*
> that so resembles a mushroom
> rolled in flour).

To Péret, poetic revolution appeared as centered once and for all upon the image, the very core of the poetic experience. Precisely because this was so, Péret's attitude may be considered typical of that of all true surrealists. It is on the level of imagery, certainly, that the surrealist writer's revolt against inherited and imposed forms and techniques has the same origins and the same ultimate aims as the surrealist painter's.

In 1935, as leading French surrealists, André Breton and Paul Eluard were invited to Prague for the opening of an International Exhibition of Surrealism, running there in late March and early April. The occasion was marked by an important lecture on the "Situation surréaliste de l'objet," in which Breton declared that the art of imitation had had its day. Now, he went on to assert, the problem of art

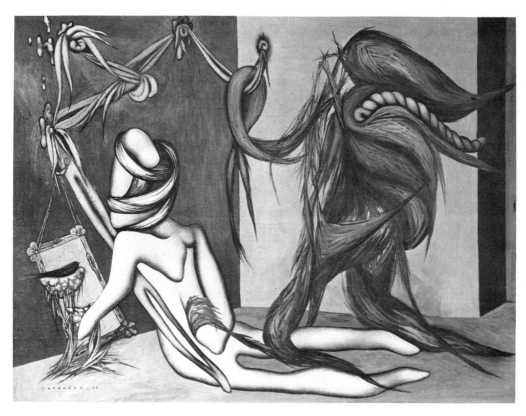

František Janoušek, *The May Evening*. 1936. Oil on canvas. Collection of the artist.

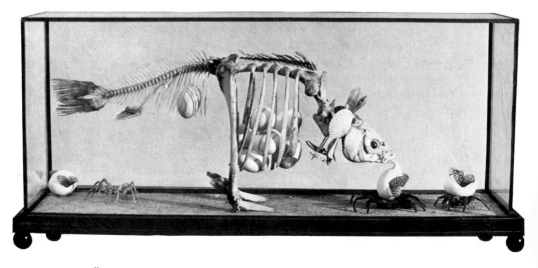

Jan Švankmajer, *Cabinet of Natural Sciences*. 1972. Object. Collection of the artist.

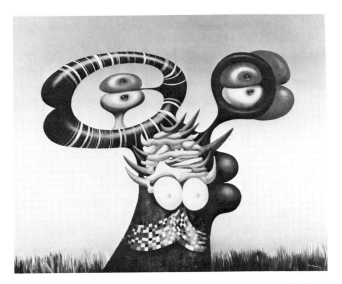

Jules Perahim, *Love Letter*. 1973. Oil on canvas. Collection of the artist.

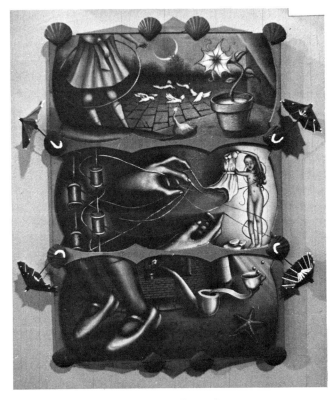

Ronald L. Papp, *My Pet Ophelia*. Oil on canvas.

consisted in "bringing mental representation to a more and more objective precision, by deliberate exercise of imagination and memory." Hence the greatest benefit surrealism so far had derived from this sort of operation was, he suggested, "to have succeeded in reconciling *dialectically* those two terms, violently contradictory in adult man: perception and representation," to have erected "a bridge" over the "abyss" separating them: "Now already surrealist painting and construction permit, around subjective elements, the organization of perceptions of objective tendency." By their very tendency to impose themselves as objective, these perceptions present a bewildering, revolutionary character "in the sense that they call imperiously, in outer reality, to something that replies to them." Breton foresaw that this something *would exist.*[1]

In part, to be sure, Breton was acknowledging the effect of historical developments that could not be denied. As early as 1920, after all, he was gladly admitting that the invention of photography "has dealt a mortal blow to the old modes of expression, in painting as well as in poetry." Since the nineteenth century, he noted, artists have aspired to "break with the imitation of appearances."[2] In addition, though, his 1935 lecture led up to something far more significant than mere acceptance of historical circumstance. Typically confident in surrealism's destiny, Breton's remarks in Prague rested squarely on an article of faith familiar to readers of the first edition (1928) of his *Le Surréalisme et la peinture:* "Everything I love, everything I think and feel, inclines me to a particular philosophy of immanence, according to which surreality is contained in reality itself, and is neither superior nor exterior to it. And conversely, for the container is also the content." Hence Breton's firm rejection of any attempt, in painting or writing, that would have the "confining consequence of withdrawing thought from life, just as much as placing life under the aegis of thought" (p. 46).

Initially, the outsider may feel entitled to interpret creative surrealism as purely escapist in nature. However, this is only because he has not had time yet to grasp what Breton meant when explaining in *Le Surréalisme et la peinture* "we refuse as tendentious, as reactionary, any image the painter or the poet proposes today of a stable universe in which the small pleasures of the senses not only could be tasted but extolled." Looking into José Pierre's *Position politique de la peinture*

[1] André Breton, "Situation surréaliste de l'objet" (1935), in his *Manifestes du surréalisme*, pp. 332–33.
[2] André Breton in Max Ernst, *Beyond Painting*, p. 177.

surréaliste we find him stressing essentials, when he points out that, where Reich and Marcuse dread the desexualization of man by sublimation, "Breton dreads his depoetization and the subordination of art to 'the manifest content of a period' "[3] (p. 22).

It is not by turning his back resolutely upon reality that the surrealist artist can hope to produce creatively. It is in directing his attention away from its manifest content toward what Breton termed its latent content. This is why, the year before the first version of *Le Surréalisme et la peinture* came out, Breton was insisting, "It would have been useless to rebel against the exterior distribution of objects, if it were not one day to put questions to something other than the shadow of these objects."[4] Breton's conclusion, as summarized in March of 1942, was that painting and poetry, each in its own domain, "necessarily had to apply themselves one day to finding once again the path leading . . . to the most profound depths."[5]

Breton's argument lacked clarity. It sounded as though he were taking refuge in vagueness. All the same, he spoke distinctly enough for the surrealists. His words find an echo when we are listening, for instance, to René Magritte, whose work confronts us, as perhaps no other does, with the pressing need to go beneath the surface of pictorial representation if we are to penetrate its meaning as image. Referring to his famous early picture *Le Jockey perdu* (depicting a jockey urging his horse through a forest in which the tree trunks are chair or table legs, turned on a lathe), Magritte spoke of it as "conceived without esthetic preoccupation, with the sole aim of *responding* to a mysterious feeling, to an anguish 'without reason,' a sort of 'call to order,' which appears at non-historical moments of my consciousness and which, since my birth, gives my life direction."[6]

If we look, at this point, at Lautréamont's celebrated image evoking a fortuitous encounter on-a dissecting table between an umbrella and a sewing machine, we soon see why it rapidly gained unrivaled popularity among surrealists the world over. Long before they began to speak for themselves, Lautréamont had arrived at a remarkably succinct summary of the aims they were to consider important, in an

[3] André Breton, "Limites non-frontières du surréalisme" (1937), in his *La Clé des champs*, p. 19.
[4] See Max Ernst, *Beyond Painting*, p. 182.
[5] André Breton, "Ce que Tanguy voile et dévoile," in his *Yves Tanguy*, p. 35.
[6] Quoted in Patrick Waldberg, *René Magritte*, pp. 251–52. *Cf.* André Breton's essay, "Le Bouquet sans fleurs," *La Révolution surréaliste*, No. 2 (January 15, 1925), p. 25, where we are told that surrealism calls for "isolating that mental substance common to all men, that substance up to now defiled by reason."

Wilhelm Freddie, *Sex-Paralysappeal.* 1936. Object. Modern Museet, Stockholm. Photo Jørn Freddie. This was one of the works exhibited during Freddie's *Sex-Surreal* show of 1937, all confiscated by the police. The artist was sentenced to be fined and imprisoned. *Sex-Paralysappeal* and two paintings were retained by the authorities and deposited in the Copenhagen Criminological Museum. In 1961 Freddie announced his intention of copying all three works and of showing the copies, if the originals were not returned. When he exhibited them the police closed the show, confiscating the copies. In 1962 the two paintings were returned to the artist but *Sex-Paralysappeal* was pronounced an offense against public decency and the artist was offered the alternative of a fine or another ten days in jail. *Sex-Paralysappeal* was not returned to Wilhelm Freddie until the end of May 1963.

image anticipating some of the main characteristics of surrealist expression. He brought together two objective forms, familiar to us all. In themselves, these forms, immediately identifiable from daily experience, seem to have no appeal outside the limits of practical utility. Hence emotion enters the word picture only where the third figurative element, a dissecting table, calls forth feelings that may range all the way from a mild sensation of disturbance to downright terror. The emotions liberated by the presence of the table do nothing, of course, to explain or justify in commonsense terms why a sewing machine and an umbrella should be meeting at all. In fact, it is more likely to heighten than diminish the impression recorded in the reasoning mind that the encounter we are witnessing is gratuitous, devoid of meaning, even. Reason's failure to furnish a basis for response to the picture Lautréamont leaves in our memory is a direct result of rational thought's resistance to the idea that such figurative elements as those he introduces have the right to come together and are likely to do so. The beauty of the Lautréamont image can catch and hold the imagination only after reasoned objections have surrendered to irrational forces released through associations evoked by the dissecting table— the locus where the strange encounter takes place.

The consequences of the posture surrealists adopt before reality are far-reaching and complement one another in verbal poetry and painting. Breton's unqualified approval of the theory that any word combination, without exception, is permissible stood for a confidence to which his philosophy of immanence lent weight. And this confidence has its counterpart in other surrealists, whose medium does not happen to be that of words.

In an essay on poetry by André Breton we read: "Language can and must be preserved from the usury and discoloration that result from its function of elementary exchange."[7] Surrealist dialectic rests on the premise that readily interpretable communication (that is, naturally, rationally interpretable communication), in whatever the artist's chosen medium, must be limited to the level of elementary exchange, or, as Breton called it more than once, "immediate exchange." Surrealists do not doubt that common sense is to be discarded in favor of another kind of sense, "pressing, divinatory," which they believe "guides man where he wants to go without knowing it." The artist must consent, therefore, to being borne along in the direction of the unknown. He must surrender intelligent criticism of his own

[7] André Breton, "Le Merveilleux contre le mystère" (1936), in his *La Clé des champs*, p. 11.

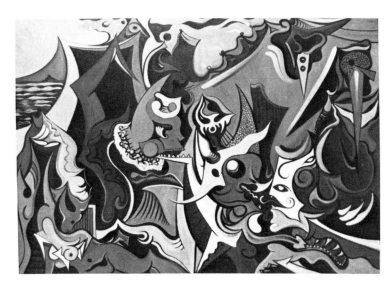

Thom Burns, *Island of Uncertain Hours*. Oil on canvas.

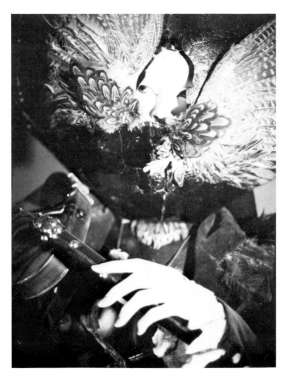

Jean-Jacques Jack Dauben, *Sade's Juliette*.
1976. Object.

actions, for the compelling reason that "lucidity is the great enemy of revelation."[8] In his *El arco y la lira* Octavio Paz has pointed out that when language is used for the purpose of immediate exchange, the word loses many of its plastic, sonorous, and emotive values. It "grows thin and weak," in fact. "All its values are extinguished or decreased, at the expense of the relation value" (p. 36). Dedicated to the mental and emotional liberation of mankind, surrealists abide by the principle categorically laid down in Breton's preface to the catalog of an international surrealist exhibition in Prague at the end of 1947: "IN ART NO PRESCRIBED ORDERS EVER, WHATEVER HAPPENS!"

Since Breton's words lend themselves to misinterpretation as advocating total anarchy, it is important to understand in which way they apply positively to the surrealist creative act. We can begin doing this by returning to Magritte's declaration that he painted *Le Jockey perdu* with no esthetic preoccupations in mind.

On the one hand, surrealists have opposed assimilation of poetry by literature. On the other, just as firmly, they have refused to treat painting as one does conventional art. Those who dismiss the distinctions persistently emphasized in surrealism, regarding these as at best fastidious and in all probability without real foundation, are guilty of doing surrealism a disservice. More than this, they deny themselves the possibility of really comprehending its scope and true meaning. There is, in surrealist theory, a noteworthy degree of identification— sometimes made more explicit than at others—between acquired technical expertise and the obscurantism of rationalism. In his *Donner à voir* Paul Eluard challenges the traditionally held view that the harmony of a poem comes from its "more or less skillful, more or less felicitous assemblage of vowels, consonants, syllables, words" (p. 142). Evidently Eluard speaks for surrealists in general. They are all persuaded that, for instance, the contribution of rhyme—and, coincidentally, of sound associations upon which rhyme depends—promises only pedestrian results in poetry. Contending that poetic language must be universal, Breton observed in the course of his lecture "Situation surréaliste de l'objet" that "the error made by Mallarmé and a number of the Symbolists" none the less will have had a salutary consequence: "provoking general mistrust with regard to what constituted, before then, the accessory, accidental elements wrongly taken to be

[8] André Breton, "Le Merveilleux contre le mystère," p. 10.

the indispensable steering wheel and brake for the *ars poetica*," in other words, "quite exterior combinations," such as meter, rhythm, and rhyme (pp. 314–15).

Elsewhere, in the preface to a catalog reprinted in *Le Sur-réalisme et la peinture*, Breton did not hesitate to call the painting of Degottex a "crucial experiment," easily recognizable as such by those who "know that painting—like poetry—has value not for the effect it produces but for the quality, the purity of the means it applies" (p. 341). This last remark would be puzzling if it did not stem from Breton's conviction, shared by his fellow surrealists, that purity of means—those means by which man liberates expression from the supervision of reason—calls for denial of esthetic concerns. Joan Miró brings things into focus when confessing, "Surrealism pleased me because the surrealists did not consider painting as an end in itself."[9] So does René Magritte, when pointing out, "People in fact know nothing about what my pictures show. Pictures and ideas have the same importance in the measure that they are capable of obliging us to consider them as approximations."[10]

A surrealist picture by Salvador Dalí possesses, as image, a value quite independent of certain painterly qualities, many of which the critics have deemed reactionary. The distance separating surrealist criteria from those applied by art critics may be estimated if we contrast Sidney Tillim's—as implied in his judgment, "The Surrealists had nightmares because they couldn't paint too [*sic*] well"[11]—with André Breton's comment on the painting of Max Walter Svanberg, to the effect that the criteria currently presiding over the appreciation of painting done by surrealists appear "ridiculous in the presence of work like this."[12] In the case of some important graphic products of surrealism it is no paradox, and no excuse, either, to say that surrealists deny painterly technique in the interest of the image. Attention is directed primarily to what is shown, made visible (Eluard's phrase *donner à voir* is significant, obviously). The way visual effects have been obtained is quite definitely of secondary interest here. Eloquent

[9] Joan Miró, "Je travaille comme un jardinier," interview granted Yvon Tallandier in *XXᵉ Siècle* (1964). Almost thirty years earlier Max Morise made the surrealist position on painterly technique quite clear in his comments "A propos de l'exposition Chirico," *La Révolution surréaliste*, No. 4 (July 15, 1925), 31–32.
[10] From an interview granted Jean Stevo in 1946, reproduced in the special Magritte number of *L'Art Belge* (1968), p. 45.
[11] Quoted in Lucy Lippard, *Surrealists on Art*, p. 2.
[12] André Breton, "Hommage à Max Walter Svanberg," *Médium: communication surréaliste*, Nouvelle Série, No. 3 (May 1954), special Svanberg number, p. 2.

testimony to this underlying feature of surrealist creativity is the out-
dated meticulousness of photographic realism, as revived by Dalí, or
the customary flatness of a Magritte canvas, where perspective receives
cursory attention at most.

The scope of surrealism's intervention in the realm of painting
cannot be defined so long as one treats as empty rhetoric Miró's dec-
laration that it was his intention to "murder painting," his assertion,
"I thought it necessary to go beyond the 'plastic fact' to attain
poetry,"[13] and his explanation in a letter to James Thrall Soby that his
goal was to "transcend the purely plastic fact to reach other
horizons."[14]

Parallel to the surrealists' dismissal of literature as unacceptably
limited in function runs their determination to make painting more
than art. In verbal and pictorial surrealism the formal restraints con-
ventional views of literature and art have condoned and even fostered
must be challenged, not only in the minds of the public but also in the
sensibility of the creator. This is why José Pierre talks of the "absolute
certainty of mediums," of the "total freedom of the insane," and of the
"total lyricism of primitives" as all representing the idea to which the
true surrealist painter reaches out. The models Pierre cites are mani-
festly indifferent to esthetic concerns, as inculcated by western culture.
So Svanberg insists pertinently, "However, it cannot be repeated often
enough that, for me, technique always remains the means and can
never be the end."[15]

In a 1941 essay reprinted in his *Histoire de ne pas rire*, Paul
Nougé termed "singularly fruitful" the surrealists' freedom with respect
to the means they apply in all areas of creative activity. On the same
occasion he denounced any painter's submissiveness to technique, any
writer's to writing—in short, the artist's submission to mannerism (p.
143). His viewpoint is shared by Octavio Paz: "When a poet acquires

[13] This is why at the time when he was painting *Le Carnaval d'Arlequin* (1924–
25)—a period when he would produce drawings in which he recorded hallucina-
tions brought on by hunger—Miró was much in the company of poets. See his
"Je rêve d'un grand atelier," *XXᵉ Siècle* (May–June 1938), p. 27.
[14] James Thrall Soby, *Joan Miró*, p. 10.
[15] Max Walter Svanberg, "Mina olika tekniker," in *Max Walter Svanberg: Grafik*,
p. 37. This statement finds expansion in Svanberg's response to an inquiry into
the "Situation de la peinture en 1954," conducted by Estienne and Pierre: "But
to try to reach full beauty with colors and lines as one's sole end seems to me
an absurd pretension, unworthy of art. That supreme beauty could not be reached
except through the play of the irrational by way of poetic timeless figuration, excit-
ing to the imagination, and in which the lines and colors will remain means"
(p. 111).

a style, a manner, he stops being a poet and becomes a constructor of literary artifacts" (p. 7). Surrealists all mistrust the estheticism that dignifies technique. This fact explains Gérard Legrand's contention that painting begins to be interesting only in its "negativity" and his argument that the same holds true of poetry.[16] During his period of association with the surrealists, Max Ernst situated his own effort "beyond painting." Louis Aragon entitled his important preface to a major exhibition of surrealist collages *La Peinture au défi* (*Painting Defied*).

A characteristic note appears in an English surrealist magazine:

> In his article on Dylan Thomas and the surrealists (*Seven* N° III) Henry Treece might have borne in mind that artistic value is not a poetic virtue. Also that surrealist poetry is not a party game but is conceived out of an inner necessity (though this may be a reaction to an external influence). Whereas Dylan Thomas provides cut flowers the true surrealist hands out the living plant. Immaculately conceived poetry (which is the true definition of surrealist productions) being to verse what the mating-call is to the sophisticated protestation.[17]

On the same page we find reproduced a collage by Max Ernst, who once confided, "Plastic expression is not my dominant preoccupation. . . . Painting is not for me either decorative amusement or the plastic interpretation of felt reality. It must be every time: invention, discovery, revelation."[18] The standpoint adopted by Jouffroy in his *Brauner* is consistent with Ernst's:

> General indifference with regard to poetry has as its equivalent only that manifested by lovers of modern art with regard to the *content* of pictorial works. The only impassioned commentaries occasioned from time to time by the latter are of an exclusively esthetic order. Every discussion of an artist's intentions and of the psychological implications of his pictures comes to grief on two rocks prepared in advance by the rhetoric of banality: the "message," considered as an obsolete and ridiculous pretension, and "literature," synonymous, for esthetes, with the most futile chatter. Thus painting is relegated to the utilitarian domain of decoration. (p. 10)

[16] See Estienne and Pierre, "Situation de la peinture en 1954," p. 44.
[17] *London Bulletin*, No. 12 (March 15, 1939), p. 21, signed A. E. [Ainslee Ellis?].
[18] Quoted in Simone Arbois, "Visite à Max Ernst," *Paru*, No. 59 (April 1950).

Only by advancing in the direction Ernst and Jouffroy both indicate can we expect to appreciate why surrealism is neither a school of painting or poetry nor a technique a painter or writer may borrow when the mood takes him. Strictly speaking, in fact, surrealism is neither painting nor verbal poetry. For this reason, beginning his *Le Surréalisme,* José Pierre promises to address himself to "a surrealist activity borrowing the means of painting" (p. 9). To do otherwise would come down to treating the surrealist who paints as no better than the "conscientious fabricator of sonnets and other poems in regular form," condemned by Pierre on another occasion.[19]

The question now facing us is the one Breton raised in *La Clé des champs* (pp. 100–101). If the criterion permitting us to identify a painting as surrealist is not esthetic, how then are we to know whether a work merits classification as surrealist?

As Breton explains it, surrealism stands between realism, understood as the mere reproduction of immediate reality, and abstractionism—abhorred by surrealists everywhere because it submits the material it presents to formal imperatives ruled out by surrealist doctrine and considered to be irrelevant, not to say definitely negative in effect. Within these broad limits, beyond which painting appears self-condemned in the surrealists' eyes, the artist enjoys "total liberty of inspiration and technique," Breton stressed in the catalog of an exhibition of surrealist painting in Europe, held in Sarrebruck in 1952. Hence the unity of surrealist conception, "which takes on the value of a criterion," is not to be sought in technique, in the "paths" followed by surrealist artists. It resides, rather, in the profound community of aim shared by all: "to reach the land of desire that everything, in our time, conspires to conceal" and to prospect it in every direction until it "renders up the secret of 'changing life.'" We shall need to look closely at the word "desire" in the context of surrealist thought. Even before we do this, however, we can see that, as *La Clé des champs* emphasizes, a surrealist work qualifies, really, by "the spirit in which it has been conceived" (p. 10).

Traditional, inherited methods can help the surrealist cause little, if at all. They may even be an impediment to success. Hence a pressing obligation faced by its earliest recruits: to discover and implement

[19] José Pierre, "Sifflera bien mieux le merle majeur," *L'Archibras,* No. 3 (March 1968), also in *Princip Slasti.*

new methods, suited to the aims they had set themselves. The *"means that had given surrealism all the others,"* we are reminded in *La Clé des champs,* is the one described in the 1924 *Manifesto of Surrealism* as being at the origin of surrealist inquiry: automatism. It was automatism, indeed, that initially promised to protect creative exploration from contamination by estheticism, so offering the possibility of a form of immaculate conception—to use a phrase we have met already. To give greater weight to his argument, André Breton published his first surrealist manifesto in conjunction with *Poisson soluble,* a practical illustration of the theory of verbal automatism.

Surrealism aims at expansion of mental experience beyond the purview of the rational mind. Something of what is involved can be glimpsed when, after reading the *Manifeste du surréalisme,* we open *Poisson soluble.*

We know André Breton, born under the sign of Pisces, believed man to be soluble in his own thought. But this knowledge hardly persuades reason to entertain the idea of a fish dissolving in its natural environment. The title *Soluble Fish* leads the mind to the brink of the impossible and then entices it over the edge, causing a vertiginous fall into the inconceivable. Now the imagination takes over to operate where reason can no longer function, except negatively.

The images of *Poisson soluble* put rationality to flight and bring imagination into play. A new day has dawned, in the form of a little acrobat ("le jour se mit à poindre, sous la forme d'un petit saltimbanque dont la tête était bandée et qui paraissait prêt à s'évanouir" [p. 100]). Since that day, Breton notes, he has known a man with a mirror for flesh ("un homme qui avait pour chair un miroir, ses cheveux étaient du plus pur style Louis XV et dans ses yeux brillaient de folles immondices" [p. 118]). The flow of language liberated by automatism draws us away from the simple comparison in a direction that the reasoning mind has no alternative to judging the pathway to madness: "He was a young apprentice very handsome under his pink tunic that made him resemble a vat full of water in which a wound had been washed. The head of this water had smiled like a thousand birds in a tree with immersed roots" ("C'était un jeune apprenti fort beau sous sa cotte rose qui le faisait ressembler à une cuve pleine d'eau dans laquelle on a lavé une blessure. La tête de cette eau avait souri comme mille oiseaux dans un arbre aux racines immergées" [pp. 103–104]).

Like that of the young man with a face like a globe with two hummingbirds flying around inside ("ce jeune homme souriant dont le visage était pareil à un globe à l'intérieur duquel voletaient deux

oiseaux-mouches" [p. 105]), the descriptions cited above evidence the transformation of reality through automatic writing. Arms become howling grottoes of pretty animals and stoats ("et tes bras seront des grottes hurlantes de jolies bêtes et d'hermines" [p. 110]). Now the exciting phenomenon of perpetual metamorphosis emerges as fundamental to the surrealist image-work. The stasis of the physical world is defied and the imagination does not have to choose once and for all between two identifiable physical forms just because one is more acceptable to reason than the other. The fold in a piece of material draped over a bed is said to open "sudden sluice-gates of milk or flowers," and Breton reports, "I was at one and the same time in front of a fan of roots and in front of a waterfall" ("Un pli qu'il faisait sur le bord du lit ouvrait des écluses brusques de lait ou de fleurs, j'étais à la fois devant un éventail de racines et devant une cascade" [p. 109]).

Description in no way limits imaginative play. It widens the distance at which automatism permits the writer to stand from reality. Speaking of newspaper advertisements, Breton remarks in *Poisson soluble* that the poor light falling on the boldest print is "sung by great poets with a profusion of details that now allows them to be judged only by analogy with white hair, for example" (" La lumière, d'ailleurs fort chiche, qui tombe sur les caractères les plus gras, cette lumière même est chantée par de grands poètes avec un luxe de détails qui ne permet plus d'en juger autrement que par analogie avec les cheveux blancs, par exemple" [p. 79]). A fold at the bottom of the fourth page of a newspaper gives rise to the following description: "you'd say it has covered a metallic object, to judge by a rusty stain that could be a forest, and this metallic object would appear to be a weapon of unknown form having something of the dawn about it and of a large Empire bed" ("on dirait qu'elle a recouvert un objet métallique, à en juger par une tache rouillée qui pourrait être une forêt, et cet objet métallique serait une arme de forme inconnue, tenant de l'aurore et d'un grand lit Empire" [pp. 78–79]).

While reason reports that it is impossible to visualize the object in question and points out that the descriptive details furnished in Breton's text are to blame for this, Breton imperturbably goes on to record other sights, just as elusive to common sense: for instance, a half-empty glass being stirred on a table of wind, on moonstone evenings ("Par ces soirs de pierre de lune où il remuait sur une table de vent un verre à moitié vide . . ." [p. 114]). At such times, the poet is likely to encounter "the splendid bird of sabotage" (p. 118), as he

lies in wait for the unforeseeable, like laughter coming out of the earth and blossoming at once as sunshades ("Je guette les rires qui sortent de la terre et fleurissent aussitôt, ombrelles" [p. 75]).

Whatever confusion surrealist automatic practice has generated in the minds of its critics, we cannot deny one thing. Automatism fosters methods that stand out with noteworthy intransigence against the norms of a literary creation based in esthetic values. And the same is true in the field of painting.

Speaking of certain pictures significantly associated with the birth of surrealism, a practicing automatist has stated authoritatively, "What was made visible [donné à voir] here, through the contingencies of art, seemed incidentally less to bear the marks of some kind of lyrical intentionality than to come, on the contrary, from a wish to question the real, demanding enough to lead the artist to set down preferentially only those aspects of it most likely to defy understanding."[20] In surrealist art, sacrifice of rational comprehension is deliberately sought through technical means inspired by verbal automatism—means like frottage, fumage, and decalcomania. Techniques of this kind, Adrien Dax observed, present the "incontestable advantage" of reducing "the conscious participation of the artist" who then relies upon "a sort of chance." Regarding the latter, he went on to say its "fortuitous character" can be revealed in the direction of "a very clear increase in creative possibilities."[21]

The important thing about the methods cited by Dax is this. Their mechanical nature at the same time rules out both rational reflection and evaluation by esthetic standards. So the artist is offered the opportunity to pursue his exploration beyond the limits imposed by reason and estheticism. Hence the enlightening analogy, drawn in Breton's Perspective cavalière, between painting and love, both said to "begin in mechanics and continue in poetry."—"Everything," comments Breton, "hangs on how much it is worth, to throw oneself out of the window so as to fall somewhere else on cat's paws" (p. 97).

Surrealists do not try to align painting and poetry by giving the one values and ambitions appropriate to or imposed by the other's formal capacities. Instead, they set painting goals that transcend its

[20] Adrien Dax, "Scories," L'Archibras, No. 7 (March 1969), p. 35.
[21] Adrien Dax, "Perspective automatique," La Nef, "Almanach surréaliste du demi-siècle" (1950), p. 82.

Adrien Dax, Automatic Drawing. 1977. India ink. Collection J. H. and Jeanne Matthews.

Yves Tanguy, Automatic Drawing. 1926. India ink and gouache. Private Collection, Washington, D.C. Photo Nathan Rabin.

strictly technical limitations, just as they set goals for the use of words that will take the writer beyond the literary exercise of language. In this area of pictorial expression, as well as in the field of verbal communication, therefore, surrealists are aware of a contrast in which they all place their faith. This contrast situates poetic expression—transgressing rules in the interest of unprecedented imaginative liberation—apart from the prosaic spirit, with which surrealist doctrine associates traditional techniques, molded by inherited concepts of beauty. José Pierre is a responsible and reliable spokesman in *Le Surréalisme*:

> It is no longer a question of knowing how to write or how to paint but "beyond painting" and writing, of knowing "how to save man," how to help him regain an equilibrium always more and more threatened. For wishing, with Marx, to "transform the world," and, with Rimbaud, to "change life," means to the surrealists "making human understanding over again" [Breton], that is to say reconciling in man intelligence and sensibility. (p. 9)

Following the line of reasoning summarized here, in a letter to James Thrall Soby, written in May 1965, René Magritte referred to Giorgio de Chirico (in whom surrealists salute a great predecessor) as "the first to have tried painting the impossible and to have always granted precedence to poetry over painting and over the various means of painting." Magritte himself, we notice, is paid a high tribute by Herbert Read, in the first number of *London Bulletin* (April 1938), where he is credited with assuming "a pivotal position in the modern movement."—"He has dared to assert the self-sufficiency of the poetic idea in painting." Only three years earlier, Breton had claimed in "Situation surréaliste de l'objet" that no fundamental difference of ambition exists between a poem by Paul Eluard or Benjamin Péret and a canvas by Max Ernst, Joan Miró, or Yves Tanguy (p. 311).

In statements such as Read's and Breton's the underlying motivation is consistently the same. For this reason, it is highly significant to anyone interested in uncovering the origins of surrealist imagery and in gauging its importance. Surrealists are uniformly determined to make quite clear that full comprehension of their aims calls for surrender of many of the postulations and suppositions upon which appreciation of traditional modes of art and literature confidently rests. Surrealists do not presume to place what they create above and beyond any form of criticism. They do insist, though, that enjoyment of what

René Magritte, *Countryside III*. 1927. Oil on canvas.
Galerie Isy Brachot, Brussels.

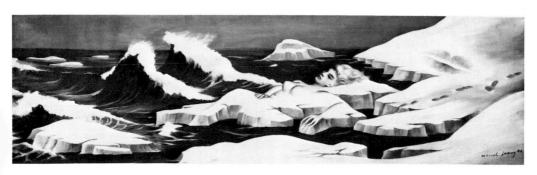

Marcel Jean, *The Gulf Stream*. 1946. Oil on canvas. Private Collection,
Paris. Photo Nathan Rabin.

they have accomplished, like appreciation of their dominant concerns, inevitably must be impeded by reluctance on our part to give serious attention to the aspirations expressed through imagery of a special kind. In these aspirations surrealist imagery finds its *raison d'être*. It is in relation to these aspirations only, surrealists argue that their images can be judged knowledgeably and responsibly. Where a surrealist image happens to appeal to a reader or spectator with no conception of its relationship to the surrealist outlook, yet with a traditional sense of beauty and form, this can only be coincidentally to fulfillment of surrealist imagery's prime purpose.

In surrealist parlance, "poetry" assumes special meaning. It is a term applicable to whatever exceeds the limits of a given artistic medium, so permitting attainment of something more important to the creator and to the informed public than either formal perfection or rehearsal of conventional themes can bring within reach. Asking what this might be, we find ourselves on the track of an answer when we begin considering the role surrealism attributes to the "inner model."

THE INNER MODEL

IT IS ONE THING to accept as theoretically applicable to surrealist painting Paul Eluard's claim in *Donner à voir* that the principal quality of poems is to inspire, not evoke (p. 81). It is quite another thing to paint pictures sufficiently endowed with this quality to prove the surrealist painter is engaged in the same endeavor as the surrealist poet with words. Their ambitions confronted the surrealists of the twenties with a problem they could not solve very easily. In fact, it might have remained unresolved but for the influence exerted by André Breton. From the first, this influence upon surrealist thought and conduct was as decisive as it would continue to be right up to Breton's death in 1966. It is no exaggeration to say, indeed, that from the very beginning Breton's attitudes, impulses, and deepest needs did more than anything else to crystallize the idea of painting in surrealism. It is conceivable that, but for Breton, active involvement of painters in surrealist activity might have remained a pipe dream—in which all the original surrealists did not share, incidentally.

Review of the situation immediately brings one important fact to light. At the outset, within the framework of surrealism Breton's thoughts on painting were far from characterized by a clear sense of purpose. The long list of writers cited in his 1924 surrealist manifesto (where surrealism is defined as "pure psychic automatism," expressing "the pure functioning of thought" in words, in writing or—significantly more vaguely—"in any other manner" [p. 41]) contrasts noticeably with the much shorter list of painters. And the latter are consigned to a footnote that reads very much like an afterthought (p. 42). It is plain to see that, to begin with, André Breton conceived of surrealism as something for which the most suitable mode of expression was

verbal. No ambiguity on this score can be detected in the *Manifeste du surréalisme,* where we read, "Words and images offer themselves as springboards to the mind of the listener" (p. 51). It is just as clear that, being a writer, Breton found it natural to formulate surrealist theory on the basis of language. He would be doing this still in his *Introduction au discours sur le peu de réalité* of 1927: "Does not the mediocrity of our universe depend essentially on our power of enunciation?" (p. 31).

From the first, the Paris surrealists took care to give their magazine, *La Révolution surréaliste,* an austere appearance, with none of the typographical fancy of the Dada periodicals. *La Révolution surréaliste* was meant to look more like a scientific journal than a vanguard art publication. Even allowing for this, though, we find scant evidence of very active and productive collaboration by graphic artists and painters.

The first page of the preface opening the first number (December 1, 1924) carried a photograph of Man Ray's object *L'Enigme d'Isidore Ducasse* (1920)—a sewing machine wrapped in sacking and tied with rope. It appeared untitled and without credit. Another Man Ray photograph, a female torso—presented anonymously again—figured on the fourth page. There were, too, drawings by de Chirico, Desnos, Morise, and Naville. Max Ernst and André Masson supplied two drawings apiece. The cover of the second number (January 15, 1925) showed a scarecrow labeled "French Art beginning of the XXth Century." Inside were more reproductions of works by de Chirico, Ernst, Man Ray, Masson, Naville, and Picasso. As before, however, these artists were represented only by decidedly minor sketches. One Picasso painting in the first issue, plus a de Chirico and a Man Ray; a Naville in the second: the harvest was not rich and contrasted with the profusion of texts expressing the spirit of surrealism, already being published in Paris. All in all, these illustrations retain a simply decorative function in the magazine.

To judge by the third number (April 15, 1925), in the spring of 1925 surrealism had to rely for its pictorial expression almost exclusively on the contribution made by André Masson and Paul Klee. It remained to be seen whether No. 4 would bring any important changes.

The fourth issue of *La Révolution surréaliste* is of historical importance, for it marked Breton's assumption of control of the magazine. In his introductory text, "Pourquoi je prends la direction de la *Révolution surréaliste,*" explaining why he was taking over editorship, he

made no allusion at all to painting. Even so, the illustrative matter in the July 15 issue displayed striking modifications. It consisted of reproductions of canvases, some of them very significant early surrealist paintings: both Ernst's *Deux Enfants sont menacés par un rossignol* and his *La Révolution la nuit,* both Miró's *Le Chasseur* and his *Maternité,* as well as Man Ray's *Marine* and Masson's *L'Armure.* In addition, that number carried Picasso's *Les Demoiselles d'Avignon* and *Jeunes Filles dansant devant une fenêtre.* A Picasso *Arlequin* (1924), his *Etudiant,* and his *Etudiante* all illustrated the first of Breton's exploratory essays on "Le Surréalisme et la peinture." Subsequently, with one de Chirico, two Ernst, two Mirós, and two Picassos, No. 5 (October 15, 1925) demonstrated that reproductions of paintings had become a regular and vital feature of *La Révolution surréaliste.* The contrast between the later and the early numbers would have been even more striking, had color reproduction been used in the first French surrealist magazine, as it was in certain later ones.

Looking back from the enlarged edition of *Le Surréalisme et la peinture,* published in 1965, Breton would confess that, at the beginning of 1925, the chances of arriving at a form of painting capable of meeting their demands were still being debated by the surrealists in Paris. Arguments ranged from refusal to accept that there could ever be a surrealist form of painting to assertion that such a form existed already. It took the passage of time, as Breton went on to note, to make it plain to all that surrealism in fact had made its entry into the field of art with the collages created by Max Ernst in 1920 (p. 64). Why, then, did it take Breton and his associates so long to acknowledge this fact? The answer is not to be found in Breton's text. It surely has to do with historical circumstances.

Eager to assert their independence of Dada, the first surrealists were more than reluctant to be caught affirming some degree of continuity between Dada—from which Breton, Eluard, Péret, Soupault, and others had rebelled—and surrealism, in which they now all placed their trust. Yet this is the very thing they would seem to be doing, in identifying their aims with those supposedly underlying graphic creations by Ernst that belonged, historically speaking, to the period of active Dada influence.

Breton's way of presenting the facts does not help matters, by any means. His own article on Ernst, dating from 1920, speaks of Dada

almost as he will be speaking of surrealism just a few years later. We
find him referring to the image as an illuminating spark, for instance.
Writing from the standpoint of Dada, he assures his readers, "It is the
marvelous facility of attaining two widely separate realities without
departing from the realm of our experience, of bringing them together
and drawing a spark from their contact, of gathering within reach of
our senses abstract figures endowed with the same intensity, the same
relief as other figures; and of disorienting us in our own memory by
depriving us of a frame of reference—it is this faculty that for the
present sustains Dada."[1] A glance at the first manifesto, which came
out four years later, is all it takes to see how closely Breton's definition
of the surrealist image follows this one. Commenting on the sensation
created among the future surrealists by Ernst's collages of 1920, José
Pierre, writing in *Le Surréalisme,* ascribes it to the close relationship
those works bore to the image as conceived by Lautréamont and
Pierre Reverdy, who wrote in *Nord–Sud* in March 1918 that one
creates images by bringing more or less distant realities together.
Later Pierre will go farther, suggesting now that the existence of
Ernst's collages encouraged Breton to think surrealism capable of
finding expression outside language.[2] However, Breton's particular
interest in painting, manifest from his youth onward, recommends
that we believe, rather, it would only have been a matter of time
before he sought to involve painters in the surrealist venture.

It is because the first participants in this venture did not all share
Breton's point of view that, looking through *La Révolution surréaliste,*
we find clear signs of confusion and even of conflict. In the first num-
ber, an article signed by Max Morise, "Les Yeux enchántés," alluded
to a mode of painting identified simply as "*x*" and went on to formu-
late an equation: a painting by a madman or by a medium is to *x*
what a medium's narrative is to a surrealist text. "But who will furnish
us with the marvelous drug that will put us in a position to realize *x*?
. . . For the whole problem is not to begin, but also to *forget what has
just been done,* or better still to *know nothing about it*" (p. 27). As
Morise understood full well, "What surrealist writing is to literature,
plastic surrealism must be to painting, to photography, to everything
that is made to be seen" (p. 26). This was the essential problem, to
which a categorical answer came from Pierre Naville, then coeditor of

<hr>

[1] See Max Ernst, *Beyond Painting,* p. 177.
[2] José Pierre, "Le Monde blanc de l'absence d'objets," *L'Archibras,* No. 7 (March
1969), p. 5.

Juhani Linnoraara, *What Has Happened Here?* 1969. Mixed Media. Collection of the artist.

Paul Hammond, *My Country's Flag.* 1976. Acrylic and emulsion paint on hardboard. Collection of the artist.

La Révolution surréaliste with Péret. In the third issue, Naville declared, "No one is ignorant any more of the fact that there is no *surrealist painting*" (p. 27).

Naville's contention was to find no favor with Max Ernst, who commented later in *Beyond Painting*, "Yet at the very time he was thus prophesying, the 'unconscious' had, as one could easily establish, already made a dramatic appearance in the practical realm of painted and drawn poetry. Thanks to studying enthusiastically the mechanism of inspiration, the surrealists have succeeded in discovering certain essentially poetic procedures whereby the plastic work's elaboration can be freed from the sway of the so-called conscious faculties" (p. 20). More immediately, André Breton appears to have felt obliged by Naville's argument to defend and expand his own ideas on the relationship between surrealism and painting. His defense took the form of a series of articles, launched in the fourth number of *La Révolution surréaliste* and soon to be collected, in 1928, under the significantly cautious title *Le Surréalisme et la peinture: Surrealism and Painting*.

Meanwhile, in response to a need that may be characterized in all fairness at once emotional and tactical, the first surrealist group show was organized. Held at the Galerie Pierre in Paris, in November 1925, it brought together pictures by Arp, de Chirico, Ernst, Klee, Masson, Miró, Picasso, Man Ray, and Pierre Roy. The list of artists represented suffices to show how uncertain the surrealists continued to be about the suitability of painting to attainment of their immediate and long-term goals. As for André Breton's articles, they had a similarly tentative quality. Breton's reluctance to speak of Dada and his willingness to return, even so, to the Cubism of Picasso and Braque had distinctly confusing consequences. To the essays on the latter two painters, on de Chirico, Ernst, Man Ray, and Masson (all originally printed in *La Révolution surréaliste*), the first edition of *Le Surréalisme et la peinture* added sections on Arp, Miró, and Tanguy, with just one paragraph on Picabia, in whose company Breton had been an active participant in Dada. All in all, it is a surrealist reading of the works discussed that we find in the 1928 edition, one that presents a few curious features, by the way.

In the first place, automatism—the cornerstone of the *Manifeste du surréalisme*—is barely mentioned in *Le Surréalisme et la peinture*. The work of Joan Miró elicits the following observation, betraying Breton's unwillingness to push the claims he was making for surrealism in painting too far:

Instead of a thousand problems which do not preoccupy him in the least although they are those in which the human mind is immersed, there is perhaps in Joan Miró only one desire, to abandon himself so as to paint, and only to paint (which for him means confining himself to the only domain in which we are sure he is possessed of means), to that pure automatism upon which, for my part, I have never ceased calling, but of which I fear Miró himself has very summarily verified the profound value and reason. True, it is perhaps in this respect that he can pass for being the most "surrealist" of us all. (pp. 36–37)

We sense in addition that, despite the early graphic experimentation of André Masson, Breton felt it unwise to try relating painting to surrealism on the level where its adaptability to surrealist purposes seemed most open to question. In short, our impression is quite definitely that Breton felt rather uncomfortable, putting together the first edition of his text. It is as though he badly wanted to hit a certain target, but was profoundly aware of being short of ammunition, or even perhaps equipped with ammunition that was not quite what he needed. How else could he bring himself to speak, albeit briefly, of Francis Picabia while yet alluding openly to the man's "complete incomprehension of surrealism" (p. 21)? Nearly a quarter of a century later, in a 1952 article subsequently reprinted in the definitive edition of *Le Surréalisme et la peinture*, Breton would talk of painting as "enjoying the privilege of being an international language and, on the plane of feeling, a means of elective exchange between men" (p. 349). Apparently, he already was convinced of this during the twenties. His difficulty at that time, though, was how to make sure painting would be and would remain a means of exchange capable of advancing the aims of surrealism.

Oddly enough, although the name of Lautréamont appears time after time in *Le Surréalisme et la peinture* from the first edition onward, Breton's text evidences marked reluctance to draw upon examples from surrealist writing to enlighten his readers with regard to painting. Perhaps he was taking special care to protect painting of the kind that had his confidence from the stigma of the adjective "literary." Be that as it may, in the definitive edition we have to wait for a 1947 article dealing with the work of Jacques Hérold to hear Breton offer an important parallel with the ideas of a poet (in this instance, with those underlying Malcolm de Chazal's *Sens-Plastique* [pp. 204–205]). The reader already has some four hundred pages of

Enrico Baj, *Little Child Playing with his Toys*. 1952. Oil on canvas.
Collection of the artist.

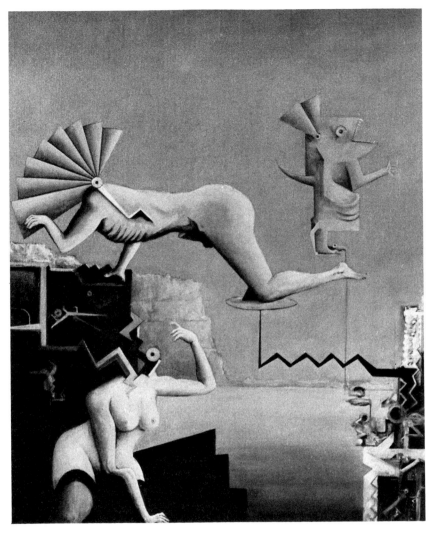

Hans Henrik Lerfeldt, *Nature Comes to Reason*. 1974. Oil on canvas. Collection Walter Ibsen, Hobro.

text behind him when, in connection with the work of Enrico Baj, he hears Breton mention the poetry of Benjamin Péret.

Does this mean that, as a document intended to demonstrate what painters can bring to surrealism, *Le Surréalisme et la peinture* accomplished but little in 1928? Hardly. Breton's interpretation of the achievement of the artists he submitted to examination showed him committed already to a viewpoint reflected less than ten years later in the following declaration, made on the occasion of the 1936 international surrealist exhibition in London: "Surrealism tends to unify today under its name the aspirations of writers and innovative artists of all countries." In the same context he would speak of "a new *common* awareness of life."[3] From the first, Breton sensed that this *prise de conscience* could provide a sound basis for fruitful cooperation between painters and writers in surrealism. He set about sketching its characteristic features from the moment when, in his articles for *La Révolution surréaliste*, he began inviting his readers to look away from external reality and from mere technical efficiency toward the "purely inner model" which he saw as holding the attention of certain significant painters.

Breton's earliest published comments on painting in relation to surrealist imperatives are brought into perspective when considered in light of two statements. The first comes from the 1924 *Manifeste du surréalisme:* "Imagination alone gives me an account of what *can be,* and this is enough to raise the terrible interdict a little" (p. 17). The second is by Giorgio de Chirico, cited in the fourth number of *La Révolution surréaliste* in 1925: "What is needed is to disencumber art of everything it contains that has been known up to now, all subject matter, idea, thought, symbol must be set aside." While de Chirico demanded that inherited material be abandoned, Breton left the surrealist artist the prospect of producing something more than a bare canvas. This is confirmed in the preface, "Il y aura une fois," to his verse collection *Le Revolver à cheveux blancs* (1932): "The imaginary is that which tends to become real." Quoting Breton in the catalog of the Paris international surrealist exhibition of 1947, Jacques Hérold was to write, "Imagination is that which tends to become real, imagina-

[3] André Breton, "Limites non-frontières du surréalisme," in his *La Clé des champs,* p. 15.

tion is also what is, but unknown."[4] Imagination connects the known and the as yet unknown. Hence it gives surrealists hope of achieving an ambition to which Breton devoted a whole book, *Les Vases communicants,* in 1932: "casting a clew between the all too dissociated worlds of waking and sleeping, of outer and inner reality" (p. 102).

The important thing to notice is that, writing from the point of view of the surrealist painter, Hérold returns to an idea expressed in an essay by the poet Eluard in his *Donner à voir:* "There is no model for someone looking for what he has never seen" (p. 131). In the absence of a model in outer reality, the surrealist creative artist, whatever the domain he has made his own, turns elsewhere. He refers instead to the inner model mentioned on the fourth page of *Le Surréalisme et la peinture:* "The plastic work, to answer the necessity for total revision of real values upon which today all minds agree, will refer therefore to a *purely inner model,* or will not exist."

We must take care not to confuse implementation of the procedure Breton advocated with a weakness for escapist tendencies in art and literature. Toward the end of his life Breton still was distinguishing literature firmly from poetry and identifying the latter with "inner adventure"—"the only one that interests me."[5] This surely is why we hear him allude yet again of the artist's inner model, ten years after the first edition of *Le Surréalisme et la peinture.* In a 1938 article on Frida Kahlo de Rivera, reprinted in the definitive version of his study of surrealism and painting, he takes the opportunity to point out that deliberate sacrifice of the outer model to the inner gives priority "resolutely" to representation over perception (p. 141).

The surrealist does not look to external reality to authenticate his pictorial or verbal images. If we may speak of the surrealist image as offering a mirror reflection, then this can only be a reflection caught in a mirror turned to face the poet's imagination and to exclude the world about him. The very first thing a surrealist image does is make this clear to us.

Among exemplary images cited in the first surrealist manifesto (p. 54) are two lines by Roger Vitrac: "Dans la forêt incendiée / Les lions étaient frais" ("In the burnt up forest / The lions were fresh"). They show how far Vitrac has outgrown the influence of French Symbolist poetry, so evident in his collection *Le Faune noir* (1919). He is already on the way to completing *La Lanterne noire* (1925), a col-

[4] Jacques Hérold, "L'Oeuf obéissant," *Le Surréalisme en 1947,* p. 86.
[5] André Breton, interview granted Madeleine Chapsal in *L'Express,* August 9, 1962.

lection of poems dedicated to André Breton. Because the surrealist's
point of departure is located by reference to the inner model, rather
than external reality, reason cannot measure with any degree of ac-
curacy the distance his images make us travel. Reason in fact cannot
decipher the milestones along the road, like the upright fingernails,
looking just like old men, to be seen around every corner in "Cœur en
bouche," from Desnos' *Langage cuit:* "A chaque tournant il y a un
ongle droit qui ressemble à un vieillard." Nor of course can reason
explain the archaic carcasses of horses shaped like bathtubs that pass
by in Char's "Le Climat de la chasse ou l'accomplissement de la
poésie" in *L'Action de la justice est éteinte:* "Les archaïques carcasses
de chevaux en forme de baignoire passent et s'estompent." And what
can reason make of the following scene, taken from "Respirer," in
Jehan Mayoux's *Ma Tête à couper?*—"Dans la rue de saumure à
façades de tessons de mariées / Un cortège pédagogique de larves
baveuses à tête de dodécagone curviligne légèrement irrégulier /
Rince des cordes de violoncelles en boyau de prêtre" ("In the street
of salmon with the fronts of the houses in brides' shards / A pedagogi-
cal procession of slobbering larvae with heads of slightly irregular
curvilinear dodecagons / Is rinsing out 'cello strings of priest gut").

Surrealist imagery expresses refusal to submit to any laws but
those imposed by inner needs. It stands, therefore, for reversal of the
rules by which our lives are regulated in a rationally ordered society.
On the first page of the third number of *La Révolution surréaliste*
Antonin Artaud declared, "It is only by fraudulent misuse of life, by
a sentence imposed on life, that one can set life in its so-called real
physiognomy, but reality does not rest on that. To me surrealism has
always been an insidious extension of the invisible, the unconscious to
hand. The treasures of the invisible unconscious become palpable,
leading the tongue directly in one spurt."

The fully expanded edition of *Le Surréalisme et la peinture* treats
surrealism in a way that reserves it an important place in modern art.
Writing on Degottex in 1955 Breton predicts, "It will be the great
exploit of modern art—poetry from Lautréamont and Rimbaud on-
ward—to have more and more bitterly attacked the world of appear-
ances, tried to reject what is only *cortical* so as to penetrate to the
sap" (p. 341). At the same time, rejection of the art of appearances
is shown to be at the source of surrealism's originality. Breton empha-
sizes as early as the third page of his text, "But the stage of emotion
for its own sake having once been passed, let us not forget that to us,
in this period, it is reality itself that is at stake."

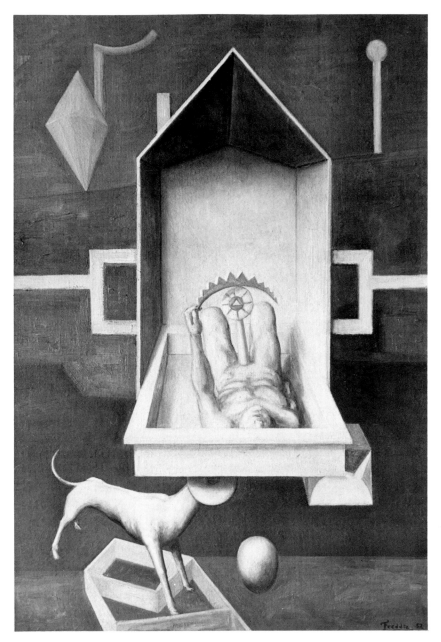

Wilhelm Freddie, *The Fountain*. 1952. Oil on canvas. Aarhus Kunstmuseum.

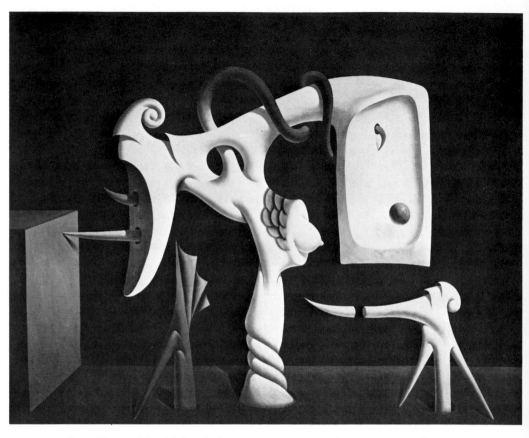

Ivan Tovar, *The Melancholy Fountain.* 1969. Oil on canvas. Collection José Pierre, Paris. Photo Alain Spy.

Recalling in a 1952 article published in *XXᵉ Siècle* his earlier definition of a painting as a window interesting only for what it looked out upon, Breton commented that he had meant to imply, "in any case, nothing of actual appearance." Artistic creation, he now went on to explain, calls for an "overturning of appearances" able to transport us as far as possible away from "conventional vision."[6] The distinctive trend in surrealist painting is, therefore, the one mentioned in Breton's 1958 essay "Du Symbolisme," reprinted in *Le Surréalisme et la peinture.* Here he speaks of "a painting that seeks to be a recreation of the world in terms of the inner necessity experienced by the artist" (p. 357). Whereas Péret refers to that inner necessity as born, in poetry and painting, of intuition,[7] Breton alludes instead to desire.

At first, Breton's word "desire" seems innocuous, almost bathetic in the context of the grandiose ambitions imposed by surrealism. In order to give desire its full force, to see why painting based on desire is, to conventional painting, what "poetry, in the highest sense of the word, is to 'best seller' prose and journalistic rambling" (p. 259), one must measure its scope in relation to an assertion in Eluard's essay "L'Evidence poétique," from *Donner à voir:* "Surrealism, which is an instrument of cognition and for that very reason just as much of conquest as of defense, works at bringing to light the profound consciousness of man" (p. 85).

Desire loses its meaning if we think of the surrealists' dedication to its expression as simply evidence of a self-centered wish to explore the world of private fantasy and daydream. Inflated as it sounds to those whose ear is not yet attuned to the resonance of certain words recurrently employed by surrealists, the closing lines of Dalí's essay "L'Ane pourrissant" faithfully reflect the surrealist point of view: "The ideal images of surrealism will serve the imminent crisis of consciousness: they will serve Revolution."[8] Indeed, the special interest offered surrealists during the thirties by Dalí's celebrated paranoiac-critical

[6] André Breton, "C'est à vous de parler, jeune voyant des choses. . . ," *XXᵉ Siècle* (1952). See his *Perspective cavalière,* p. 13.
[7] Benjamin Péret, "La Soupe déshydratée," *La Nef,* "Almanach surréaliste du demi-siècle" (1950), p. 54.
[8] Salvador Dalí, "The Stinking Ass," trans. J. Bronowski, *This Quarter,* 5, 1 (September 1932), p. 54. *Cf.* the following statement in Paul Nougé's *Fragments,* Huitième Série, Brussels: Les Lèvres Nues, 'Le Fait accompli,' No. 118–19 (July 1974), no pagination:

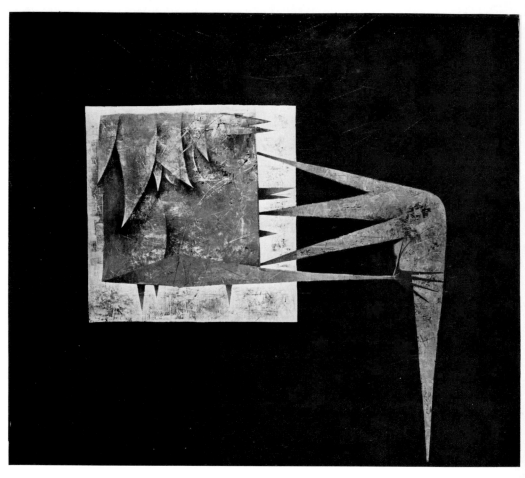

Mikuláš Medek, *The Sleeping Woman*. 1957. Oil on canvas. Collection of the artist.

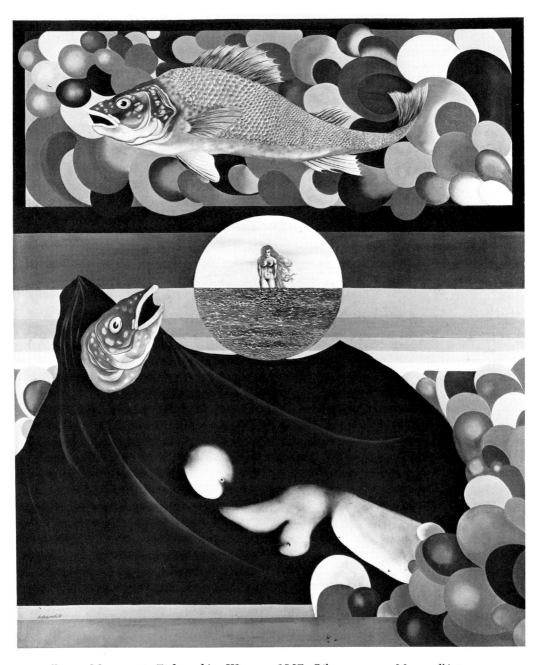

Renzo Margonari, *Fish and/or Woman*. 1967. Oil on canvas. Museo d'Arte contemporanea, Sassoferrato.

method lay in its subjection of outer reality to the inner necessity ex-
perienced by the artist. For paranoia, as understood by Salvador Dalí,
"uses the external world in order to assert its dominating idea and has
the disturbing characteristic of making others accept this idea's reality."
In this way, the reality of the outer world "is used for illustration and
proof, and so comes to serve the reality of our mind" (p. 98). Hence
Dalí's much publicized double images were obtained in a manner he
termed "clearly paranoiac."[9]

Although his use of the word "paranoia" was typically provocative,
Dalí was behaving in conformity with surrealist directives. The
paranoiac-critical method stands for something of more lasting sig-
nificance than Daliesque self-advertisement. Three decades later, Jean
Schuster commented on the diversity of methods practiced within the
surrealist movement as indicative of an aspect of surrealism which
must persuade any critic of good faith that he is not dealing with a
school of painting or poetry. Schuster went on to insist: "The common
link in all surrealist creations lies in the very method that consists in
granting mental representation free play by releasing it, as broadly as
possible, from physical perception. The inner model, then, cannot
but take on the appearance of the *unique,* move about in a *unique*
light and set up with the spectator (or reader) a *unique* communica-
tion."[10] The persistent influence of Breton's thinking is easy to detect
here. For surrealists never cease to stress, as he did in "Situation sur-
réaliste de l'objet," "the inner representation *of the image present in
the mind*" (p. 311).

So far as we can detect signs of some evolution in Breton's attitude
toward the inner model's relationship to external reality, it is reflected
in the lecture just cited. Here that relationship, represented in the
original edition of *Le Surréalisme et la peinture* in a manner José
Pierre's *Position politique de la peinture surréaliste* frankly terms "ter-
rorist," takes on greater subtlety. The artist is allowed more latitude,
now, given firmer guarantees of escaping *poncifs,* the stereotypes

Points of Departure
Descartes: I think, therefore I am.
 Me: I desire, therefore I am.
Everything has to be done all over again, starting with the second phrase.
[9] "By a double image is meant such a representation of an object that it is also,
without the slightest physical or anatomical change, the representation of another
entirely different object, the second representation being equally devoid of any
deformation or abnormality betraying arrangement."
[10] Jean Schuster, "A l'ordre de la nuit Au désordre du jour," *L'Archibras,* No. 1
(April 1967), p. 6.

Breton himself had rejected toward the end of his *Manifeste du sur-réalisme* (p. 58). As we listen to Breton discussing it in his 1935 text, painting confronts inner representation with the concrete forms of the real world so as to attempt "this supreme step which is the poetic step *par excellence:* excluding (relatively) the exterior object as such and considering nature only in its relationship to the inner world of consciousness." Such a close fusion of the two arts of painting and poetry tends to take place, Breton points out, that "it becomes more or less a matter of indifference to men like Arp, like Dalí, whether they express themselves in poetic or plastic form" (p. 312).

The implied purpose behind Breton's rejection of external reality ten years or so before has become explicit now, with clarification of painting's important role in the surrealist venture. "The real value of art," declare Magritte and Scutenaire in the twelfth number of *London Bulletin* (March 1939), "is a function of its power of liberative revelation" (p. 14). Similarly clarified is Breton's emphasis upon desire as the underlying element in the process of recreating reality, when we hear Péret evaluate the work of Toyen as aiming at "nothing less than correcting external reality in terms of [*en fonction de*] a desire that feeds upon and grows out of its own satisfaction."[11] Breton's *Nadja* (1928) testifies eloquently to the fact that desire would lose its fascination in surrealism if it were limited to conscious aspiration. Here desire defined is desire confined. Hence any approach calculated to bring about anticipated results must fall short of the full attainment of desire. Awareness of this helps us appreciate the enthusiasm with which *Le Surréalisme et la peinture* salutes Wolfgang Paalen's contribution to the "methodological treasure of surrealism" (collage, rayogram, frottage, décollage, and spontaneous decalcomania). Paalen's fumage is said to be valuable because it substitutes the inner image for visual perception (p. 138).

Closer examination of the methods employed in graphic surrealism can be postponed for the moment. For now, we need notice only that these methods are pictorial equivalents of automatic writing. They bring about through drawing and painting the precipitation of images. Unobtainable by conscious, deliberate effort, the latter transmit desires of which the thinking mind remains ignorant. Hence the prestige of certain mechanical procedures, of a process of conception that, because reasoned control has been eliminated during its operation, Breton and

[11] See Benjamin Péret "Au Nouveau-Monde, maison fondée par Toyen," in Péret et al., *Toyen.*

LEFT. Toyen, *The Huntress.* 1959. Oil on canvas.

RIGHT. Jindrich Styrsky, *The Somnambulist Muse.* 1937. Oil on canvas. Photo K. Kuklík.

Eluard were the first to term immaculate.[12] Hence, too, the surrealists' disposition to respect whatever revelations these procedures may bring.

Interpretation of the image obtained by mechanical processes is not ruled out *a priori*. It may be voluntarily delayed, though, until the nonreflective stage is complete. Or, alternatively, it may seem superfluous to the surrealist for whom immaculate conception suffices in itself, as it does for Breton and Schuster: "The dreams of man and his delirium have culminated in my poems. It is not up to me to make them state their names; proteiform, they culminate several meanings. I have respected their confusion. I have let their flight have free course. My words testify to their perpetual metamorphosis."[13] Such an attitude would seem to bring with it a definite risk of courting the disaster of incomprehensible confusion if it were not that, in surrealism, pursuit of desire is undertaken in full confidence beyond the constrictive limits of reasonable projection and articulation. Breton speaks for all true surrealists when pointing out in *La Clé des champs,* "a certain number of works, poetic and otherwise, have value essentially because of the power they possess to appeal to a faculty *other* than intelligence. Beauty demands to be enjoyed before being understood and entertains with clarity only very distant and secondary relationships." It is not that beauty rebels against elucidation, exactly, but that it tolerates elucidation only "*a posteriori* and as though outside itself" (p. 186).

As described in Eluard's *Donner à voir,* the surrealist poem "desensitizes the universe to the sole benefit of human faculties, permits man to see in another way, other things. His old vision is dead or false. He discovers a new world, he becomes a new man" (p. 147). "Let us change the past," Nicolas Calas urges in *Confound the Wise,* "and transform the future! Let us fill them with the new images of our desires!" (p. 82).

While some surrealists deliberately set themselves a goal as Calas does, others would find themselves powerless to act in this fashion. Miró, for one, confessed in the third issue of *Minotaure,* in 1933, "It is difficult for me to speak of my painting, for it is always born in a state of hallucination, provoked by some shock or other, objective or subjective, for which I am entirely without responsibility" (p. 18). This, then, is what gives so much importance to the inner model

[12] See André Breton and Paul Eluard, *L'Immaculée Conception,* first published in 1930.

[13] André Breton and Jean Schuster, "L'Art poétique," *BIEF: jonction surréaliste,* No. 7 (June 1, 1959), no pagination.

furnished by unvoiced desire. It explains why, in *La Clé des champs*, André Breton declines to look upon great artists as visionaries and sees them as auditives instead. Breton makes his position perfectly clear: "No, Lautréamont and Rimbaud did not see, did not take pleasure *a priori* in what they described, which amounts to saying that they did not describe at all; they confined themselves in the dark wings of being to listening to something indistinctly said and, when they wrote, without understanding any better than we the first time we read, to certain works accomplished or accomplishable." Erroneously ascribing this extract to *Les Pas perdus*, Ferdinand Alquié's *La Philosophie du surréalisme* (p. 140) interprets Breton's recommendation that the mind remain passive as proving creation to be less important to the French surrealist leader than revelation. It seems more fitting to say, however, that one can speak of creation in surrealism, above and beyond the exercise of acquired technical skill, only when revelation has taken place.

Prefacing Karel Kupka's *Un Art à l'état brut* (1962), Breton demonstrated his continuing fidelity to views put forward earlier:

> First love. There will always be time, afterward, to question oneself on what one loves to the point of no longer wanting to be ignorant of anything concerning it. Before as after this inquiry, it is the inner resonance that counts; without this at the beginning we are almost irremediably deprived and nothing of what one will have been able to learn will be able to take its place if, along the way, it is lost. That is the obvious fact that everyday is reinforced by so many "literary analyses" obstinately seeking to reduce the "obscurities" of a poem when what matters above all is that, on the affective plane, *contact* be established spontaneously and that the *current* flow, arousing the person receiving it to the point of creating no obstacles for him in those very obscurities. Just as a plastic work, whatever it might be, could not hold any vital interest for us except so far as it intrigues or captivates us long before we have elucidated the process of its elaboration.

In essence, then, the creative process stands or falls according to its aptitude for eliciting a resonance born of desire. Hence measurement of the degree of success achieved may be likened to the act of recognition, extending sometimes far beyond the limits prescribed by previous knowledge, or acquired familiarity; in effect, re-cognition of something never before seen or known. Each of us, in Breton's phrase, has to "blaze his own inner trail." In consequence, the artist's role is

to provoke recognition by inducing us to seek out a trail never followed before. More than this, the creative artist too may find himself participating, through his creation, in a process of recognition beyond all anticipation. For this reason, in his review of Marcel Jean's history of surrealist painting José Pierre emphasizes that surrealism remains open to "*that in which it recognizes itself.*"[14]

Surrealism pursues through the inner model something quite different from the ideals of romantic narcissism. In the prolog to his *Anatomy of My Universe* André Masson tells us, "I know that I am surrounded by the Irrational. I let my reason go as far as it can. It traverses the court of objects and reaches finally the wasteland of infinite desolation: it is a *truly human* place, which creates its own time." Describing his own graphic universe, he now confides:

> It is composed of images that fill my expectations, signified by the sheet of white paper. Whence come these imaged forms? They come from my impassioned meditation, an attitude that poses an object, even in its first movement when it seems to be completely sunk in the undetermined. But soon, as in the process of dream-inducing hallucination, or after a first stage composed uniquely of vertical schemas, there appear forms already plastic like dreams and this meditative disposition calls up forgotten sensations, buried dreams. It is their polymorphous play that I orchestrate in their becoming.
>
> But to what has this gushing forth of different elements responded? It has responded to the call of desire.

More than his relationship with the world outside consciousness, the artist's very relationship to the self is implicated in the act of creation. So Hans Bellmer, for example, conceived of "the desirable continuity of our expressive life" in the form of "a succession of deliberative ruptures that lead from malaise to an image of it." Expression, with all the pleasure it entails, is "a displaced pain": "it is a deliverance."[15] Similarly, in her discussion of Bellmer's drawings, Nora Mitrani likens man's consciousness to a "plate sensitive to all the tremors of the macrocosm," interposed between the self and the universal: "The gestures, the reactions that derive from it, tend toward a permanent poetry, of practical utility." This is because, "Thanks to

[14] José Pierre, "Miroirs voilés," *BIEF: jonction surréaliste*, No. 10–11 (February 15, 1960), no pagination.
[15] Quoted in Constantin Jelenski, *Les Dessins de Hans Bellmer*, p. 20.

some of those gestures, forever inexplicable to our reason, there emerges a complicity between the individual and all that he is not."[16] Reviewing Hans Bellmer's *Anatomie de l'image*, Jean-Louis Bédouin takes the surrealist argument a step further: "To the lucid witness to this play of alternating construction and destruction which goes on between desire—the subjective—and necessity—the objective universe—it is clear that everything follows from the power of expression, with which human beings find themselves endowed to the highest degree and that allows them to face the constant excitement to which they are subject."[17] As Bédouin sees it, this is a "resolutely *lyrical* conception of man's relationship to the world," one that evidently translates human desire *"in its continual fluctuation,"* just as Breton emphasized in *La Clé des champs* (p. 99).

"Man proposes and disposes," we read in the first surrealist manifesto (p. 31). "It rests with him alone to belong entirely to himself, that is to say, to maintain in a state of anarchy the band of his desires, every day more formidable. Poetry teaches him how. It carries within it perfect compensation for the miseries we endure." In relation to desire, the surrealist image assumes a meaning that often defeats rational formulation, while yet speaking directly to man. From the outset, Breton felt drawn to Reverdy's definition of the image as serving to bring together two distant realities. He made a point of stressing in his *Manifeste du surréalisme,* though, that it would be incorrect to claim the mind grasps the relationship between the two realities in confrontation: "It has, to begin with, grasped nothing consciously" (p. 52). For the *"light of the image"* comes from a contact of a fortuitous nature, established between the two realities in question: "The value of the image depends on the beauty of the spark produced; it is, in consequence, a function of the difference in potential between the two conductors."

Devotion to the inner model fosters in the surrealist creative sensibility an instinct for surmounting obstacles, erected by rational thinking, that keep one mode of perception or experience quite apart from another. It opposes traditional and habitual categorization. Hence

[16] See Hans Bellmer, *25 Reproductions,* p. 13. *Cf.* Paalen's remark, "Nature is not my master, but my mistress."
[17] Jean-Louis Bédouin, "Usage interne," *Le Surréalisme, même,* No. 3 (Autumn 1957), p. 16.

Ragnar von Holten, *Many to play the Diabolo*. 1964. Oil on canvas. Collection of the artist.

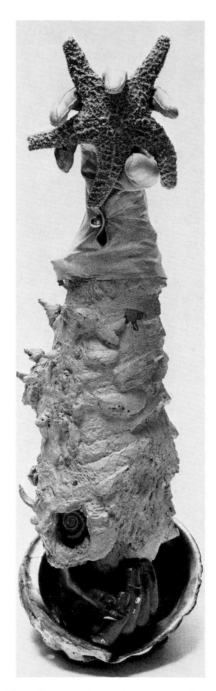

Brooke Rothwell, *The Heights of Candor*. 1976. Object. Collection of the
artist.

response to the surrealist image will take place on a level where understanding in the light of reason appears to have but negligible value. All in all, preoccupation with the inner model brings about a rift in human consciousness. This explains why René Crevel entitled one of his books *L'Esprit contre la raison* (*The Mind against Reason*). The surrealist mind turns against rationality, generally assumed to serve the purpose of expressing the highest qualities of the mind of man.

An unprecedented synthesis now occurs. Cast in the form of an image, it embodies a new sense of beauty. Concern for the evocation of an inner model thus entails rejection of inherited esthetic values as well as repudiation of the standards set by these. In surrealism, beauty is seen as directly related to the pictorial or verbal image's success in closing the distance which rational thought would have us believe must separate various forms of reality from one another, once and for all. Beauty is to be measured and appreciated in relation to the surrealists' conviction that we must turn away from conventional esthetic judgments if we are to enter a new realm of discoveries. In other words, beauty captures and holds the surrealist's attention whenever an image makes him aware of a welcome break in the continuity of rational thinking, wherever it offers a rupture with preconception and past experience. This form of beauty is the one termed "convulsive" in the last line of Breton's *Nadja*. It is, surrealists contend, the very form of beauty to which Lautréamont was alluding when he spoke of an inexplicable chance encounter taking place on a dissecting table.

Since the distance traveled by the spark released through the image depends on the distance between the two conductors utilized, Breton argues in the first manifesto that it is not within man's capabilities to situate his conductors deliberately with a view to producing the hoped-for spark. Conscious intervention, on the contrary, must be confined to recognizing a spark that, in the circumstances, cannot be the result of premeditation. Seen from this angle, pleasure through convulsive imagery is located in a zone inaccessible to the reasoning mind. The result is that the image-work is situated in a highly distinctive light, making the function of imagery both special and— surrealists insist—indispensable. In *Poisson soluble* Breton writes of "an adorably polished woman's torso," floating inexplicably in the Seine. Although it was without head or limbs, those who saw it "affirmed that this torso was a complete body, but a new body, a body such as had assuredly never been seen, never caressed" (p. 74). For Jehan Mayoux in "Habitante de sa robe" (*Ma Tête à couper*) "Desire and love are the wings of the most sudden egg-plant."

Hans Bellmer follows a line of argument somewhat different from Breton's, while developing out of it: "The 'image' would therefore be a synthesis of two pictures [*images*] actualized simultaneously. The degree of resemblance or dissimilarity or antagonism between these two pictures probably constitutes the degree of intensity of reality and the 'shock' value of the resulting image, that is to say the 'perception-representation' image." Where Bellmer moves away from Breton is in presenting the synthesized image as "practically controllable" and so, by implication, as subject to improvement by conscious control.

We face here no fundamental disruptive conflict in surrealist theory. The important thing to a surrealist is not proving himself right and his associates wrong. Each surrealist, in fact, chooses his path according to personal disposition. For one, it is the path to which deliberation points the way. To another, the absence of deliberation's control makes it all the more exciting to be moving forward. This being the case, the surrealists' attitude toward chance and its potential role in the creative process has much to teach us about the richness and variety of surrealist imagery.

Because this attitude is more complex than might be anticipated, however, and more significant for complete understanding of the full extent of surrealist ambitions, we must take special care to approach the question of chance with an open mind. Otherwise, preconceptions about the nature of chance and about its place in life and art, which ordinarily would seem to be beyond dispute, could easily confuse the issue, coming between us and appreciation of why and in which ways chance is granted a major role in surrealism. Circumspection recommends that we approach a discussion of surrealist chance—if we may call it so—by a route seemingly circuitous. This, though, is the route that will bring us to our goal with least delay. Moreover, it is one well worth taking for what it permits us to see along the way: the contribution made by collage to the formulation and realization of surrealist aspirations.

COLLAGE

As ONE REFLECTS on the principles laid down in the 1924 surrealist manifesto, with its insistence upon the imperative need for us to release the mind from reason's control and to free expression from the tyranny of realistic representation, it must seem, to begin with, that regulation of effect during the creative process, carefully deliberated and calculated, is in conflict with the essential purpose of surrealist inquiry.

Rejection of premeditation in Breton's 1924 text certainly provided many surrealists with a viable and fully satisfying framework for creative activity. It did so for Benjamin Péret, whose writings are universally admired in surrealist circles precisely for their *purity*. However, persuaded no doubt that the urgent necessity to release creativity and response from confinement of one kind led Breton to imply limitations of a different sort, other artists, no less devoted to the cause of surrealism, have found that premeditation can play an important role, fully in accord with the spirit of the manifesto. Examination of the products of surrealist creativity soon makes us aware that, in reality, on the subject of premeditation the line of demarcation is by no means so readily perceptible as if one simply had to distinguish formally disciplined effort, on the one side, from undisciplined incoherence on the other.

This is largely because the *Manifesto of Surrealism* in no way condones mere self-indulgence presenting itself in the guise of artistic integrity uninhibited by accepted rules. The demands surrealism incessantly imposes on painters and writers alike are sternly uncompromising. They require that, whatever the artist's medium, he submit himself to judgment by standards that invest the creative act with true

meaning in surrealist eyes. "What matters in each artist," declared Aragon in *La Peinture au défi*, "is the discovery he makes beyond previous discoveries, and in their direction. . . ." What is the nature of the artist's discovery? In which direction does it take him? These are questions to which answers begin taking shape when we consider how surrealist standards are met in surrealist collages.

For our point of departure we must move onto ground that surrealist theory has made familiar. We have to start with the distinction drawn in *La Peinture au défi* between painting—obviously understood here in its traditional forms—and collage. Aragon states that the practice of collage "is more reminiscent of the operations of magic than of those of painting." To appreciate more fully the relationships of collage to magic, one has only to refer to Pierre Reverdy's 1918 definition of the image as linking distant realities: "The more distant and more accurate the relationship between the two realities, the stronger the image will be—the more emotive power and poetic reality it will have." Everything, essentially, hinges on the artist's success in persuading us to recognize as accurate the relationship now established between normally distant realities, and in making us recognize their connection on the plane of poetry. Asked, "Do you think your collages are visible poetry?" Jean Arp replied in *Jours effeuillés*, "Yes, this is poetry made with plastic means" (p. 433).

E. L. T. Mesens, a composer who gave up music to devote himself to surrealist poetry and, eventually, to collage, guides our first steps.[1] He argues in the catalog of a Max Ernst exhibition held in Knokke-Le-Zoute in 1953 that the *papiers collés* of Braque, Picasso, and Henri Laurens are "simple plastic solutions" in which the cut-out elements imitating real materials (wood, marble, newspaper, and so on) "play the role of counterpoint to the lines or shapes the artist has invented or interpreted." In contrast, as Mesens carefully stresses, plastic construction is of very secondary concern in Ernst's collages: "In one go, he plunges us into drama by opposing the elements of our known world, in an irritating, violent manner," so implicating customary forms of thought, logic, and morality. In this way, comments Mesens, Ernst's black humor "leads us far beyond satire toward lands still unknown."

[1] Mesens edited *London Bulletin*. "Introducing E. L. T. Mesens" in the first issue (called *London Gallery Bulletin*, April 1938), Alberto Cavalcanti quoted him as saying, "In 1924 I abandoned music for moral reasons and decided to concentrate on poetical expression whose manifestations will conquer all the domains of human activity" (p. 19).

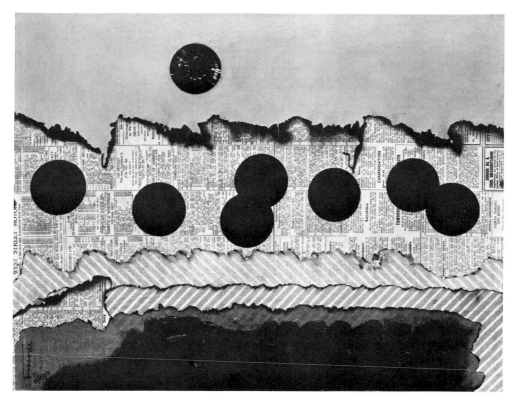

E. L. T. Mesens, *Landscape*. No. 15/1958. Collage. Photo Wallace Heaton Ltd.

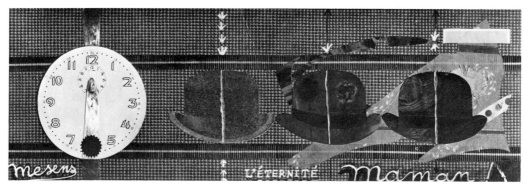

E. L. T. Mesens, *Eternity Mama*. 1961. Collage. Collection Simone and Edouard Jaguer, Paris.

Only on the elementary plane of method, with all considerations of intent set aside, can use of pieces of glued paper in certain Cubist paintings be said to anticipate the technique by which composite pictures made with scissors and paste come into being under surrealist influence. In fact, the Cubist *papier collé* is so different from surrealist collage that we can believe in some connection between them only if we confuse technique—rigorously treated as a means to an end, in surrealism—with the function it is intended to serve. The *trompe l'œil* effect of *papiers collés* was designed to create the illusion of textures and forms already present in the visible world. It produced results far distant from those that, in contempt for realistic representation, surrealists obtain by way of collage. The difference is so important, indeed, that Jacques Brunius, prefacing the catalog of a major retrospective show of Mesens' collages, comments:

> One is tempted for a moment to see in the word itself a confusing factor and perhaps one that breeds disaffection. *Collage* is a felicitous vocable to the extent that it smacks of antiartistic provocation, which it takes from dada, but "if it is feathers [*les plumes*] that make plumage," remarks Max Ernst, "it isn't paste [*la colle*] that makes collage." And indeed, it is quite possible to stick the elements of a "collage" together without paste. . . . It is even possible to imagine an ". . . age" the elements of which would be left loose in a flat box with a transparent lid, and which would make up, as in certain games of patience or skill, a different picture each time they are shaken. Such an object, in which the part played by chance and by studied effect would be difficult to establish, would bear witness to a fine degree of modesty in the artist. . . or to a fine degree of presumptuousness.

These words of Brunius' find authority in Ernst's insistence that, of the fifty-two collages he exhibited at Breton's invitation, at the Galerie Au Sans Pareil in Paris (May 1921) soon after his arrival from Cologne, only twelve had been made with scissors and paste. Brunius' conclusion is as follows. If one wished to characterize the technique of collage, "it would be better to say *découpage* or *assemblage*, or *juxtaposition*, or *contiguité*, or *promiscuité*, or according to a recent coinage of Edouard Jaguer's: *greffage*." If, alternatively, one wishes to express "the spirit of the thing," it is the word *rencontre* that Brunius suggests one uses.[2]

[2] Jacques Brunius, "Rencontres fortuites et concertées," in the catalog *E. L. T. Mesens, 125 Collages et Objets*, Knokke-Le-Zoute, July–August 1963.

Brunius' pertinent distinction emphasizes how collage reflects the spirit of surrealism in bringing about a discovery on the plane of *la rencontre:* an unprecedented encounter, imaginatively stimulating. On the other hand, it points to a *method.* Here, as the noun *rapprochement* shows clearly enough, pictorial collage is to be seen as the counterpart, in graphic terms, of the process of bringing words into unwonted proximity approved by André Breton in his *Anthologie de l'Humour noir,* where Francis Picabia is cited as "the first to understand that any *rapprochement* of words without exception was permissible and that its poetic virtue was all the greater because it appeared gratuitous or exasperating at first sight" (p. 402). Picabia's treatment of words, Jean-Louis Bédouin tells us, justifies considering him one of the principal initiators of surrealism. Bédouin therefore reproduces no less than eleven of Picabia's poems in his anthology *La Poésie surréaliste.*

Surrealists support in theory any *rapprochement* of words and forms. However, this does not mean they are of the naive opinion that any alignment of words at all is sure to produce, magically, the spark of revelatory imagery. It means that surrealism encourages the poet to venture, without fear of ridicule and with unreserved optimism, into word combinations such as reason would outlaw, in his search for an illumination which, surrealists are convinced, rationally concerted phrases could not provide.

The fruits of the poet's new-found freedom include a rich variety of images, all presenting the same structural features. The *rapprochement* is effected through use of prepositions. These serve to bring and hold together realities normally thought to be incompatible. In Jean Arp's "Monte Carlo," from *Le Siège de l'air,* such a *rapprochement* frees objects from the utilitarian role they have to play in everyday life and gives them quite unforeseeable characteristics: "la plume nage dans le miroir au nombril de lumière" ("the feather swims in the mirror with a navel of light"). From André Breton's *Fata Morgana* comes, "Ce matin la fille de la montagne tient sur ses genoux un accordéon de chauves-souris blanches" ("This morning the daughter of the mountain is holding on her knees an accordion of white flittermice"). In Pierre Dhainaut's *Mon Sommeil est un verger d'embruns* there is a nest of echoes where the bird of the wind sleeps ("Le nid des échoes / où dort l'oiseau du vent"). "Dans le sommeil quelquefois," in Georges Schehadé's *Poésies III,* shows us "le pavot des paupières innocentes" ("the poppy of innocent eyelids"). A verse collection by Maurice Henry is called *Les Paupières de verre* (*The Glass Eyelids*).

Georges Henein published a small collection of stories under a title borrowed from the name of one of them, *Un Temps de petite fille* (*Little Girl Weather*). Poems by Achille Chavée appeared under the heading *Le Cendrier de chair* (*The Flesh Ashtray*). Marcel Mariën gave the name *La Chaise de sable* (*The Sand Chair*) to one of his books.

This list grows considerably longer when we turn to images in which the preposition *à* fills the role we have seen taken by *de*. André Breton called one of his verse collections *Le Revolver à cheveux blancs* (*The Whitehaired Revolver*), for instance. Drawing words into unforeseeable and therefore apparently fortuitous combinations, the surrealists' use of prepositions results in poetic constructs that apply grammatical relationships in a zone outside reason's jurisdiction. Prepositions link nouns in unprecedented fashion, connecting levels and modes of experience in accordance with laws that past experience affords us no opportunity to define. Thus, utilized by a poet like Benjamin Péret, they give bearded soap, a peacock-eyed storm, a handkerchief with stained-glass windows, to say nothing of a vagina's rainbow, a deep-sea diver of fire, steaks' tears, and the strident cry of red eggs.

Péret calls upon the preposition to play its designated role as grammatical connective. In so doing, through verbal automatism he shows its use to be potentially unlimited, once we have ceased to believe in the restrictions imposed by reasonable language. As a result, he arranges our first meeting with birds of flour, butter violins, water lilies of suspenders, malefactors in the shape of tunnels, and trumpet-shaped noses playing a funeral march. More than this, releasing some words from their normal function, from the confinement of accepted usage, Péret's writings invest them with an ambiguity for which we are not prepared. A great wave in *A Tâtons* has blinders that may be the *Crystal Blinkers* that interest Marcel Mariën and are at the same time eyeteeth: *une grande vague à œillères*. In *Le Grand Jeu* how are we to interpret "aigrettes" in the phrase *les œufs aux aigrettes de soie* ("eggs with silky aigrettes")? Outside the "wan light of the utilitarian" things glint suggestively, illuminated by the imagination, which, Eluard once pointed out in an essay on Péret, "does not have an instinct for imitation."[3]

The function of the preposition in imagery of this kind is al-

[3] Paul Eluard, "L'Arbitraire, la contradiction, la violence, la poésie," *Variétés*, June 15, 1929.

together like that of glue in surrealist pictorial collage. It brings into
unfamiliar proximity elements between which experience and reason-
able supposition can establish no satisfactory connection. It helps us
see why, discussing collage, Max Ernst—the man whose collages have
exerted most influence in surrealist circles—explains his aims as he
does, in *Beyond Painting*. First, he quotes Lautréamont's image of the
fortuitous encounter of a sewing machine and an umbrella on a dis-
secting table. Then he goes on to furnish this definition which, with-
out apology, paraphrases Lautréamont: "I am tempted to see in collage
the exploitation of the chance meeting of two distant realities on an
unfamiliar plane or, to use a shorter term, the culture of systematic
displacement and its effects, . . . *the coupling of two realities, ir-
reconcilable in appearance, on a plane which apparently does not suit
them*" (p. 13).[4]

Three interesting and instructive assumptions underlie Ernst's
definition. First, it reveals that he sees collage as exploiting, in the
interest of the illuminating spark, the very discrepancy reason is bound
to note between the elements brought into proximity by collage.
Second, Ernst speaks from a standpoint fully in keeping with the
underlying principles of surrealism. He treats the two realities collage
makes it possible to bring together as irreconcilable in appearance
only, just as he regards the plane on which they are presented as only
apparently unsuited to them. Creative energy in the surrealist col-
lagist, we gather, will be generated by his will and ability to cultivate
systematic displacement and its effects. Thus the essential role of
collage in surrealism is to dispose of apparent contradictions and
discrepancies. Its purpose is not to hold up a faithful image of reality
as habit has accustomed us to see it, but to communicate instead the
higher sense of reality which is surreality. Above and beyond reason-

[4] Partisanship can be detected in a comment made by a former participant in
Dada, Hans Richter: "Max Ernst's work was rightly described as 'Dadaist' until
1923. From 1924 onward, thanks solely to the word-magic of André Breton, it
turned 'Surrealist' without really changing at all." *Dada: Art and Anti-Art*, p. 164.
What matters in the context of the present study is not stealing Ernst away
from Dada but acknowledging in his collages the quality that lends them sig-
nificance in the surrealists' eyes. Carlo Sala has ascribed these collages "an im-
pression of novelty" among the products of Dada—"that is to say the intrusion
of unconscious *données* searched for and provoked by means of all sorts of steps
permitting the artist to stimulate his hallucinatory capacities" ("Les Collages de
Max Ernst et la mise en question des apparences," *Europe*, No. 475–76 [Novem-
ber–December 1968], p. 134). "In this new perspective, at once psychological
and plastic, the traditional combinative order of elements finds itself profoundly
altered by the subversive power of the dream. A new figurative syntax comes to
light" (p. 133).

able anticipation, a collage will take its effect upon a plane that looks to be unsuited to providing illuminating encounters—from the perspective of common sense, that is—yet lends itself perfectly well to meeting the demands of surrealist poetic communication. Hence a third significant assumption, to which Ernst's reference to coupling unambiguously directs attention. The encounter precipitating the image is the very feature that led Louis Aragon to liken the operations of collage to those of magic. By speaking of forms that couple after the fashion of animals, Ernst demonstrates his preference for an analogy with the generative act rather than with magical procedures. In this, he follows the example set by André Breton in an important early essay, "Les Mots sans rides," from *Les Pas perdus*. Here the names of Jean Paulhan, Paul Eluard, Francis Picabia, Lautréamont, Stéphane Mallarmé, Guillaume Apollinaire, and above all Marcel Duchamp and Robert Desnos are cited in relation to "a veritable chemistry" which Breton sees as following Rimbaud's "alchemy of the word," and which leads to the following assertion:

> Let it be fully understood what we are saying: a play upon words when it is our most certain reasons for being that are at stake. Words anyway have finished playing.
>
> Words are making love. (p. 171)

Freudian interpretation of Lautréamont's umbrella and sewing machine imposes upon their exemplary encounter an indisputably sexual significance. And this is quite consistent with the famous image's fascination over the minds of Ernst, Breton, Eluard, and other surrealists. "The embrace of the umbrella and the sewing machine," declares Harold Rosenberg, with much enthusiasm, "has become the device on the banner of absolute freedom."[5] Particularly noteworthy, therefore, are two facts that come to light when we consider the influence of Lautréamont's example upon the concept of pictorial collage in surrealism.

To begin with, Lautréamont himself employed a technique Gérard Legrand has summed up this way: "whole texts (since he went so far as direct plagiarism of Buffon), whole paragraphs of ex-

[5] Harold Rosenberg, "Life and Death of the Amorous Umbrella," *VVV*, No. 1 (June 1942), p. 12.

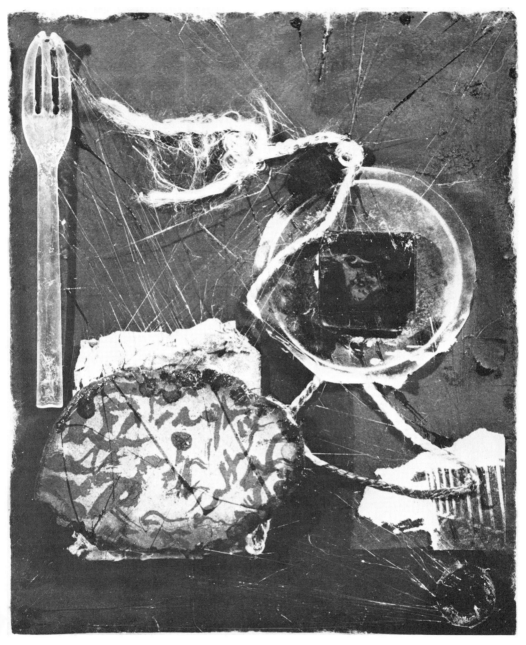

Mario Cesariny, *To Rimbaud, the Invisible, the Untouchable, the Inaudible.*
1956. Poem-Object. Collection of the artist. Photo Alvard Campião.

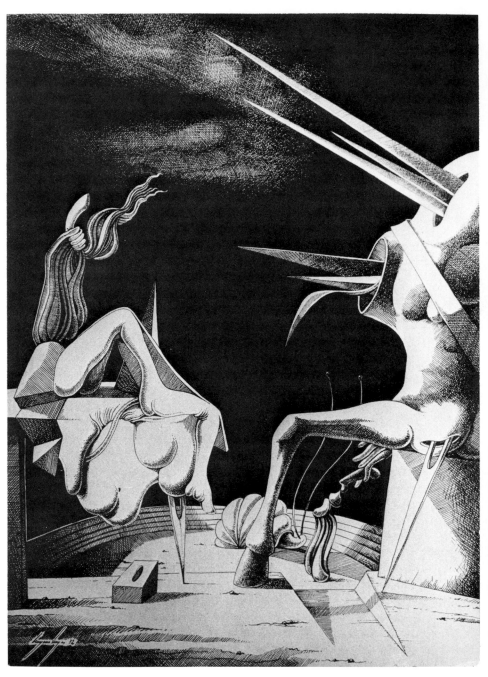

Artur Cruzeiro Seixas, *The Alchemy of the Word*. 1972. Drawing. Collection of the artist.

tremely classical appearance break up suddenly on a phrase brought
in from elsewhere that gives birth to a new development in appear-
ance, I was going to say rational, but let's say rhetorical."[6] Thus ac-
cording to Legrand, "poetry bursts forth so to speak from the en-
counter of those two elements which clash in a succession that
commands attention by extending over a considerable lapse of time."
In short, Lautréamont, whose imagery has provided surrealist graphic
collagists with a model, himself practiced verbal collage, deriving from
it benefits to which, as a surrealist, Legrand shows himself duly
sensitive.

This fact highlights the other, a more important one. References
to Lautréamont abound in surrealist theoretical writings. A 1938 edi-
tion of *Les Chants de Maldoror* was illustrated by Brauner, Dominguez,
Ernst, Espinosa, Magritte, Masson, Matta, Miró, Paalen, Man Ray,
Seligman, and Tanguy, each painter having elected to execute a draw-
ing inspired by the strophe most appealing to him. There exists no
comparable tribute on the part of surrealist writers, however. In *La
Peinture au défi* Aragon pronounced Lautréamont's use of collage "a
poetic procedure," one "absolutely analogous to that of the poetic
image." Yet, in spite of his promise in a footnote to return to "collage
in literature," Aragon never did take up the question of verbal collage
in surrealism. The material he might have studied has attracted so
much less notice than pictorial collages that one's first impression is
that he was compelled by lack of evidence to give up the idea of
complementing *La Peinture au défi* with a study of the role of collage
in surrealist writing.

Faced with what Brunius has called "the poetic inflation of the post-
war years," Mesens more or less stopped writing after 1945 and turned
to collage as "a fresh and unpolluted source." Those who know this
may feel they have reason to believe it superfluous to look in the work
of surrealist writers for any other kind of verbal equivalent of pictorial
collage than we have met so far. Such a conclusion would be prema-
ture, however. We soon see this as we follow Brunius' testimony
further:

When Mesens is tired of writing poems, he relaxes by devoting him-
self to manual work: he makes collages, as others would do carpentry,

[6] See Ferdinand Alquié, *Entretiens sur le surréalisme*, p. 21. Legrand cocdited
with Georges Goldfayn the first *édition commentée* of Lautréamont's *Poésies*
(Paris: Le Terrain Vague, 1960 [actually published in 1962]).

or rather would garden. If certain of his gardens are two-dimensional compositions, while upon others the bumping together of elements and the play of color confer depth, we are dealing none the less with aspects of the same park where every curve of the path uncovers new sights. . . . Despite the variety of styles, poem or garden, collage or picture, it is only a question of speaking in *images*.[7]

And this is by no means true of Mesens alone.

Speaking of "a whole spectrum of possibilities certain of which—I am convinced—have not been explored," Legrand specifies:

> There is notably verbal collage, which is not widely practiced. There is a very fine example of it in a poem by Breton, that is, the appearance of a pharmaceutical prescription following its scientific designation, the prescription that contends with the "galoping sound," that is to say the angina pectoris syndrome, and which is made up of a certain number of grams of plant roots. These are enumerated purely and simply in the poem, without interrupting it at all, in spite of their scientific character . . . , then the poem takes its course in a normal manner, so far as a poem has a normal course.[8]

Now the drama to which Mesens alluded in connection with Ernst's collages can claim our attention only when the technique of pictorial collage ceases to be of importance to us, except so far as its effect is to bring reality into question. In this respect, collage is typical of all the techniques promoted in the name of surrealism: a method valuable solely because its function is to circumvent the obstacles separating us from totally emancipated mental representation. It is by no means certain, then, that the form of verbal collage cited by Legrand functions the way Ernst's collages do.

Apparently, Legrand is impressed by the Breton poem he cites because it demonstrates poetry's ability to assimilate elements conventionally excluded from verse. Not only does he come close to suggesting that surrealist verbal collage has little if anything new to offer beyond what is to be found in Apollinaire's poems. Also, with his stress on assimilation, he implies a criterion for collage with words markedly different from the one set by Max Ernst. Asking in *Beyond Painting*

[7] For an interesting parallel see Joan Miró's article "Je travaille comme un jardinier": "I work like a gardener or like a vine-grower. Things come slowly. My vocabulary of forms, for example, I did not discover all at once. It took shape almost in spite of me."

[8] See Alquié, *Entretiens sur le surréalisme,* p. 40.

what "the most noble conquest of collage" is, Ernst answers his own question in these terms: "The irrational. The magisterial eruption of the irrational in all domains of art, of poetry, of science, in the private life of the individual, in the public life of peoples. He who speaks of collage speaks of the irrational" (p. 17). To Ernst, the nature of collage is "something like the alchemy of the visual image" (p. 12). With the Breton example quoted by Legrand we are a long way indeed from Ernst's "MIRACLE OF THE TOTAL TRANSFIGURATION OF BEINGS AND OBJECTS WITH OR WITHOUT MODIFICATION OF ANATOMICAL ASPECT." Allowing for the fact that Breton was not concerned with "beings and objects," we see that, although he and Ernst are employing comparable methods, the function of these methods is not at all the same.

This is not to say that verbal collage is incapable of lending itself to the same purposes as graphic collage. The important thing for surrealists, after all, is not introducing elements banned by esthetic principles or reasonable anticipation in a manner that avoids creating a disruptive effect. Indeed, such inhabitual elements are welcome to the extent that they do violence to the reader's or spectator's expectations, so reorienting the mind by soliciting responses that conventional realism never evokes. The arresting originality of Ernst's pictorial revelations through collage were particularly exciting to the early surrealists. He could be seen to have tampered as much with patently nonlyrical aspects of the visible world as with its emotional exaggeration in engravings illustrating turn-of-the century novels, often incorporated into his collages.[9] Hence, seeking a true counterpart to the pictorial collage inaugurated by Max Ernst, we find it not so much

[9] Aaron Scharf has noted, "Many of the compelling hieroglyphic by-products of experimental scientific research, not to mention the evocative engravings to be discovered in books popularizing science such as Amedée Guillemin's *The Forces of Nature* and Figuier's *Marvels of Science* and in illustrated popular-science journals, served this twentieth-century necromancer [Ernst] well." See Aaron Scharf, "Max Ernst, Etienne-Jules Marey and the Poetry of Scientific Illustration," in Van Deren Coke, ed., *One Hundred Years of Photographic History* (Albuquerque: University of New Mexico Press, 1975), p. 119. Scharf cites Henry Selby Hele-Shaw, working before the turn of the century, as among the first to propose a hydraulic theory of electricity. Hele-Shaw brought invisible electrical phenomena into view by shooting thin streams of colored glycerine under pressure into a transparent glycerine matrix. Scharf comments pertinently, "The current moves into areas of least resistance, just as in magnetic field experiments, thus producing seriatim the characteristic and very attractive rhythmical delineations. These things are worth describing, as they throw light on Ernst's transformations of this rather esoteric imagery into mystifying excursions into landscape and seascape" (p. 121). A report on Hele-Shaw's work appeared in the September 1901 issues of *La Nature,* a periodical from which we know that Ernst borrowed material.

in the example supplied by Legrand as in another text of André Breton's.

Asserting in his first manifesto that surrealist methods need to be extended, Breton declared, "Everything is good for obtaining desirable unexpectedness from certain associations" (p. 57). He went on, "It is even permissible to entitle POEM that which is obtained by the assemblage, as gratuitous as possible (let us respect syntax, if you wish), of headlines and parts of headlines from newspapers." As much by the method Breton proposed as by Ernst's, elements taken from everyday reality—torn from the context investing them with commonsense meaning—are made to play a subversive role. They offer the imagination stimulation of a kind that reality is unable to provide without assistance from the creative artist. Interestingly enough, Breton omits to tell us how far premeditation entered into the composition of the poem he now transcribes in the *Manifesto of Surrealism*. It begins:

Un éclat de rire
de saphir dans l'île de Ceylan

Les plus belles pailles
ont le teint fané
sous les verrous
dans une ferme isolée
au jour le jour
s'aggrave
l'agréable

Une voie carrossable
vous conduit au bord de l'inconnu

(A burst of laughter
of sapphire in the island of Ceylon

The finest straws
have a faded color
under the bolts
in a lonely farm
from hand to mouth
the agreeable
is getting worse

A carriageable route
leads you to the edge of the unknown)

The inadequacies of the English version given here indicate that verbal collage shares with other forms of surrealist linguistic expression advantages coming directly from elimination of reasonable sequence. Placed outside the framework of rational discourse, a noun (*teint*), a verb (*s'aggrave*), and a whole phrase (*au jour le jour*) are endowed with a polyvalence that translation cannot convey, expanding the imaginative suggestiveness of the French text. A complementary effect has been obtained by Jehan Mayoux. Phrases found in proof pages of a treatise on maritime law, used to wrap books received through the mail, take on distinctly perceptible though indefinable resonance, when used as titles for some Mayoux poetic texts with which rational thought can connect them in no way.[10] Elements supposedly forever confined to the humdrum routine of everyday living take on unsuspected qualities when collage relocates them on the plane of poetry. And this happens even when the resulting poetic phrase seems to aim at placating reason, not at defying it. Thus we hear Breton, apparently in conciliatory mood, avow in the poem he reproduces in the first surrealist manifesto:

une paire
de bas de soie
n'est pas

Un saut dans le vide
un cerf

(a pair
of silk stockings
is not

A leap into space
a stag)

The fact that one thing is admittedly not what reason forbids it to be is no guarantee at all that, by the same token, it cannot be something else again, just as unacceptable to reasonable thinking. Surrealist collage, using verbal or pictorial means, entices the mind onto a slippery

[10] See J. H. Matthews, *Surrealist Poetry in France*, pp. 149–51. *Cf.* Max Walter Svanberg's remarks on his own collages: "I take all the cut-out things out of their univocal existence and put them together to make a polyvalent world." *Svanberg*, p. 35.

slope where reason loses its equilibrium and sometimes, even, is made a reluctant accomplice in the overthrow of rationalist thought. "To the mind," asks the *Manifesto of Surrealism*, "is not the possibility of wandering rather the contingency of good?" (p. 17).

The essence of verbal collage, as surrealists turn it to account, lies in its success in bringing into unwonted proximity elements reasonable language declines to associate. Basically, the effect is no different from what Ernst, Styrsky, and Toyen all achieve by means of pictorial collage: "One perceives," remarks José Pierre appositely, "that it is a matter of speculating on fragments of pictures, already perfectly significative, which their more or less arbitrary meeting will place in a situation overflowing their original meaning."[11] In other words, everything depends on how the artist makes use of verbal or pictorial material to extend or expand meaning by borrowing recognizable elements in a way that, undermining their original function, will release them for other purposes. It is in this sense that we may speak of a creatively assimilative process, fruitfully bringing together disparate materials in the image-making process. The implications of verbal collage agree exactly with those of pictorial collage in this respect. Words and pictures challenge the tyranny of pictorial and verbal forms, liberating expression by pushing back its physical limits while new relationships are established in defiance of the habitual. The process of grafting, as Jaguer suggests we term collage, brings renewed vitality and nurtures unprecedented forms.

Titles add weight to the blow dealt realistic representation by surrealist collages. Never used in such a way as to reduce the distance between the pictorial image and familiar reality, never offered in the spirit of conciliation, they serve instead to widen that distance. They aggravate the realist's sense of grievance by accentuating the discrepancy between what the habitual has led him to expect and what collage technique has enabled the artist to show.

Now and again, Ernst would inscribe a title on the back of a collage. At other times, he would place the title around the margin of

[11] José Pierre, reviewing the exhibition "Les Palimpsestes de Ragnar von Holten," *La Quinzaine littéraire*, January 1–15, 1975, p. 18. In his *Toyen*, Radovan Ivsic has pointed out, "And if the surrealist liberation of language had permitted Breton to note that 'words make love,' thanks to Toyen forms at last make love" (p. 65).

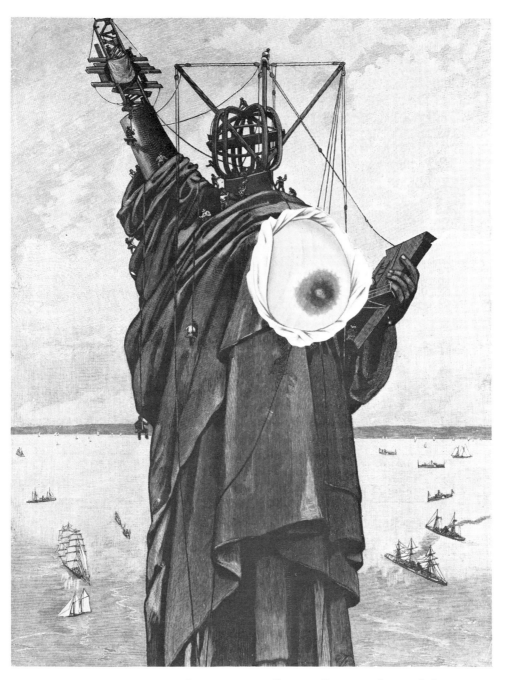

Jindrich Styrsky, *Statue of Liberty*. 1939. Collage. Collection Robert Lebel, Paris.

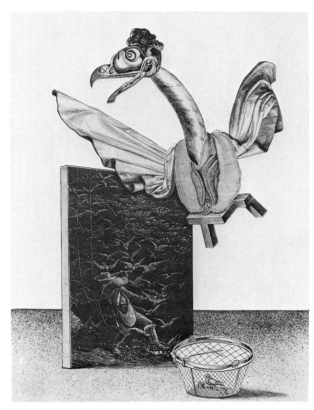

Albert Marenčin, from the collage cycle *Returns to the Unknown*. Collection of the artist.

Artur Cruzeiro Seixas, *The Basis of Language—I, You, He*. 1960. Collage. Collection of the artist.

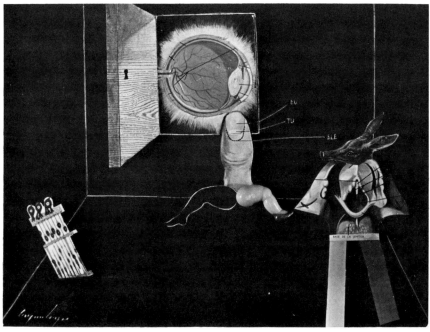

his picture, or even incorporate it into the collage itself. Whether we take an example of the former ("The transformation of the chameleon on Mount Tabor takes place in an elegant limousine while the angels and canaries fly off from the houses of man and the very holy coat of our Lord exclaims De Profundis three times before lashing the flesh of exhibitionists") or select one of the latter ("This is already the twenty-third time that Lohengrin has abandoned his fiancée for the first time / it's there that the earth has spread its tree-bark over four violins / we shall never see one another again / we shall never fight with angels / the swan is very peaceful / it rows hard to reach Leda"), we detect no real difference between the visible titles and the concealed ones. "No one will ever have had it said as much as Max Ernst of these pictures," comments Aragon in *La Peinture au défi*, "*but this isn't painting.*" No one, we can agree, except E. L. T. Mesens.

Mesens has shown that, just as the collage can take reality apart and then reassemble it according to new rules, so too the title of the finished product is similarly subject to dissection and reassemblage in a manner that appropriately echoes and gives resonance to its poetic message. Some of his titles appear to be no more than labored and even quite childish examples of word play, especially when considered apart from the works to which they belong. But Mesens' habit of introducing a title into the collage it completes rules out misunderstanding on this score. *Man-hat-tan, To Make Ends Meat:* these two titles in English support Brunius' contention that, to Mesens, word play was the verbal equivalent of pictorial collage. More than a sign the artist passed through Dada before joining surrealism, puns of this sort impress Brunius as Mesens' way of expressing his wish to suggest "artistic–antiartistic ambiguity."

As is always the case in surrealism, humor is a significant factor in undermining confidence in the permanence of familiar reality.[12] Subversion of well-known phrases by means of linguistic dissection rebuffs habit and interrogates the forms placed before us by pictorial collage, in works like Mesens' *La Dame au Camée lia . . . quoi?* Sophistication and archness would count for nothing here. For playfulness strips away the sophisticate's blasé acceptance and compels him to take a second look at reality, which collage technique shows to

[12] This is humor as described in Breton's "Limites non-frontières du surréalisme": "humor as the paradoxical triumph of pleasure over the real conditions of the moment in which the latter are judged most unfavorable, is at present called upon to take on a defensive value during the period, overloaded with threats, we are living in." See *La Clé des champs*, p. 17.

be far from reassuring. Verbal and figurative elements collaborate in advancing the aims to which Breton alluded in *La Clé des champs,* when discussing surrealism between the wars: "But what, I ask, what is the narrow 'reason' that can be learned if this reason must . . . give way to the unreason of war? For this to be so, must it not be that this supposed reason is a decoy, must it not be that it usurps the rights of a *reason,* true and without eclipses, which we have to substitute for it at all cost and toward which, to begin with, we can reach out only by making a clean sweep of conventional modes of thought?" (p. 62).

In short, it is no coincidence that the way Mesens arrives at some of his titles—through a process that follows the destruction of words with their recreation—bears comparison with Matta's. Matta's belief that disintegration and reconstruction of the visible world are connected with the disintegration and reconstruction of language has led him to coin neologisms as a stimulant to pictorial inspiration. Engaged in what he terms *conscienture,* the painting of consciousness, Matta makes up strange titles from pedestrian materials: *Je m'honte* from *Je monte* and *Je m'arche* from *Je marche,* for example.[13]

Whereas Matta has found inspiration upon occasion from verbal neologism, Ernst's method is more representative of surrealist poetic practice in general: "Never do I impose a title on a picture: I wait for the title to impose itself upon me. After painting, I often remain—sometimes for a long while—haunted by the picture, and obsession ceases only at the moment when the title appears as though by magic."[14] With Ernst, this custom evidently dates back to his first collages. Here, according to Marcel Jean, the title inseparably fits in with the image, "highlighting the humor of the procedure while enlarging its poetic possibilities" (p. 79). The technique by which the image has been given form is not the really important factor, of course. What counts is this. In naming his collage or painted canvas, the surrealist artist ironically mocks the impulse that will make bemused spectators refer hastily (if surreptitiously) to the exhibition catalog—looking to its title to explain, to excuse even, a work they do

[13] See Maxime Alexandrian, *Surrealist Art,* pp. 166–67.
[14] Max Ernst, *Propos et présence,* p. 16. In 1959, four years after Ernst's exclusion from the surrealist movement for accepting the *grand prix* at the 1954 Venice Biennale, Ernst was still saying, "It's in the morning, around five o'clock, at the time when I'm awakening and when I'm trying to get back to sleep again for a while that I find most of my titles. Making a picture is like creating a ghost. It's there, inside me, present, and it pursues me so long as I've not found a name for it. Afterwards only, I am released. Ghosts haunt you so long as you've not identified them." See Alain Jouffroy, "Conversation avec Max Ernst," in his *Une Révolution du regard,* p. 142.

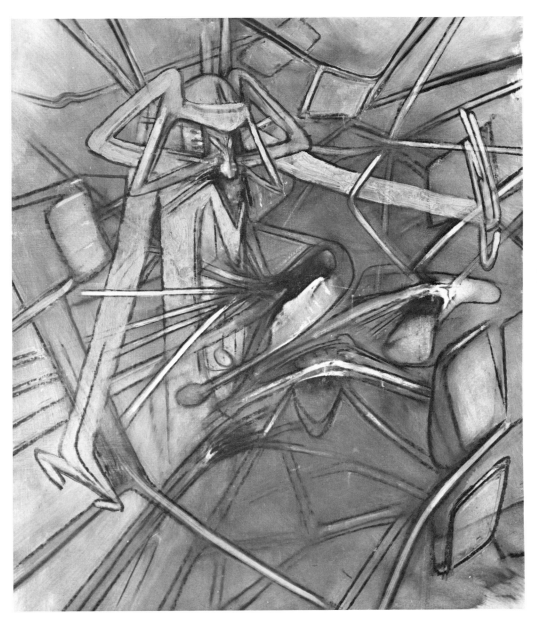

Sebastian Matta Echaurren, *The Unglimpsed*. 1956. Oil on canvas.

Enrico Baj, *Mary Augusta Arnold Ward, English Writer*. 1975. Collage on wood. Collection of the artist.

not comprehend immediately. In one of Miró's picture-poems, "Un oiseau poursuit une abeille et la baisse," the painter's command of French amusingly falls short of his intentions: he obviously meant *baise* not *baisse* in a title reading "A bird chases a bee and fucks it." But this error hardly justifies Dupin's prim comment that there is "no need to dwell on the title" (p. 164).

In the course of an extended essay on René Magritte in *Histoire de ne pas rire*, Paul Nougé makes the following general comment: "The title of a picture, if it is effectual, does not fit in with the painting after the manner of a more or less subtle and adequate commentary. But, by the help of the picture, the title is born of an illumination analogous to the one that has determined what it names. The best titles come about this way. The others, those that come to us from a purely logical and conscious search, are distinguished almost always by some air of vanity" (p. 238). As the man who devised many of the titles for Magritte's pictures, Nougé spoke with some authority. The titles selected by Mesens and by Ernst respect the fundamental principle of surrealist practice laid down by Nougé. They back up the argument outlined in Breton's *L'Un dans l'autre:* "To close oneself off from play, at least from the play of imagination as adult discipline bars it, is, one can see, to undermine in oneself the best part of man."

When they indulge without reserve in various forms of play, like Breton in a poem from *L'Air de l'eau* surrealists "sing of the unique light of coincidence," the illuminating conjunction of elements objective reality keeps apart from one another. Hence the creative process is likened—in the 1928 edition of *Le Surréalisme et la peinture*—to "the game of patience of creation," in which parts no longer drawn together by any "particular magnetism" seek to "discover new affinities with one another" (p. 25). At stake, therefore, is our sense of what is real and deserves to be granted the respect generally commanded by objective reality. This, at all events, is the drift of the penultimate paragraph in the first edition of *Le Surréalisme et la peinture:* "In reality, if you know now what we mean by this, a nose is perfectly in place next to an armchair; it even takes the form of the armchair. What difference is there *fundamentally* between a couple of dancers and the cover of a beehive? Birds have never sung better than in this aquarium" (p. 48). Less aggressively, borrowing Ernst's title "Au-delà de la peinture," Paul Eluard affirms in *Donner à voir,* "It is not

far, by bird, from image to man, it is not far, by image, from man to what he *sees,* from the nature of things real to the nature of things imagined. Their value is the same. Matter, movement, need, and desire are inseparable" (p. 97).

Eluard's phrasing makes his argument sound less of a challenge to reasonable thought than Breton's, and therefore more subtle. In fact, though, both surrealist commentators are equally uncompromising, for their statements have the same point of departure. We detect the central issue with least delay when we recognize what collage means to a surrealist.

Collage shares with other modes of surrealist expression in rescuing thought from the reductive effect of reasonable postulation. It helps show reason's function to be, as Breton put it, a decoy, leading those who place reliance on it in the opposite direction from the one in which exciting and fruitful discoveries are to be made. Collage represents a necessary reversal of modes of perception which, for the surrealist, is the beginning of true vision. Thus the humor so often characteristic of surrealist collage significantly marks a release, a liberative assertion of rights that reason, out of self-interest, never ceases to deny.

The critical factor here is that of apprehension. This is why there is no difference at all, to the surrealist mind, between the ambitions governing pictorial rearrangement of external reality through collage and the use of language unrestricted by rationalist preconception. In an interesting essay from *Perspective cavalière* inspired by Welsh bardic poetry, Breton assures us that, before it became "a means of utilitarian exchange between men," language was "a break-through into the unknown, an opening in the blue sky" (p. 131). Hence the poetic revolution culminating in surrealism has the immediately perceptible consequence of bringing out "the fallacious character of—I repeat—'literal' modes of apprehension of a language not having yet abdicated or aspiring to reconquer its original purpose" (p. 132).

These observations of Breton's lose much of their force if we fail to appreciate that, referring to language, he is speaking not merely of words but of a mode of communication embracing pictorial as well as verbal means. To be combatted on all fronts is the utilitarian sense by which the world is invested with an air of rational organization. Thus, as Breton confides indirectly in *La Clé des champs,* surrealists dream of a place outside the world of reason. Here man-made objects that have lost their utilitarian value, have not yet found it, or have become

Paul Delvaux, *The Woman with the Rose*. 1936. Oil on canvas. Galerie Isy Brachot, Brussels.

Peter Weis, collage for *The Arabian Nights*. 1958. Collection of the artist.

perceptibly separated from it are endowed with a secret quality allowing the adult to see them with the freshness of a child's vision. Next to these objects which, one might say, have been freed from their assigned function are strange natural objects, the product of *"a most obscure necessity,"* that immediately engage attention. Both types of objects, Breton claims, appeal to each of us "as *revelatory of his own desire,* at least as interceding between this desire and its true object, often unknown" (pp. 26–27).

The ultimate aim of surrealism is attaining the goal of desire fulfilled. The immediate means used in the pursuit of this goal, so far at least as the public senses what the artist seems bent on doing, appears to be implementation of a technique employed with the express purpose of provoking surprise. True enough, we read in Breton's *L'Amour fou* that "surprise must be sought for itself, unconditionally" (pp. 122–23). Even so, oversimplification is dangerous here. In *La Peinture au défi,* Aragon agrees that the element of surprise is present in collages, but prefers to speak of the marvelous and, even more exactly, of *"un dépaysement extraordinaire,"* an extraordinary disorientation: "The miracle is an unexpected disorder, a surprising disproportion. And it is in this respect that it is the negation of the real and becomes, once accepted, a miracle, the conciliation of the real and the marvelous. The new relationship thus established is surreality, a thousand times defined, and always differently definable; that real line which links all the virtual images that surround us." The word *dépaysement* is footnoted in Aragon's text so that readers may be referred (somewhat inaccurately, by the way) to an aphorism of Breton's: "La surréalité sera fonction de notre volonté de dépaysement de tout." Defining surreality in terms of "our will to take everything out of its natural surroundings," this maxim comes from Breton's "Avis au lecteur" in Ernst's *La Femme 100 têtes.* Taking the hint given by Aragon, we may turn for expansion and elucidation of his statement in *La Peinture au défi* to the *romans-collages* of Max Ernst, the novels in collage form, of which the first to appear was *La Femme 100 têtes.*

The surrealists' dedication to the *dépaysement de tout* comes as no surprise. At this stage it gives us less pause than seeing Breton's preface to *La Femme 100 têtes* link *dépaysement* with *volonté.* It is easy enough to see why a surrealist would prize disruption and rearrangement of materials borrowed from nature. More difficult is perceiving how such *dépaysement*—making the reader or spectator feel he has been transported to another world—can result from deliberate intent. Does not the latter, the very premeditation rejected in the *Manifesto of Surrealism* out of preference for spontaneity, preclude the

discoveries to which *La Peinture au défi* alludes? Does it not reduce, anyway, their ability to excite us by subjecting the technique of collage to the control of intentionality?

Marcel Jean seems to be willing to brush these questions aside. He writes, "*Dépaysement* is not *given,* in the work of Max Ernst. It appears at the moment when the poet adapts, delimits and situates phantasms. Thanks to this touching up, without which Leonardo da Vinci's wall evidently would be a mere wall, the picture-poem acquires a *vibration* that is its very life, it attains true lyricism, in which the lights of hallucinated consciousness sparkle" (p. 128). A footnote explains that *vibration* in painting, or *pulsation* in "literary expression," is always "the conscious–unconscious exchange that gives life to the picture or poem." Following a similar line of reasoning, Jean Schuster appears to go farther than Jean only because he openly characterizes the touching-up mentioned by the latter as an intellectual process, expressive in consequence of a posture deliberately adopted and consciously maintained. Jules Monnerot implies the same thing when referring to "l'insolite surréaliste," the surrealist's pursuit of the unwonted, the surprising, as "conceived against contemporary society, the real powers that govern it in fact," and as an "intersubjective, transpersonal unwonted" that fights "a hated norm" in "an enterprise of opposition" (p. 135). For Monnerot, indeed, the surrealist spirit is "l'attente de l'insolite"—at the same time awaiting the unwonted and expecting its manifestation: "l'attente d'une délivrance, l'aspiration vers une plénitude" (p. 127).

All this requires us to go beyond merely acknowledging with Nougé, in *Histoire de ne pas rire,* that "the reality of an object will depend closely upon the attributes with which our imagination has endowed it, upon the number, the complexity of these attributes and upon the manner in which the invented complex fits into the whole, pre-existing within us and existing in the minds of those like us" (p. 37). We have to face up to the inference to be drawn from Eluard's observation in "Physique de la poésie," from *Donner à voir:* "The vanity of painters, which is immense, has for a long time impelled them to install themselves in front of a landscape, in front of a picture, in front of a text as though in front of a wall, to repeat it. They did not hunger after themselves. They would apply themselves. The poet, though, thinks of *something else.* The unwonted is familiar to him, premeditation unknown" (p. 73).

Are *l'insolite* and *la préméditation* incompatible, mutually exclusive even? This is a question to which, speaking of his own collages, Max Ernst has responded in self-contradictory ways.

On the one hand, in the passage from his *Beyond Painting* claiming the irrational to be "the most noble conquest of collage," Ernst tells us, "Making collages follow collages without choosing, we were surprised by the clarity of the irrational action that resulted." On the other, he speaks of having "composed" *La Femme 100 têtes* "with violence and method" (p. 9). How to reconcile the latter statement with the opening sentences of the celebrated essay "Inspiration to Order," reprinted a few pages further on?—

> Since the beginning of no work which can be called absolutely surrealist is to be directed consciously by the mind (whether through reason, taste or the will), the active share of him hitherto described as the work's "author" is suddenly abolished almost completely. The "author" is disclosed as being a mere spectator of the birth of the work, for, either indifferently or in the greatest excitement, he merely watches it undergo the successive stages of its development. Just as the poet has to write down what is being thought—voiced—inside him, so the painter has to limn and give objective form to *what is visible* inside him. (p. 20)

We do not dispose entirely of the problem by reminding ourselves that Ernst is commenting on the origins of a surrealist painting, rather than talking about putting together a succession of collages to form a narrative sequence. We come closer to finding a satisfactory answer, perhaps, if we return to *La Peinture au défi*. Here Aragon contends that negation of technique, evidenced in collage, and negation of "the technical personality"—evidenced in a famous Duchamp gesture (adding a moustache to the Mona Lisa) and an equally iconoclastic gesture by Picabia (designating an ink blot *The Holy Virgin*)— give rise to something he calls "the personality of choice."

Aragon leaves us with the conclusion that it is impossible to say where and when spontaneity takes over from purposeful organization in the collages brought together under the title *La Femme 100 têtes*. Could one really expect it to be otherwise, when the same ambiguity distinguishes the collages used in Ernst's first *roman-collage*, and in his second and third as well? As it inevitably must be, Russell's analysis of "the two basic procedures in this inexhaustibly curious and beautiful work" is limited to identifying effects. It does not come even close to penetrating the mystery of motivation, buried at a level where the personality of choice asserts itself with admirable assurance: "In almost every case one particular plate has been taken entire and meta-

Georges Hugnet, Untitled Photo-
montage. Circa 1935. Collection Tim-
othy Baum, New York. Photo Nathan
Rabin.

Karel Teige, Untitled Collage. 1942.
Photo Jiří Hampl.

morphosed by a very few additions or alterations. In cases where the
basic material has a dramatic or a sensational character, Max Ernst
has usually added a note of paradoxical nonchalance. Where the basic
material is, on the other hand, merely informative and has no distinct
emotional connotation, Max Ernst has put the fear of God (or, more
commonly, of Lautréamont) into the unpretending [sic] scene" (p.
189).

Except for three at the end of Chapter Seven, each constituent
collage of La Femme 100 têtes is captioned. At first glance, the present-
ation resembles nothing so much as that of a comic book, in unex-
pectedly austere black and white. Closer examination reveals that the
relationship between word and picture is not by any means the con-
ventional one. The pictures do not simply illustrate legends, and words
do not merely account for the peculiarities of the graphic image. Con-
sidered together, as they are meant to be, words and pictures show
how difficult it is to measure the contribution of deliberate intent in
the composition of Ernst's first roman-collage. If we may assume he
follows his customary practice of letting the pictorial image suggest
its own title—and in some cases he obviously has done this—then he
has gone about things in a manner proving beyond dispute that the
role of titles is not to domesticate graphic imagery.[15] Far from it, the
legends make up a commentary that Waldberg (p. 286) quotes
Gilbert Lely as classifying among "the finest surrealist poems one can
conceive."

Lely's questionable evaluation need not detain us. What really
matters is this. Anyone who has a copy of Le Poème de la Femme 100
têtes in his possession but does not have to hand the relevant collages
would be hard put to make sense of the text.

It is in this that rationalist processes of interpretation are sharply
rebuffed in Ernst's roman-collage. Viewed at a distance from one
another, the constituent elements of the picture are unexceptionable.
Only in the encounter engineered by collage do they disturb common
sense. Ernst's predilection for source material unenlivened by color
and distinctly dated—not only by the costumes and hairstyles of the

[15] It is difficult to follow Aaron Scharf's argument: "But Ernst's titles [in La
Femme 100 têtes] are by themselves unreliable as evidence of his intentions, . . .
they participate in the deliberate dislocation of reality in a garbled syntax, that
route to the psyche beloved of Surrealists" (p. 119).

human characters but just as visibly by their attitudes, posture, poses, and activities—heightens the impression of reality as dislocated, forced to participate in breaking its own rules; for instance, when laws of proportion and perspective are flouted. And so where the legend is descriptive, it remains obstinately indifferent to reason's demands for an explanation. It is as though the text were meant to insist, very often not without irony, that the collagist has made no involuntary mistakes when depicting what he has us see. Where the caption goes beyond a form of itemization, it does so in a manner that broadens the gap between familiar reality and what the collage shows. In one picture we see, from behind, two men bending over a billiard table while a little boy kneels in the foreground, a half-draped nude in pensive pose sitting on his back. It bears the title "Succession of games, diurnal, crepuscular and nocturnal."

Dislocation of reality is, of course, a negative way of referring to what happens in *La Femme 100 têtes*. Dislocation has its positive counterpart: relocation.

It is because they relocate the real, not because they offer a story in picture-book form, that the succeeding collages of *La Femme 100 têtes* make up a novel. Ernst's book displays the same disregard for sustained narrative and for plot continuity that characterizes surrealist novels like Michel Leiris' *Aurora*. In fact, the discontinuous nature of these collages is a sign that Ernst's *roman-collage* treats the novel form with as little respect as it does visible reality by blending its forms in inhabitual ways. On the extreme right, by a bed in which lies a human figure, head completely bandaged, stands a priest, his features apparently grotesquely masked. Closer to us, to the left, an Amazon, her face concealed but her breasts visible, stands in a pose reminiscent of that of a Flamenco dancer. Discreetly crouching far left is a monkey, the only figure seemingly borrowed without modification from the natural world. Diverting reason from its prime task—establishing what is going on here—the caption asks: "Would this monkey be Catholic, by any chance?"

The light of magic may shine anywhere. At the beginning of the third chapter of *La Femme 100 têtes* it shines inexplicably from the pubic area of a nude of ambiguous sex, to cast light on the portrait of a man—or perhaps actually to create that portrait—visible on a canvas laid on an easel. On such occasions, reasonable thought gains nothing from turning to the collage's title for reassurance. Drawn by curiosity to a railing at the end of a street, adults and children look toward a nude male, his hands raised to his chest, going down a flight

of steps to where, below, the upper part of a nude female is visible. This collage is called "The Stridulations of Sunday Ghosts."

More commonly, unwonted manifestations are not relegated to the status of phantasm. Usually their tangible presence goes unquestioned. Hence the humorous point of one legend—"Then I'll introduce you to the uncle whose beard, on Sunday afternoons, we used to like to tickle"—is that it appears beneath a collage where we see a man whose beard is a nude woman's torso, distinguished by generous mammary development. No sooner has the uncle been strangled, the next picture shows and tells us, than the incomparable young woman flies away, presumably liberated by the "Sorcery or some macabre prank" to which reference is made in the following collage. Here someone who could be a stage magician holds up the torso that used to adorn the uncle's chin.

The poetry of Ernst's legends in *La Femme 100 têtes* is no more subject to limitation by rationalist thinking than the arrangement of pictorial forms: "A cry of great diameter stifles the fruit and pieces of meat in their coffin." If, here, the cry has come from behind the handkerchief one man is holding to his mouth, it presumably has adopted human form. For we see another man kneeling in the foreground, nailing down a coffin in which fruit and meat will suffocate before long.

In *La Femme 100 têtes* we can detect no evidence of any effort to compensate through tonal unity for the bewildering diversity of pictorial material, turned to subversive account. The presence of humor does not preclude use of the macabre, often taking frightening form. Hence—so far as we may speak of this *roman-collage* as developing themes—the theme of dismemberment, like that of explosion, or shipwreck, or torture, underscores the procedure to which collages owe their existence. In one picture, a man hurrying away from a train carries a suitcase to which a human arm is strapped as accessibly as an umbrella. The caption urges him to open his baggage. . . Over the innocuous title "Yachting," the next picture shows a male figure in sailor uniform standing on a pier looking out at sailboats on the sea. Behind him, closer to us (the disturbing, disruptive features administering a jolt to the real world often take up the foreground in Ernst's collages), a large human arm rests on a bench, together with something that might be a section of leg. Is this the morning's catch? Where Max Ernst invites speculation by association, it is always with unsettling effect.

Everywhere in *La Femme 100 têtes* Ernst generates alarm, as

when the great bird figure Loplop—his familiar, one might say—flies menacingly across the page, or "is made flesh without flesh [he is built like a Sumu wrestler at such times] and will dwell among us," while workmen stand among the débris of a collapsed building. For la femme 100 têtes, "my sister," "lighter than the atmosphere, powerful and alone," is Perturbation. We find her seated at ease in the middle of a city square where troops are shooting down civilians. "Each bloody uprising will make her live full of grace and truth," says the text, confirming that among Ernst's sources for verbal collage is the Bible.

One legend runs, "In the blindness of wheelwrights will be found the seed of very precious visions." The relevant collage shows a wheelwright emptying a bucket of water, from which a semi-nude reclining female seems to have spilled. The man and his two companions evince not the least surprise. It appears that, as the caption suggests, they cannot see the woman at their feet.

Time after time our impression is the same: that of being permitted to see things concealed from those whose presence gives the picture its basis in reality. "And nothing will be more common than a Titan in a restaurant," predicts Ernst. The accompanying picture shows a Titan resting on one knee on a restaurant table, right in front of a customer. The Titan's attitude indicates he is trying to attract the waitress' attention, yet she is no more aware of his presence, it seems, than the customer, who appears to be placing an order. As we look at scenes of this kind, where we are privileged to see things unaccountably invisible to some of the participants, we notice how precise is Ernst's collage technique. At the risk of generating misunderstanding, we can speak now of his craftsmanship.

At first the uninitiated spectator has the feeling he is being asked to condone the random rearrangement of apparently irreconcilable elements. After more careful consideration, however, he cannot deny that these collages have been unified with great skill. The Titan fits perfectly into the space between the standing waitress and the seated customer. He occupies his designated place, even though this is not the one the everyday world reserves for him. For this reason, the collage technique employed in *La Femme 100 têtes* presents much more of a challenge to reason and its interpretive processes than we should find in a drawing depicting exactly the same event. Reasonable expectation is put to flight by the meticulous accuracy with which two modes of experience are subsumed in a new and totally unfamiliar one. We are told, for example, "Every Friday, the Titans will pass

through our washhouses in rapid flight, swerving frequently." The
accompanying collage seems at first glance to break down into two
separate parts. Titans writhe in the upper part of the picture. Repre-
sented, just like the one in the restaurant, without shading, these
mythical figures have the whiteness of marble statuary. Their stark-
ness offers the very same contrast with the appearance of the other
characters, realistically represented below, that causes the Titan's in-
explicable presence in the restaurant to claim attention immediately.
The lower half of "Every Friday . . ." depicts a scene in a nineteenth-
century washhouse. It would serve quite well to illustrate the opening
pages of Zola's *L'Assommoir*. The washerwomen work as if uncon-
scious of the presence of their weekly visitors. But before con-
cluding that familiarity has bred contempt, we should notice this. One
woman is beating wet clothes with a paddle. At the other side of the
washhouse—balancing the picture before us—another woman is doing
the same. The second woman, however, does not grasp a paddle but
the wrist of a reclining Titan. Is she about to pound her laundry with
an unconventional implement? Who can say? Quite literally, though
for no reason common sense can detect, Ernst has linked elements
the rational mind would be far more comfortable seeing kept apart.

What is the meaning of *La Femme 100 têtes*? It takes its strange
title from word play that concisely fosters confusion: said aloud in
French, 100 (*cent*) sounds like the word for "without" (*sans*). Ernst's
woman is a headless one with a hundred heads. Six legends in the
concluding pages of the novel deliver the same message: that the
hundred-headless woman keeps her secret. *La Femme 100 têtes* can-
not but disappoint and frustrate reasonable-minded people. Neither
the words nor the pictures will help them interpret Ernst's intentions.
Arriving at the final section, they learn for sure that, seeking rationally,
they will not find. Under a subtitle produced by reversal of one fre-
quently met at the top of serials in newspapers or magazines, "Con-
tinuation and Conclusion," this part of *La Femme 100 têtes* presents
a "Conclusion and Continuation," consisting of one collage only.
Being the very collage that opened the novel, it sends us back to the
beginning once more.

Noting that the archetypes of prose are discourse and narrative,
speculation and history, Octavio Paz comments appositely, "The poem,
on the contrary, offers itself as a circle or a sphere: something that is
closed on itself, a self-sufficient universe in which the end is also a
beginning that returns, is repeated and re-created" (p. 57). So the
question with which we started goes unanswered at the close of *La*

Femme 100 têtes. Use of words in conjunction with pictures has done nothing but deepen the mystery surrounding the genesis of Ernst's *roman-collage.* We still cannot say where and to what extent premeditation took over from spontaneity during its composition. What, though, if there are no words to read? What happens if we turn from *La Femme 100 têtes* to *Une Semaine de Bonté?*

Because no legends accompany the pictures of the latter work, one might incline to believe the arrangement of collages here subject to less strict narrative demands than in *La Femme 100 têtes.* And yet, thumbing through the pages, we are struck at once by an impression of increased and sustained dramatic tension, of tighter structure and hence of more urgent narrative progression than before. People manifestly are the focal point of the scene created in each collage. Emotional stress unifies the pictures in their succession. As a result, it seems paradoxically more appropriate to speak of a plot in *Une Semaine de Bonté,* even though no legends appear to offer the semblance of narrative thread, and the book is divided according to the days of the week, not by chapters.

Our first general impression takes on firmer outline, when we set about examining *Une Semaine de Bonté* systematically. Moreover, our perplexity is increased, now, when it comes to explaining the origins of this *roman-collage.* Ernst has arranged his collages after an extract drawn from Alfred Jarry's *L'Amour absolu.* Are we to assume this quotation has dictated the order in which the collages appear, no doubt influencing the composition of many of them, if not quite all? Or are we to surmise that Jarry's curious statement struck the author as appropriate to his purposes only when the arrangement of his material was complete, or almost so?

The passage taken from Jarry is too enigmatic to afford real assistance: "The ermine is a very dirty animal. It is in itself a precious bedsheet, but because it does not have a pair for changing, it does the laundry with its tongue." Renée Riese Hubert's interpretation of its pertinence to Ernst's picture series is enlightening: "This quotation, which announces the 'appearance' of the ermine in the subsequent collages, opens the door on paralogism, deception, and non sequiturs, while warning the reader to beware of paradox. Both sheets and ermine suggest purity, but by putting them on the same level, Ernst makes the royalty and the emblematic dignity of ermine vulnerable to the vulgar and erotic connotations of the sheets."[16] So far as one may

[16] Renée Riese Hubert, "The Fabulous Fictions of Two Surrealist Artists: Giorgio de Chirico and Max Ernst," *New Literary History,* 5 (1972–73), p. 155.

ascribe Mrs. Hubert any assumptions concerning the relative contribution of spontaneity and premeditation to the ordering of the collages in *Une Semaine de Bonté*, it seems fair to infer that her inclination is to see Ernst's book as the product of deliberation. This, certainly, would explain why she speaks of collage as applying a method interestingly likened to the surrealist use of language (p. 165).

A striking feature of *Une Semaine de Bonté* is its success in avoiding communicating the impression of having resulted from the unimaginatively mechanical application of routine devices, such as weaken an imitative work, Jacques Carelman's *Saroka la géante*. The superiority of Ernst's use of collage in *Une Semaine de Bonté*, as in his earlier *romans-collages*, surely lies in the give and take of controlled effect and uninhibited revelation. In this respect, Ernst can be said to have solved the old riddle about the precedence of the chicken over the egg exactly as Péret described its solution in "La Soupe déshydratée": "the egg is at once egg, cock and hen" (p. 51). As formulated by Péret, the contrast is plain with abstract art, where "the cock is metamorphosed into a hard-boiled egg that can be peeled and eaten if one feels the desire." Explaining himself in a phrase typically his own, Ernst has shown his determination to save his art from such a fate, by speaking of "inspiration to order."

Taking time to consider how much the technique of collage makes possible, when used according to surrealist directives, we learn before long that measurement of the contribution demanded of intentionality, as opposed to the part played by accident—the relative roles of premeditation and spontaneity—is not the central issue for surrealists. What matters to them above all is the important role collage is able to assume in externalizing the inner model and in communicating its image. This suggests that Ernst's early preoccupation with inspiration to order was nourished by something quite different from an impulse to devise methods for creating art upon demand.

No less than others dedicated to the surrealist cause, Max Ernst looked upon surrealism as holding out the promise of fulfilling Lautréamont's prediction that poetry will be made by all. But Ernst did not contend that the arrival of ideal conditions for creative activity can be hastened just as soon as artists agree to search for and studiously implement a set of routine practices bearing the stamp of surrealist approval. He recognized without delay that nothing better

is obtained this way than results as predictable as they are dismally limited. And so at the end of his essay "Inspiration to Order" he stated his own position in terms that betray far more ambitious goals:

> We maintain that surrealist painting is within the reach of everybody who is attracted by real revelation and is therefore ready to assist inspiration or make it work to order.
>
> We do not doubt that in yielding quite naturally to the vocation of pushing back appearances and upsetting the relations of "realities," it is helping, with a smile on its lips, to hasten the general crisis of consciousness due in our time. (p. 25)

This statement of principle removes technique once and for all from the realm of self-centered virtuoso display. It asks us to weigh the significance of technical command in relation to discoveries it makes possible through destruction of the supposed stability of accepted reality. Making inspiration work to order is not a mechanical process governed—so far as it is controlled at all—by dry intellect, forever suspect in surrealist eyes. Rather, Ernst's text betrays his eagerness to guarantee inspiration the fullest possible freedom of expression by assisting it, facilitating its operation, in other words. The goal is not merely the fantastic, in which surrealists detect disappointing evidence of facility or of methodological trickery, revealing nothing deeper than contrivance. It is the marvelous, in which, as Breton insists in his introduction to Pierre Mabille's *Le Miroir du Merveilleux,* our affectivity as a whole is caught up.

Not every surrealist collagist works exactly according to the same rules. For some, accident may play a more significant role than design. For others, the contrary is true. A surrealist may even work with greater or lesser conscious control over his material and the image it precipitates at one moment than another. The speed with which Péret wrote his automatic poems (in which verbal collage is of course a sign of the unrestricted play of free association) contrasts notably with the painstaking slowness of Mesens who, after deciding to introduce a leaf into a collage, would copy one meticulously from nature. We end up in confusion, attempting to decide whether Péret or Eluard (who preferred to treat automatism as a source of raw materials from which poems could be made) comes closer to making inspiration work to order, whether Mesens or Heisler does.[17] What counts for

[17] The fifth number (January 1974) of the Belgian magazine *Gradiva* is devoted to Heisler.

Max Ernst, collage from *Rêve d'une Petite Fille qui voulut entrer au Carmel.* 1930. The legend reads: ". . . or down below, that indecent Amazon in her little private desert . . ." Collection Timothy Baum, New York.

each of these surrealists, as for Ernst, is establishing how the motivation behind their work reflects compliance with the fundamental aims of surrealism. Dealing with surrealists, we have more hope of attaining this goal, it seems, if we concentrate upon their dedication to developing "means of forcing inspiration," as Ernst put it.

Study of surrealist collage helps us advance an appreciable distance toward explaining Ernst's phrase. More than once in "Inspiration to Order" reference is made to "the intensification of the mind's irritability." We can see then where Ernst looked for means of forcing inspiration and understand why he chose the direction he did. The ideal is not to do imagination violence, to subject it to distortion, perhaps, by obliging its natural expression to submit to "order." On the contrary, Ernst testifies to his belief that rationalist thought and esthetic assumptions exercise such tight censorship over imaginative play that imagination has to be encouraged to assume its rights. It must be forced into activity, if necessary. Thus the means to which "Inspiration to Order" attributes value are those that will assist imagination in eluding the repressive vigilance of reason and in claiming the prerogatives reserved for it in surrealism.

Only momentarily are we detained by a paradox that seems to confront readers of Ernst's text. For, in spite of its title and of its author's contention that inspiration can be forced, Ernst betrayed no inclination to go back on his assertion that a surrealist work cannot be directed consciously by the mind. There is no sign of disagreement here with the declaration made by Breton in his "Position politique du surréalisme": "Lyrical thought cannot be directed" (p. 69). All in all, the goal is not imagination's conditional release from confinement, with careful and inevitably intrusive supervision over whatever it undertakes to accomplish thereafter. It is, instead, fruitful stimulation of imaginative activity unrestrained by regulation of any kind.

Russell quotes Ernst as remarking, apropos of *La Femme 100 têtes*, "The intensity of those collages derives as much from the emotional commonplace which serves as their point of departure as from the use—no less sacrilegious, one could say, than purely absurd—to which they are put" (p. 192). Looking over a statement like this, we start off on the wrong foot if we place too limited an interpretation on the word "use." This is the really important lesson to be learned from the following passage, borrowed from an essay, "Les Images défendues," in Nougé's *Histoire de ne pas rire*, "The idea of an 'inner model' could become a dangerous notion: It risks giving the impression that the picture exists in the mind of the painter before being painted. The

truth is quite different and infinitely more complex. It is made up of an almost inextricable mixture of partial illuminations, of acts, second thoughts, desires, private pleasures, uncomfortable feelings, distractions, sleeps, reawakenings—in the end, the picture exists" (p. 246).

To Max Ernst rejection of whatever assistance spontaneous association may afford in bringing his collages into existence would have meant imposing quite arbitrary limitations on the evolution of pictorial forms. Just as arbitrary and no less confining would have been any reluctance to take advantage of associations, *rapprochements*, established with the help of conscious choice and purposeful arrangement; so long, of course, as the latter was not submissive to the claims of the "art of imitation" or of estheticism. The freedom of the dream world most certainly sets the criteria giving value to the products of the surrealist collage technique. Nevertheless, these criteria do not rule out as inadmissible or inapplicable effects obtained by quite deliberate experimentation with forms, such as Jaguer's word "grafting" suggests, and careful tending of their growth to bring them to fruition, of the kind implied in the analogy between the origin of pictorial imagery and gardening, drawn by Brunius and Miró.

In surrealism, for the creative artist no less than for his public the essential thing is, as Breton emphasized, recognizing or not recognizing. But recognition is exciting and truly revelatory only when it takes place at a level where familiar associations have been rendered inoperative. Re-cognition occurs here without prior acquaintance, in contradiction with and defiance of what everyday reality teaches us to expect. Surrealism offers us the chance to find ourselves acknowledging as *fitting* liberative images that cannot be evaluated by past experience. This way surrealist collages help initiate us into a mode of perception that releases us from the tragic confinement of time, from the sense of inescapable temporal sequence so often repudiated in surrealist verse.

Can recognition of something never seen before occur anywhere but on the plane of atemporal desire? Surrealists clearly believe it cannot. Hence the special interest of surrealist pictorial collages. First contact suggests they have come into being in the absence of artistry, thanks to the use of strictly mechanical means. Only when we try to apply these means ourselves do we really grasp the meaning of Ernst's observation, "Ce n'est pas la colle qui fait le collage."

Whether attained by assimilative or disruptive effect, the surrealist ideal is invariably transcendence of habitual reality. The inescapable conditions of collage-making—the fact that the materials

selected for inclusion, by whatever random method, have to be brought together in a way calling for minimal technical skill (be it no more than the ability to apply paste to paper neatly enough to amalgamate pictorial elements in an order that will surprise reasonable anticipation)—these point to the sources of certain reservations in the minds of the earliest surrealists, dubious about the suitability of painting to creating imagery as expressive of their aspirations as those a writer might offer. And so the revelation brought by Ernst's first collages was particularly stimulating to the surrealists. Ernst was demonstrating, it seemed, that the mystery of creation and the true nature of the discoveries to which Aragon would allude in *La Peinture au défi* are to be sought in the exchange taking place between unformulated desire and the material means permitting it to find release and concrete expression. Having been brought together by desire, necessity and will were found to be progressing in his work in the very same direction—that of *dépassement*.

We can liken the phrase "la femme sans tête" to the kind of picture upon which Ernst worked to make his collages. The occurrence of such a phrase in everyday conversation would be no less conceivable than the presence of such a picture as illustrative material in a book depicting day-to-day experience. Thus substitution of "100" for "sans" can be seen to have exactly the same effect on the sense of "la femme 100 têtes" as Ernst produced by introducing extraneous elements that, superimposed upon certain parts of the original picture, changed its significance radically.[18] Replacing the word "sans," "100" fits exactly over it, just as the new materials stuck on with glue covered up and replaced parts of the picture in producing a pictorial collage. Listening to the resultant phrase, we hear nothing against which common sense is entitled to protest. It is left to the eye to meet the obligation of acknowledging, as in the collage-picture, the presence of something with which rationalist thought is unable to deal satisfactorily. The very same thing happens in the title of a Benjamin Péret short story, "Et les seins mouraient." On the printed page, a phrase that sounds quite acceptable to reason ("And the saints were dying"), proves to be a trap set to ensnare common sense, "seins" ("breasts")

[18] Interpretation of the title *La Femme 100 têtes* as *La Femme s'entête* is not pertinent to the present discussion.

taking the place that we expect to see reserved for its homonym, "saints."

The simplicity of the means by which rational thought is faced with images it cannot condone demonstrates well enough why, as Breton's second manifesto emphasizes, the surrealists first launched their revolution on the level of language—the most vulnerable to attack of all the modes of expression available to traditional art. It is not difficult to track down numerous examples comparable to those mentioned above. During the twenties especially, surrealists were drawn to experiments with language that present important points of comparison with pictorial collage. In this direction, the major influence came from Marcel Duchamp, whose word play was much admired in surrealist quarters. Duchamp's way of practicing the "chemistry of the word" found an attentive and very appreciative audience among surrealists. We must bear in mind, when estimating Duchamp's influence upon the latter that the tradition of the *contrepèterie* in French literature is long and respectable. Moreover it embraces both unintentional displacement of letters that radically change the significance of a given statement (slips—often lending themselves to interpretation in the light of Freudian theory—that are called Spoonerisms in English) and also quite deliberate experimentation having the same effect. The kind of linguistic exploration conducted by Duchamp, prolonging the tradition of *contrepèterie,* impressed the surrealists as destructive of the limitations of significant verbal communication.

How to do violence to reasonable preconception without at the same time destroying the framework of grammatical form, so leaving the reasonable mind free to dismiss what reaches it as being without justifiable claim to serious attention? This question, so important in surrealism, where revolt against conventional expression is not taken as an excuse for incoherence, is one that Duchamp handled with admirable success. The example he set is surely accountable for the enthusiasm with which Roger Vitrac explored *contrepèterie* in his *Peau-Asie* (1923) and Robert Desnos investigated the same form of word play in his *Rrose Sélavy* (= *Eros c'est la vie:* Eros is life), written between 1922 and 1923. Duchamp encouraged surrealists everywhere to approach language playfully, while never ceasing to take it seriously. Paul Nougé exploited the title of a play by Marivaux in his *Le Jeu des mots et du hasard* (*The Game of Words and Chance*). For one of his works Georges Henein deemed the title *Déraisons d'être* fitting. So reasons for being (*des raisons d'être*) became *Unreasons*

Conroy Maddox, *The Invitation*. 1969.
Collage-Painting. Collection of the artist.

Ladislav Novak, *Landscape-Face* (*The Giantess*). 1971. Alchimage-Collage. Collection of the artist. Photo Enrico Cattaneo.

for Being. Published pseudonymously, erotic texts by Benjamin Péret, *Les Couilles enragées* (*Enraged Balls*), appeared beneath a cover bearing the false title *Les Rouilles encagées* (*Encaged Rust*). Surrealists writers were not slow to find a way of dealing with a problem that was the exact equivalent of the one faced by practitioners of surrealist pictorial collage: how to implicate elements borrowed from objective reality in a new representation, formal enough in appearance to engage the attention of the reasoning mind, without at the same time submitting expression to regulation by rationalist thinking.

Michel Corvin looks upon the interest taken in proverbs by some first-generation surrealist writers as no more than a sign of a general tendency, common to the young of all generations (p. 53). True, there is amusement to be derived from word manipulation such as Lewis Carroll found in what he termed portemanteau words. These give, for instance, the Rocking-horse-fly which, we are told in the third chapter of *Through the Looking-Glass,* is made entirely of wood, and "goes about by swinging itself from branch to branch" when it is not feeding on sap and sawdust, and the Snap-dragon-fly, that lives on frumenty and mince-pies and has a body of plum pudding, wings of holly-leaves, and a head that is a raisin burning in brandy. Max Ernst's *phallustrade* seems to be a comparable example of surrealist word play. However, it is possible to visualize the Rocking-horse-fly and the Snap-dragon-fly—Tenniel made drawings of them both. How much success do we have trying to visualize the *phallustrade,* "an alchemical product, composed of the following elements: autostrade, balustrade and a certain amount of phallus," or the kind of roses called "gentle rhinoce-roses" in Arp's *Le Voilier dans la forêt?*

There is more here than proof that participants in surrealism share youth's disrespect for conventional values which we can expect to hear them defending soon enough, once age has overtaken them. Something valuable is to be learned from examining certain surrealist proverbs as verbal collages, quite distinct from those classifiable as literary word collages.

An example of the latter is the following phrase from *Finnigans Wake:* "The Mookse and the Gripes." Our first reaction, incomprehension, gives way soon enough to the kind of satisfaction afforded by sophisticated word puzzles. We are on the safe road to understanding once we recognize that we are dealing, quite simply, with a collage of

words, connecting the title of a well known fable, "The Fox and the Grapes," and the names of two characters in *Alice in Wonderland*: the Mock Turtle and the Gryphon. Unable to reach the grapes hanging above his head, we remember, Aesop's fox pronounces them sour as well as green. This provides an identifiable link with the Mock Turtle's song about a beautiful soup, also green. A common allusion to color bridges Aesop's reference to an animal that must go hungry and Lewis Carroll's to another animal altogether—"the thing Mock Turtle Soup is made from."

The important point is not persuading ourselves that this interpretation of "The Mookse and the Gripes" is unquestionably accurate but appreciating that literary word collages like this invite interpretation by anybody capable of responding to their referential quality. In fact, full enjoyment depends on the reader's ability to track down literary references wherever they may be and wherever they lead him. The literary verbal collage rewards those who have read widely and are blessed with mental alertness and associative powers.[19] Having quite another basis, the surrealist verbal collage differs radically in operation and function from what one finds in Joyce's *Finnigans Wake* or Nabokov's *Lolita*.

Generally speaking, the images from which familiar proverbial phrases once drew life have lost their power to stimulate the imagination. Handed down from generation to generation, with the passage of time they have lost their luster, no longer retaining any intrinsic appeal. The vitality still remaining in them comes from the moral code established and defended by society and from the wisdom that enduring sociocultural values associate with them. The phrase "Strike while the iron is hot" no longer commands attention except as an exhortation grounded in the profit motive.

Pausing over this seemingly unpromising example gives us the opportunity to appreciate how collage technique contributes to the formulation of surrealist proverbs. In their *152 Proverbes mis au goût du jour* (*152 Proverbs adapted to the Taste of the Times* [1925]) Paul Eluard and Benjamin Péret offer a version that reads: "Strike your mother while she is young." As in pictorial collage, superimposition of

[19] Ben Stoltzfus cites Joyce's "The Mookse and the Gripes" as pointing to "the imagination and creative spirit of the author" and, by extension, "an invitation to the reader to participate in the recreation of meaning." Hence Stoltzfus agrees that this is "pure literature." He disagrees with the interpretation offered here in regarding "The Mookse and the Gripes" as illustrating the "poetic qualities of language." See his "Alain Robbe-Grillet: the reflexive novel as process and poetry," *Symposium*, 30, 4 (Winter 1976), p. 345.

Ludwig Zeller, two collages from the series "The Downfall of the Church" (1969–72). Collection of the artist.

incongruous elements upon familiar ones—sometimes coupled, as in this case, with rearrangement of materials retained from the original— produces an injunction in conflict with the usages of our distinctly materialistic society. Both the message conveyed and the image it calls up are challenging in their antisocial novelty.

Such a proverb represents something more significant than humorous and anticonformist parody of good sense and acceptable conduct. In *152 Proverbes* the code of behavior set by socially approved norms is contravened in ways markedly similar to those in which Ernst's collage pictures evidence subversive tampering with socially agreed standards. A surrealist proverb may take definition from the clear contrast it presents with the model it has distorted. An act upon which our culture frowns—striking one's mother is stigmatized, whereas there is nothing reprehensible about striking one's children, and (if one heeds a certain Russian proverb) it is no less good for a wife to be beaten than for an almond tree—stands out in the imagination against the banality of the blacksmith's gesture at the anvil. Meanwhile, the circumstances that conceivably might justify mother-beating are totally at odds with those that make striking a hot iron an acceptable parallel for laudably purposeful opportunism. No less than the pictorial collage, the surrealist collage proverb catches the imagination at the very moment when what we read departs from predictability and ceases to mirror common experience. "Rinse the trees," advise Eluard and Péret. "Don't sew animals." "No gesture is worth a bridge," Schehadé points out in *Rodogune Sinne*. "Too many summers make even the square round," observes Jean Arp in *Jours effeuillés*.

Proverbs based in tradition are aphorisms elaborated by convention and cherished by defenders of inherited values. Denying those same values, surrealist proverbs often confront us with images that reach far beyond mere reiteration of judgments persistently encouraged by society. Leaving behind "We reap what we sow," Eluard and Péret arrive at "Whosoever sows fingernails reaps a torch." The hackneyed comparison likening someone who is flustered to a hen fussing over her chick ("comme une poule qui n'a qu'un poussin") yields "like a pulley in a pie" ("comme une poulie dans un pâté").

Manipulation of the materials utilized in a surrealist proverb may be quite elaborate. *152 Proverbes mis au goût du jour* takes "Porter de l'eau à la rivière" ("To carry water to the river," or coals to Newcastle) and makes of it "Porter ses os à sa mère." "Eau" and "os" are homonyms, as are "mère" and "mer"; hence: "To carry one's bones to one's mother." Alternatively, the degree of interference may be mini-

mal, although the liberative effect on the image is quite striking. "Une tempête dans un verre d'eau" ("A storm in a teacup" [literally: "in a glass of water"]) gives way to "Un trombone dans un verre d'eau"— "A trombone in a glass of water."

Surrealist verbal poetry extols virtues that can be detected in language, just as soon as we have set aside the laws limiting sense to the narrow purposes of rational communication. This is why Guy Cabanel assures us, in a theoretical text called "Tunnel," accompanying his *A l'Animal noir*, that extolling language (its *exaltation*, as he calls it) "will consecrate the bankruptcy of proverbs and maxims" that lay claim to formulating generally applicable laws. Cabanel forecasts that maxims and proverbs of this kind will be stifled and ridiculed by the "multiplicity and equal authenticity" of the maxims latent within them, which, in many cases "transform them into veritable Lichtenberg knives."

Very often, we are all the more impressed by a surrealist pictorial collage for noticing how limited has been the artist's intervention. Everything borrowed from external reality is in the place that everyday existence habitually reserves for it. Yet the one detail that reason judges discordant suffices to relocate what we are being permitted to see, to situate it outside daily experience. So the picture afforded by what is shown is enhanced by our awareness of the distance traveled imaginatively in the artist's company. Seen from where he now stands, elements in his picture still faithful to the realistic tradition only highlight departures from realism, brought about by the collage method. The same effect is achieved, very often, by the surrealist's use of words. Banality sets off images that break with convention, as in Desnos' "Cœur en bouche," from *Langage cuit*:

> Son manteau traînait comme un soleil couchant
> et les perles de son collier étaient belles
> comme des dents.

> Une neige de seins qu'entourait la maison
> et dans l'âtre un feu de baisers.

> (Her coat dragged like a setting sun
> and the pearls in her necklace were beautiful
> as teeth.

> A snow of breasts that the house surrounded
> and in the hearth a fire of kisses.)

A comparable verse from Eluard's "Nuits partagées," in *La Vie im-médiate,* runs, "Dans les cavernes terrestres, des plantes cristallisées cherchaient les décolletés de la sortie" ("In the terrestrial caves, crystallized plants were looking for the way out's plunge-line"). The surrealist poetic imagination characteristically moves away from the norms by which we customarily judge experience. Mayoux's "Passé minuit," from *Traînoir,* offers this spectacle: "Passé minuit la ville présente son aspect accoutumé à ce détail près que les trottoirs sont parcourus en tous sens par un grand nombre de roues de bicyclettes voilées allant de front par trois celle du milieu debout sur son grand axe quand les deux autres ont leur centre de gravité au plus bas et inverse-ment ce sifflement particulier des horloges quand la maison va brûler les accompagne" ("After midnight the town has its accustomed ap-pearance but for this detail that the sidewalks are traveled in all directions by a great number of veiled bicycle wheels going three abreast the middle one standing on its long axis when the two others have their center of gravity lowest and conversely that peculiar whistling of clocks when the house is going to burn accompanies them"). The effect is enhanced by stress upon departures from the habitual, as it is by the aphoristic nature of surrealist proverbs.

In form, surrealist word collages bring to mind conventional proverbs that categorize familiar experience and modes of conduct according to norms firmly rejected in surrealist imagery. The same is true of maxims like this one from *L'Immaculée Conception* by Breton and Eluard: "Ne t'attends pas" ("Don't wait for yourself" or "Don't expect yourself"). The aphoristic mold in which the proverb has been cast inspires the rational mind to confidence. It lends the credibility of formal structure to statements against which rationalist thinking soon will have to defend itself. Surrealist proverbs derived by collage from traditional sayings do not conceal their source. It is entirely to surrealism's advantage that they should not do so. Through maxim and proverb, the surrealist tears apart a verbal framework consecrated by public approval. He uses these linguistic formulas to convey images and ideas that invite revision of the standards by which we live. This is why verbal collage in surrealist proverbs so often produces telling results by uncovering a disturbing disparity between linguistic form and logical content, in the very places where we have been accustomed to assume the former to have come into being solely for the purpose of communicating the latter.

The formal aspects of the proverb, of the maxim too, gives the surrealist statement an air of stability that sharpens its subversive

effect. For when we go on to examine the statement's meaning, the surrealist's revolutionary outlook takes its toll of reasonable expectation. Concision and impeccable syntactical relationships undermine our trust in language as a reliable vehicle for reasoned discourse, when we read in *152 Proverbes* "Elephants are contagious" or "Peeling skin goes to heaven" ("Peau qui pèle va au ciel"), or again in Desnos' *Rrose Sélavy* "Le mystère est l'hystérie des mortes sous les orties" ("Mystery is the hysteria of dead women under the nettles").

The primary aim pursued in surrealism has never been truth to nature. Surrealists have been concerned all along with attaining a "revolutionary truth," defined in André Breton's *La Lampe dans l'horloge* as at once "rupture et dépassement" (p. 47): breaking with what is termed customarily the real and going beyond reality. How then is the *encounter* that is to surpass objective reality to be brought out in collage? To say that the surrealist achieves desired results in blind ignorance of what is taking place is no more accurate than saying it comes about while he continues to be always totally conscious of what he is producing. In any case, to hold the surrealist's attention, the encounter occurring on the pictorial plane has to bring about the equivalent of the spark generated by the surrealist verbal image. For it is illumination of desire that the reader or spectator has to be made to witness.

André Breton certainly expressed things succinctly in his verse, "I sing of the unique light of coincidence." A supremely important factor in surrealism practice, the very one investing surrealist collage with value, is that coincidence—the encounter recorded in the collage—appears to the artist and to those appreciative of his purposes anything but a meaningless accident. It testifies persuasively to the operation of an enlightening force. The latter seems to find expression through the accidental, no doubt, yet in fact is not so removed from man's influence as to deny him hope of soliciting and participating in its manifestation. Faith in the beneficent intervention of such a force in human affairs underlies pronouncements like the following, which it endows with a gravity, a sense of responsibility that the aggressive tone affected here by Breton and Schuster in their "Art poétique" comes close to concealing: "I have been reckless enough to glory in my boldness and recommend it as a principle. My imprudence is always felicitous, I take pride in it. I have counted above all on the

presents of fate, provoking them without measure to accentuate the force of my imagination and the generosity of my heart. I have accepted them with pride, rejoicing once again in owing them to myself alone."

Nothing will ever permit us to explain to our complete satisfaction the mystery surrounding the genesis of a surrealist collage. Still, there is something that will enable us to gauge how significantly deep that mystery is: further consideration of the "presents of fate." Collages owe their provocative value to the spectacle they furnish of chance meetings between disparate elements. As a speculative act—one that therefore, theoretically, risks loss while it aspires to gain—surrealist collage aims at surpassing the significative value conventionally assigned to the materials it utilizes. Through a process of juxtaposition, the collagist looks for an expansion of meaning in which the materials drawn from external reality find themselves implicated. Reason, of course, will judge the methods used quite arbitrary. Before we can accept this evaluation as indisputable, though, we need to give some thought to the question of chance and to the role assigned chance in surrealist theory and practice.

CHANCE

THE *papiers collés* of Cubism answered an esthetic need and so provided a strictly esthetic solution. Surrealist collages, on the other hand, are born of quite a different need to rebel against "the exterior distribution of objects," condemned in Max Ernst's *Beyond Painting*. The need felt by surrealists does not betoken wilfully destructive impulses. Nor does it come from frustration or childish perversity. More significantly, it is evidence of a purposefully iconoclastic spirit that views the existing order of physical reality as a serious impediment to man's fulfillment. Because it takes its vitality from the conviction that man alone can better his own life, the iconoclasm of creative surrealism militates actively in revolt against acceptance of "things as they are."

Such an effort would appear quite fruitless, were it not that surrealists are firmly convinced things merely seem to be what we accept them as being. Avoiding the temptation of transcendentalism, surrealists are persuaded that man may enjoy the privilege of being able to correct the erroneous impression normally rendering him submissive to the dreary fate of acceptance. All that is required, surrealism teaches, is for him to see the natural order given a jolt. While not strong enough to overthrow reality altogether, this still can be a blow capable of rocking its supposed stability. Asked how such a jolt is likely to be engineered, most surrealists would respond that it is produced very effectively with the aid of chance.

Like the French word "le hasard," the English "chance" is confusing because, in the context of surrealist thinking, it takes on a savor that really detaches it from accepted usage. Chance is given a specific quality, implying special characteristics. These, in turn, guarantee chance a particular and valuable role in surrealist activity.

117

The result is a conflict between its connotative force in surrealist language and in current usage. The conflict is so sharp that our progress surely would be faster if surrealists had discarded the word "chance" from the beginning and coined another altogether. What is missing, actually, is a word denoting form of chance arbitrary in appearance only and invariably beneficent in its effects. Defining chance as a beneficent phenomenon means showing how and why surrealists see it as working consistently and irresistibly for the liberation of man. And this is imperative before we can advance our inquiry into the nature, origins, and significance of surrealist imagery.

The central position tantalizingly occupied by chance in surrealist thought is attested by Breton's assertion in "Situation surréaliste de l'objet" that it "remains the great veil to be raised" (p. 72). As Breton went on to explain, this is because chance could be the "form of manifestation for outer necessity forcing its way through the human unconscious." Our first question, in consequence, has to do with the meaning of outer necessity in relation to the surrealist's inner model and to his idea of chance. Another look at Max Ernst's *Beyond Painting* will put us in a position to view this question squarely.

Two events recounted in *Beyond Painting* are presented in terms so similar that, casually leafing through the book, one easily might think Ernst has told the same story twice. The first is related in these terms:

> . . . finding myself one rainy evening (August 10, 1925) in a seaside inn, I was struck by the obsession that showed to my excited gaze the floor-boards upon which a thousand scrubbings had deepened the grooves. I decided then to investigate the symbolism of this obsession and, in order to aid my meditative and hallucinatory faculties, I made from the boards a series of drawings by placing on them, at random, sheets of paper which I undertook to rub with black lead. In gazing attentively at the drawings thus obtained, "the dark passages and those of a gently lightened penumbra," I was surprised by the sudden intensification of my visionary capacities and by the hallucinatory succession of contradictory images superimposed, one upon the other, with the persistence and rapidity characteristic of amorous memories. (p. 7)

The second runs as follows:

One rainy day in 1919, finding myself in a village on the Rhine, I was struck by the obsession which held under my gaze the pages of an illustrated catalogue showing objects designed for anthropologic, microscopic, psychologic, mineralogic, and paleontologic demonstration. There I found brought together elements of figuration so remote that the sheer absurdity of that collection provoked a sudden intensification of the visionary faculties in me and brought forth an illusive succession of contradictory images, double, triple and multiple images piling up on each other with the persistence and rapidity which are peculiar to love memories and visions of half-sleep.

These visions called themselves new planes, because of their meeting in a new unknown (the plane of non-agreement). It was enough at that time to embellish these catalogue pages, in painting or drawing, and thereby in gently reproducing only that which *saw itself in me,* a color, a pencil mark, a landscape foreign to the represented objects, the desert, a tempest, a geological cross-section, a floor, a single straight line signifying the horizon. . . . thus I obtained a faithful fixed image of my secret desires—from what had been before only some banal pages of advertising. (p. 14)

While the second passage alludes to the origins of Ernst's exploration of collage as a means of projecting the inner model furnished by desire, the other deals with something altogether different: discovery of frottage in a series of rubbings from which came his *Histoire naturelle.*

Placed side by side, these two passages offer parallels too close to be merely accidental. More exactly, similarities detected in the procedures of collage and frottage prompted Ernst to explain the former by use of the very words used to explain the latter. *Beyond Painting* admits as much. Indeed it stresses the links connecting collage and frottage. Still, there is something to notice that this text does not bring to our attention, something Ernst may not have found worthy of emphasis or even may not himself have recognized as important. Both incidents took place at a time when, during a vacation, rain kept him indoors.

One might discount this coincidental circumstance as unimportant. Conversely, it may be interpreted as having created, not surprisingly, the necessary conditions of enforced inactivity without which Ernst would have felt no inclination at all to thumb through a catalog without intrinsic appeal for him or, even more obviously, would have had no call to scrutinize the floorboards of his hotel room. However, acquaintance with a major text of André Breton's lets us see here more than at first meets the eye.

Max Ernst, *The Forest*. 1925. Oil on canvas. Galerie Isy Brachot, Brussels.

Summary of the events related in Breton's *Nadja* would take us out of our way. It is enough to note that Breton's succession of meetings with a young woman calling herself Nadja took its point of departure in circumstances that appear to have been decidedly inauspicious: he tells us his first encounter with her occurred on one of those tiresomely boring afternoons all too familiar to him (p. 57). No more than Ernst does he draw any conclusions from his feelings of acute boredom. All the same, one can detect in both men the same symptoms, having the very same consequences.

In a work published earlier than *Nadja*, *Les Pas perdus*, André Breton recalls his custom, at one time in his life, of leaving the door of his hotel room open, in the hope of awakening one morning beside a female companion he had not chosen (p. 12). Of course, he did not set out one day in 1926 to look for Nadja, whose very existence was unknown to him, any more than Ernst avidly searched a catalog with a view to creating collages, or stared at scrubbed floorboards because he wanted to invent frottage. Nevertheless, we notice how boredom—discontent with current circumstance—engendered in both men not only dissatisfaction but a highly significant predisposition. The latter was all the more powerful for being without precise orientation. It stood for readiness to respond to stimuli the banal conditions of the moment seemed likely to preclude. This was the selfsame predisposition we have met under the name of *attente,* in which waiting is already a form of expectation, unrestricted by anticipation of one kind rather than another. The celebrated *disponibilité* preached by André Gide is given a specifically surrealist value. In consequence, we are not facing some new artistic technique so much as witnessing the effects of preconditioning in thought and feeling, attuned to the manifestation of something excitingly new. Thanks to the intervention of beneficent chance, the latter sets perception and lived experience on a new level.

Man's visionary capacities are not fostered by chance, of course. Nor are they improved by it. But even though chance does not actually precipitate vision, it can create conditions so favorable as to intensify the faculties upon which the "vision surréaliste" depends. Crystallization through chance of the virtual image (clumsily called "that which *saw itself in me,*" in the translation of Ernst's statement reproduced above) gives prominence to the fascinating interplay between the manifest content of reality and its latent content. The creative process linking represented objects and a landscape foreign to them, yet derived from them, is no less mysterious in a frottage by Max Ernst than

in a canvas by Yves Tanguy. The closest Ernst comes to describing what goes on is this statement in *Beyond Painting:* "I insist on the fact that the drawings thus obtained lost more and more, through a series of suggestions and transmutations that offered themselves spontaneously—in the manner of that which passes for hypnogogic vision— the character of the material interrogated (the wood, for example) and took on the aspect of images of unhoped-for precision, probably of a sort which revealed the first cause of the obsession, or produced a simulacrum of that cause" (p. 8).

Because surrealist frottage brings out images previously not detected in the world of physical reality or in faithful photographic reproductions of that reality, it takes us a long way indeed from the art of imitation to which those who collect churchyard rubbings pay tribute. When Ernst speaks of having obtained "a faithful fixed image" he specifies that this is an image of his own hallucination, not of external reality. Thus the chance pictorial revelation made possible by frottage points in the same direction as revelations resulting from the surrealist use of language in which, Breton has told us, enunciation depends essentially on the speaker's power of "voluntary hallucination." Whether employed only in drawings or adapted to painting, declares Ernst, frottage reveals "a field of vision limited only by the capacity of irritability of the mind's power."

The voluntary complements the involuntary, when closing the door upon imitation of outer reality and upon the language of reasonable exchange has the effect of opening it to chance. In other words, frottage is an investigative process, obsessive in origin and visionary in effect. It shows clearly that, to Ernst, implementing means of forcing inspiration was not an idle activity in which the artist is free to indulge casually, as in a mere pastime. Rather, it represented a concentrated imaginative exploration prompted by a need no less profound for being, initially anyway, without exact definition. As he himself has indicated, born of desire, this need made him turn to chance unconsciously at first but quite deliberately later on, once the benefits of frottage had shown it to be the agent of revelation. For although a strictly pictorial mode of imaginative stimulation, frottage has wide implications for imaginative play in general, for eliciting images in unexpected ways.

Max Ernst first made rubbings to fix images implicit in outer reality, so that these virtual images then could be submitted to development by imagination. The latter provided the link between the external world—outer necessity—and the inner world where the

image had been conceived. Imagination, by which the first surrealist manifesto tells us we are given an inkling of "what *can be*," treats the exterior world of physical reality as important only so far as it furnishes the constituent elements of imagery born of an interpretive sense, liberating perception from the confinement of realistic representation.

Now we understand the exemplary value of both collage and frottage. Excitement is generated in the surrealist artist by the perceptible contrast between the image obtained through these means and the banal sources (the grain in a wooden floor, brought out by repeated scrubbing) from which chance has allowed him to derive his image. Chance demonstrates the practical possibility of breaking down barriers that seem to stand between man and attainment of his desires. So, in the name of surrealism's philosophy of immanence, it combats the pessimistic mood of acceptance rendering us prisoners of ambient reality. It furnishes the spectacle of reconciliation between outer necessity—normally so oppressive in its claims upon our attention—and the inner world of creativity, where desire supplies the model and elaborates images for its communication. This explains why, writing in 1927, Breton described Ernst's dream as a "dream of mediation."

Somewhat paradoxical as it may seem, the general underlying assumption in surrealist creative practice is that when one appeals to chance one risks nothing. At least, one risks less than by unresisting acceptance of "things as they are." Such a conception of chance betrays a hint of despair regarding present conditions and unlimited confidence in the future. This confidence is heightened by the firm belief that man alone may decide how long he will continue to endure a mode of existence persistently separating him from happiness. The surrealist's trust in chance as ever beneficent in its effects may look like a sign of naiveté. It may even be taken for hopeless surrender: admission of his failure to act positively upon the world in which he finds himself. It is, in fact, a token of confidence in the existence of an underlying order in life. Concealed from sight most of the time by disheartening contingent circumstance, this is an order that chance affords us the reassuring opportunity to glimpse. Surrealist reliance on chance is something far more significant than blind faith in luck (the luck by which one stands to lose as much as one hopes to gain). It rests squarely on the following conviction. A better world, far more in keeping with man's needs and aspirations, lies behind the forbidding façade of everyday reality.

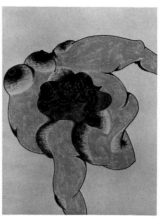

Suzana Wald, drawing from the series
"Skinscapes." 1974. Colored pencil.
Collection of the artist.

Suzana Wald, Untitled Drawing. 1975. Ink
and colored pencil. Collection Ludwig Zeller.

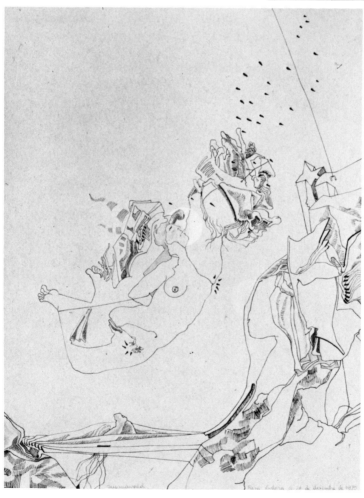

In a text published for the first time in *On My Way* Jean Arp reports, "The 'law of chance' which embraces all laws and is unfathomable like the first cause from which all life arises, can only be experienced through complete devotion to the unconscious" (p. 77). Arp's preoccupation with chance as a fundamental law is not a private aberration. It serves to guide us in handling chance as a revelatory agent, free of the taint of capriciousness. Ultimately, one might say, through trust in chance surrealists affirm their refusal to accept the accidental: coincidence marks for them the inevitable and fully satisfying coming together of circumstances, whether in lived experience or in creative action through imagery.

Appreciating this, we comprehend why response to chance may range among surrealists all the way between two extremes. At one end of the scale, the artist is grateful for and content with whatever chance brings his way. Enjoyment of the *trouvaille* (the find), a gift of chance, is seen as requiring no more than acceptance, sometimes through the simple but meaningful act of nomination—a token of glad recognition of something never previously encountered. Sometimes again the *trouvaille* may tantalize the surrealist's mind, unable at first to identify what makes the new discovery significant. The first chapter of Breton's *L'Amour fou* tells how a mask found by chance met a need experienced by the sculptor Giacometti and how a spoon, also found in the Paris flea market, helped Breton analyze his own emotional state. In the eyes of the surrealist, then, no discovery, no *trouvaille*, is ever simply accidental.

At the other end of the scale far more active participation seems indicated. Here the artist stands ready to prove his willingness and ability to assist chance in manifesting itself. This is the case when Ernst applies his means of forcing inspiration. Now chance may play a complex role, either initiating inspiration or seconding it as it achieves full expression. On such occasions, the artist collaborates with chance and just as willingly invites its collaboration. Examination of the opening chapter of *L'Amour fou* makes plain that chance significantly relates to choice. For the gifts of chance quickly lose their meaning and become the aimless residue of accident, if they are not accepted. And as such gifts press themselves upon us with an insistence not to be ignored, acceptance calls for acknowledging them to be the precipitate of desire. In surrealism it is desire—expressed and made tangible through external objects, very often—that gives chance its profound meaning. Desire takes chance out of the area of random, bewildering coincidence and draws it into the zone of human necessity.

In these circumstances, it is fruitless to attempt a careful distinction between premeditation and spontaneity. Far more to the point, where the intervention of chance is welcomed so gladly, is the surrealist's realization that habit and routine (affecting our thinking as well as our material lives) have a debilitating effect on creativity. They exercise a retarding influence over the free expression of chance revelation. For this reason above all, surrealists adopt methods they hope and believe will help beneficent chance manifest itself profitably. By placing creative thought on a new track, surrealists argue, these methods will spare us the unexciting experience of journeying yet again to the known, the all-too-familiar. They will extend the artist and his audience the stimulating possibility of traveling into the unknown.

The important feature of pictorial games of chance such as frottage is that they allow us to pass through one form of reality to another. Now the material borrowed from the objective world surrenders its claim upon our attention, or rather continues to exercise the right to be considered only because it serves to encourage imaginative exploration. Development of the virtual imagery of physical reality in the frottages that appear in Ernst's *Histoire naturelle* is comparable to the imaginative correction of natural law to be found in the collection of poetic texts published by Benjamin Péret under the very same title.[1] Had Péret's book come out before his, we can be sure Ernst would have directed his readers' attention to the parallel between his own frottages and Péret's automatic poems. The following extract from *Beyond Painting* proves conclusively that it would have served Ernst's purpose to do so:

> The procedure of *frottage*, resting thus upon nothing more than the intensification of the irritability of the mind's faculties by appropriate technical means, excluding all conscious mental guidance (of reason, taste, morals), reducing to the extreme the active part of that one whom we have called, up to now, the "author" of the work, this procedure is revealed by the following to be the real equivalent of that which is already known by the term *automatic writing*. It is as a spectator that the author assists, indifferent or passionate, at the birth of his work and watches the phases of its development. Even as the role of the poet, since the celebrated *lettre de* [sic] *voyant* of Rimbaud, consists in writing according to the dictates of that which articulates itself in him, so the role of the painter is to push out and *project that which sees itself in him.* (p. 8)

[1] Benjamin Péret's *Histoire naturelle* is a rare work privately printed in an edition of 273 copies, of which 253 copies were offered for sale, by subscription only.

Neither chemistry nor physics, neither anthropology nor sociology can offer us any assistance in deducing the laws of natural history underlying the universe depicted in Péret's *Histoire naturelle*. The world is represented here as self-generative by way of rationally unaccountable metamorphosis and evolution. Watered soil gives "lipstick from which the kiss is extracted." Two sorts of lipsticks can be distinguished, in fact. The first is an undulating one "with long waves that, by distillation, gives flags." The second is a light lipstick whose flower produces the kiss. The latter, incidentally, is obtained in two different ways—by "desiccation of the flower plucked the moment it opens" and by "crushing the seed that gives a very volatile essence, difficult to preserve." Watered soil gives, also, the Turkish bath— obtained by kneading moist earth with curdled milk—which makes so much noise that it has to be packed off to a desert place. In gives, too, the frog slowly devouring the earth and the 'cello, used more and more frequently, Péret assures us, in the treatment of arthritis and very good, too, for washing fine lingerie. Spectacles for shortsighted people, meanwhile, can be obtained by softening earth in boiling China tea, before cooking in a double saucepan (p. 12).

Scientific hypotheses have no applicability in a world where one of the elements, fire, assumes a variety of forms, of which among the most common is stinking fire, "obtained by steeping a bishop in cod liver oil"—valuable, despite its pestilential smell, because it promotes the cultivation of asparagus: "for stinking fire destroys the drawers that gnaw at it as soon as it is born" (p. 25). To anyone who feels he must object that all this is scientifically indefensible and to anyone content with truisms like the one about the child being father to the man, Péret has the same answer. The principle of causality, he says, "soluble in oil," is "father to the artichoke" (p. 21).

Looking at Ernst's frottages and reading Péret's *Histoire naturelle*, we are left in no doubt that, as surrealists see things, the pursuit of beauty represents to the painter and the poet not so much an esthetic venture as, to quote Philippe Audoin, an "adventure." Hence, says Audoin, automatic writing may be regarded, in relation to traditional literary endeavor, as "a sort of adventure that, in contempt of the esthetic criteria on which people relied at the time, attempted to find 'convulsive' beauty once again or, at the very least, to verify the 'real functioning of thought.' "[2]

André Breton did not advocate "pure psychic automatism" as a

[2] Philippe Audoin, "Le Surréalisme et le jeu," in Alquié, *Entretiens sur le surréalisme*, p. 460.

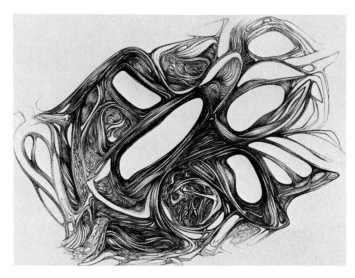

Robert Lagarde, *The Shadow Goes on Moving*. 1974. Drawing. Collection of the artist.

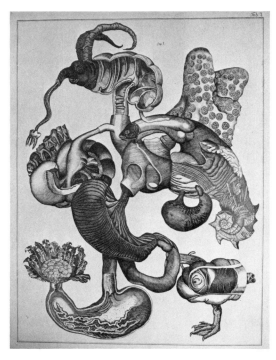

Jan Švankmajer, *Histoires naturelles*. 1973. Etching. Collection of the artist.

conveniently accessible literary tool. As prescribed in the definition set forth in his *Manifesto of Surrealism,* automatism's role was to be the one of which Audoin has just reminded us: to express the "true functioning of thought." Already in his 1924 text, the implications of Breton's argument were quite definite: reasonable language, rationally controlled, cannot reveal how thought really functions. One of the central principles of surrealist doctrine, so far as it touches upon language, is this. Rational supervision of language leads to distortion of thought. Thought is therefore irrational. Its freedom is restored when and where rational controls have been eliminated. Automatism may be considered to have a valuable part to play in liberating language because it takes expression beyond the bounds of rational discourse. According to Octavio Paz, therefore, automatic writing is the first step toward "the restoration of the golden age" and the "higher logic" demanded by Novalis: "I is you, this is that. The unity of opposites is a state in which knowledge ceases, because he who knows has been fused with what is known: man is a purveyor of evidences" (p. 227). Paz means, obviously, evidences of the kind to which Breton alludes in an essay from *La Clé des champs:* governed by "the spontaneous, extralucid, insolent relationship that is established, in certain conditions, between this thing and that, which common sense would hold us back from bringing face to face" (p. 112)—the kind of evidence assembled in Péret's *Histoire naturelle.*

To the surrealist, inviting the intervention of chance through verbal and graphic automatism does not mean leaving himself open to the discordant influence of the haphazard. Surrealists look upon the participation of chance as a valid means to defeat the purposes of reason. Thus suspension of reflective control in automatic writing is analogous to the method of frottage. The approach to reality linking the writer and the graphic artist in the same purpose is significantly oriented. In a 1936 article published in *Cahiers d'Art,* André Breton took encouragement from the open rationalism of certain scientific thinkers (initiated by the concept of non-Euclidian geometry, non-Maxwellian physics, and so on), to propose a corresponding "open realism," or surrealism. This, he was confident, would bring about the ruin of "the Cartesian–Kantian edifice," and turn the sensibility upside down.

We face, now, one of the recurrent themes of Breton's writings which repeatedly allude to "making human understanding over again."[3]

[3] See for instance Breton's 1947 article "Comète surréaliste" in his *La Clé des champs,* p. 105.

A pertinent comment by Anna Balakian, discussing Breton's concept
of verbal automatism, confirms that Ernst was not exaggerating when
he claimed frottage to be the pictorial counterpart of automatic
writing:

> In emphasizing the involuntary character of the encounter of
> nonsequential word groups and of the images they conjure, Breton did
> not agree with his elder colleague Pierre Reverdy that this was an
> active, voluntary exercise on the part of poets. He came to see in this
> kind of *rapprochement* not a consciously inventive process but a self-
> instructive one, a training device rather than one of artistic expression.
> In other words, the poet did not bring these words or images together;
> rather, he observed them gravitate toward each other by making him-
> self open-minded or dream prone so that he would not impede their
> course and not interpret their collision in terms of meanings that have
> been inculcated in him by his culture.[4]

Naturally, the surrealist is not altogether detached from the *rap-
prochement* he witnesses. However, the impression of being a privi-
leged witness, present as unwonted images manifest themselves, is
common to Breton and Ernst. It is one of the most treasured rewards
known to participants in surrealism. We hear Philippe Audoin give
prominence to this very sense of surrealist privilege in his explana-
tion of automatic writing:

> The automatic writer has no cause to take pride in the products of
> his activity. The voice he allows to speak within him goes beyond in all
> directions the register where he is situated, and it has been said, with
> good reason, that his attitude was [*sic*] closer to that of the medium
> than of the writer. Let us point out in this respect that the repressive
> forces, exterior as much as interior, against which Surrealism has not
> ceased to be in revolt, tend to let only the "god" speak, that is to say
> an immediacy entirely dominated by the Reality Principle and social
> conditioning: when all's said and done, an enslaved "ego" would speak
> only the language of enslavement.
> In contrast, the untamed voice of automatism which no doubt has
> its laws, but sufficiently unformed by the Pleasure Principle to take on
> a character openly or implicitly subversive, is less that of the "subject"
> than that of all men.[5]

[4] Anna Balakian, "From *Poisson soluble* to *Constellations:* Breton's Trajectory for
Surrealism," *Twentieth Century Literature,* 21, 1 (February 1975), p. 50.
[5] See Audoin's statement, reproduced in "Le Téléphone surréaliste, Prague–
Paris," in *Princip Slasti.*

Audoin has highlighted one of the most compelling reasons surrealists have for being drawn to automatism: their conviction that, allowing the artist to delve into the unconscious, it permits him to speak for all men, so bringing appreciably closer the day when, in fulfillment of Lautréamont's prediction, poetry will be made by all.

Through words and pictures, the automatic practices sponsored in the name of surrealism were intended to direct attention to "the world—in small part aerial, in large part subterranean—that the mind explores like the plant, by means of antennae," just as Arp is said to do in Breton's *Anthologie de l'Humour noir* (p. 478). Faith in automatism is so deep-seated that we wonder momentarily if we are facing a contradiction, when we hear two surrealists condemn as "a colossal aberration" reduction of automatism to the level of technique, like collage and paranoiac criticism. Automatism, they declare, "is not going through the looking glass, but already the *other side*."[6] José Pierre's comments dispel confusion, as he explains, "There are two different things: first the will to leave the door wide open to unconscious forces, and then the procedures. . . . there is no code of automatism, with warning signs. On the other hand, automatic procedures on the pictorial plane are multiple. There is collage, frottage, decalcomania."[7]

We must not mistake the method for the principle it applies. Hence, in his article "Perspective automatique," Adrien Dax speaks of "a libertarian reeducation of sight" as the way in which the practice of automatism displays a close relationship to "diverse divinatory procedures" (p. 88). Similarly, resting his argument on Freud's teachings about the role of the unconscious in human motivation, Breton speaks of automatism in "Situation surréaliste de l'objet" as not only "a method of expression" but also "the first solicitation with a view to a general revision of the modes of cognition" (p. 71).

In short, it is difficult to exaggerate the significance with which surrealism invests the automatic principle. Breton's "Limites non-frontières du surréalisme" credits it with giving men hope of resolving the fundamental antinomies that make them discontented with their

[6] Simon Hantaï and Jean Schuster, "Une Démolition au platane," *Médium: communication surréaliste*, Nouvelle Série, No. 4 (January 1955), p. 61.
[7] José Pierre, "Le Surréalisme et l'art d'aujourd'hui," in Alquié, *Entretiens sur le surréalisme*, p. 415.

lot: waking and sleeping (or reality and dreaming), reason and mad-
ness, objective and subjective, perception and representation, past and
future, the collective sense and love, and even life and death (p. 18).
This viewpoint assists us in understanding better why Breton spoke in
Le Surréalisme et la peinture's definitive edition of graphic and verbal
automatism as "the only mode of expression that fully satisfies the
eye or the ear by realizing *rhythmic unity*" (p. 68).

By the time he wrote the essay from which these words come
(1941), Breton's position on automatism had modified somewhat. He
was prepared, now, to admit that premeditated intentions could
combine fruitfully with automatic methods in pictorial and verbal
poetic creation. All the same, he still insisted that "one runs a great
risk of moving away from surrealism if automatism stops making its
way at least *as an undercurrent*" (p. 70). An example illustrative of
what he had in mind is provided by the work of André Masson.

In the essay cited a moment ago, "Genèse et perspective artistiques
du surréalisme," Breton speaks of Masson as fully committed from the
time of surrealism's origins to the very same cause as Ernst, "but
searching much earlier for principles authorizing him to build on
them in a stable fashion." So Masson turned to automatism at once
(p. 66). Noting how much benefit Masson derived from graphic
automatism, Breton goes on—for the first time in *Le Surréalisme et la
peinture*—to draw a parallel between verbal and pictorial surrealism:
"The essential discovery of surrealism is, indeed, that, without pre-
conceived intention, the pen that moves to write, or the pencil that
moves to draw *spins* an infinitely precious substance not all of which
perhaps is material for immediate exchange but which, at least, ap-
pears charged with everything emotional the poet or painter has
within him at the time" (p. 68). José Pierre comments more specifically
in his *Position politique de la peinture surréaliste:*

> The way so many of the automatic drawings and paintings of Masson,
> in 1924–1925, spontaneously associate a fruit, a bird, or a woman's
> breast with an open hand would seem to bear witness at the same time
> to the dilatory process proper to long-term surrealist inspiration and
> to the irresistible precipitation with which are produced associations
> that, formerly unconscious (or repressed), become conscious during
> their transcription to canvas or the sheet of paper.
> This would amount to saying that, in Masson's unconscious,
> diverse emotions have accumulated, followed or not by effects, relative
> to an apple, a pigeon, or a nude woman, which on the occasion of later

insertion into nonpremeditated graphic or pictorial composition (or one resulting from relatively little premeditation) elude the status of realistic transposition (portrait or still life) to discover for themselves symbolic signification (the apple then *equalling* the breast and the bird, who knows? the phallus or erection. . .) within surrealist metamorphosis. (p. 20)

Might it have been wise of Pierre to add a word of caution? One can see why he would not have thought it necessary. Reference to a symbolism he hesitates to interpret indicates well enough where he stands. He would consider it a serious error to assume that surrealist principles condone compromise of automatism by contrivance, acting through symbolic intent. Although visually perceptible, the symbolism of Masson's early work still remains elusive, because it is intuitive and quite beyond the control of intentionality. It is no less fruitless to try analyzing the symbolic structure of his pictorial symbolism than to try to penetrate the symbolic significance of the Chinese lanterns and Prince Rupert's drops recurring in the verse of Benjamin Péret.[8] Intention does have its designated role in surrealism, of course. But, as we hear when Breton is talking of Matta in *Le Surréalisme et la peinture,* its function is more that of initiating exploration than of dictating where and how exploration will be conducted: "In his work nothing directed, either, nothing that does not result from the will to make the faculty of divination more profound by means of color, a faculty with which he is endowed to an exceptional point" (p. 148).

The process by which, following the instructions set forth in the first surrealist manifesto, the poet intending to practice automatic writing first empties his mind of preestablished themes so as to inculcate "the most passive, or receptive state possible" (p. 44) is not different from Miró's method, described by Christian Zervos in the following terms: "Miró no longer prepares his paintings; he gives them not the slightest thought in the world before taking brush or pencil in

[8] José Pierre does not look upon symbolism and automatism as incompatible. Picking up a phrase used by Breton, "rhythmic unity," Pierre identifies two major directions in pictorial surrealism. These classifications underlie the presentation of painters in his *Le Surréalisme:* rhythmic automatism and symbolic automatism. The former corresponds to automatic texts. The adjective used to describe the latter is understood in its Freudian sense. The same classification is proposed in Pierre's text "Le Surréalisme et l'art d'aujourd'hui," pp. 401–402. It goes without saying that the surrealists are perfectly willing to leave to specialists of psychoanalysis any interpretation of the symbolism that so often makes it possible for the inner model to be transcribed in graphic and verbal surrealist imagery.

hand. He departs from nothingness with [*sic*] the point of view of conscious effort, but this is a nothingness rich in all the dreams of a true poet. The forms install themselves on the canvas without a preconceived idea. He begins them by spilling a little color on the surface and then circulates a dipped brush around the canvas. As his hand moves, the obscure vision becomes precise."[9] Nor is it any different from the method favored by Arp, as described in *Jours effeuillés*: "I allow myself to be led by the work in process of being born, I place my trust in it. I do not reflect. The forms come, pleasing or strange, hostile, inexplicable. . . . They are born of themselves. It seems that, for my part, I only move my hands about. These lights, these shades that 'chance' sends us we ought to welcome with astonishment and gratitude. The 'chance' for example that guides our fingers when we tear up paper, the figures that appear then, give us access to mysteries, reveal to us the profound progress of life" (p. 435).

On the one side is chance, the tantalizing source of unpredictable revelation. On the other side are the methods by which the artist hopes to tap that source. In devising and applying such methods, surrealist writers and painters share the same optimistic motivation. All therefore are in open revolt against the motives that lend meaning to traditional techniques. Thus the spirit of revolt pervading surrealist poetry—understood in the broad acceptation of the term habitually defended by surrealists—eliminates the egotism that so often underlies the creative act. For example, in the graphic experimentation with automatism he first began to conduct around 1947, Dax consistently has demonstrated his disinterest in authorial ambitions. Notably, a process he invented in 1955, *impression de relief*—in which foreign objects (pins, nails, pieces of trash, and so on) are introduced between paper and stone before a lithograph is pulled—confirms the vitality of creative impulses to which Ernst's frottages owe their fascination in surrealism. "I have banished clarity, devoid of any value," declare Breton and Schuster in their "Art poétique." "Working in the dark, I have found lightning. I have disconcerted."

Sometimes, unfortunately, readers and spectators are disconcerted to the point of drawing conclusions that can only hurt the cause in which automatic methods have been adopted. When automatism is thought to represent not only abdication of the exalted status of creative author but also a weakness for facility, the effect it can produce in a bemused public is dangerous. This is why in a 1939 essay on

[9] Christian Zervos, "Joan Miró," *Cahiers d'Art*, 1–4 (1934), p. 14, as cited by Soby, p. 66.

the most recent tendencies of surrealist painting, reprinted in *Le Sur-réalisme et la peinture,* Breton argues, "On the part of the young painters of today, the fact of opting most clearly for automatism does not exclude, very much to the contrary, taking into consideration the most ambitious problems" (p. 148).

Separating chance itself from the methods by which surrealists have endeavored to avail themselves of its valuable assistance helps us avoid the confusion experienced by some observers in their review of surrealism's history. As early as 1934 Breton confessed openly in *Point du jour,* "The history of automatism would seem to be, I am not afraid to say so, that of a continual misfortune" (p. 226). His adversaries have not been slow to pick up this statement and to interpret it as an admission of failure. In their haste to do this, they have shown themselves eager to discredit surrealism and to pass it off as lacking firm foundation. One can subscribe to their views only by ignoring the following. Eight years later, interviewed by Charles-Henri Ford in the American magazine *View* (August 1941), Breton still was asserting that "the descent in the diving bell of automatism, the conquest of the irrational, patient coming and going in the labyrinth of calculated probabilities are far from having been seen through to the end."

Considered from one side only, automatic writing has all the limitations of a mere method. Being no more than a technique, it is by no means an inexhaustible source of revelation. Despite the luminous example set by Péret in whom inspiration never seemed to run out, we must assume that, with time, verbal automatism as a method for exploring the unconscious must cease to turn up anything the practitioner will find new. In part, this is because the individual unconscious is not limitless, after all. In part, though, it is because (unless the writer voluntarily excludes some things on the basis of deliberate choice) memory and association necessarily must intervene now and again to furnish once more fragments of what has been revealed in previous exercises in automatic writing. Here the ultimate threat is that of repetitiveness. Then, too, there is another peculiarly insidious risk, one the surrealists have not always evaded with complete success. This is the inherited temptation to submit the products of automatic methodology to the discipline of formal presentation. In the early surrealist painter and poet alike, the fear of disorder and of incoherence was too deep-seated, apparently, to be discounted in any evaluation now made of the fruits of their automatism. After all, Breton's "Les Tendances les plus récentes de la peinture surréaliste" confesses that in collage, frottage, and the earliest results of paranoiac critical

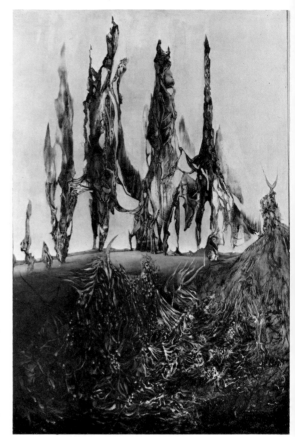

Wolfgang Paalen, *The Strangers*. 1937. Oil on canvas. Private Collection, Rome.

Adrien Dax, Impression de relief. Collection J. H. and Jeanne Matthews.

activity there was something equivocal about the relationship the in-
voluntary bore to the voluntary. And this, he suggests, did not dis-
appear until Paalen discovered fumage and Dominguez invented
decalcomania without preconceived object. Thus more than one sur-
realist may have had cause to echo the regret voiced by Eluard in
Donner à voir: "When chance shows us our limits can be pushed back
indefinitely, we regret our prudence and our methods, we are un-
happy" (p. 136).

Breton's 1938 essay on Paalen in *Le Surréalisme et la peinture*
designates fumage "a contribution of the first order": "endless tresses
of the woman loved in the shadows" (p. 138). The importance Paalen
himself attached to fumage takes definition from two essays in the
magazine he edited in Mexico, *Dyn.* Discussing the new image in the
first issue (April–May, 1942), Paalen called automatism a divinatory
technique, destined to bring an unforeseeable image out from es-
thetically amorphous material. Examining surprise and inspiration in
the second number (July–August, 1942), he spoke of inspiration as the
liberation of the torrent of imaginative association by the shock of
surprise. In this he anticipated Breton's comment in the special issue
of *Médium* devoted to his work (Nouvelle Série, No. 2, February
1954): "One rule for and against everything: inspiration."

Several examples of decalcomania, by various hands, appeared in
the eighth number of the magazine *Minotaure* (1936), together with
a story of Péret's inspired by them, beginning, "I was to be drowned.
. . . ." In an essay on Oscar Dominguez, written the same year, de-
scribing the process of decalcomania without preconceived object
(or decalcomania of desire), Breton commented, "What you have
before you is not perhaps da Vinci's paranoiac wall, but it is this wall
taken to perfection. All that is needed, for example, is for you to en-
title the image obtained in terms of what you discover in it, stepping
back a little, to be sure you have expressed yourself in the most
personal and valid manner."[10]

Which way should the artist head when knowing no more about
where he wants to go than this: his goal cannot be reached along
paths blazed by others who have preceded him? How, indeed, does
an artist set to work, when his every instinct is to treat premeditation

[10] See André Breton, *Le Surréalisme et la peinture,* p. 129.

as an impediment to progress and true discovery? These questions set value on techniques by which the surrealists have sought to put inspiration on a new track. A method like decalcomania helps solve the problem facing the artist who looks to his own work to function as a mirror where he can catch the reflection of an image that does not exist at the level of conscious awareness. Such an image does not simply reproduce or project something visible in the mind's eye. It actually anticipates the mental image.

On the technical plane, the essence of surrealist decalcomania lies in its purely mechanical characteristics: color is spread over a sheet of paper, upon which another sheet is laid and pressed down before separation. This direct appeal to chance guarantees the integrity of the resulting image by eliminating intentionality from the creation of the visual spectacle obtained with either ink or gouache.

It is imperative then that, practicing decalcomania, the surrealist artist refrain from preconceived notions regarding the pictorial results of his chosen method. His humility is reflected in willingness to hold himself available for bringing the image into being. Exclusion of all preconceptions about what the picture must depict liberates the sensibility, leaving it free to explore visual possibilities beyond the capacity of conscious selection. To the extent that interpretation of the resulting pictorial elements may ensue, this is the consequence of illuminating interplay between suggestive features already visible on paper and the artist's dedication to externalizing the inner model. Hence the product of decalcomania may well serve to initiate a visual experience dependent for its appeal upon the responsiveness it elicits, first within the artist and then—after he has made his interpretive contribution—within the spectator.

Like a variety of other creative procedures promoted by surrealism, decalcomania may serve to set in motion an interpretive process. Here the artist's primary role is to probe his own imaginative potential, a form of self-exploration undertaken under incitement from the graphic elements his method has placed before him. Technique becomes initiative, because its function is to jolt the artist out of visual habits. It provides protection from esthetic and formal preconceptions. In so doing, it makes possible a leap into the unforeseen of pictorial forms. And it allows the surrealist artist to return to zero every time, so escaping the confinement of mannerism and even of the insidious repetitiveness that may be an inescapable consequence of obsessive preoccupation. Hence the surrealist artist's contribution signifies willing collaboration, finding its impetus in glad acknowledgment of the

Oscar Dominguez, De-
calcomania. Black and
blue gouache. Collection
Conroy Maddox, London.

Oscar Dominguez, *Pro-
fessor of Surrealism*.
1944. Ink and gouache
drawing and decalcoma-
nia. Private Collection,
New York. Photo Nathan
Rabin.

beneficent role of chance revelation. At one and the same time, the artist explores his capacity for response and outer reality's ability to answer man's needs. Thus, surrealism teaches, artistic creation marks a diminution of the anguish of alienation to which rationalism consigns man.

At what point exactly does the lion in *Le Lion-bicyclette* (1936) cease being a lion and become a bicycle? Dominguez' decalcomania denies us reassuring certainty in answering this question. The reconciliation of irreconcilable phenomena has come about through a technique dispensing with the kind of controls that would permit us to plot the progression from lion to bicycle and back again. And so it is interesting to note that the amalgamation of disparate realities occurs with greater subtlety and suggestiveness in the decalcomania *Le Lion-bicyclette* than in the gouache, *La Femme-bicyclette*, dating from the following year.

Dominguez in his decalcomanias and Dax in his *impressions de relief* both obtain a singular and quite vertiginous effect of depth. The eye is drawn down into the picture. Our sense of equilibrium forsakes us here, just as it does so frequently in the plunging and bewilderingly contradictory perspectives favored by Matta. We advance into the pictorial universe of these artists with an inescapable feeling of having lost our footing. Here reassurance comes from no stable elements such as forms instantly recognizable from day-to-day experience. The absence of a horizon line by which we might find our bearings is at once alarming to reason and exciting to imagination.

To retain its vitality, the automatism preached in the 1924 surrealist manifesto must not be submitted to any kind of dogmatism. Instead, comments José Pierre in his "Le Surréalisme et l'art d'aujourd'hui," it must be adapted by each individual writer and painter to his own "inner necessity" (p. 398). On the basis of this argument, in his *Position politique de la peinture surréaliste* (p. 19) he likens the mechanism of artistic creation in surrealism to a triangle in which the three points represent respectively emotion, the unconscious, and artistic expression. Direct communication of emotion by technical means will produce a work "with no loud echo," as Breton puts it in "Position politique du surréalisme" (p. 37), a mere "work of eloquence" (p. 38) in fact. By indirect communication of feeling via the unconscious, such as automatism makes possible, the artist can avoid these pitfalls.

Behind this theory lies the belief that immediately communicable emotion is ephemeral because of its strictly private origin. By the

same token, immersion of feeling in the unconscious gives it a higher affective charge since it is imbued, now, with significance for all men. Logically taken a step further, surrealist theory sets store by works produced under conditions most people would consider quite frivolous. Thus participation of several individuals is invited in surrealist games having rules designed to solicit the intervention of chance quite directly. The rules are simple in every case, and strikingly similar. They exclude deliberate choice and any controls that might be exercised by reason or esthetic sense. Meanwhile unrestricted freedom of expression is guaranteed. In every instance, the same underlying confidence can be detected: "The activities of play, charged with all the powers of analogical thought," declares Vincent Bounoure, "will one day make daily life benefit from the incalculable riches they already place in our hands."[11]

Nowhere more immediately than in surrealist games are we made aware of the triumph of the pleasure principle over the reality principle. Hence our first step is acknowledging their primary appeal as a source of amusement, of relaxation. The "riches" about which Bounoure speaks are not a bonus, exactly. But they do represent a profit that could not be estimated in advance, at the time when the rules of the game were laid down. Meanwhile, everything in the surrealists' approach to life and art predisposes participants to the highest confidence in the potential advantages of pooling the unconscious resources of several players and of realizing desires in common. Not only do such games provoke manifestations of chance, they offer too the appeal of fulfilling the surrealist ambition of poetic anonymity—to use Hugnet's phrase. This is the very ambition that led André Breton, René Char, and Paul Eluard to collaborate in writing the poems of *Ralentir Travaux* (1930).[12] Not surprisingly, examples of the game called *cadavre exquis*—both verbal and pictorial ones— appeared anonymously when they came out first in No. 9–10 of *La Révolution surréaliste* (October 1927).

As defined in the *Dictionnaire abrégé du Surréalisme*, *cadavre exquis* is "a game of folded paper that consists in having a phrase or a drawing composed by several persons, without any of them being able to take into account the preceding collaboration or collaborations."

[11] Vincent Bounoure, "Au Lever du rideau," in *Princip Slasti*.
[12] *Cf.* the early collaborative work of Arp, Ernst, and Baargeld humorously termed fatagaga—*fabrication de tableaux garantis gasométriques*—in which Carlo Sala sees the prefiguration of surrealist *cadavres exquis* ("Les Collages de Max Ernst et la mise en question," p. 135).

Folding the paper after each word or graphic element has been set down conceals it from the person following. He, in turn, must put down another word or add to the drawing, his freedom of choice being ensured by ignorance of what has gone before. The game takes its name from the first phrase produced according to its rules: "Le cadavre exquis boira le vin nouveau"—"The exquisite corpse will drink the new wine."

The only rules applied uniformly in verbal *cadavres exquis* are those that govern grammatical relationships. Their one consistent feature, in consequence, is regularity of form, guaranteed by the rules of the game. In each case, a prescribed grammatical structure, always carefully respected, provides the same framework. Subject, qualifying adjective, verb, and object: these are its elementary constituents. On the surface, such a linguistic framework appears as reassuring to rational thinking as the aphoristic concision of surrealist proverbs. The fact remains, though, that the essence of *cadavre exquis* lies in its content, not its form. Specifically, it can be traced to the shift of meaning engineered by chance and rendered communicable by formal coherence and cohesiveness. The difficulty presented the literary critic by *cadavres exquis* is the very one, therefore, confronting him in *Les Champs magnétiques* or Péret's *Histoire naturelle*. He has no excuse for believing that the sentence before him means anything but what it says: "The anemic young girl makes the waxed tailor's dummies blush," or "The oyster from Senegal will eat the tricolor bread," or again "The dormitory for friable little girls rectifies the odious box," or perhaps "The endless sex sleeps with the orthodox tongue." What confuses him is the nature of the information engaging his attention through respectable linguistic form. The material before him does not lend itself to analysis according to rules he is sure are appropriate to the evaluation of literary texts. He cannot discern a pattern to the image-work, because he is not facing something that has come from the sensibility or mental state of one individual only. Regularity of form is a purely external characteristic from which no pertinent conclusions can be drawn. In fact, it mocks his efforts at analysis because its sole function is to supply a vehicle for conveying linguistic elements brought together by a wilfully arbitrary process that Tristan Tzara did not hesitate to call a "recipe."

The ingredients brought together in accordance with the recipe for making *cadavre exquis* appear to reason not to belong together at all. Yet this is precisely what generates the spark of the image, in the surrealists' estimation. Ernst, for example, seeing the strength of the

surrealist image as proportionate to "the degree of arbitrariness it displays," comments in *Beyond Painting* that surrealists use "the cadavre exquis process" in the hope of increasing "the fortuitous character of elements utilizable in graphic composition." So "their abruptness of association" is increased, as the part played by chance is limited to "the role played for the first time by mental contagion" (p. 23). When, in a 1948 essay called "Le Cadavre exquis, son exaltation," reprinted in *Le Surréalisme et la peinture,* André Breton cites some verbal examples, the ones he selects are "chosen from among those that have given us the greatest impression of *dépaysement* and *jamais vu,* in which we most appreciated the jolting value" (p. 289).

Possibly, Breton's remarks, taken up in the catalog *Le Cadavre exquis, son exaltation,* lend support to Renée Riese Hubert's argument that *cadavre exquis* may be regarded as "essentially an exercise in collage."[13] One thing is certainly clear. The important thing about their *cadavres exquis* was, for the surrealists—as André Masson observed in *Le Cadavre exquis, son exaltation* (p. 28)—"the *arrival of the surprising image.*"

Surrealists feel sure that certain games in which the individual gladly joins with others enable him to go where he could never succeed in going alone, and in the very direction where an exciting impression of disorientation is accompanied by a refreshing sense of fulfillment. Whether visual or verbal, the image born of *cadavre exquis* stands as proof of how far the imagination can travel, once certain obstacles have been removed. And the latter, surrealists believe, can be cast down best by collective effort. As Breton intimates in his article, the fruits of *cadavre exquis* bear a stamp that one mind, working alone, could not give. They are endowed with "the power to drift upon which poetry could not set too high a value." For *cadavre exquis* places at our disposal "an infallible means of holding the critical mind in abeyance and of freeing the metaphorical activity of the mind to the full" (p. 290).

A noteworthy feature of graphic *cadavre exquis* is highlighted in Breton's essay, which remarks upon these drawings' "pre-existent will

[13] Renée Riese Hubert, "Collages and Surrealist Genres," *Proceedings of the Comparative Literature Symposium,* Vol. III (Lubbock, Texas: Texas Tech University, 1970), p. 166.

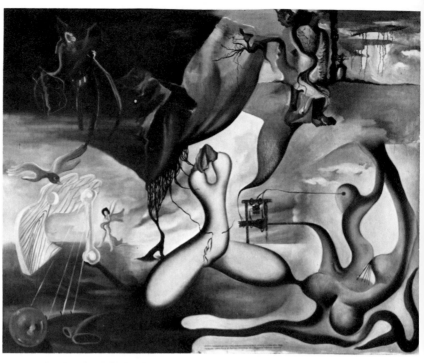

António Pedro, Fernando de Azevedo, Vespeira, Joâo Moniz Pereira, António Dominguez, Exquisite Corpse. 1948. Oil on canvas (1.5m x 1.8m).

André Breton, Frédéric Migret, Susanna Migret, Anon., Exquisite Corpse. Circa 1930. Colored chalks on blue paper. Collection Timothy Baum, New York. Photo Nathan Rabin.

to compose in personages" (p. 290). With a frequency not to be ignored, the chance elements going to make up the finished drawing form a grotesque figure distinctly resembling a human being, though plainly not of this world. Breton shows no reluctance to identify in this curious anthropomorphism an effort (unconsciously made, of course) to "accentuate prodigiously the life of relationships that unite the outer world and the inner world." In this respect, these figures categorically deny "the ridiculous activity" of imitating aspects of physical reality through art. They apply instead those "precepts of intractability" for which Breton's text lodges an appeal.

To a significant extent, the art of imitation is subverted thanks to the conditions under which such an image has been produced. Application of the precepts of intractability has become the effect of prescribed methods far more than of conscious intent. In this, *cadavre exquis* is essentially a means of associating supposedly incompatible elements—words or shapes—having this special attraction: it eliminates interference by the instinct for ordered presentation of ideas or shapes, bred in artists by inherited traditions of verbal or pictorial representation. In other words, the benefits accruing from the conditions of production imposed by the rules of *cadavre exquis* are fundamentally the same as those Victor Brauner sought in his "drawings done with eyes closed," or his "drawings done in a mediumistic state." Indeed, Brauner once confided, "I start out from a pencil line without knowing where I'm going. I follow my hand, I understand gradually what I want to do, and from a certain moment onward the drawing itself commands my intention."[14] Interestingly enough, the strange

[14] See Sarane Alexandrian, *Les Dessins magiques de Victor Brauner*, p. 19. In his *Brauner*, Alain Jouffroy has remarked, "Therefore the artlessness of a painter is often the very condition of his work's depth. People delude themselves by sempiternally opposing artlessness and consciousness. An artist can be at the same time conscious and artless. He can try to paint, like Brauner, inner life or psychological Space, in a manner at once spontaneous and lucid. A work is infantile if it is only artless, docile if it is the exclusive product of the will. Brauner reconciles these contradictions. He knows and he does not know what he is painting. He is the most sensitive to his own discoveries. He tries ceaselessly to reinterpret them for himself" (pp. 11–12).

In 1938, attempting to separate two friends in violent argument, Victor Brauner was blinded in one eye by fragments of a glass thrown by Oscar Dominguez (fragments which radiography revealed to have struck the eye in a geometrical pattern). Six years earlier he had painted an *Autoportrait à l'œil énuncléé*, showing his eye pierced by a swordlike object marked with the letter D. Between whiles, he had painted several pictures on the theme of ocular mutilation.

When he first came to Paris in 1932 Brauner had taken a photograph of a

composite characters we meet in Brauner's drawings—sometimes part human, part animal, part machine—often resemble the figures brought to light by *cadavres exquis*. All the same, as we look at a number of them in succession, a distinct impression of repetitiveness gives them an inescapably predictable quality: relying solely upon his own resources, one man cannot hope to compete with the variety of collective experimentation.

To assure inventiveness its vitality, while yet escaping the unenviable consequences of what Breton felicitously termed "self-kleptomania," the surrealist artist must be willing to take advantage of means of forcing inspiration. These means need not take on the scope of identifiable techniques, like collage, frottage, or fumage (development of the virtual image left on a sheet of paper passed at random over the smoky flame of a candle). What matters, basically, is acceptance of the principle of chance suggestion, unconfined by any concern other than that for bringing out the image. Thus Miró, who in his early years made a virtue of necessity when painting under the influence of hunger—in a state he has likened to hallucination—was to comment later on: "What is most interesting to me today is the material I am working with. It supplies the shock which suggests the form just as cracks in a wall suggested shapes to Leonardo."[15] Referring to the period of the late thirties, Miró observed, "Also the material of my painting began to take on a new importance. In watercolors I would roughen the surface of the paper by rubbing it. Painting over this roughened surface produced curious chance shapes."

Perhaps the most striking thing about this statement is that it shows Miró, working in self-imposed isolation, turning for suggestions to the materials of his art, just as other surrealists were doing. Tanguy's approach differed only in the methods it called forth, not in the ambition dictating them: "I found that if I planned a picture beforehand, it never surprised me, and surprises are my pleasure in paint-

street entertainer, outside the very house where eventually he would lose his eye. The snapshot shows a man blindfolding a woman prior to a demonstration of thought transference. Looking back, Brauner was to confide in Jouffroy, "I was caught up alive in an adventure of nonresponsibility" (Cited by Jouffroy, p. 32).
[15] Quoted in James Johnson Sweeney, "Joan Miro: Comment and Interview," *Partisan Review*, No. 2 February 1948), p. 210. *Cf.* Miró's "Je travaille comme un jardinier": "I begin my pictures under the effect of a shock I feel that makes me escape reality. The cause of this shock can be a little thread coming away from the canvas, a drop of water falling, that fingerprint I've left on the brilliant surface of that table." One of Ernst's pictures bears the title *Hallucination provoked by a Piece of String on my Table.*

Sebastian Matta Echaurren, Esteban Frances, Gordon Onslow-Ford, Exquisite Corpse. 1940. Colored Chalks. Collection Conroy Maddox, London.

Ronald L. Papp and Jean-Jacques Jack Dauben, *Conscious Asleep, Unconscious Awakened.* 1976. Collective Painting.

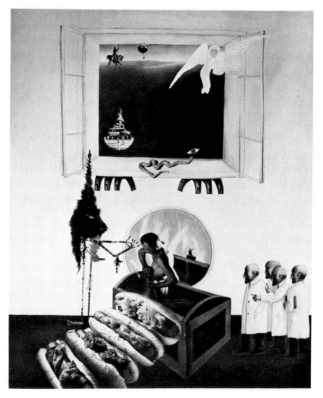

Eva Švankmajerová, Karol Baron, Vratislav Effenberger, Albert Marenčin, Juraj Mojźiš, Martin Stejskal, Ludvik Šváb, Andy Lass, Jan Švankmajer, *Security.* 1973. Collective Picture.

ing," Tanguy said, adding, according to Soby (p. 17), that what interested him was the way one motif suggested another, then another, then yet another, unpredictably: "I expect nothing of my reflections," he explained, "but I am sure of my reflexes." As for Svanberg, he stated in his response to an inquiry conducted by Estienne and Pierre, "Situation de la peinture en 1954," "The formal plastic materials prepare the provocative character of the image's content. The importance of formal values as elements of attraction does not operate for the observer alone; for the painter, too, color, for example, is a constant stimulant in the course of creation . . ." (p. 46). In his book about Svanberg, José Pierre comments appositely:

> The free development of the image in terms of means of expression in the work of Max Walter Svanberg establishes clearly the responsibility of plastic means in the elaboration of the vision (p. 96)
>
> Giving the conception of the picture precedence over its realization, one risks shutting oneself off not only from the very justification of the surrealist experience, but from the essential province of contemporary art: *automatism,* which implies at least partially the interdependence and simultaneity of these operations. (p. 99)

In the work of Ernst and Masson, appeal to chance through automatism precipitates violent, spasmodic, dynamic distortions of familiar forms. In marked contrast, it yields strikingly ordered forms in creations by Tanguy and Arp who affirmed in a 1955 article on collages, reproduced in *Jours effeuillés,* that "chance is also a dream" (p. 420). This, no doubt, is the dream of mediation that fascinated Breton in Ernst's collages. For, whatever the form in which chance helps communicate an image of the inner model, it gives weight to Breton's prediction in *L'Art magique:* "The feeling of being moved, not to say *put into play,* by forces that exceed our own, will not cease, in poetry and in art, to become more acute, more pervasive."

Irrespective of its possible though quite accessory esthetic charm, the image precipitated by *cadavre exquis* is typical of the imagery of surrealism in general. Its prime value to the surrealist mind lies in signposting the route to total imaginative liberation, unattainable without the cooperation of chance. Are we to conclude, nevertheless, that chance remains an elusive phenomenon? Man would like to bring

it under control. But he cannot dictate to it without at once impairing its revelatory power, or even diverting that power from the service of surrealism. Is there no hope at all of harnessing chance, so to speak, without paying altogether too high a price for doing so? We need do no more than pose this question to appreciate how important is a discovery that came late among surrealist games: *l'un dans l'autre.*

Could a game be devised by which "the unconscious reality in the personality of the group," noted by Calas, would persuade chance to operate in one direction rather than another, producing results truly verifiable though unforeseeable? *The one in the other* appeared to be such a surrealist game, favoring among participants increased awareness of desires experienced in common. This game was all the more fascinating in its implications because it offered tangible evidence to reinforce the surrealists' long-established belief that behind the manifest content of reality lies a latent content, far more significant for man.

Surrealists had become convinced early on that, at one end of the scale, rigid confinement of available possibilities urgently and successfully solicits fruitful intervention from chance. As proof of the validity of their arguments they could cite Mesens' *Alphabet sourd aveugle* (1933), for instance. It contained a poem for each letter of the alphabet, each line of each constituent text beginning with the same letter. What, though, were the possibilities at the other end of the scale? Here confinement must give way entirely to a freedom in which, it seems, chance may well be at liberty to sink into the haphazard, dissipating its precious energy at random and so undermining the surrealist theory of beneficent chance instead of strengthening it. Moreover, at the same time serious doubt must be cast upon the surrealists' views regarding poetic analogy, according to which every object belongs to a unique whole and bears to any other element in that whole a relationship Breton insisted we treat as *necessary.*

In the circumstances, it is difficult to exaggerate the importance of a "brief illumination" leading, a few months later, to invention of *l'un dans l'autre.*

Around March 1953 Breton and some of his friends were discussing analogy, in the café where they met regularly on the Place Blanche in Paris. Seeking a concrete example to bring out his argument, and thinking the flame of a match would "give" a lion's mane, Breton claimed that it could be easy to describe a lion by starting from a description of a match. He found the idea intriguing that any object is "contained" this way in another and that therefore, to obtain the former, it is enough to singularize the latter in substance, color,

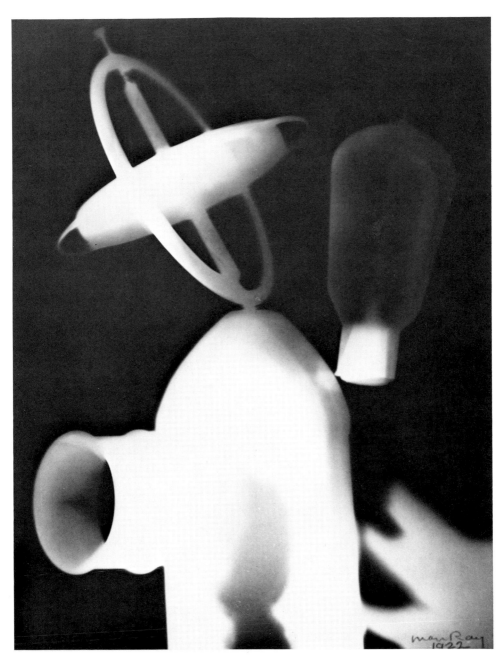

Man Ray, Rayograph. 1922. Private Collection, New York.
Photo Nathan Rabin.

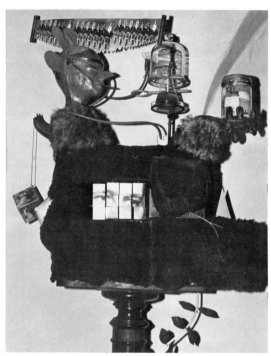

Karol Baron, Alena Nádvorníková, Eva Švankmajerová, Emila Medková, Vratislav Effenberger, Albert Marenčin, Martin Stejskal, Ludvik Šváb, Jan Švankmajer, *Phantom Karel Teige*. 1975. Collective object.

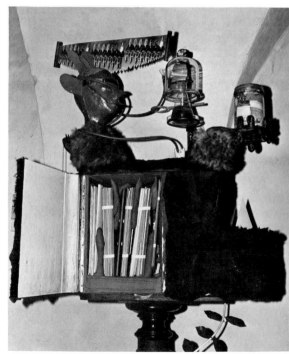

structure, and dimensions. On July 29, still speculating on the possibilities, Breton and Péret reached the conclusion that any action and any character might be described by way of any object, and conversely. Delighted at seeing *"all obstacles in every direction"* bypassed this way, they decided without delay to give these "identities" the greatest possible extension through the activity of play.

Leaving the room, one player elects privately to identify himself with some object or other. In his absence, the other participants agree he will have to present himself as an object of their choosing. Upon his return, he is required to describe himself as the latter. He must do so in such terms as to make the image of the object he himself has chosen to represent superimpose itself on the description of the one that the other players have asked him to impersonate. If his monolog does not make it possible for listeners to identify his object within two to five minutes, they are free to question him, so long as they do not seek to elicit realistic descriptive details at variance with the spirit of the game, intended to give rise to *"allegorical sketches."*

Not infrequently, during the three hundred or so times *l'un dans l'autre* was tried out in Breton's vacation home in Saint-Cirq-la-Popie, identification of the object sought came with stupefying rapidity. In no instance did it fail to result, as Breton puts it, "indirectly, by proxy transmitted to another person," in a way he categorizes as enigmatic. Citing a work much admired in surrealist circles, Johan Huizinga's *Homo Ludens,* Breton notes that it establishes a close correlation between poetry and enigma. He goes on to comment, "It so happens then that the game of 'the one in the other' offers us fortuitously the means of setting poetry back on the sacred path it had originally and from which everything subsequently conspired to divert it."

Breton never returned to furnish the additional commentary on *the one in the other* he felt warranted by the game's importance. Separately published in 1970, *L'Un dans l'autre* merely reproduces the text published earlier in the Parisian surrealist magazine *Médium* (May 1954). It presents the same examples as before, examples such as the following:

André Breton

I am a WILD BOAR of very small dimension that lives in a thicket of very bright metallic aspect, surrounded by more or less autumnal foliage. I am all the less to be dreaded because my teeth are on the outside: made up of millions of teeth ready to pounce on me.

CHOCOLATE BAR

Here the analogical force of the image lies in the discrepancy between the banal everyday object serving as the key to the enigma and the strange animal whose description provides that key. Elsewhere the process of poetic transference takes place somewhat differently.

Evidently Breton wished to test the resistance of the *l'un dans l'autre* method to the weight of apparently antipoetic objects like chocolate bars. Péret, though, when asked to represent himself as an object that would not have been out of place in his own poetic universe—a coffee sock (that is, a sock for coffee, just as a teacup is a cup for tea)—at once set about describing it in language fully in keeping with that to be found in his *Histoire naturelle:*

Benjamin Péret

I am the biggest COFFEE SOCK in the world, although I am, in reality, only a coffee half-sock spread out on the ground. I discharge every day an immense quantity of liquid perceptibly lighter than usual coffee, in which populations that swim and fly find their food. The origins of this coffee have been the subject of long controversies.

NOZⱯWⱯ

It is true, of course, that a suggestive link between coffee and Brazil may help shorten the distance existing in reasonable thought between a sock and the Amazon river, especially for members of the French surrealist group, who knew how many years Péret had spent in Brazil. Nevertheless the tantalizing enigma of poetic communication subsists, bound up with the mystery of metaphorical language. The same holds true for this next example, furnished by a painter this time:

Toyen

I am a toothless COMB used with the feet to part level and very tough hair.

ƎLⱯꓘS ƎƆI

So far as the surrealists are concerned, the spark loses none of its brilliance because, for instance, Péret's description of the Amazon as a *chaussette à café* leaves us suspecting that the *rapprochement* of these two elements—one drawn from nature, the other from the imagination (distant realities indeed)—may benefit from the help of some form of mental telepathy. Breton declares, "Nothing better than

the game of 'the One in the Other' has the power to bring out the precarious and even ultra-fallible character of the notions upon which what we agree to understand by the 'real' world rests." And so too Breton identifies the main interest of *l'un dans l'autre* as "fostering a continual fermentation permitting the transformation of 'every' thing into 'every' thing else, the specific agent of the operation—the mental yeast, possession of which is indeed all that poetry dreams of assuring us—revealing itself here to be up to the task of provoking the effervescence in common of the 'sensa' (otherwise called 'precepts') and images, the only constitutive elements of the mind."

In such an operation, we may conclude, the mechanism of associative thought signifies that participants in *l'un dans l'autre* not only have chance on their side but actually have created a situation in which chance will reveal what they seek. How else to explain the speed with which the second object emerges from the first, so to speak, when the latter's description has not brought reasonable association into play?—

> I am a flexible BROOM HANDLE spreading out at the same time vertically and horizontally and multiplied in such a way as to make up a considerable number of squares.

In this case, imagery stimulates mental activity into pressing confidently ahead of rational deduction, to arrive at a solution—proposed, as it happens, by Péret, who grasped that the broom handle was a fishing net—which reason still is incapable of formulating.

On occasion, identification of the second object from antinaturalistic description of the first, or rather from its evocation, revealed to all participants at once the existence of a relationship between those objects which had remained hidden from sight. This description by Georges Goldfayn is a case in point:

> I am a PENNY, of base metal or metal said to be precious, that people like, for the sound, to let drop on another penny. Completely devalued today, I was common currency for a long time. Certain people drew me out of large purses, but others, before putting me into circulation, took pleasure in polishing me in an ornamental or symbolic spirit.

Recognizing this penny as rhyme uncovered in Goldfayn's strange identification a poetic reminiscence: Paul Verlaine's verses "Art poétique," where rhyme is likened to "penny jewelry."

At first, no link is visible between the tear that Anne Seghers had decided to be and the fritter she was asked to represent. Only when her evocation of a *beignet* had led to the solution, *larme,* were the other players reminded of the banal phrase "baigné de larme" ("bathed in tears") in which, thanks to the homonymous *baigné,* Breton acknowledged a "foot-bridge" erected between *beignet* and *larme.* Instances such as this one are especially intriguing to surrealists, because they testify to the objective manifestation of chance: there is no possibility, they are persuaded, that the results coming from Anne Seghers' participation in *l'un dans l'autre* depended upon any special aptitude or mental preconditioning. Thus *l'un dans l'autre* displays the characteristics of a rite, and we hear Breton remark, "It is in the limitless field of possible associations that the rite is called upon to make its choice by appropriating it to a fundamental human need." It is to chance, benevolently watching over the participants in the game it supervises, that the rite owes its meaning.

L'un dans l'autre casts chance in the role of *agent provocateur,* functioning in a way that brings reassuring proof of the following. Man need not be separated from his desires forever, in a world implacably opposed to their realization and to his attainment of happiness. This game rewardingly demonstrates that things are not merely what they seem to be to the materialist's eye. Its rules are no more complex than in other surrealist games. Indeed, the simplicity of these quite external means of forcing inspiration contributes in no small measure to provoking wonder among participants, as well as pleasure. Furthermore, *l'un dans l'autre* brings out an instinct that, looking back, we sense has been affecting the surrealist approach to chance all along. Up to now, though, its influence has been manifest only intermittently. Here and there, we have felt entitled to ask whether the surrealist artist is not reluctant to admit its effect, or even whether he has not wished quite definitely to divert attention from it, in **his** determination to give chance maximum credit. Until we have examined the process with some care, it will be impossible to comprehend the significance of certain objects invented by artists involved in surrealist activities. These objects disturb or shock, always with subversive effect and almost always with subversive intent.

Before the twenties were out, Breton was appealing for the materialization of oneiric objects, concretely presenting things that reveal themselves only in our dreams. The value of such oneiric objects

speaks for itself and requires no special examination or defense on the level of surrealist theory: as Breton's first manifesto depicts him, man, and surrealist man especially, is a "definitive dreamer." All the same, when it comes to devising objects appropriate to the spirit of surrealism, the passive receptivity recommended in the 1924 manifesto can bring only relatively limited results. The artist must be content with waiting on his dream. He must acknowledge himself powerless, except when dream experience intrudes into creative consciousness. Making oneself a slave to one's dreams—either to those visions granted by sleep or to the more or less conscious desires resident in one's inmost thoughts—is a perfectly legitimate way of protecting oneself against inculcated literary and artistic traditions, naturally. It is a method of liberating creative forces suppressed heretofore, or perhaps diverted from their function. None the less, taking this step can pose its own limitations upon the creative act. It may deny the artist the possibility of communicating his protest against ambient reality except in terms and exclusively at the dictate of feelings that surface while he is asleep. Is there no way of forcing inspiration here, without either inhibiting its expression or distorting its message? In short, can chance revelation be *used* and not merely accepted in humble gratitude?

This is the delicate point of balance so fascinating to surrealists. If chance intervenes with nothing but beneficent effect, then how far can we take human intervention—a cooperative act, after all—without risk of reducing that effect, modifying it adversely, or even destroying it entirely? How far can we go in games of chance, while yet seeking to abide by Raymond Roussel's dictum, "We must oblige the dice to fall just right"? Are we in fact still playing games of chance, under those circumstances?

Surrealists look upon questions of this kind not as a warning of potential disaster but as an indication that profoundly optimistic responses are in order. How else are we to interpret the eagerness, indeed the feeling of distinct privilege, with which the medium is permitted to guide pictorial exploration or is treated as a rich source of latent images? Already we have had the opportunity to see in surrealist practice a strong and highly important link between chance and intentionality, between accident (so called) and design. This in fact is the artist's sole justification for presuming to interfere, where chance has made its contribution. The private sources of individual sensibility, activated—more exactly brought to the level of conscious awareness—by chance revelation, have the right to develop whatever chance has provided. More than this, they are obligated to bring out

the latent imagery of chance discovery when the latter can receive full development only with man's help. Here the creative sensibility does not come to terms with outer necessity in a process of reluctant submission, marked by nostalgia for something reality has eliminated. Instead, it engages in a deliberate act of clarification, whereby an image of the inner model finally becomes visible. In his "Tendances les plus récentes de la peinture surréaliste," Breton furnished an apposite example: "Esteban Frances, after distributing colors in absolutely no order on a piece of wood, submits the preparation so obtained to a no less arbitrary scraping [*grattage*] with a razor blade. Thereafter he confines himself to bringing out the light and shade. Here an invisible hand takes his and helps it bring out the great hallucinatory figures that have lain in posse in this mixture" (p. 148).

The inspirational source of Frances' grattages, the will to collaborate with chance, is evidenced less dramatically but no less significantly in Arp's method of "interpreting" his own works; "I give them titles like 'shadow of flowers,' 'cobra-centaur,' 'shepherd of images,' 'contour of the wind.' "[16]

> In 1925 I exhibited at the first surrealist group show and contributed to their magazines. They encouraged me to ferret out the dream, the idea behind my plastic work, and to give it a name. For many years, roughly from the end of 1919 to 1931, I interpreted most of my works. Often the interpretation was more important to me than the work itself. Often it was hard to render in the content of rational words. . . . These titles were often abbreviated little stories such as this one from "Mountain-Table-Anchors-Navel" in my book *Unsern täglichen Traum* (*Our Daily Dream*): "A dreamer can make eggs as big as houses dance, bundle up flashes of lightning, and make an enormous mountain, dreaming of a navel and two anchors, hover over a poor enfeebled table that looks like the mummy of a goat."[17]

The collaborative process whereby the surrealist artist consciously modifies the gifts of chance is exemplified in pictorial techniques aimed first at soliciting the intervention of chance and then at elaborating upon its precious revelations. There are techniques like fumage, grattage, coulage (the method of dripping paint over a canvas which, since its invention by Max Ernst, has made the fortune of more than one abstract expressionist), and écrémage—skimming a sheet of paper

[16] Jean Arp, response cited in Charles Estienne and José Pierre, "Situation de la peinture en 1954," p. 49.
[17] Jean Arp, "Looking," in James Thrall Soby, *Arp*, p. 14.

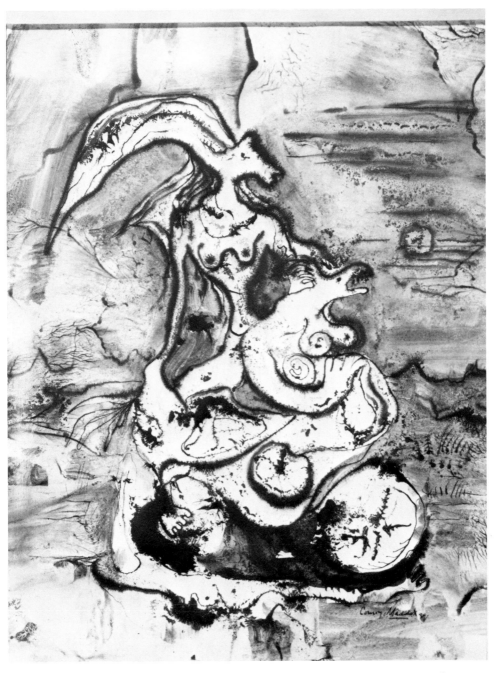

Conroy Maddox, *Figure*. 1939. Ecrémage. Collection J. H. and
Jeanne Matthews.

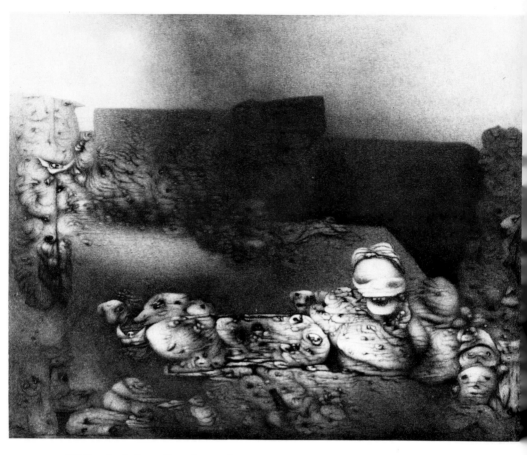

Richard Oelze, *Burial Celebration*. 1972. Oil on canvas. Private Collection.

over the surface of water on which gouache has been poured. Here the mechanical nature of the initial stages of creation, during which no part is played by private feelings, thoughts, or beliefs, is treated as a prerequisite. It clears out of the creative personality everything likely to subject the eventual image to dependence upon past ideas, associations, and discoveries, or upon methodological habit or esthetic routine. Surrealists look to nonreflective means that call chance into play in shortcircuiting the current flowing from past experience.

Eliminating *tics* (abhorred by Lautréamont) and guarding against the dangers of falling into stereotypes (against which the *Manifesto of Surrealism* forewarned), the mechanical means the surrealist relies upon to lead him off in search of images not yet perceptible in consciousness are expected to have a liberative effect. The work method finding most favor among surrealists for whom chance is a spur to inspiration presents an analogy with that of automatic writing, as its use is recommended in the first surrealist manifesto. Here Breton writes that, should the flow of words be interrupted for any cause, the automatist has only to start again with a word, any word, beginning with a letter selected at random, and *in advance*. The surrealist painter asks of the mechanical means in which he places his trust a point of departure tantalizingly furnished by chance for the pictorial investigation on which he is about to embark.

The investigative process lends itself to discussion most readily perhaps when we limit our attention to surrealist pictorial art or to the creation of surrealist objects. Yet the underlying motivation appears no different, when we examine certain comparable forms of linguistic experimentation. Now we observe interplay between chance—manifest largely in the choice of materials to be subjected to dissection and rearrangement—and disruptive intent. Taking these materials out of their normal context, the latter relocates them in unfamiliar surroundings, creating unwonted relationships. And it does so the better to examine their capacity for revelatory modification. This is certainly the case with Paul Nougé's verbal collages. As with word collage we have met before, imagery is elicited here by dislocation of phrases, borrowed this time from classic writers like Guy de Maupassant.

Why mention at this point Nougé's experiments *Quelques Ecrits et quelques dessins* (published under the name of Clarisse Juranville, whose book on French grammar furnished him with material for verbal collage)? The reason is that Nougé's ideas on the poetic creative act as an essentially intellectual process indicates something

quite definite. In his writings we face collage utilizing elements arranged carefully, not at random, and to disconcerting effect.[18]

An unpretentious but noteworthy parallel approach is cited by Gérard Legrand:

> One of my friends, Jean-Claude Silbermann, has had the idea of taking prospectuses, instructions for using detergents and other products, and of simply replacing the name of the product with a word that has deep resonance, of the type *mystery, death,* or *spring,* and of seeing what that would give if one followed through completely. One arrives immediately at a remarkable poem at the cost of just a little touching up, and there it's really language itself that continues under its own impetus, since the syntax of the sentence is respected, and even the general articulation of the text, which retains its appearance of publicity while yet dynamiting it.[19]

Silbermann's idea is less original than Legrand appears to believe. As early as 1944 Hans Bellmer's *3 tableaux, 7 dessins, 1 texte* offered a passage where advice to dressmakers intermingled with instructions to surgeons. Even more remarkable is the following section:

> Lightly scoop up a foot, without rolling it, into one heap; if it is already too soft to be scooped up by hand, gather it with the blade of a knife, and knock each new part off on a piece of lace so it sticks there. As soon as it has been brought together this way, lay everything on a stool sprinkled with ground straw and let it warm to allow it to mature and recover in its own time for a couple of hours, if possible.

Taking as his source a cookbook, *Recette de cuisine pratique* by G. Shéfer and F. François (Paris, 1942), Bellmer substituted *pied* (foot) for *pâte* (pastry) and then went on to devise a recipe that would have surprised Mme François's students at the Cours normal d'enseignement ménager de la Ville de Paris, but hardly surprising to someone acquainted with Bellmer's graphic work.

Employing more complex means than those proposed by Silbermann, Bellmer made it clear that dynamiting language, as Gérard Legrand speaks of it, gives the surrealist something far more valuable in his estimation than the mere satisfaction of negation. In fact, it is

[18] More details on Nougé's use of collage in the context of his poetic theories will be found in J. H. Matthews, *Toward the Poetics of Surrealism,* pp. 118–20.
[19] See Alquié, *Entretiens sur le surréalisme,* p. 26.

important to him so far as he finds positive value in it, affecting the supposedly quite innocuous means of verbal immediate exchange in a manner that promises enrichment of man's powers of enunciation. In *l'un dans l'autre* surrealists examine the feasibility of the idea that one thing can be contained in another. In a word game of quite a different kind, they subject language to scrutiny in order to raise a question that takes special significance from the general orientation of surrealist thought. Can a noun commonly treated as the verbal identifier of only one object be seen to carry within it an image, standing at some distance from generally accepted sense, that imagination is capable of spanning while reasonable thinking is compelled to admit defeat?

This question was posed implicitly by Antonin Artaud when, in the third number of *La Révolution surréaliste* (April 15, 1925), he introduced some experiments with language conducted by Michel Leiris and himself, to which the title "Glossaire: j'y serre mes gloses" had been given: "Dissecting the words we love, without bothering to follow either etymology or agreed signification, we discover their most hidden virtues and the secret ramifications that spread throughout all language, canalized by associations of sound, form and idea. Then language is transformed into an oracle and we have here (however slender it may be) a thread to guide us through the Babel of our minds." The characteristic bias of surrealist thought, identifying rationalist procedures with confusion, frustration, and the collapse of human aspiration, here becomes aggressively assertive. The results obtained by Leiris can be seen in *Glossaire: j'y serre mes gloses,* finally published in book form in 1939.

In surrealism a strong tradition of word play, aimed at putting rationally sequential thought to flight and at administering words a much-needed jolt, has not ceased to stimulate verbal experimentation. The latter testifies to a new awareness of language, born of healthy mistrust of its conventional processes. The influence of Marcel Duchamp is all-pervasive. Robert Desnos practiced his elaborate puns under the name Duchamp had devised for himself, Rrose Sélavy—an indication of the pride surrealists have taken in acknowledging that influence. However, the mechanism of Leiris' play with words has more in common with that of Brisset's than of Duchamp's. The words upon which Leiris draws have no poetic aura in everyday exchange, where their role is merely to occupy the place allocated them by reason during the communication of pedestrian ideas. In a significant number of instances, in fact, the words brought to his attention by chance refer in day-to-day usage to objects concretely evoked (shoulders, legs, and so on). Even when he turns to predominantly abstract

terms he does not speak of ephemeral or elusive states of mind, suggestive because largely indefinable. He talks, rather, of things that find expression in ways everyone can recognize: crime, for instance, or passion. His purpose here is not to take advantage of ambiguity or vagueness. Instead, he wants to rock the stability certain words are commonly assumed to guarantee the rational thoughts they help communicate.

Ignoring etymology is the first step taken in pursuit of an interpretation that is free, evidently, to draw inspiration more from sound than from sense. The two syllables of *cerveau* form the basis of new words, *cercueil* and *renouveau*. In this way, the brain can be defined as "*cercueil de verre, sans renouveau*" ("coffin of glass, without renewal"). This quite mechanical procedure interestingly transposes agreed signification by means of an image that removes the patina laid on words by repeated use: *épaule* yielding two syllables—*pôles* and (modified somewhat) *ailes*—gives *pôles des ailes disparues*. Hence, shoulders become "poles of disappeared wings." The mystery of creation under impetus from chance deepens, as Leiris interprets the sounds he hears. A crime is (and not merely is like) a mine of cries, when *crime* gives *une mine de cris*. Dust is said to grow between the talons of light or—we must not allow ourselves to fall into the error of translating, from habit, in the manner least offensive to reason—between the greenhouses of light: *Poussière: elle pousse entre les serres de la lumière.*

For Leiris the word becomes an object, to be analyzed and rearranged at the instigation of extrarational forces. These are the very forces underlying poetic analogy, as understood in surrealism. Desire comes into play, to defy a sense of order in which surrealists see no cause for placing any trust. Creative play, at once relaxing and enlighteningly stimulating to the imagination, then treats nature just as Baudelaire wished to do, as a decipherable cryptogram, yet declines to employ reason as the key to the cipher. It gives weight to a typical surrealist argument: everything that exists objectively is surrounded by an ever-widening circle of possibilities which imagination has the privilege or even the obligation to explore. Play corrects a hostile universe, as Benjamin Péret insisted that poetry always must.

The images for which we are indebted to Michel Leiris illustrate the operation of imagination in creating objects without any counterpart in external reality. Other surrealists have not been content to let imagination bend nature to desire in the mind only. They have sought to place before their public objective creations that function as veritable object lessons.

OBJECT LESSONS

P AUL NOUGÉ might have been speaking for all the surrealists whose activities we have just been considering when, in a letter to René Magritte reproduced in *Histoire de ne pas rire,* he defined the essential problem of painting and poetry: "It's a matter of getting chance on one's side by going by *calculation* as far as calculation can take us. Then begins the adventure that is to compromise us as it compromises those to whom we address ourselves" (p. 218). We can be sure that Magritte, certainly, was in full agreement with Nougé's theories about the benefits of intentionality, to an artist reaching out for revelatory images. Magritte himself identified imagination with intelligence. He spoke of an intelligence that has divested itself of "the finical will" that imposes meanings on things so they may be *used*—that is, of course, submitted to the utilitarian principle, domesticated, in other words. Intelligence, Magritte demonstrated time after time, is "the friend of the enigmatic and marvelous light that comes from the world." He saw its essential role as celebration of "the unforeseen advent of a poetic image."[1]

When Magritte worked, the role of intelligence was never played out fully until the painted image finally had received its title. In *Histoire de ne pas rire* Nougé explains:

> With Magritte, titles play an important role, that is not the one we should be tempted to imagine. The title is not a program to be filled. It comes after the picture. It is so to speak its confirmation and often constitutes an exemplary manifestation of the efficacy with which the image is endowed. This is why it is immaterial whether this image

[1] Cited in Gérard Legrand, "De l'Analogie comme pensée absolue chez Lautréamont," *L'Archibras,* No. 7 (March 1969), p. 1.

Marcel Mariën, *The Object*. 1969.
Découpage. Collection Christian Bussy,
Brussels.

Tatsuo Ikeda, *The Eyeball of Vigilance*.
1976. Silk screen. Collection of the artist.

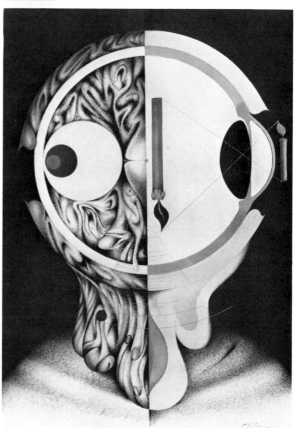

is born after the event in the mind of the painter himself or in some other head, up to the level of that painting. I am fairly well placed to know that it is almost never Magritte himself who invents the titles of his canvases. His painting could do without titles and so people have been able to write that the title constituted, all in all, only a conversational convenience. But if it does without titles and suffers no loss, this is on condition it is in contact with minds of a certain quality. Face to face with others, the title prevents the painting it protects from being drawn into lowly places not its own. (pp. 250–51)

Magritte himself has expanded on Nougé's statement in a remark quoted by Waldberg: "The titles are chosen in such a way that they prevent my pictures from being situated in a familiar region, which automatism of thought would not fail to evoke, to save itself from uneasiness. The titles then must be an added protection that will discourage all attempts to reduce poetry to a game without consequence" (p. 169). Despite the hint of confusion introduced by mention of automatism in a nonsurrealist sense, Magritte's meaning is clear enough: his titles were chosen with the express purpose of inculcating "a justifiable mistrust in any tendency the spectator might have to over-ready self-assurance."[2] The whole purpose behind the selection process was to treat the image represented on canvas in a manner that would guarantee its poetic virtue, in a way complementing the one by which Michel Leiris searched for the poetic image implicit in this word or that. The picture-object took its place beside the concept-object, as Magritte refused to allow the significance of his picture to be limited by what it seemed to depict.

In "Genèse et perspective artistiques du surréalisme" André Breton comments: "The approach of Magritte, nonautomatic but on the contrary fully deliberate, buttresses . . . surrealism. The only one having this tendency, he has overflowed painting in the spirit of "object lessons" and, from this angle, has worked up a systematic case against the visual image of which he has taken pleasure in underlining

[2] René Magritte, "La Ligne de vie," cited by Lucy Lippard, *Surrealists on Art*, p. 159. Asked on one occasion what he understood by "inspired thought," Magritte responded, "Well, then, it's a thought that unites visible things in such a way that mystery is called forth. An example is a nocturnal landscape under a sunny sky." See René Magritte, *Deux Entretiens*, Brussels: Les Lèvres Nues, 'Le Fait accompli' No. 108–109 (March 1974); from a radio interview conducted by Jean Neyens in January 1965. Magritte specified that the form of mystery he found interesting was by definition inexplicable. *Cf. Histoire de ne pas rire*, where Nougé speaks of the appropriate use of visible elements to encompass the invisible (p. 212).

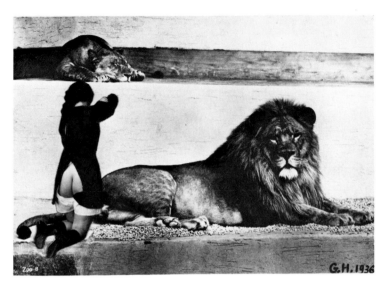

Georges Hugnet, Untitled 1936. Photomontage. Collection
Timothy Baum, New York. Photo Nathan Rabin.

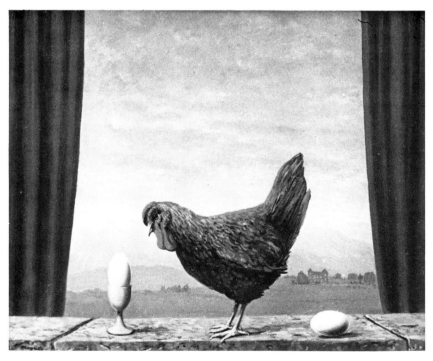

René Magritte, *Variant on Sadness*. 1955. Oil on canvas.

the weaknesses and stressing the dependent character in figures of language and thought" (p. 72). Before Magritte's painting can be given the attention it deserves, we must look more closely at Breton's term "object lessons." Awareness of the importance of this phrase, as surrealism authorizes its use, escapes us only too easily if we do not pause to consider how and why the surrealists became interested in creating and circulating objects of a distinctive kind, without precedent in the world of familiar experience and for which a special function is reserved.

Marcel Brion writes soberly, "One of the great merits of contemporary Surrealism is to have brought the *subject* back into honor, at a time when, since Impressionism especially, the sole preoccupation of the artist was with pictorial values and the plastic values of the work of art" (p. 224). With rehabilitation of subject matter came renewed interest in material objects, examined now for themselves, not treated as excuses for experiments with form and color. Early in the 1928 edition of *Le Surréalisme et la peinture* Breton reminisces:

> I remember a very empty time (it was between 1919 and 20) when all sorts of common objects, deliberately contradicted in their meaning, their application, rejected from memory and as though copied from themselves, were ceaselessly being born to several existences and dying, existences in which the words that up until then had served to designate them no longer seemed adequate, in which the properties they were generally granted obviously were no longer theirs, in which a pessimistic will to control, which some people will judge absurd, demanded that something it suffices to characterize by sight be touched, that an effort be made to perceive in the smallest detail something asking to present itself only as a whole, that it be no longer possible to distinguish the necessary from the accidental. *That* was, not only on my part but on the part of some others, a profound disposition and it is perhaps this disposition that has brought me to the point where I am today. (p. 21)

The title of an article Breton wrote in 1936 under the title "Crise de l'objet" makes one thing quite plain. The surrealists' interest in objects proves their continued preoccupation, throughout the thirties,

with the "crisis of consciousness" which, according to surrealist theory, has become acute in our time. The attention given to things in surrealism, to material objects—and especially those modified or actually devised by surrealists themselves—takes on its full significance only in relation to twentieth-century man's crisis of consciousness. The authentic surrealist object is born of its creator's readiness to let "things think for him," just as Mayoux does in one of his poems. "Poets and artists," we read in "Crise de l'object," reprinted in *Le Surréalisme et la peinture*, "meet with men of science at the center of those 'force fields' created in the imagination by the coming together [*rapprochement*] of two different images. This faculty for bringing the two images together permits them to rise above consideration of the manifest life of the object, which generally constitutes a boundary mark. Before their eyes, on the contrary, this object, however complete it may be, goes back to being an uninterrupted succession of *latencies* which are not peculiar to it and call for its transformation" (p. 279). A year before, Breton had reaffirmed in "Situation surréaliste de l'objet" a conviction voiced in Brussels the year before that: only examination of surrealist experiments with objects can "make it possible to grasp in all its scope the present-day attempt of surrealism" (p. 306).

In the way that contemporary physics tends to rest on non-Euclidian bases so, we are informed in "Crise de l'objet," the creation of surrealist objects "answers the need to found, according to the decisive expression of Paul Eluard, a veritable 'physics of poetry'" (p. 279). Seen in this perspective, the surrealist sculpture of Arp and Giacometti, like the architecture of Gaudi and the "ideal palace" built by the mailman Cheval, confirms "the irrepressible human need" to extend to the arts, as Breton puts it in "Situation surréaliste de l'objet," "that which was considered for a long time the prerogative of poetry." This need, Breton was convinced, would overcome soon "the routine resistance that tries to conceal itself behind the demands claimed for utility" (pp. 313–14).

These statements of Breton's send us back to the very question he raised when distinguishing the necessary from the accidental. According to surrealist doctrine, necessity is not to be assessed in terms imposed by utilitarian principles. All surrealists tend to identify necessity far less with practical utility than with fulfillment of man's inner needs. It is to the latter, certainly, that surrealist objects correspond most closely. For surrealist necessity takes definition through the object. Posing the question of functionality, the surrealist object leaves

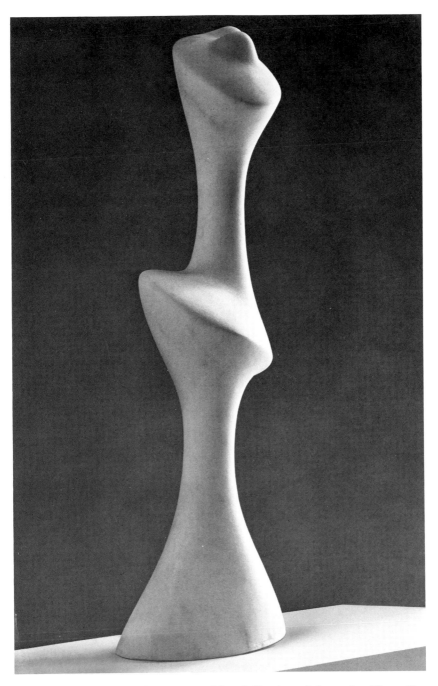

Augustin Cárdenas, *Girl*. 1972. Marble. Collection of the artist. Photo Cav.
I. Bess.

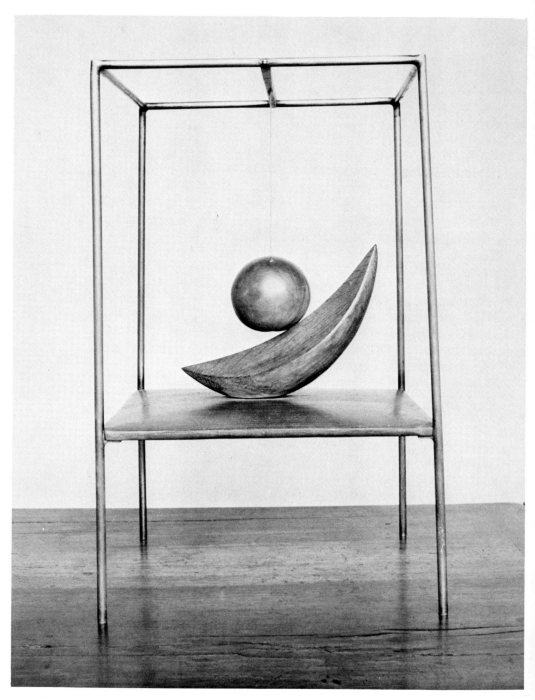

Alberto Giacometti, *The Hour of the Traces*. 1930. Object.

us asking about a form of necessity having other bases than those rooted in the demands of day-to-day living. In the first issue of *La Révolution surréaliste* Louis Aragon spoke of that "mysterious point" where "*pure invention* is called forth neither by the use reserved for it in the future, nor by a meditative necessity, but where invention appears, is perceived, arises." In other words, invention is "a new relationship," or again "a delirium that turns a little later into reality" (pp. 22–23). In their preface to *La Révolution surréaliste*, J.-A. Boiffard, Paul Eluard, and Roger Vitrac agreed completely: "Any discovery changing the nature, the destination of an object or of a phenomenon constitutes a surrealist fact" (p. 2).

Not surprisingly, these are among the important points we are asked to bear in mind when approaching surrealist objects, so as to be sure not to misjudge their value. In "Crise de l'objet" Breton argues that "poetic objects" find their value in something quite different from "their plastic qualities." If they happen to satisfy some people's esthetic demands, "it would be no less an error to try to appreciate them in those terms." In this respect, the surrealist object is directly comparable to the mathematical object. Both have come into existence to do more than simply appeal to our esthetic sense. Breton elaborates:

> When, for example, in 1924, I proposed the manufacture and circulation of objects that have appeared in dreams, bringing these objects into concrete existence, despite the unwonted aspect they were able to assume, really was envisaged as a means rather than as an end. True, I was ready to expect from the multiplication of such objects a depreciation of those whose *agreed usefulness* (though often contestable) encumbers the so-called real world; this depreciation seemed to me very particularly of a nature to unleash the *powers of invention* which, at the end of all we can know of dreams, would have been magnified by contact with objects of oneiric origin, veritable solidified desires. But above and beyond the creation of such objects, the aim I was pursuing was nothing less than objectification of the activity of dreaming, its passage into reality. (p. 277)

Surrealist objects express the essential ambitions of surrealism. They reflect the fundamental needs surrealist artists hope to meet through the creative process.

In February 1939 the tenth number of *London Bulletin* carried a photograph of Paalen's *Nuage articulé* an articulated cloud made in

1937 in the form of a sponge umbrella. Beneath appeared, in French, the legend: "A sponge umbrella, anticipating another umbrella that has become regrettably famous." Allusions to sociopolitical life like this one (Neville Chamberlain's fetish object, the rolled umbrella, brought him little success in Munich in 1938) are of the utmost rarity in the surrealists' comments on poetic objects. The surrealist object is born of abiding concerns far deeper than those generated by historical circumstance.

Objects created earlier under Dada influence frequently had incorporated antiartistic and even ephemeral material. The latter, especially, could be relied upon to invalidate the product of esthetic vanity, as it brought about the inevitable decay and collapse of the Dada object. But not content with merely challenging the exalted status of art forms, the surrealists went further. They were more than ready to ignore form, to bypass it out of concern for matters they considered more urgent. Thus it was not their purpose to harp on the impermanence of art, a recurrent theme of Dada. Instead, they set themselves outside artistic preoccupation altogether, rejecting in the process the mode of respectability to which artistry normally aspires. Their objects are not meant to be assimilated by art in the way that, ironically, so much surviving from Dada has fallen under assimilation. On the contrary, surrealist objects serve to deny art's assimilative tendency, while yet doing so incidentally to achieving their primary purpose. This is because they reflect a profoundly serious motivation— serious, very often, in the humorous forms through which it manifests itself—an extra-artistic motivation that Dada, in its skepticism, always lacked.

It is on the level of motivation that we most appropriately can draw a line between Dada and surrealism. For on the plane of technique surrealism often appears quite willing to prolong Dada. So ready do surrealists seem to follow the example set by the Dadaists, on occasion, that one has the impression, here and there, that we ought to be speaking of continuity, not contrast. We are tempted to consider surrealism an evolved form of Dada, "the French form of Dada" to which Michel Sanouillet refers in his *Dada à Paris*. Important differences become visible, really, only when we take note of the surrealists' determination to question certain preconceptions, to resist certain habits. This determination lends surrealist objects a value the objects of Dada were denied by its persistent and somewhat self-indulgent negativity. It helps us detect a significant cause of confusion regarding the exact location of the dividing line between Dada and surrealism.

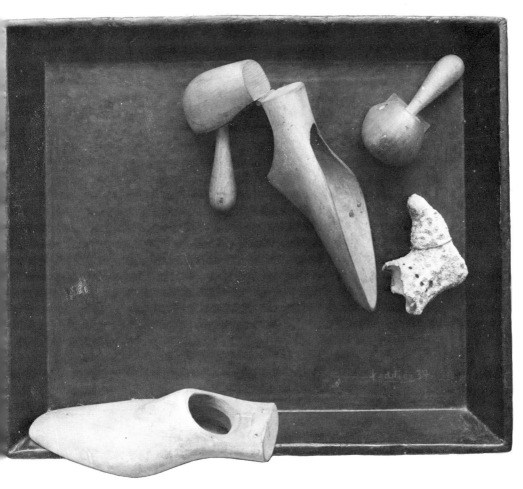

Wilhelm Freddie, *Mrs Simpson's Pink Shoes.* 1937. Object. Fyns Stifts Kunstmuseum, Odense. Photo Jørn Freddie. The following text by Freddie accompanies this object: "Mrs Simpson's pink shoes woven from blossoming thyme were traveling all alone on the Paris-Lyons-Marseilles line. To think that the choral groups in the small garrison towns were playing 'La Madelon' would be to profane the solemn mission of the pink shoes. The Eiffel Tower, Buckingham Palace and the Statue of Liberty hummed the heroic tune that was making all the watches in the world stop."

Although Man Ray's *Cadeau* (*Gift*)—a flatiron with nails projecting from the bottom—was made in 1921, during the period when he was active in Dada, Breton had no hesitation later in classifying it among the surrealist objects. The flatiron communicates the destructive message of Dada, naturally. More than this, though, the artist's interference has liberated an everyday object from the confinement of its agreed utilitarian function. The iron now elicits wonder, bred by the *insolite*. For the latter is capable of engaging the imagination in rationally uncontrolled speculation, once reason has been obliged to confess its inability to identify the use to which this flatiron can be put. "Matter conquered or deformed in the utensil," Paz remarks pertinently in *El arco y la lira*, "recovers its splendor in the work of art. The poetic operation is the reverse of technical manipulation." Hence, to Paz's mind, "Nothing precludes our regarding plastic or musical works as poems," if they are able to meet two conditions: deny "the world of utility" and undergo transformation into images, "thus to become a peculiar form of communication" (p. 12).

To be sure, we must take care not to let ourselves be misled by talk of motivation, here. Authentication of the surrealist object does not come with approval of conscious intentions alone. It may be related directly to deep-seated impulses, fashioning the object while the artist's critical faculties are held in suspense. Arp implies as much in an essay on collage from his *Jours effeuillés:* "The figures of this visible world that surrounds me and used to force me from time to time to erect monuments to neckties, navels, torsos, moustaches, dolls, established the link with my poetry and the surrealist poets, my friends" (p. 421).

Appositely referring once again to the *latencies* mentioned in *Le Surréalisme et la peinture,* Breton takes their explanation a stage further in this text from *Yves Tanguy:* "Up to Tanguy the object, to whatever assault from outside it was submitted, remained in the final analysis distinct, and a prisoner to its identity. With him we enter for the first time a world of total latency: 'In any case, nothing of actual appearances,' Rimbaud promised" (p. 36).

At one end of the figurative scale is the found object, the precious gift of chance, fully satisfying in the form under which it claims and holds the surrealist's attention. At the other is the painted canvas, or even—in some instances—the verbal poem. The trajectory of surrealist endeavor ranges from grateful acceptance of certain things *as they are* (especially, like the mask found in the flea market that helped Giacometti complete the features of a sculpted standing figure,

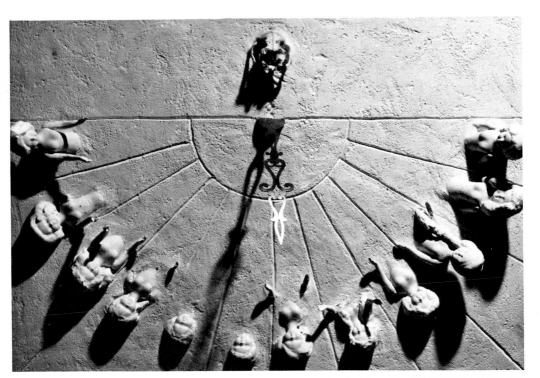

Micheline Bounoure, *Camera Obscura*. 1962. Object. Private Collection, France. Photo Vincent Bounoure.

Yves Tanguy, Untitled Gouache. Private Collection, France.

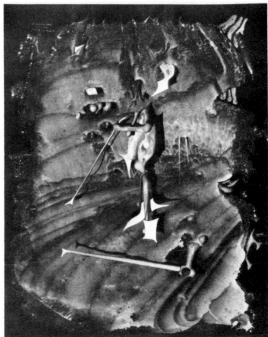

things having a use that eludes rational identification) to objects imaginatively devised and created under impetus from forces by no means clearly comprehensible. The incontestable triumph of which Breton boasted in his "Situation du surréalisme entre les deux guerres"—that of the art of imagination and creation over the art of imitation—embraces special sensitivity to objects serving as *concretions* (the word is Arp's, used to describe some of his own creations) of desire. In fact, objects assume a particular responsibility in the surrealists' never-ending struggle against the art of imitation.

The surrealist object gives form to vigorous protest against artistic assumptions and predispositions. Borrowing as he does from the material world, taking either familiar natural elements or objects manufactured for everyday or technological use, and then bending these to his own purposes, the surrealist implicates external reality in the projection of his private dreams. And he does this even when not quite cognizant of his own purposes or fully conscious of what his dreams are. José Pierre concludes in *Le Surréalisme* that the surrealist object and poem-object come about "in relation to the forms and functions of nature, to the creative approach of the insane and of South Sea Island or American primitives: one would be therefore in a position to judge them more specifically surrealist than painting properly so called" (p. 55).

The Dada object reflected an ironic posture before the consecrated forms of art. The surrealist object differs significantly in this respect. It stands for a mysterious relationship with the outer world established by man's sensibility in a way that involves concrete forms in projecting the artist's inner model. For this reason, when discussing wholly invented objects and also those that modify whatever nature has provided, Pierre feels entitled to speak of symbolic automatism. Here, naturally, "objects functioning symbolically" are of prime importance in casting light on objective chance, operating beyond the range of reason. The object therefore frequently exemplifies the happy conjunction of natural necessity and human necessity. So Breton declares, in "Crise de l'objet," "Any stray object to hand must be considered as a precipitate of our desire."

Now the enlightening encounter escapes esthetic associations, such as the practice of collage cannot banish entirely. It is situated in the mind of the spectator witnessing through his own response the

emergence of a link between the inner world and the outer world. Naturally, then, the so-called artifacts of primitive peoples do not interest surrealists as art. In an enthusiastic preface to a 1948 Paris exhibition titled "Océanie," reproduced in *La Clé des champs*, Breton exclaimed, "Oceania. . . what prestige will that word have enjoyed in surrealism! It will have been one of the great lock-gates of our hearts" (p. 179). He identified the art of the South Seas with "the poetic (surrealist) view of things" and with "the greatest immemorial effort to give an account of the interpenetration of the physical and the mental, so as to triumph over the dualism of perception and representation, so as not to be content with the bark but to go in to the sap."

In *Le Surréalisme* José Pierre aims beyond praise to appraisal: "The spring of metaphor, wound tight in the work of Lautréamont, Rimbaud, or Saint-Pol-Roux, finds itself for the first time an equivalent among the plastic arts in the profusion of New Ireland *malangan*, the dizzying spiral constructions of the Trobriand Isles, the perpetual mutations of the Sepik" (p. 13). Surrealists unhesitatingly respond without mental reservation to the sight of the metaphorical principle exemplified in the mutant forms produced by imaginative play in so-called primitive societies, where forms borrowed from nature are submitted to modification under the compelling influence of dream, respect, love, and desire. They look upon the primitive artist as having set an example they are more than willing to emulate and indeed already have begun following. Hence these observations by Vincent Bounoure:

> Never were the totemist peoples afflicted with this near-sightedness which makes us see the only reality compatible with technical use. For them, as is the case in critical-paranoiac activities, there is no reality that is not ready to slip toward another and more revealing one. Perhaps it is given to sculpture to bring us some confirmation of this. But, whether the aim is ritual or not, what matters most is to witness the very objectization of a certain daily behaviour which has never ceased being that of Surrealism.[3]

"At the point where we now stand," Breton remarks in *Le Surréalisme et la peinture,* "the poet or artist could not qualify, or lay

[3] Vincent Bounoure, "Surrealism and the Savage Heart," in the catalog *Surrealist Intrusion in the Enchanters' Domain*, p. 28. French text subsequently published in *L'Archibras*, No. 2 (October 1967), 4–7.

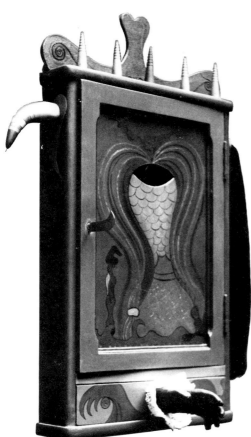

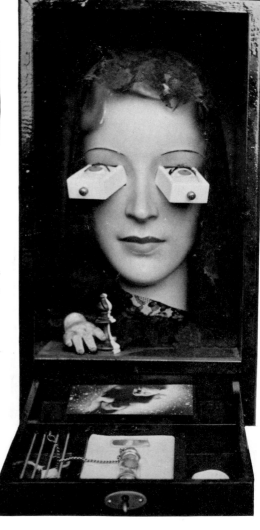

Jorge Camacho, *Sovereign*. 1965. Object-Painting. Collection of the artist. Photo Marc Lavillier.

Her de Vries, *Without One Ever Knowing Why*. 1963. Object. Collection of the artist.

claim to durable gratitude, except so far as he has risen up against the
specific forms assumed nowadays by alienation, in the nonclinical
sense of the term" (p. 407). The respect participants in surrealism
show the art of the insane testifies to their disagreement with society's
judgment on the subject of alienation. Their open letter to the directors
of mental institutions is a well-known document from the twenties.
Paying tribute to Antonin Artaud—the man who drafted that broad-
side and who subsequently was to spend so many years confined as
mentally deranged—Breton wrote in December 1959 an article to be
found in *Perspective cavalière*. Here we read, "There could not be,
for poetry, any other dangers than banality and universal consent"
(p. 171).

In a 1927 letter to René Magritte published in *Histoire de ne pas
rire,* Paul Nougé wrote:

> What at once puts off the judgment of the vulgar herd on mad
> people and ourselves is this very general way of supposing that *our*
> main concern is to *represent* some spectacle we think exists outside us
> or some thought whose existence we believe we note within us. And
> if one can admit this to be the real concern of the mad and that the
> incoherence of their representations with respect to habitual representa-
> tions is to be explained by madness, we know very well, my dear
> friend, that it's quite different with our approach and that with us it's
> a matter of inventing a universe and not of describing it. (p. 220)

It was only to be expected that Nougé's intellectualism would lead
him to express considerable caution. It remains clear all the same that
surrealists must feel they have more to learn about the purposes of
art from the insane than from the Impressionist painter, shall we say,
or the Symbolist poet. The distance is certainly greater from the latter
than from *l'art fou* to the poem-objects invented by André Breton in
1929 and later.

The poem-object compares favorably, too, with the sculpted
forms and fetishes from primitive societies that fire the surrealists'
imagination. The definition of poem-objects Breton furnished suggests
that they have a potentially wide and stimulating application. A
poem-object "consists in incorporating into a poem everyday objects
or objects of a different kind, more exactly in composing a poem in
which visual elements find a place between the words without ever
duplicating them." The odd thing is that Breton himself was prac-
tically alone in exploring the possibilities of poem-objects. One might

have expected wider interest among the surrealists. For poem-objects participate actively in removing the barrier set up by tradition and maintained in an excellent state of repair, to separate poetry from the plastic arts. And this is the very barrier surrealists saw from the beginning as a major obstacle to full expression of poetry in its broadest sense.

The poem-object offers a valuable object lesson indeed. It presents in combination—and Breton made it clear that it is imperative for each of these creations be a unified entity in which the constituent elements are not, so to speak, forced to take their place against their will—words and forms that come together to make neither a verbal poem nor a piece of sculpture, but a new poetic phenomenon. The latter communicates its message plainly only when we have succeeded in surmounting the prejudice that, in the past, has persuaded us to believe words call for appreciation of one sort while forms demand another.

Poem-objects and certain primitive stone and wood carvings have something in common. Their origins may be traced to the operation of a distinctive metaphorical principle. Among surrealists, this is commonly called the analogical principle. It is the very one that lends significance to other surrealist objects, concretely presented three-dimensionally for our examination, or imaged on the painted canvas.

The special contribution made by Dalí to the surrealist concept of the reality of things is this. His paranoiac-critical method vigorously affirmed the polyvalent function of visible forms. "L'Ane pourrissant" reduced natural inclination to theory, when it stated that the number of images visible to us is limited only by "the mind's degree of paranoiac capacity" (p. 98).

During the thirties, the very exaggeration of Dalí's claim made the surrealists listen attentively. They were ready to approve the general trend of his theory, even if not quite willing to agree with its systematic application. What really mattered to them, and would continue to do so after Dalí's exclusion from their company, was this. Poetic objects test our sense of what is real, of what makes objective phenomena real to us. It is of no moment that, in the end, treatment of the concrete materialization of dreams may lead somewhere different from the self-serving arguments expounded in "L'Ane pourrissant." Dalí, after all, departed in some important respects from the

André Breton, Poem-Object. 1934. The poem reads:
> The automobile torrent of sugar candy
> Collides with a long vegetal shiver
> Thrashing [currycombing/fleecing] debris
> of Corinthian style.

Collection Timothy Baum, New York. Photo Nathan Rabin.

surrealist standpoint. He opposed to objective reality "the intensity and traumatic nature of things," denying "interpenetration between reality and image," and asserting "the (poetic) impossibility of any kind of *comparison*," on the grounds that such a comparison, if it could be made tangible, "would clearly illustrate our notion of the arbitrary" (p. 99). Yet the arbitrary has no meaning in surrealism, except as a false impression that inevitably must give way to a more rewarding sense in which apparently unrelated elements and conflicting factors become excitingly one.

The whole purpose behind surrealism's treatment of physical reality is to surmount the debilitating sense of the arbitrary and to project, in its place, a refreshing feeling of unity, in which the inner existence of consciousness and outer reality are no longer in conflict. If this were not so, then the opening lines of Breton's article "Signe ascendant" and all that come after would be harder to understand: "I have never experienced intellectual pleasure except on the analogical plane. For me the only *evidence* in the world is governed by the spontaneous, extralucid, insolent relationship that is established, under certain conditions, between this thing and that, which common sense would hold us back from bringing face to face." Fundamentally it matters little whether, as here in *La Clé des champs* (p. 112), Breton is speaking of verbal poetry or whether, in "Situation de la peinture en 1954," Wolfgang Paalen is assessing painting. What Paalen has to tell us sheds light on the surrealist object, just as Breton does, from the angle of analogical play:

> To exalt the joy of the virgin glance.
> To discover the potential prolongations of things through affective cognition, which, by analogy, I call their intra- and ultra-forms. (p. 46)

The important thing is that, as Breton demonstrated toward the end of his life while introducing an exhibition by Jean-Claude Silbermann, surrealists consider the analogical mechanism to be inherent in man, offering him the only means available, deep inside himself, for finding his bearings and making progress.[4] Reprinted in *Le Surréalisme et la peinture*, this essay on Silbermann "A ce prix," declares that the analogical process responds to "an organic exigency in man," demand-

[4] See André Breton, interview granted Guy Dumur in *Le Nouvel Observateur*, where the introduction to the catalog of the Silbermann show is discussed. *Cf. Perspective cavalière*, p. 234.

ing to be neither held in suspicion nor restrained but, "quite to the contrary, stimulated" (p. 407). Surrealists never stop being in full agreement about this. "Everything is comparable to everything else," declares Eluard in *Donner à voir*, "everything finds its echo, its reason, its resemblance, its opposition, its development everywhere. And this development is infinite" (p. 134).

As Breton's 1945 essay on Gorky stresses, surrealists are convinced the key to the mental prison can be found through defiance of customary modes of cognition, which Breton himself dismissed as "ridiculous." It is to be found, Breton intimates, in the "free and limitless play of *analogies*." Thus Gorky's celebrated painting *Le Foie est la crête du coq* can be regarded as "the great door open upon the analogical world."

When we look at *Le Foie est la crête du coq* reason's defense mechanism, triggered by an appeal to the title to explain the forms assembled under Gorky's brush, is rendered inoperative. A conscientious search for the liver and the cock's comb promised in the title can identify neither—independently or the one in or as the other. Nor does reconciliation with commonsense expectations come from the text in which the painter describes *The Liver is the Cock's Comb:* "The song of a cardinal, liver, mirrors that have not caught reflections, the aggressively heraldic branches, the saliva of the hungry man whose face is painted with white chalk." The dissatisfaction that prompts Rubin to dismiss this puzzling description as "pretentious" (p. 402) betrays an instinct for itemization. Apparently, Rubin believes a painting's title must provide a catalog of constituent pictorial forms.

What a contrast between such an assumption and the outlook of René Magritte, reflected in a letter to Paul Nougé:

> I've done two canvases up to now, here are their titles and what I can say of them, (this is an unobjective description, but is I think a sort of equivalent)
>
> *A Walk in the River.*—A few companions had spoken too much near the violet water. The band, filled with panic, run off and I've found myself incapable of following them. I entered the water, which became luminous at the bottom; distant fern could be made out well enough. Other obscure plants were kept from rising to the surface by their reflection. Red streaks took on every form at the whim of invisible, no doubt violent currents. A woman made of plaster, as she moved forward, made me make a movement that was to take me far.
>
> *The Legs of the Sky.*—The floor lit by the moon, which one knows

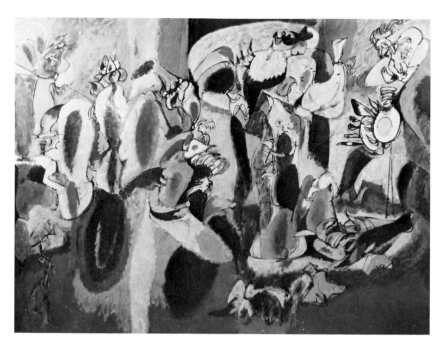

Arshile Gorky, *The Liver is the Cock's Comb*. 1944. Oil on canvas. Albright-Knox Art Gallery, Buffalo, N.Y.

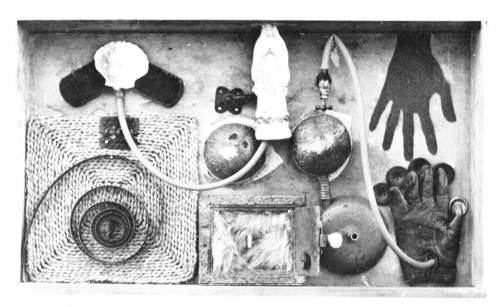

Jan Švankmajer, *Unforgettable Encounter*. 1976. Uncovered tactile object. Collection of the artist.

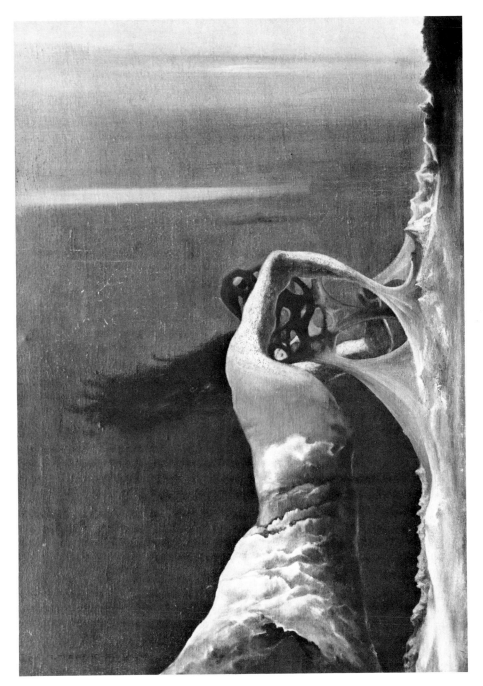

Václav Tikal, *Symbiosis*. 1945. Oil on canvas. Collection of the artist. Photo
K. Kuklík.

to be behind one, is not surrounded by walls; it hides, with distant trees, a piece of sky. But a piece of floor is itself hidden by the sky's legs, which come to rest upon it, and which could not be the occasion for useless thoughts.[5]

It is art critics and not the surrealists themselves who elect to treat surrealist painting as "literary." If the artist were to conceive of titles as simple verbal keys to visible shapes and to their arrangement on the canvas, then titles would lose their resonance, their capacity to appeal to the spectator's poetic sense. They would be, instead, a confining framework, limiting response to diligent search for identifiable forms, assumed to be present even if temporarily elusive. This would turn a surrealist picture into a kind of puzzle which, eventually, could be expected to surrender its solution to the spectator's persistence. In fact, though, we can measure the authenticity of surrealist inspiration in proportion to the degree of difficulty presented rational interpretation by the pictorial evidence before us. Drawing a distinction between Dalí's work and Magritte's, František Šmejkal inadvertently points up the relative superiority of the latter: "The apparently absurd grouping of incoherent objects in Dalí's pictures is not an enigmatic and nondecipherable puzzle as it is in Magritte's works. It has a profound symbolic meaning and can therefore be interpreted" (p. 29).

The supposedly literary quality ascribed to surrealist painting is rejected by everyone participating in the surrealist movement. Thus Breton's *Le Surréalisme et la peinture* acknowledges the innate weakness of the paranoiac critical method to be that it "permits apprehension of only silhouetted anecdotal aspects (in no way transcending the immediate world)" (p. 186). Dalí's multiple-image technique, useful as it is in shaking confidence in the stability of visible forms, still has the characteristics of a sophisticated picture puzzle for children. It never probes beneath the surface of recognizable visible shapes (the dog's head that is at the same time a scene on a ski slope), drawn from the familiar, everyday world. Matta, by contrast, takes disintegration of exterior forms a long way in a very different direction. This, Breton would have us believe, is because "for anyone who

[5] See *Lettres surréalistes* (*1924–1940*), Brussels: Les Lèvres Nues, 'Le Fait accompli,' No. 81–95 (May–August 1973), p. 53. Letter probably dated September 1927. The two descriptions appear separately under the title *Les Jambes du ciel* as 'Le Fait accompli' No. 6 (July 1968).

knows how to see, all these aspects are *open*, open not only like Cézanne's apple to the light but to all the rest, including *other opaque bodies,* because they are constantly ready to fuse, because in this fusion *alone* is forged a key that is the *only* master key to life" (pp. 186–87).

In the company of Gorky, Magritte, and Matta we go beyond witnessing Dalí's multiple imagery—which after all is no more than an optical trick—to appreciate what Nougé meant when, in "Les Images défendues," he remarked in *Histoire de ne pas rire:*

> We see only what we have some interest in seeing. The interest may be born suddenly, that makes us discover what we have been brushing against for years. And it really is a matter of *seeing*, not of *looking*. Terror illuminates the object brutally, or desire, pleasure, and we speak of menace, charm, disgust when later we have to have things out with ourselves.
>
> What is true of objects is true also of their image. (p. 223)

As the title of Nougé's essay intimates, it is the forbidden image (*l'image défendue*) that is the image defended (*l'image défendue*) in surrealism. And so, Nougé tells us, "It is not enough to create an object, it is not enough for it to *be* to be seen. We have to show it, that is to say, by some artifice, to excite in the spectator the desire, the need to see" (p. 224).

Paul Nougé has brought us back to the crucial question upon which all surrealist creative activity is centered: What is the relationship between perception and representation, and what role falls to physical reality in establishing and expressing that relationship?—"Let man go where he has never been, experience what he has never experienced, think what he has never thought, be what he has never been. He must be helped, we must provoke this transport and this crisis, let us create bewildering objects" (p. 239). Nougé's call for bewildering objects complements Breton's demand in "Situation surréaliste de l'objet" that the artist "bewilder sensation." The *objets bouleversants* for which "Les Images défendues" appeals owe their "subversive virtue," Nougé affirms, to their capacity for filling human consciousness "to the point of drying up the monotonous tide flow, to

the point of forcing the mind to invent the means for going on." Breton agrees, writing in "Crise de l'objet": "Here as elsewhere track down the wild beast of usage" (p. 279).

Above and beyond anything else, surrealist objects must disturb, disorient expectation born of the spectacle of habitual reality. The effect in view is the one produced by Victor Brauner's glass hand holding a flesh glass, his famous wolf-table, and his tandem-hat—to be worn, presumably, by a man with two heads, only one of which is visible.[6] In a general study of the object in surrealism, Conroy Maddox makes the following important point. "These objects reflect a universe brought back to life. Obeying only the laws of chance or of psychic necessity, they establish a kind of cannon of the unexpected, lending coherence to a dream world which identifies itself with a new and exciting poetic experience."[7] Placed under the sign of the marvelous ("the fathomless depths of the unconscious"), the "object-image of surrealism," according to Maddox—the best surrealist collagist to come out of England—"smashes repose": "It opens up a gap, it draws blood, it discredits completely the world of immediate reality" (p. 39). In this way, surrealist objects "bring into question our existing conventional reactions to dreams, obsessions, hallucinations, diurnal fantasies, love, fear, insanity and hysteria" (p. 45). For surrealism is indeed as Matta has described it—"more reality." Matta's emphasis leaves no room for equivocation: "There is always the need for man to grasp 'more reality'; for only in this way can we create a truly *human* condition."[8]

Offering more reality—the higher reality implied in the substantive *surrealism*—surrealist objects form a link between man and concrete things and at the same time between man and a more truly human condition. They diminish the sense of alienation that so often separates man from his material environment.

Maddox once made a typewriter on each key of which stood an erect, menacing finger nail, rendering customary use of the machine inconceivable. Years later Konrad Klapheck decided to aim at exactitude, in reaction against the *tachisme* fashionable among painters during the mid-fifties. His attention held by an old Continental typewriter, he set out to reproduce it on canvas as exactly as he could:

[6] Photographs of the wolf-table have appeared in several publications. There is a drawing of the tandem-hat in Brauner's *Dessins magiques,* p. 41.
[7] Conroy Maddox, "The Object in Surrealism," *London Bulletin,* No. 18–20 (June 1940), p. 39.
[8] Cited in Lippard, *Surrealists on Art,* p. 4.

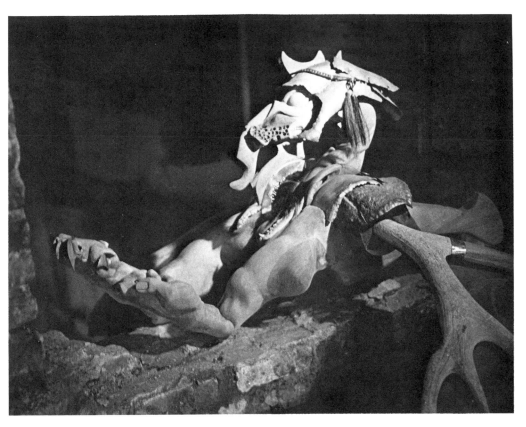

Robert Green, *The Drake*. 1976. Wood construction. Collection of the artist.

"But the machine took vengeance on me for my exhibitionist joke. Without my wanting this, it was becoming an unusual monster, strange and familiar at the same time, an unflattering portrait of my own person." Klapheck had made a valuable discovery. "With the assistance of a machine, I could extract unknown worlds from myself. The machine was obliging me to confess my most hidden wishes and desires."[9] There followed a whole series of paintings of typewriters (Klapheck sees these as male in sex, representative of the father figure, politics, and the artist, because they serve to formulate the most important decisions of our lives), sewing machines (female—naturally, after the example set by Lautréamont—virgin, mother, or widow, because they help us cover our nudity), telephones (representing the voice of remorse and of commands by unknown authorities), faucets and shower-stall equipment (erotic creatures, these, associated with physical intimacy), boot-trees (evocative of the pleasures and inconveniences of marriage, and therefore perhaps associative with the lace-up lady's boots, joined at the toe, created by Meret Oppenheim), and bicycle bells, which childhood memories lead Klapheck to connect with family and social life.

What Klapheck tells us about the meanings of the things he paints, creating a pictorial universe where man appears to have been ousted by objects, does not amount to a careful explanation of conscious symbolic intentions. It is an interpretation of a number of significant compulsions. Rather than a carefully elaborated symbolic system, we face in his work the uninhibited operation of the analogical principle by which the artist finds himself returning time after time to employ the same analogical correspondences, without for all that falling into shallow repetitiveness. Rendered with hard-edge exactitude and captured in blue-gray tones that exaggerate contrasts between light and shade, Klapheck's pictures momentarily put us in mind of Pop Art. Only upon looking more closely do we realize his paintings present us with the need to see, as Nougé spoke of seeing. Unless we acknowledge and respond to this need, we cannot expect to succeed in going beyond contemplation of familiar forms to the point where we can grasp their poetic significance.

In this respect, the rigorously faithful rendition of supposedly antipoetic motifs, characteristic of Konrad Klapheck, complements the suggestive ambiguity of the forms inhabiting Yves Tanguy's world. Here mock-anecdotal titles like *Mama, Papa est blessé!* (*Mama, Papa*

[9] Konrad Klapheck, "La Machine et moi," in the catalog of his exhibition at the Galerie Sonnenbend, Paris, in 1965.

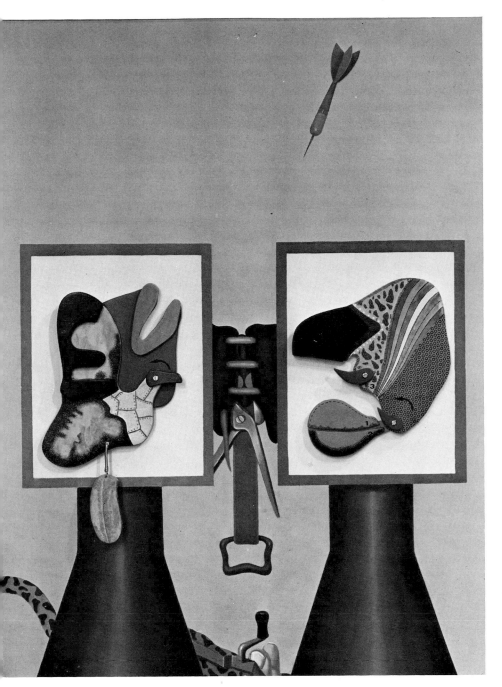

Carlos Revilla, *Devourer of Pearls*. 1970. Oil on canvas. Collection of the artist.

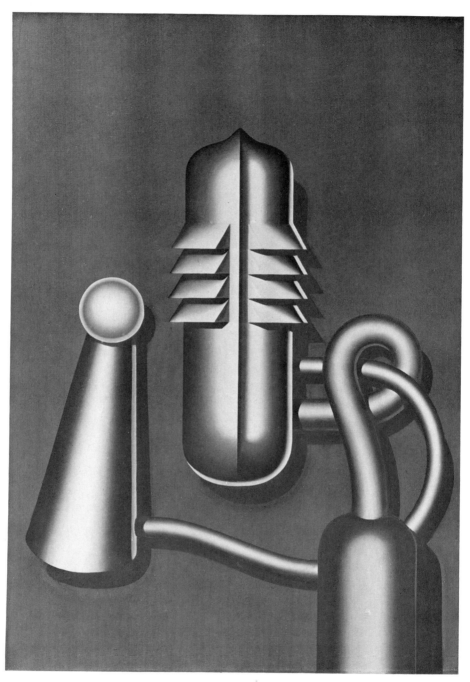

Konrad Klapheck, *The Face of Terror*. 1963. Oil on canvas. Collection
André Goeminne, Nazareth, Belgium. Photo Walter Klein.

is wounded!) defy commonsense elucidation even while they seem to call for it. In *Le Surréalisme et la peinture*, Breton shows he considers it obvious that those who, placing their hope in "what they call *reality*," think they can distinguish on a Tanguy canvas a sort of animal here, something like a shrub there, have altogether too high an opinion of themselves. One might add that, from where the surrealists stand, such a process of identification by the norms of physical reality stands self-condemned. At one extreme, the formal multivalence characteristic of Tanguy's painted forms; at the other the unrelenting precision distinguishing Klapheck's depiction of everyday objects; in both cases, transcendence of visual elements, their occultation (a key word in the surrealist's vocabulary) in poetic analogy. And between Klapheck and Tanguy stands Masson.

In an essay called "Prestige d'André Masson," taken up in *Le Surréalisme et la peinture*, Breton praises Masson for possessing to the highest degree the "taste for risk" that carries man along "the path to the unknown" (p. 152). According to Breton, in Masson's work this special taste leads to particular interest in metamorphosis: "Technically the means of progression, of propulsion is furnished here by the plastic metaphor in its pure state, I mean untranslatable in literary terms, of which the perfect example was realized in the *green gag with pansy mouth* on the dressmaker's dummy presented by Masson in January 1938 at the International Exhibition of Surrealism, rightly considered its major diamond" (p. 154).[10]

As Breton discusses and Masson practices it, the pictorial metaphor is more than just the pictorial equivalent of a certain mode of figurative language, or something passed off as such. Hence Nougé, in the section of "Les Images défendues" subtitled "La Métaphore transfigurée," looks forward optimistically to the day when metaphor will not be considered a mere artifice of language, a means of expression "without reverberation in the mind using it or in the world to which it is addressed." He writes, "And so it is that one can arrive at wishing for *a metaphor that lasts*, a metaphor that deprives thought of its possibilities for return. Toward which tends the only poetry we recognize as valid. And painting, which confers upon the sign the concrete evidence of the thing signified, evidence from which there is no longer any escape" (pp. 253–54).

[10] A photograph of Masson's dummy (head and shoulders only) appears in Marcel Jean, *Histoire de la peinture surréaliste*, p. 282. A full-page photo appears, with photographs of the other *mannequins* from the 1938 exhibition, in Man Ray, *Les Mannequins—Résurrection des Mannequins*.

The most serious error anyone could make about the surrealist use of metaphor is to assume it refers back to its constituent elements. Breton spoke of this in his essay "Signe ascendant." There, still basing his concept of the poetic image on Reverdy's theories regarding the coming together of distant realities, he emphasized that the process of *rapprochement* is irreversible. For this reason, attempting to catalog the motifs of a surrealist painting, with the assistance of the title that seems intended to sum up its contents, is as unenlightening as trying to increase one's appreciation of one image, "La rosée à tête de chatte," in Breton's text *Clair de terre,* by dismembering it, so ending up with dew on one side and the head of a female cat on the other. Pursuing this unproductive course, we soon learn from failure why Breton firmly rejected the word "therefore."

Analysis of "La rosée à tête de chatte" and of similar images in which prepositions bring about strange *rapprochements* presents intelligence with an impossible task that rational deduction is not slow to pronounce thankless. Amalgamation of dew and the head of a cat clearly lies outside the bounds of practical possibility and has no model in the world of physical reality. Thus the idea of cat-headed dew brings rational thought to a halt. The reasoning mind declines to venture beyond the limits of the physical universe. Conversely, by luring us outside those very limits, "La rosée à tête de chatte" stimulates imaginative response. The same principle operates recurrently throughout Breton's best known poem, *L'Union libre* (1931), where the convulsive beauty of the surrealist image is a token of the liberative effect of love: "Ma femme aux doigts de hasard et d'as de cœur" ("My wife with fingers of chance and ace of hearts").

Breton's method of questioning the order of the world where we live through verbal constructs of this kind is by no means the only approach to mental liberation granted validity in surrealism. It is not a common mechanism that is characteristic of surrealist verbal imagery so much as a common orientation. Interruption of the processes from which rationalism draws strength and purpose is just the first stage in a movement culminating in imaginative emancipation.

A passage in one of Breton's *textes surréalistes,* printed in the sixth number of *La Révolution surréaliste* (p. 6), shows where the surrealist image is leading. It runs:

Les rideaux qui n'ont jamais été levés
Flottent aux fenêtres des maisons qu'on construira

> Les lits faits de tous les lys
> Glissent sous la lampe de rosée
>
> (The curtains that have never been put up
> Wave in the windows of the houses that will be
> constructed
> The beds made of all the lilies
> Slide under the lamp of dew)

Here temporal limitations are denied through contradiction, so that a perfectly familiar phenomenon—the sight of curtains in house windows—becomes an apparent impossibility. The curtains exists nevertheless, in the imagination, next to a totally unfamiliar phenomenon, conjured up, this time, not by recollection of something to be seen every day, but by word association, unrestrained by rational censorship, through the homonyms *lits* and *lys*.

Participation in the liberative experience initiated by surrealist imagery requires us to free ourselves from a narrow interpretation of the principle of causality. Moreover, ceasing to aim at providing a novel method of restating the familiar or the habitual, the surrealist metaphor prospects the still unknown. Hence our inability to translate it to our satisfaction in terms of past experience or our anticipations is a measure of its annunciatory character. The difficulties we must meet in any attempt at interpretation are easily foreseen therefore. We shall have to consider them in some detail before long. For the time being, it is enough that appreciation of the pictorial and verbal metaphors of surrealism is likely to be the privilege of someone who, responding on the same wavelength, so to speak, feels no reluctance to follow the example set by Benjamin Péret, reacting to the work of Toyen.

Péret recognized in Toyen's painting an impulse to correct outer reality in relation to a desire feeding and growing on its own satisfaction. He did this all the more readily because his own poetic expression had the same origins. Thus Péret wrote, "At the instant when the leaf becomes a wing, hand, insect, mushroom, plate, while the blossoming haricot bean flies off on hesitant wing, Toyen regulates the progressive appearance of a woman's body becoming incrusted in an old wall (which did not expect such pellitory) or extracts from another a wolf gnawing at beef tongues."[11] Elsewhere, he observed, she offers

[11] Benjamin Péret, "Au Nouveau-Monde, maison fondée par Toyen," in Péret et al., *Toyen.*

us the myth of light, which he proceeded to evoke as follows: "In the beginning was the rain of black gold. Its wings were losing their feathers from breaking in the rainstorm, becoming viscous like toads during winter, letting the song of a spring day be heard, and in the autumn would gather in troops that suddenly fled, letting the rain collapse on the soil." Péret's text continues for a long paragraph. Yet at no time does it attempt to describe Toyen's painting, to itemize formal motifs or catalog themes. Even so, it comes closer than conventional analysis to communicating the "feel" of things in Toyen's work, their metaphoric play.

Aided by Péret's comments on Toyen, we are better prepared for admittance to the pictorial universe Max Walter Svanberg has made his own.

Offering his impressions of "La Situation de la peinture en 1954," Svanberg took the opportunity to stress that imitative art has no meaning for him:

> . . . the image must, in the measure of its means of expression, develop freely, creating its own visages: the vital rendering concrete explosive forces accumulated in the unconscious.
>
> *This power, resident in the content of the image, to stimulate the imagination,* seems to me essential. The image is like nature in constant transformation, the forms of objects are completely relative notions, we are in worlds created by all the objects we dream up, we are the result of a singular juxtaposition of innumerable worlds. (p. 46)

Beauty, "full, thrilling, multiform," can come, Svanberg believes, only from the irrational play found in a "universally poetic figuration," capable of liberating the imagination. Form and color are not ends in themselves. They are means used with a view to "the greatest intensity, resident in the function of the image as liberator of the imagination."[12] This accounts for Svanberg's description of his own work, "the hymn to woman," couched in language much like that used by Péret to communicate his impression of Toyen's painting:

[12] Max Walter Svanberg, "Besatt av Kvinnan," in *Svanberg*, p. 10.

She is a solitary person in a rainbow colored room. Her skin is made up of strange garments and of clouds of butterflies, events and odors, of the pink fingers of the dawn, of the transparent suns of full daylight, of the blue loves of twilight and of the big-eyed night fish.

Her cheeks feverish and rainy, drowned person's eyes circled with a carbonized forest, the kiss and the butterfly, the flower burning in the gaping wound, the dialog between the fish and the bird by means of a shell-fish, the high heels tapping on the sidewalk and the ear that forgets nothing, all that is clearly defined in the extreme, to the point of becoming the changing landscapes of the Woman I dream of, to become her elective attributes that, unveiling and concealing at the same time, shock, ornament, intensify. But she is always a vision in transformation and, at the moment when one thinks to have laid hands on her, she escapes, leaving behind her, who knows, the opal hand of misty dawn that feeds me, the wriggling fish of a day coming to life, which promises me while I am eating it the strange gestation of new strange encounters, of visions opening out their faces, their landscapes. (pp. 10–11)

No one has gone so far as Svanberg in celebrating woman as an object, without for an instant taking her fascination away; no one, that is, but Hans Bellmer.

Bellmer's signal contribution to the imagery of surrealism takes three forms, separated on the level of method, but fully complementary in function. Technically speaking, the first two, pencil and chalk drawing and engraving, are not original. Still, they are quite without equivalent in surrealist graphic experimentation, even where Bellmer's work brings to mind a series of color prints, *L'Anatomie du désir* (1933), in which Victor Brauner arranged the female body without regard for anatomical precedent (prolonging a woman's torso into a "lover-bearing seat," for instance). As for Bellmer's doll, that could be disassembled so as to permit redistribution of the constituent elements of the adolescent feminine form, its invention during the early thirties was to bring something indispensably unique to surrealist imagery.

"I am going to construct an artificial girl with anatomical possibilities capable of rephysiologizing the vertigo of passion to the point of inventing desires," declared Bellmer. In 1934 he selected a dozen photographs of his doll, publishing them anonymously at his own expense, under the title *Die Puppe*. For each picture he had posed his model carefully, "with the necessary background of vice and enchantment." The doll and the photographs taken of her would inspire his graphic variations on the female nude, granting them an imaginative

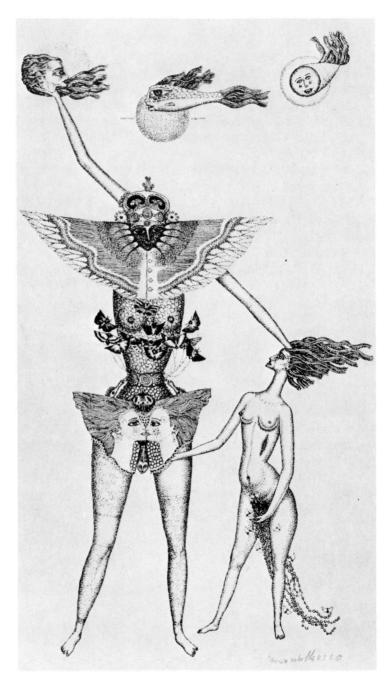

Max Walter Svanberg, *Rich Woman Experiencing the Metamorphoses of the Day*. 1950. Lithograph from Svanberg's *8 originallitografer* (Malmö: Image, 1950).

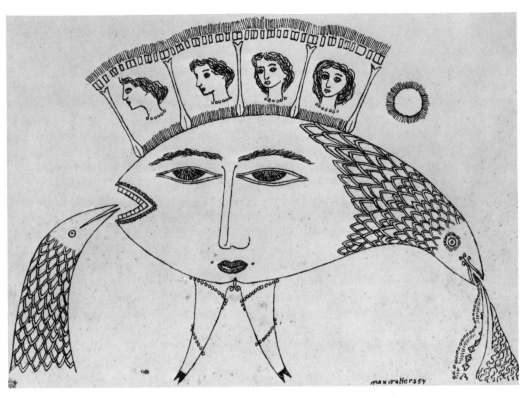

Max Walter Svanberg, Untitled Drawing. 1954. Pen and ink. Collection
E. F. Granell, New York.

freedom and an erotic suggestiveness without precedent or compare in surrealism or anywhere else.

In the 1938 *Dictionnaire abrégé du surréalisme* the following definition of "doll," extracted without acknowledgment from *Die Puppe,* appears over the initials H. B.:

> Would it not be in the doll which, despite its accommodating, limitless docility, shrouded itself in a heart-breaking reserve, would it not be in the very reality of the doll that imagination would find what it sought in the way of joy, excitement, fear? Would it not be in the definitive triumph over adolescent girls with big eyes that turn away, if the conscious glance pillaging their attractions, aggressive fingers assailed plastic form, and slowly constructed, limb by limb, what the senses and the brain have appropriated? (p. 22)

These questions already having found an answer to the writer's satisfaction, they have no more than rhetorical force. As Paul Eluard writes of Bellmer's doll in *Les Jeux de la poupée,* "anything one can say about her confines her, limits her."

> It's a girl! where are her eyes?
> It's a girl! where are her breasts?
> It's a girl! what game is she playing?
> It's a girl, it's my desire.

Handling his doll, Bellmer proved to be master of the art of erotic suggestion. "Follow quietly the contours of the valleys, taste the pleasure of rounded forms, make pretty things," he suggested, "while distributing not without some resentment the salt of deformation, take care not to lay bare the thoughts held back by these little girls and preferably render one's deepest thoughts through the navel: panoramas revealed in the depth of the belly by a multicolored electric illumination—wouldn't that be the solution?"

Die Puppe culminates in a photo of a pair of legs meeting in a white rose. This image, lacking subtlety, is quite banal in its associative range. Indeed, it would not be worthy of notice if it did not allow us to measure the progress toward erotic refinement Bellmer made after conceiving the idea, in 1937, of inserting a ball and socket joint in his doll's midriff. A "Note au sujet de la jointure à boule," serving as Bellmer's preface to *Les Jeux de la poupée,* offers an illuminating

comment on the possibilities that placement of the joint seemed to grant the human body as image:

> . . . the body, just like the dream, can displace the center of gravity of its image capriciously. Inspired by a curious spirit of contradiction, it superimposes on some what it takes away from the others, the image of the leg, for example, over that of the arm, that of the sex over the armpit, to make them "condensations," "proof of analogies," "ambiguities," "play upon words," strange anatomical "calculations of possibilities." (p. 27)

Bellmer's revolutionary conception of anatomy as providing the elements of a new mode of imagery led him to liken his play with the doll—his exploitation of its "algebraic possibilities"—to "experimental poetry." The preface to *Les Jeux de la poupée* (*The Doll's Games*) opens with this declaration: "Play belongs to the category of 'experimental poetry.' If one retains essentially its method of provocation the toy presents itself in the form of a provocative object." To Bellmer's mind, in fact, the best kind of game has endless possibilities for unforeseen suggestion beyond the short-term limits of predetermined effect. Hence the best kind of toy is "rich in accidental application and possibilities."

We have to look elsewhere to see Bellmer outline his theory connecting games with the doll and those that, using pencil or chalks, or employing the engraver's tools, he played on paper or the engraving plate. We find what we are seeking in his *Petite Anatomie de l'inconscient physique ou l'Anatomie de l'image* (1957), which appeared more than twenty years after *Die Puppe*. In a letter written later still, on November 1, 1964, Bellmer explained that *Petite Anatomie* was intended to show there exists a *"purely subjective, imaginary"* anatomy of the human body:

> For, it so happens, in the course of my combinations of doll parts or combinations of more or less complete parts of "Doll," I found some that had no meaning, that did not provoke a feeling of the "probable," or the "desired"—they communicated absolutely nothing. On the other hand I found some *that released incomparable pleasure in me*, strictly comparable to what one must experience upon finding a treasure feverishly sought over 20 or 30 years.[13]

13 See *Obliques*, unnumbered, undated (1975) special number devoted to the work of Bellmer, pp. 117–18.

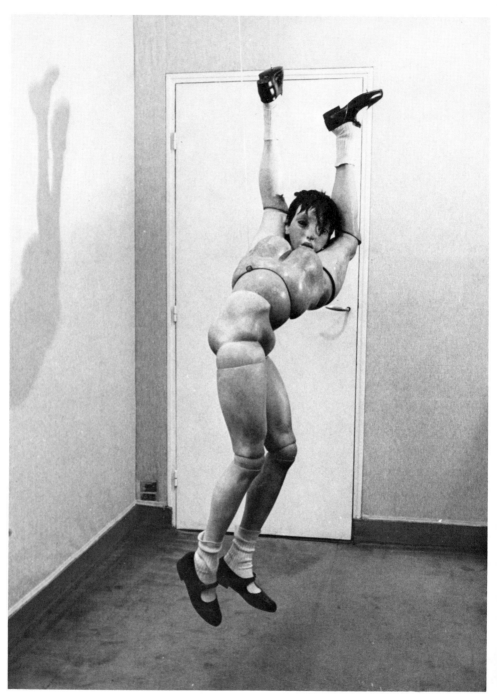

Hans Bellmer, *The Doll*. Galerie A.-F. Petit, Paris.

In *Petite Anatomie* Hans Bellmer speaks of the "anatomy of love" because he is convinced of one thing: so far as the intensity of its images goes, desire takes its point of departure not from the whole, but from the part, from details. To make his point, Bellmer cites as an example the idea of having a hand unexpectedly stick out of a pair of pants, in place of a foot. He calls this "provocative of quite another degree of reality." At the same time, he asserts, it is essential to notice that in "the monstrous dictionary of analogies–antagonisms, that is the dictionary of the image," such a detail is perceptible, accessible to memory, and available ("in short, is REAL") only if desire does not take it inevitably for a leg. And so we encounter in one section of his book headed "L'Anatomie de l'amour" an illustration showing a woman whose torso is an erect penis, the testicles serving as breasts and the glans becoming one with the buttocks. In 1954 Bellmer had sketched a portrait of his mistress, Unica Zürn, in which the right eye coincided with a vulva. Elsewhere, an inserted phallus takes the place of the nose in an engraving from the series dedicated to Sade. Among the engravings illustrating Joyce Mansour's *Jules César* is the face of a man, his nose a detumescent penis, surmounting an anus-mouth. "The object identical only to itself," argued Bellmer, "remains without reality." And his 1964 letter insists that this statement was not made for effect, but is the expression of "an absolute conviction."

When Bellmer goes on to discuss the world of outer reality in *Petite Anatomie*, it is to declare, "an object, a woman's foot, for example, is real only if desire does not take it inevitably for a foot." In Bellmer's depiction of woman, the sense of anatomical functionality is governed not at all by medical textbooks. Instead, it is controlled by desire of an unashamedly sexual nature. Eluard's comments go to the heart of the matter, when he writes, "These 'metamorphoses,' that Bellmer calls very precisely 'anagrams of the body,' are proof of that radical transformation of reality which human desire carries as a seed." Hence, of course, the enthusiasm evidenced in Bellmer's 25 *Reproductions* by yet another surrealist, Nora Mitrani: "All his research is directed toward elucidating, perfecting and extending this mode of correspondence of the physiological to the psychic and of the pyschic to the objective" (p. 10). As though with foreknowledge of the discovery of *l'un dans l'autre*, in which she did not live long enough to participate, Mitrani remarks, "That there now exists a principle of universal participation according to which everything is inside everything else, this is too attractive an hypothesis for us not to accept it as an assumption refusal of which would make us, inevitably, lunatics

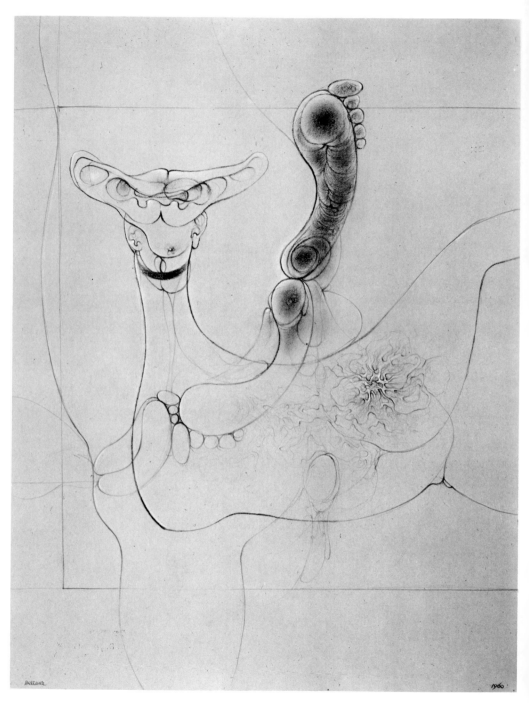

Hans Bellmer, Untitled Drawing. 1960. Galerie A.-F. Petit, Paris.

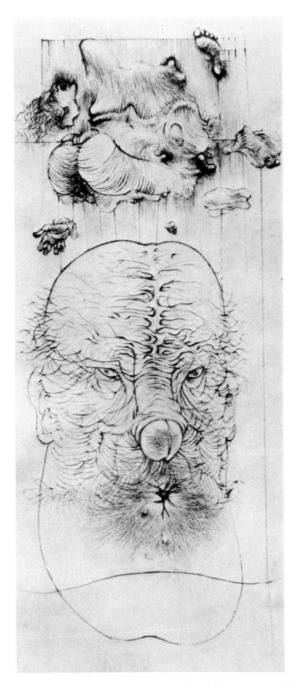

Hans Bellmer, engraving for Joyce Mansour's *Jules César*, 1958. Collection
Joyce Mansour, Paris.

[*des aliénés*]" (p. 12). "Thus," she adds, speaking very much like Eluard in *Donner à voir*, "any object can come to resemble any other, and more than this, become that other, on condition pleasure discovers a common character between the two terms."

In the work of Hans Bellmer erotic suggestion is never fettered by realistic principles. One of the etchings done for Georges Bataille's *Histoire de l'œil* shows a reclining woman. A human face is depicted on her nude body, so located that the left eyebrow becomes one with the vulva and the right eye is penetrated by the penis sodomizing her. Later in life Bellmer devised the *céphalopode*, a woman consisting only of head and legs, the latter frequently displaying a fetishistic motif, the high-heeled shoe or buttoned boot. Discussing the *céphalopode* in *Petite Anatomie*, Bellmer remarks, "But even before being born of subtraction and division, it derives from several intermingled methods, one of which is what mathematicians call 'permutations.'"

Invention of his doll made it possible for Bellmer to explore the universe of erotic satisfaction in total disregard for conventional projection. In *Tour menthe poivrée à la louange des petites filles goulues* (*Peppermint Tower* [or: *Peppered Torment*] *in Praise of Gluttonous Little Girls*), the phallic candy cane and the six hands we see lend themselves to developing the central motif of penetration eagerly invited and accepted. This situates the little girls' gluttony in unambiguous light. Penetration is either vaginal, anal, or even oral, since fellation, after all, is not excluded by an artist who represents it in an engraving for Sade's *Les Crimes de l'amour*.

The simultaneity with which Italian Futurists experimented proved to be of no more than technical interest and of limited resonance in the imagination. Bellmer's superimpositions—representing several erotic attitudes and activities at once—give simultaneity richer emotional value. Serving imaginative expansion, superimposition in his graphic work extends the field of response, through juxtaposition of images acting concurrently upon the sensibility. At the same time, simultaneous variations on erotic experience present reconciliation of contradictory yet complementary elements. In the drawing *Tête de mort* (1961) a death's head incorporates both gaping vulva and tumescent penis, at once buttocks and breasts.

In *Mode d'emploi* (1944) Hans Bellmer speaks of "The simultaneous spectacle of structures, not only of past, present and future states

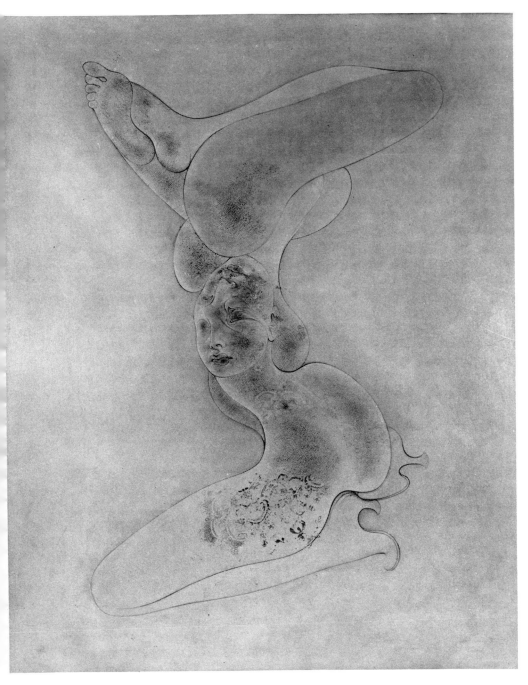

Hans Bellmer, *Little Anthology of the Ink-Well* (*Reversible Cephalopod*).
1950. Oil on canvas. Private Collection, New York. Photo Nathan Rabin.

of matter, but also that of subcutaneous, constructive elements." On the same occasion, he insists, "And notice that the structure becomes tangibly different, to the point of becoming the opposite of what it was at the beginning, it is metamorphosed in imperceptible transitions, avoiding any air of disjointedness." In an engraving done to illustrate Sade's *Les 120 Journées de Sodome* an erect phallus can be seen plunging into pubic hair which, as it extends upward, becomes one with the tresses of a smiling young girl, her thighs spread to reveal an erect male member emerging from her vulva. In one of the etchings for *Histoire de l'œil*, superimposition of images obliges us to identify the navel of a naked woman, her body arched backward, as the anal orifice of another, bending forward. The two women share the same vagina.

In Bellmer's work, the centrality of erotic motivation in human life is never left in doubt. Yet naturalistic detail gives way everywhere to imaginative developments that—if the subject matter were not *scabrous*, as Breton used the adjective—one might call fanciful. A woman's torso emerges feet foremost from a pair of pants, among the engravings executed for Bataille's *Madame Edwarda*. Faces adorn the sole of the feet framing the sex of a crouching woman, seen from below in another engraving, *Transfert des sens* (1961). More aggressively still, a painting, *Les Bas rayés*, shows a leg that ends in a hand, masturbating a woman whose legs only are visible. Nipples are present on the spread thighs between which the sexual act is represented, presumably in an erotic daydream of *La Jeune Fille au canapé noir*, drawn in 1960. In an engraving meant for Sade's *La Philosophie dans le boudoir*, a woman takes full advantage of an erect phallus, conveniently growing upward from the seat of her stool.

In his *Petite Anatomie* Hans Bellmer speaks of the human body as "comparable to a sentence that invites us to disarticulate it, so that, through a series of endless anagrams, its true contents may be recombined." Considered this way, disarticulation and even dismemberment of the body is anything but a sign of brutal indifference to feminine beauty. It is a token of desire, in which attention to constituent parts pays sincere tribute to the attractiveness of the whole. In Bellmer's work, the underlying destructive–constructive force of surrealist inspiration opens up a pathway to rearticulation, for which there is a parallel in the verbal anagrams he worked out with Nora Mitrani.

Bellmer looked upon the anagram as born of "a violent and paradoxical conflict": "It sustains maximal tension of the imaginative will

and, at the same time, exclusion of all preconceived intention, because that would be sterile." Working with Mitrani, he spent hours forming anagrams of the phrase *rose ouverte la nuit* and of Gérard de Nerval's verse, *rose au cœur violet*. His comments on the experiment remove it from the category of time-filling amusements: "The monstrous pessimism in which I live and which, with age, become blacker, assumes as a counterbalance veritable miracles of perception and imagination. The transference, metamorphoses, 'impossible' permutations . . . the shock and surprise of which make up a little for the bitterness of having lived. To obtain by simple permutation the sentence, 'Oh, to laugh under the knife,' after starting out with the phrase, 'Rose with violet heart,' that is a miracle!" Bellmer's keen interest in anagrams, his faith in what we may term their redemptive role, is a key to his pictorial universe. It helps us understand why his graphics combine unrivalled imaginative freedom with precision of draftsmanship. Although standing alone among surrealist graphic artists, Bellmer has produced images that lend themselves to comparison with what Guy Cabanel achieved during the early stages of his evolution as a surrealist writer. Bellmer's procedure, taking the human form to pieces and putting it together again, is the pictorial counterpart of Cabanel's manipulation of language, so destructive of its customary order that Cabanel himself has likened his method in *A l'Animal noir* (1958) to the "rape" and "sodomization" of language.[14]

On some occasions more directly than on others, surrealists have justified the creation and circulation of objects, at the same time defining the role intended for them, by reference to the work of poets they esteem highly. The implication is clear. The value of the surrealist object is to be gauged by standards set in verbal poetry. Very significantly, in theoretical discussion of the contribution to be demanded of objects and comments upon the practical application of these theories through objects inspired by them, surrealists have borrowed some of the terminology usually thought to be more appropriate to the art of writing—metaphor, anagram, and analogy, notably. As they use these terms to explain how and why they and their friends have experimented with creating objects, they confirm the fundamental unity of surrealist imaginative exploration, highlight-

[14] The only discussion of Cabanel's method that has appeared to date is to be found in Matthews, *Surrealist Poetry in France,* pp. 179–82.

ing therefore the essential role of image-making in surrealist creative activity.

The image-making process from which surrealist objects result accords perfectly with the one to which we owe certain verbal surrealist images. So there is no need to marshall numerous examples of the latter in order to demonstrate how the poet with words provides object lessons comparable with the concrete objects offered by certain artists. All the same, to demonstrate that agreement between surrealist writers and creators of objects is not confined to the level of theory and speculation, a sampling may be taken from surrealist poetic texts as a reminder that surrealist writing contributes its share of bewildering objects.

In the short poems of André Pieyre de Mandiargues's *Les Incongruités monumentales* (1948) abound disconcerting objects inexplicable to reason. A Spanish general's tear and a Portugese general's both tremble in an urn shaped like nasal mucus that will be hung from the skeleton of a cow in future deserts. A traveler back from India reports that rajahs wash their feet in pieces of furniture shaped like Queen Victoria. Fuegian honor, we are told, demands a billiard table of seaweed, in which three lobsters roll about in glass balls. Mandiargues brings before us, also, a tongue of green porphyry, two yards thick; the corset worn by the model who posed for the Statue of Liberty, now used as a lampshade on the Speaker's rostrum in the French Senate; a hat, "unbuttoned like a closet," full of crushed brains, serving as a hive for bluebottles; a lighthouse modeled on the leg of a king's mistress; a tongue piano that feeds on diplomat semen and is led about on a leash by Meret Oppenheim.

The poems of Benjamin Péret, Jehan Mayoux, and Maurice Henry yield a comparably rich crop of objects. Some of these, in fact, point to an imaginative freedom that does not have to take into account practical considerations of three-dimensional representation. It is fitting, all the same, to give more attention to tangible surrealist objects than to their two-dimensional images in words. For the real significance with which these objects are invested in surrealism lies in their function. They materialize dreams, aspirations, needs, and compulsions. It is in this sense that we must understand the statement by René Magritte cited in Breton's *Le Surréalisme et la peinture:* "My pictures are images. The valid description of an image cannot be made without the orientation of thought toward liberty" (p. 269).

To give Magritte's words their full weight, we have to note that he does not mean description to serve as an explanation. His *Manifestes*

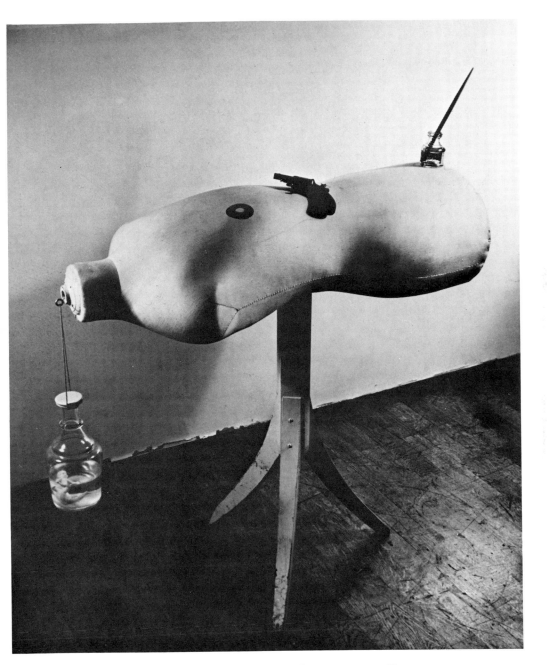

Wilhelm Freddie, *Zola's Writing-Desk*. 1936. Object. Louisiana Kunstmuseum, Humlebæk. Photo Jørn Freddie.

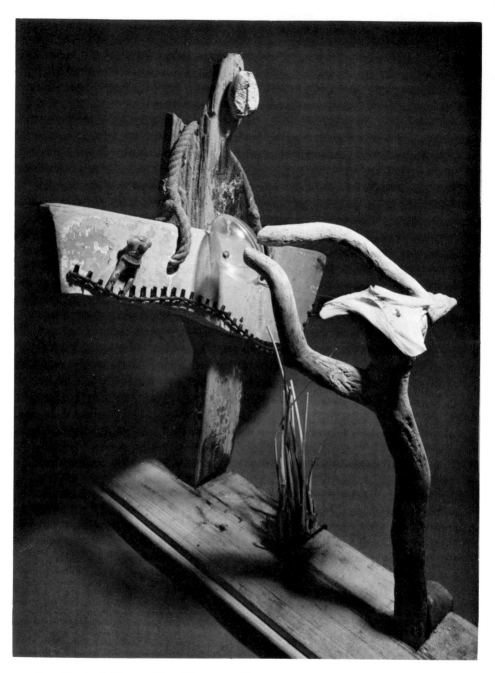

Jean-Louis Bédouin, *The Algonquin Tango*. 1972. Object. Collection of the artist. Photo Pierre Bérenger.

et autres écrits states categorically: *"One explains nothing, by the
way, in any domain"* (p. 123). As Magritte sees it, what customarily
passes for an explanation always comes down in the end to "a neces-
sary deforming translation" of the very thing being explained. We are
close indeed to Breton, dismissing *explication de texte*—the method of
literary analysis fed as a staple diet to French high school children—as
irrelevant to the true appreciation of poetry.[15] Moreover, René
Magritte takes us farther than we could go without him. Recurrently
and consistently, his work shows him rejecting the view that two-
dimensional representation of a familiar object is to be interpreted
simply as a translation of the same object, perceived three-dimen-
sionally in the day-to-day world. It is through *décalage*, the *shift* made
possible by pictorial representation (ironically realistic in appearance),
that he appropriates everyday objects to surrealist purpose.

In a letter written to Nougé during the twenties, Magritte
confided:

> I'm realizing more and more that the objects appearing in my
> painting have no cause (there is more to the effect than to the cause)
> but the effect is not obtained if it is due to a simply ingenious arrange-
> ment. The operation must be carried out by a feeling that knows no
> hesitation or enthusiasm. A sort of advance, there's no doubt about it,
> toward what is unknown, the departure alone being known. The whole
> difficulty for me lies in having that feeling.[16]

Contrivance must be eschewed, Magritte believed. Otherwise,
the effect produced by the pictorial image will be diminished. In one
of his canvases, a rock looks like a sculptured garment—even as we
note this impression we find ourselves paying tribute to an order of
precedence established by common sense: the latter tells us we are
looking at a rock represented as a garment, because it cannot accept
substitution of a garment for a rock, where, from the standpoint of
reason, it would be more appropriate to find the latter. During a lecture
delivered under the title "La Ligne de ma vie" at the Musée des
Beaux-Arts in Antwerp, on November 20, 1938, Magritte commented:

[15] André Breton, "Braise au trépied de Keridwen," preface to Jean Markale, *Les
Grands Bardes gallois.* This text is reproduced in Breton's *Perspective cavalière.*
See especially p. 130.

[16] See *Lettres surréalistes* (*1924–1940*), p. 68. Letter probably dated February–
March 1928.

I painted pictures in which objects represented with the appearance they have in reality, in a style objective enough to ensure their bewildering effect—which they would reveal themselves capable of provoking thanks to certain means utilized—would be experienced in the real world from which the objects had been borrowed. This by a perfectly natural transposition.

In my pictures I showed objects situated where we never find them. *They represented realization of the real of unconscious desire existing in most people.*

Beyond any question, the poetic function of the pictorial image, as Magritte understood it, is to resist the assimilative process that allows the human eye, when trained by reason, to classify and locate objects, while often the image appears to invite such classification through exact reproduction of objective forms borrowed from life. This is the nature of the "figurative bias" for which Breton praises him in *Le Surréalisme et la peinture:*

It is a matter, certainly, first, starting out from the objects, sites and people that make up our everyday world, of giving us back appearances with complete fidelity, but much farther still—and it is here that Magritte's totally original and capital intervention lies—of awakening us to their latent life by appeal to fluctuation in the relationships they bear one another. To strain, if necessary to the point of violating them, these relationships of size, position, lighting, alternation, substance, mutual tolerance, development, this means taking us to the heart of a second figuration that transcends the first by all the means rhetoric enumerates as "figures of speech" and "figures of thought." If the concrete figuration, in the descriptive sense claimed by Magritte, were not so scrupulous, this would be the end of the great *semantic* bridge permitting passage from the proper sense to the *figurative* sense and of combining both these senses in one glance with a view to a "perfect thought," this is to say one that has reached its complete emancipation. (pp. 269–70)

On the level of technique, Magritte's work presents no great complexity and certainly no subtlety. It is not even original. Add to the example set by Ernst in his collages the influence of Giorgio de Chirico's metaphysical painting, and there is little excuse for trying to present Magritte in the guise of a technical innovator. What im-

presses, though, is the simplicity, at once disarming and unsettling, with which he applies borrowed methods. Magritte offers object lessons in which things, taken in eminently recognizable form from the world about him, are arranged in a manner that undermines generally accepted notions regarding objective reality.

At the same time, objects are represented with scrupulous care. Magritte's method is so far removed from the painterly sophistication characteristic of much twentieth-century art that he comes closer, it seems, to the naiveté of the self-taught Sunday painters—Douanier, Rousseau, notably—than to the expertise usually considered a prerequisite for greatness or even for respectability among the painters of our time.

Shadows are rarely given close attention, except where they serve to dramatize a scene, just as in the early paintings of de Chirico. Normally, Magritte's work betrays little or no concern to present people and things in the round. It is not their presence that matters but their potential—brought out by their unwonted proximity—for triggering new associations. These associations do violence to the ordered universe familiar to us all, where, so we thought, everything has its designated place and prescribed role. An enumeration of typical elements in Magritte's pictorial universe introduces Nougé's statement in "Les Images défendues," "L'expérience va commencer." What is about to begin is at once an experience and an experiment (both rendered by *expérience* in French). In "Ligne de vie" Magritte furnishes a specific example:

> One night in 1936, I awakened in a room where a cage and the bird sleeping in it had been placed. A magnificent visual aberration caused me to see an egg, instead of a bird, in the cage. . . . From the moment of that revelation I sought to find out whether other objects beside the cage might not likewise show—by bringing to light some element that was characteristic and to which they had been rigorously predestined—the same evident poetry as the egg and the cage had produced by their coming together.

Magritte speaks of evident poetry. Eluard writes an important theoretical article under the title "L'Evidence poétique," and Breton explains in *La Clé des champs* how the only evidence that counts for him is governed by relationships insolently established in defiance of common sense. Surrealist poetry renders evident things that reason

can neither project nor encompass, and may well not be able to
tolerate. Péret proclaims, "J'appelle tabac ce qui est oreille" ("I call
tobacco that which is ear"), while Magritte paints a picture, *La Clé
des songes* (*The Key to Dreams*), divided into six panels, each oc-
cupied by a titled object: an egg (called acacia), a woman's shoe
(the moon), a bowler hat (snow), a lighted candle (the ceiling), an
empty glass (the storm), and a hammer (the desert). In a statement
quoted by Marcel Brion, he explains, "The art of painting, as I con-
ceive it, permits representation of visible poetic images" (p. 280).[17]

Upon the apparently innocuous premise that painting is the art
of representation, Magritte found he could build in such a way as to
disturb the spectator's confidence in the art of imitation. Waldberg
reports this axiom: "One can create new relationships between words
and objects and render precise a few characteristics of language and
objects, of which people are generally ignorant in daily life" (p. 172).
In the special number of *L'Art Belge* devoted to his work Magritte
goes into greater detail: "The art of painting—which really deserves
to be called the art of resemblance—makes it possible to describe,
through painting, a thought capable of becoming apparent. This
thought comprises exclusively the shapes [*figures*] that the apparent
world offers us: persons, trees, pieces of furniture, weapons, solids,
inscriptions, etc. Resemblance spontaneously brings these shapes to-
gether in an order directly evocative of mystery" (p. 42).

Here is the key to the figurative system operative in Magritte's
painting. Meaning comes from redistribution of familiar forms for
which there is no counterpart or precedent in daily experience. Thus
forms are valuable less for the associative memories they bring up
than as testimony to a new order. Magritte goes on to point out,
"Inspiration gives the painter what he must paint" (p. 43). In other
words, the first obligation imposed upon any spectator is to transcend
banal associations that do not serve the poetic purposes of painting.

Magritte's pictures take issue with the conventional modes of
perception and interpretation by which we customarily measure re-
semblance. In this respect, they stand for *La Trahison des images*—the
betrayal of images—to avail ourselves of the significant title of one of
his canvases. But the process of poetic expression is not purely nega-

[17] Discussing the work of Magritte ("Envergure de René Magritte" [1964]) in
Le Surréalisme et la peinture (p. 403), André Breton avails himself of the very
same figure of speech as in his introduction to the writings of Péret (*Anthologie
de l'Humour noir*, p. 505): that of the alchemical transmutation or sublimation
of base matter.

tive in function. Appreciation of the work of René Magritte requires us to be able to go beyond appearances in order to grasp meanings perceptible only when we have come to understand resemblance as Magritte himself did:

> . . . resemblance which is a thought capable of becoming visible through painting: for example, the thought in which the terms are a pipe and the inscription "This is not a pipe" or again the thought constituted by a nocturnal landscape under a sunny sky. . . .
> Resemblance does not trouble itself to accord with or defy "common sense." It spontaneously brings together shapes from the apparent world in an order furnished by inspiration. (p. 112)

The precision, the care for exact rendition of shapes taken from everyday reality, with which Magritte paints forms he has no intention of using in their familiar connotation—like the smoker's pipe that is not what it appears to be—seems so paradoxical that his work is a source of perpetual confusion to the reasoning mind. A 1960 statement cited by José Pierre in *Le Surréalisme* insists:

> The art of painting really deserves to be called the art of resemblance when it consists in painting the image of a thought that resembles the world: to resemble being a spontaneous act of thinking and not a relationship of reasonable or delirious similitude.
> Resemblance—capable of becoming visible through painting—comprises only shapes as they appear in the world: persons, curtains, weapons, stars, solids, inscriptions, etc., brought together spontaneously in an order in which the familiar and the strange are turned over again to mystery.

Clarification of this concept of resemblance comes most easily, perhaps, when we turn to Paul Nougé's *Pour illustrer Magritte*. Noting that a familiar object normally indifferent to us can move us, when seen out of its normal environment [*dépaysé*], Nougé asks himself why this should be so. He adduces two reasons. The first is that, in a new world, this object "gratifies our secret desire to overturn [*bouleverser*] the universe that is given us." Seen again in habitual circumstances, it retains a more or less pronounced "*vertu de provocation.*" The second reason follows from the first. Nougé remarks that in daily life most objects are "practically invisible." The rest we perceive only

as *"signs."* A chair serves merely to signal that we may sit down. "But place that chair on a sea of cloud, and relocation [*dépaysement*] no longer permits us to be content with recognition of a few significant traits at the expense of the multiple qualities obscured by that recognition."

Resemblance, for Magritte, comes from realizing, as Nougé puts it, that "The object exists *qua* object and moves us by its up to now misunderstood virtues."[18]

Three aphorisms by Magritte, published in the twelfth number of *Rhétorique* (August 1964), sum up what he has told us so far:

Nothing is confused, except the mind.

What is invisible cannot be hidden from our eyes.

There is moonlight and the locomotives are returning from the sea.

The last two, especially, illuminate Magritte's approach to painting. In the same magazine he comments on his conception of the painter's art, which can be explained "if some kind of superiority is not granted the invisible over the visible." This is to say that the work of Magritte is most comprehensible in terms appropriate to explaining the existence of surrealist objects. These objects and the Magritte canvases stand for faith in an art of concrete presences which cannot be ignored as irrelevant to human experience. Magritte made his special contribution by persistently employing only forms borrowed from day-to-day reality, in accordance with his conviction that "what the world offers by way of the visible is rich enough to constitute a poetic language evocative of the mystery without which no world and no thought would be possible."

On two occasions we have heard René Magritte refer to "thought." At no time in some forty years of creative endeavor, though, did he confuse thought with didacticism, with implementation of a theory for which the picture would provide suitable illustration. So consistent was his attitude that reason's inability to interpret the thought sus-

[18] Paul Nougé, *Pour illustrer Magritte* (*1932–1936*), Brussels: Les Lèvres Nues, 'Le Fait accompli,' No. 34–35 (April 1970), no pagination.

taining his work has left many with no alternative to believing—all too conveniently perhaps—thought to be altogether absent from his work, that therefore Magritte was a painter of mediocre talent and no defensible sense of purpose. Such people are incapable of appreciating what he had to say in the last issue of *La Révolution surréaliste* (No. 12, 1929): "an object never serves the same function as its name or its image." Responding fruitfully to the work of René Magritte means benefiting from a process of reeducation of vision and of the deductive faculties by which recognizable forms are to be interpreted in their interrelationship.

Published in *Rhétorique* in October 1962, a text of Magritte's called "Leçon de choses" ("Object Lesson") indicates that "An unknown image of the shadows is called forth by the known image of the light." Two close friends of the painter help elucidate this statement. Louis Scutenaire does so when looking back to the pictures Magritte painted during the years 1926–1936—"the result of a systematic search for a bewildering effect that, obtained by bringing objects on stage, would give the real world, from which these objects were borrowed, a poetic sense, thanks to a perfectly natural exchange":

> The means employed were firstly the relocation [*dépaysement*] of objects, for example: the Louis-Philippe bust on the ice floe. It was fitting that the choice of objects to be relocated should fall on very familiar objects so as to give relocation maximum efficiency. A child on fire will move us, in fact, more than a planet being consumed. . . .
>
> The creation of new objects; transformation of known objects; the change of materials in some objects; a wooden sky, for example; use of words associated with images; false designation of an object; implementing in a work ideas furnished by friends; representation of certain visions seen when half-asleep, were in general the means of obliging objects to become sensational at last and of establishing a profound contact between consciousness and the outer world.[19]

Paul Nougé's contribution, in "Les Images défendues," leads us beyond the forms represented to speculate upon their function within the picture:

> We notice now that if Magritte paints an action in process of accomplishment, he will never fail to render its mental development

[19] Cited in Patrick Waldberg, *René Magritte*, pp. 170–72.

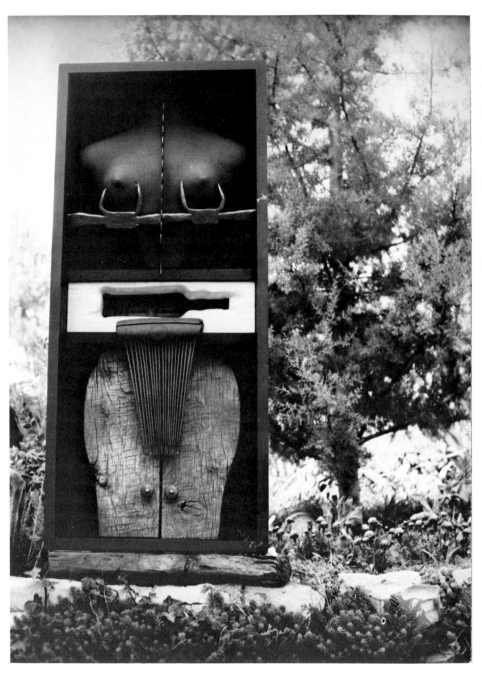

Robert Lagarde, *Closed House [Brothel] on the Courtyard, We Visit the
Garden.* 1965. Object. Collection of the artist.

René Magritte, *Painted on a Summer's Night*. 1926–27. Oil on canvas.
Galerie Isy Brachot, Brussels.

impossible by a few almost always identifiable methods, the most important of which have to do with the *strangeness* he confers on that action, its particular absurdity.

This strangeness once guaranteed, all the other elements of the picture will be treated according to the viewpoint of habit, which guarantees everything, by a sort of familiarity of access, the maximum of bewildering effect. (p. 252)

One picture, typical of so many, exemplifying the characteristics singled out by Scutenaire and Nougé, shows a circus strongman holding just above shoulder level a weight-lifter's bar that he evidently is strong enough to raise one-handed to the full extent of his arm. However, the weight at one end of the bar is the performer's own head: he cannot raise the bar without lifting his head from his shoulders.

Magritte's form of visual poetry is especially impressive to one poet with words, Gui Rosey: "Poetry leaps at my eyes more often than it invades the mind secretly. It looms on the far reaches of an ideal region, just this side of the unknown. Image and thought are one, where painting [*peindre*] and depicting [*dépeindre*] are two contrary forces." Rosey has heeded the warning voiced by Magritte in a private letter: "A symbol is never identified with what it symbolizes. . . things are significant in themselves."[20] We too must heed this warning, if we are to give the attention they deserve not only to Magritte's pictures but also to the three-dimensional objects of surrealism.

[20] Gui Rosey, "Divagations d'un amant maladroit," in *Magritte: Les Images en soi,* catalog of a 1967 exhibition at the Alexander Iolas Galleries in Paris, New York, and Milan.

INTERPRETATION

SURREALISM has a highly original way of raising the question of the function of artistic creation, of asking how it comes about, by what means, and for what purpose. Coincidentally it poses a basic problem. How are we to respond to artistic creation, if we do not wish to distort the artist's purpose?

The impression often gained from looking at surrealism from the outside is that of a closed circle of individuals, well content to exclude from appreciation and enjoyment of their activities anyone they have not seen fit to grant the privilege of initiation. If the creative surrealist benefits fully from listening "in the dark wings of being," as Breton loftily put it, then how are the rest of us to react to what he later reports back to us?

One thing at least is clear. As described by Breton, "the poetic step *par excellence*" reverses the process by which comprehension normally dawns in our minds and appreciation takes shape. In surrealism, it treats nature—external reality, that is—in relation to the inner world of consciousness. How then are we to respond to surrealist revelation, supposing lucidity to be for all true surrealists what it was for Breton, "the great enemy of revelation"? Can its effects be measured accurately and recorded faithfully in a language elaborated for the lucid communication of ideas and impressions? How can the interpretive framework of rational language be imposed upon a work conceived in a state of hallucination, or under conditions eliminating recourse to the reflective process? How is *"contact"* established now? How does the *"current"* flow? Questions like these lead nowhere if we fall into the trap of condemning surrealist imagery for failing to meet reason's demands, when in fact it bypasses them.

In an essay published in 1926 in *Cahiers du Mois*, Robert Desnos commented, "I have often asked myself what held us so closely together. Probably something that resembled the fellowship of those who are going to blow up a city in a spirit of revolt." Desnos' declaration gives us a starting point for an approach to the problem of interpreting surrealist works. He indicates that, before anything else, response to surrealism and the only basis upon which interpretation of its works is feasible, must be something of an act of complicity. It is really not possible to phrase pertinent questions that will set works of genuine surrealist inspiration apart from mere products of imitation until the following fundamental problem has been resolved. To what is the surrealist artist attentive as he looks or listens, and in which ways does he address himself to the material he makes his own?

Authentic surrealist endeavor in painting excludes the self-serving opportunism of those, content to follow popular trends, who seek to take advantage of a conveniently accessible "manner" of painting. The same holds true for surrealist writing. In consequence, an evaluative procedure calculated to assess surrealist works on the level of technique alone has very limited application. Evaluation of surrealism must reach beyond identification of the means the artist has employed. It calls for examination of the underlying motives of creative action. The commentator's task is complicated by the surrealists' dedication to capturing the inner model. A single example will suffice to demonstrate how complex the job of interpretation promises to be.

On an evening in December 1947 Alain Jouffroy experienced a strange visual hallucination—he saw a vast illuminated crown in the sky. As the vision faded, he found himself uttering words:

> I have forgotten what my words were, but I know at that moment I felt the terrible and voluptuous sensation of *entering* poetry. In the total darkness illuminated by what I believed I had seen, the images evoked in me by words sketched themselves with almost photographic directness in my brain. An even more remarkable thing was that these images engendered one another, after the manner of those unicellular creatures that reproduce by a process of breaking down, repeated indefinitely. They organized themselves on their own, and it was as though my thoughts were dividing up into hundreds, thousands of drops of mercury so that they, too, resembled the phenomenon I had witnessed.

The very next day, Jouffroy began to write *Aube à l'antipode*, from which this statement is taken. Opening his book, he tells us, the reader

"must not only read between each line of these notes but between each word: the mental phenomenon *Aube à l'antipode* seeks to pin down could never be limited to a single poem, or even a single line or verse."

The difficulty with which surrealist imagery faces the observer is this, then. What he sees, hears, or reads offers external signs of an inner experience. As such, the images he encounters mark recognition of something never seen before, creating anew, as Eluard put it, a delirium without a past.

The surrealist artist himself is confronted by a problem. His work must reflect total commitment to revealing the latent content of life. Yet he necessarily seeks to effect communication by means customarily used in handling life's manifest content, be these verbal or pictorial. His recurrent difficulty lies in raising the language he employs above the level of "elementary exchange." Thus the public's predicament is a related one, as it turns out. For them, it is not just a matter of having trouble seeing the wood for the trees. As Magritte makes quite clear, it is often, more challengingly, a question of seeing something in place of the very trees the artist appears to be concentrating upon showing.

During a discussion following the paper delivered by José Pierre at the colloquium on surrealism held in Cerisy during 1966, Jean Schuster took up the question of authenticity in surrealist painting:

> Now, there, I really believe no one has understood . . . that surrealism did not intend to be compartmentalized in a category, whether it be the category of pictorial expression or the category of literary expression. On the contrary, what is required of people participating in surrealist activity (whether they express themselves by means of painting or by other means) is a certain number of moral and intellectual resolves, that go considerably beyond the framework of their specific means of expression. This is why the criterion of authenticity in a surrealist painter cannot be judged except according to the individual case.[1]

Schuster makes himself clear enough when speaking of surrealism as a view of the world, quite apart from and opposed to mere innovative technique or decorative art, attained through the simple application of a method. His phrasing is somewhat careless, none the less.

[1] See Ferdinand Alquié, *Entretiens sur le surréalisme*, pp. 414–15.

It is more than likely to provide enemies of surrealism with welcome ammunition. His statement can be read as implying the following. While authentic surrealists manage to avoid the stereotypes of acquired mannerism, their work still incurs the risk of being submitted to authentication by a rigid system of theoretical postulations that surely imperil individualism and reduce surrealist expression to the dutiful and unimaginative rehearsal of sanctioned themes. Paul Nougé shows this to be far from true, when commenting in his *Histoire de ne pas rire:* "In Magritte, it is not on the side of painting that I would look for the decisive features. But rather in that somewhat badly defined area where virtues reside, difficult to grasp, regarding which one does not know if they come from intelligence or from ethics, if one cares about such frontiers" (p. 247). Equally to the point is Breton's firmly insistent assertion, in the homage to Saint-Pol-Roux published in *Les Nouvelles littéraires* on May 9, 1925: "It is by the force of images that, in the sequence of time, true revolution could well come about." And with this goes another affirmation, from the "Art poétique" cosigned by Breton and Schuster: "One forces locks, not images."

Behind aphorisms of this kind lies something quite different from an egotistical impulse to alienate the public at large. Surrealists are not determined to keep everyone else at arm's length. In fact, they wish to restore to poetry a quality they feel sure it has lost. Questioned by Guy Dumur in *Le Nouvel Observateur,* André Breton revealed as late as December 10, 1964, that he still had not wavered in this ambition:

> From time immemorial, in all latitudes, it is poetry that governs the sensitive plexus of man and it could not give up one of its prerogatives without as it happens betraying man. Once and for all, Rimbaud has brought out the poet's responsibility, but all the more increasing it, "If what he brings back from *out there* has form, he gives form, if it is formless he gives formlessness." The fact that in this sentence he has underlined the words *out there* shows well enough that it is in them that everything lies. Everything, when we face a work, consists in calculating to what depth out there its author has been able to go. . . . It is above all, for our part, this fundamental conviction that authorizes speaking of an esoteric attitude in surrealism.

Returning to Schuster brings some clarification of the process by which the surrealist artist is to report back findings made *out there,* where rationality has no guaranteed prerogatives:

Emila Medková, *The Widows*. 1967.

Gabriel Der Kevorkian, *High Precision*. 1975. Oil on canvas. Collection of the artist. Photo Marcel Lannoy.

Surrealism, as an interrogation of the world from day to day, sets down permanently the question of the relationship between the rational and the irrational. Not only do we accept the idea that the irrational is but a state, hence that its irreducibility to reason is only provisional and that it tends to give way in the end, to become rational, but, taking into account the complementary idea that the irrational field is limitless, we recognize in it the possibility for constant and infinite poetic progress. Here the idea of the surrealist conception of art comes in, an absolutely unacceptable conception, I grant you, to anyone who has not liquidated, among his mental habits, the oldest one of all, the most occidental and harassing of all, the one that comes from the principle of non-contradiction.

The work of art—poem, picture, object. . .—if it is the product of mental representation, enters, as soon as it is finished, as soon as brought to light, upon a process of rationalization. In this way it begins to belong to the objective world, and this confers upon it something like practical dignity. But . . . it possesses the power of perpetuating its own charge of irrationality and of setting up a network of subjective communications whose density and efficacy, as a brake upon the objective process of rationalization, depend upon what we really must call genius.[2]

Schuster does not have in mind the ultimate and supposedly unavoidable collapse of the irrational before the rational. He is preparing to argue something quite different: that, to genius as we have just heard him speak of it, "genius of emission," corresponds a "genius of reception." The latter makes it possible, despite the encroachments of reason, for the works surrealists extol to continue to "broaden the irrational field."

We realize where Jean Schuster is leading when we identify the distinction he draws between "genius of emission" and "genius of reception" as patterned after one made in the *Anthologie de l'Humour noir*. Here André Breton points out how necessary it is in certain circumstances to separate "humor of reception" from "humor of emission." He himself has to do this when examining Jean-Pierre Brisset's quite involuntary humor. Most of the forty-five authors presented in the definitive edition of Breton's compilation practice humor of emission and are granted a place there for that very reason. The care Breton took in making his original selection and in bringing it up to date shortly before his death is proof enough of the importance with

[2] Jean Schuster, "A l'ordre de la nuit Au désordre du jour," p. 6.

which surrealism endows voluntary humor of a distinctive kind. Similar testimony comes from a large variety of surrealist images. Dealing with these, however, the public sometimes experiences more than a little confusion. The latter results in an erroneous but apparently quite defensible conclusion: that surrealist imagery in general has more to do with humor of reception than with humor of emission.

Numerous images cited above possess a humorous quality that has not received comment before this. They deserve reconsideration now, because when some of them come under review we perceive that amusement is far from being, in every instance, the effect of the same kind of response to what they show or make us imagine. In fact, someone who has had but little contact with surrealism may discover that, on some occasions anyway, he has been laughing at the surrealists and not with them. Discomfited by what they show and tell, he may well have been laughing out of incomprehension or—as he naturally prefers to put it, in significantly reasonable language—because the things he was seeing and hearing were just too ridiculous to take seriously. In short, he considers himself fully entitled to explain his enjoyment of surrealism in terms of humor of reception. Because he has been educated to place the fullest confidence in the very process of rationalization adamantly resisted by the surrealists, such a witness to surrealist effect is more than likely to admit only with extreme reluctance that, fostered by ignorance, his laughter expresses his inability to understand. So far as it betokens lack of sympathy for the surrealist image, it is a defense mechanism. One cannot deny that any amusement he feels is profoundly different in nature from enjoyment born of true sensitivity to the creative surrealist's humor of emission. Really, laughter of this kind can come only from appreciation and ungrudging acknowledgment of the antirational poetic quality of surrealist imagery.

Laughing with the surrealists and laughing at them are decidedly contradictory reactions. They pinpoint the very root of humor, as it is reflected in surrealist imagery. Taking his lead from Sigmund Freud, in the *Anthologie de l'Humour noir* Breton speaks of humor as a "process permitting us to brush reality aside in what is most painful about it" (p. 368). Those who do not find reality painful in the way surrealists do may laugh sometimes at the same things. There is little likelihood, though, of their doing so for precisely the same reasons and with exactly the same sense of pleasure. Accepting reality as at least tolerable—their abiding faith in rationalism bears witness to this—they do not share the surrealist's deep-seated need to break its

Wilhelm Freddie, *Young Girl with Umbrella*. 1969. Acrylic and collage. Galerie Svend Hansen, Copenhagen. Photo Jørn Freddie.

Philip West, *The Lovers*. 1976. Oil on canvas. Collection of the artist.

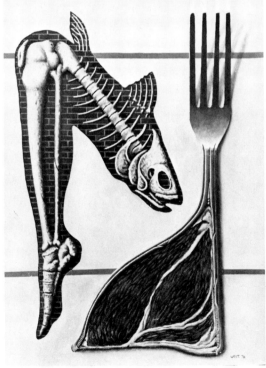

hold, to disturb its accustomed order, and to rearrange it according to the dictates of human desire. They cannot truly share in the surrealist artist's compulsion to "make human understanding over" by attacking "universal assent" with the weapon of humor so as to rid us of the form of good sense castigated in Breton's anthology (pp. 87–88). Nor can they expect to understand why surrealists the world over look upon breaking with universal assent as able to take us beyond an amusing gesture, soon forgotten, to a veritable cognitive act. In surrealism, the latter is identified very often with humor and is brought to fruition through revolt against commonsense assumptions, habitual thought processes, and the principle of practical utility. How else are we to understand Desnos' reference in "Un jour qu'il faisait nuit" ("One day when it was night") from *Langage cuit* to "the cross without arms"? How else to comprehend Breton's warm praise of Georg-Christoph Lichtenberg—inventor of the bladeless knife from which the handle is missing—for having formulated a "special kind of interrogation on the plane of cognition" (p. 72)?

Breton's *Anthologie de l'Humour noir* speaks of Lichtenberg as "the very prophet of chance, of that *chance* about which Max Ernst will say it is the 'master of humor' " (p. 74). Ernst's definition leaves no room for misapprehension regarding the relationship between humor and chance in surrealism. Serving chance during the creative process of collage- or object-making, humor assumes a valuable supportive role. It contributes directly to expanding knowledge, as it works against reason. So it resists the encroachments of rationality and broadens the field of irrationality.

It is easier, now, to grasp the connection surrealists set up between humor of emission and genius of emission, on the one hand, and between humor of reception and genius of reception on the other. However it may seem to the outsider, the genuine surrealist looks upon the two forms of humor as no more in conflict than the two forms of genius. In fact, their complementary nature brings out a critical question. This arises the moment we begin wondering how to interpret surrealist imagery.

Schuster does not go so far as to contend that adequate interpretation presupposes gifts so superior as to warrant use of the word "genius." Even so, he does intimate that it is essential to avoid letting reception act upon the image like a brake, applied for the benefit of rationalization. He demands that response to art in all its forms be up to the level of the genius of emission that has brought it into existence. Still, there is one great drawback. Unfortunately, the language

customarily favored in critical commentary—an indicator of the nature of the response it places on record—shares in the objective process of rationalization to which Schuster has referred so pointedly. Does this mean, therefore, that attempting to interpret surrealist imagery promises to be a task of insurmountable difficulty?

In *El arco y la lira* Octavio Paz takes care to emphasize that poetry exceeds the limitations of language. This is to say that without ceasing to be language ("sense and the transmission of sense"), the poem is "something that is beyond language" (p. 12). Paradoxically, that which lies beyond language can be reached only through language itself. This explains Paz's argument that "a painting will be a poem if it is something more than pictorial language." To be a great painter, in Paz's view, is to be a great poet: "one who transcends the limits of his language" (p. 13). Sentences and phrases, the basic elements of language, are means. They may serve to explore the impossible. Hence, Paz contends, the image, "sustained by itself," is not really a means at all, being its own meaning: "Images cannot be reduced to any explanation and interpretation" (p. 95). We are put in mind of Breton's sharp protest against a literary critic's paraphrase of certain images by Saint-Pol-Roux, and of his insistence that the poet meant exactly what he said. Paz comments apropos of Paul Valéry's definition of the poem as the development of an explanation, "The poem—mouth that speaks and ear that hears—will be the revelation of that which the exclamation indicates without naming. I say revelation and not explanation. If the *development* is an explanation, reality will not be revealed but elucidated and language will suffer a mutilation: we shall have ceased to see and hear and we shall only understand" (p. 36).

With its stress on irrational images of subversive force, surrealism presents special difficulties. These are no less acute when observers attempt evaluation of a surrealist text than when a surrealist painting or object is under examination. Critics whose methods and approach are adequate enough to the task of assessing the achievement of this school of painters or that group of poets cannot boast of comparable success with surrealism, satisfied though they may be with the results of their investigation into the characteristic features they identify in the works it has inspired. More often than not, in fact, they speak in terms that surrealists judge to be irrelevant. They address themselves to aspects of the work under consideration which it is their custom to scrutinize. And they do this, usually, without realizing that those very aspects appear to the author and to his close associates as decidedly

secondary in importance, at best. Criteria eminently suited to weighing the accomplishments of other artists have a way of falsifying perspectives here. Irrespective of the good intentions the observer brings with him, his standards tend to make the products of surrealism look out of focus. Meanwhile his attention goes distractingly to accessory details rather than to things the surrealists deem essential.

What we witness here is the regrettable effect of a form of critical zeal, misapplied in good faith. Generally speaking, the signs point in the same direction. Critics have a lesson to learn from the surrealists themselves. It is, unfortunately, a lesson most of them find altogether too difficult to grasp, even when they appreciate the importance of trying to take it to heart.

The reason so many critics go astray when evaluating surrealism is not hard to trace. We cannot open Breton's *Le Surréalisme et la peinture,* or Bédouin's preface to his selection of Péret poems, or any other text in which one surrealist talks of another, without noticing the effects of partisanship, of an unforced inclination to view the material under examination from one perspective only. The latter eliminates many of the concerns critical analysis usually treats as fundamentally important, substituting for these other priorities, not all equally comprehensible or meaningful to the layman. In the circumstances, it is best to begin by accepting certain emphases as accompanied in surrealist evaluative procedures by a no less significant neglect of other aspects of artistic communication, usually far more familiar. Also we must acknowledge facing here indications of basic trends. These take us beyond evaluative standards to give an inkling of the surrealist creative process itself. There is something even more important to note than the surrealists' tendency to view creativity from this angle or that, and to be totally disinterested in other perspectives. It is the way they comment about one another from the standpoint they deem supremely important, the manner in which they solve the problem of adapting the language of critical commentary to interpreting surrealist works.

In the foreword to his collection of essays *Yves Tanguy,* André Breton gives fair and explicit warning:

> Do not look in what follows for anything resembling art criticism: no explicit attempt to situate the work under consideration historically

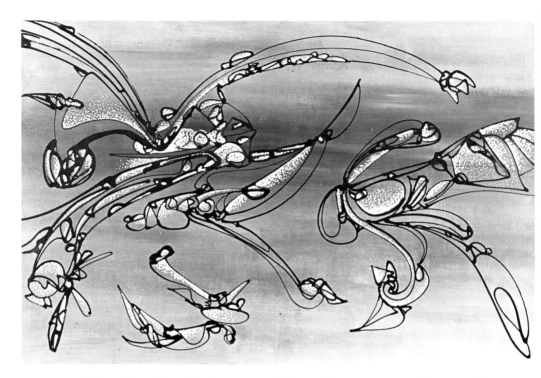

Adrien Dax, Untitled Painting. 1977. Acrylic on wood. Collection of the artist.

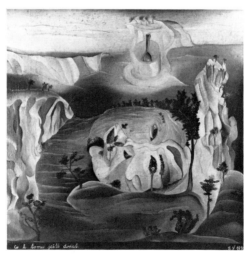

Eva Švankmajerová, *What needs to be added?* 1971. Oil on canvas. Collection of the artist.

or to analyze the means peculiar to it. Excluded a priori from these pages is any didactic intent. They are offered as a succession of echoes and flashes that this work has succeeded in bringing forth from one person at moments quite distant from one another: hence the disparate forms they assume. Their deeper unity comes from the fact that they mark out an uninterrupted quest for emotions through this work and, beyond those emotions themselves, tend to locate a series of *indices* likely to cast light, albeit from a flickering flame, on the route taken by man today. To the extent that this quest is pursued here as the work unfolds and as the witnesses "changes," that is to say in life itself, the interpretation does not avoid, along the way, a minimum of drift. As such, it is thought to be capable of sweeping with a slim beam of light a fragment of human development and—at the very least—of finding favor in that it does not transgress the principle: criticism will be love or will not exist.

There is nothing uncharacteristically apologetic about Breton's tone here. On the contrary, it bears the stamp of his firm belief that objectivity and critical appraisal are quite incompatible; that, in fact, appraisal cannot be anything other than a passionately subjective response. And this is especially the case when one is assessing works like those of the surrealists, which plumb desires common to all of us. Hence this statement of faith, from Breton's article, "Flagrant Délit," published in *Le Figaro littéraire* on July 4, 1949: "The virtue of a work of art manifests itself only very secondarily in the more or less learned exegesis to which it gives rise What counts in my opinion, and nothing else, is that decisive instant of *approach* when life, as it was conceived up to that moment, changes direction, is suddenly lit by a new light." To put it simply, for the surrealist everything important is governed by the pleasure principle. This is why, "At the beginning, it is not a question of understanding but really of *loving*," while gaps in our understanding are unimportant, or may even be welcome, "like clearings in the woods."

Breton has no intention of preaching a doctrine of unintelligibility. He does want to point out, however, that our need to understand is limited. The limitations he sees as confining that need lead him to formulate the following hypothesis: "Furtive absences, confused backgrounds are perhaps necessary to the recreation of receptive faculties submitted to a very great tension." It is not simply that there may exist a marked tendency in man's unconscious to honor beings and things "in inverse proportion to the proximity which, from whatever

side, we feel with respect to them." For Breton takes us well beyond curiosity about anomalous products of nature when declaring, "Anyway, there is always a corner of the veil that expressly demands not to be raised; whatever imbeciles say, this is the very condition of enchantment."

In the final analysis, appreciating surrealism for what it has accomplished in relation to what it has wished to do means being able to respond to aspects of the works it has inspired that do not need to be explained in reasonable terms in order to be enjoyed. Some of their most essential features situate the surrealist object, painting, and word poem outside the field of explanation, rationally expressed. Everything the surrealists have done signifies the conviction that their purpose is basically incompatible with explication. Thus the unifying characteristics of surrealist creative effort elude identification by well-tried methods that traditionally underlie responsibly reasoned evaluative judgment. Surrealism in the end slips through the net of esthetic and moral values with which critics have fished profitably for such a long time. It is distinguished by an indefinable quality that makes its art the celebration of a mysterious rite, repellent to some, impertinent to others, unjustifiable to many. Surrealism is really exciting and fully rewarding only to someone who, as he responds to it, naturally and sincerely dispenses with the need to understand with his mind and who embraces the surrealist work in the act of love about which Breton spoke.

This does not mean that surrealists are content merely to address themselves to the heart, in preference to the head. It would be a serious error indeed to take emotionalism for the be-all and end-all of surrealist activity. Breton alluded to love, rather, in order to indicate how much broader and deeper will be our appreciation of surrealism and our ability to participate in it, as we place less and less trust in the intellect. When he refers in his second manifesto to the general problem raised in surrealism as *"that of human expression in all its forms,"* he does not even hint that he is advocating return to some sort of anticlimactic reaffirmation of the romantics' belief in emotionally based language as capable of resolving the problem of communication.

Over the work table of every surrealist writer and in the studio of every surrealist painter seems to hang the same sign. It enjoins the artist, in Rimbaud's phrase, to "Find a language." The more honestly he works in accordance with this injunction, the more difficult he makes it for others to translate the language he has fashioned for himself.

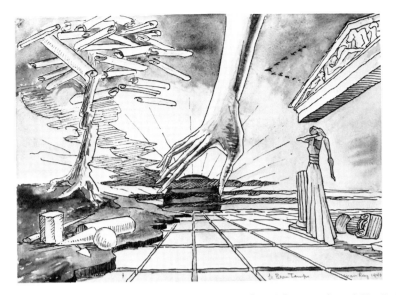

Man Ray, *Fine Weather* (also called *The Adventure*). 1940. India ink and watercolor. Private Collection, Atlanta, Ga. Photo Nathan Rabin.

Rik Lina, *Heart-Source*. 1977. Oil on canvas. Collection of the artist.

The use of paint is far less confined than that of words by the processes of everyday communication, based on the reasonable exchange of ideas. This is why the advantage rests with the painter, when it comes to expressing his sense of the accomplishment of a fellow surrealist working in another medium. From the writer's point of view, at all events, the fact that the surrealist painter is privileged to create something that must escape exact description in words grants the graphic artist's tribute to his associate both enviable freedom and admirable suggestiveness.

Active collaboration between painters and writers has been a regular feature of surrealist activity all along. For the most part, though, this collaboration has reflected a pattern now quite a tradition in the twentieth century: the graphic artist supplying one or more illustration—drawing, lithograph, woodcut, or collage—as a fraternal gesture to the writer. Ironically, of course, surrealist publications have tended in consequence to attract the attention of many a bibliophile who would never dream of reading their contents. For the painters of surrealism have found an appreciative audience more quickly than its writers. Noting this fact, we notice at the same time that, although publications of this type may be classified as illustrated books, they are not truly collaborative works, as Max Ernst defines these in *Beyond Painting:* "When the thoughts of two or more artists were systematically fused into a single work (otherwise called collaboration) this fusion could be considered akin to collage. I quote as examples two texts resulting from the collaboration of my good friend Paul Eluard and myself; the first taken from *Misfortunes of the Immortels* (1922), the second from an unfinished book which proposed to find new techniques in the practice of love, *Et Suivant Votre Cas* (1923)" (p. 17). In *Les Malheurs des Immortels* poems in prose written by Eluard and Ernst appear beside collages executed by the latter.[3]

Works like *Les Malheurs des Immortels,* in which word and picture receive equal stress, are comparatively rare in surrealism. Beside the Eluard–Ernst volume, a book like *Une Ecriture lisible* by Georges Hugnet and Kurt Seligmann deserves mention, however. Reviewing it in the eleventh number of *London Bulletin* on March 1, 1939, Louis Scutenaire observed, "Hugnet's words, eggs of stone, are

[3] On *Les Malheurs des Immortels* see Renée Riese Hubert and J. D. Hubert, "Une Collaboration surréaliste: 'Les Malheurs des Immortels,'" *Surrealismo* (Rome: Bulzoni, 1974), 205–19. Mrs. Hubert has published also an article on "Ernst and Eluard, A Model of Surrealist Collaboration," *Kentucky Romance Quarterly* (Spring 1974), 113–21.

indispensable to Seligmann's pictures, domain of sparks." Here no priority is reserved for words over pictures. Instead, we witness an inquiry undertaken in parallel by two surrealists whose aims are the same, but whose means differ. This is true also of a book on which Vincent Bounoure and Jorge Camacho worked together, *Talismans* (1967).

Both Camacho and Bounoure have written poems published in separate collections (Camacho's under the pseudonym Ohcamac). Their collaboration in *Talismans*, as described in an introductory text called "Passe-boule," was to "blazon the feminine body, the attitudes of seduction and love." Bounoure found a model in the old French poetic tradition of *blasons*, tributes in verse to specific parts of the human body. Camacho, meanwhile, executed a corresponding series of strange heraldic shields. In this way their subject matter became "the pretext favorable to a dual transcription in drawing and poetry." Here neither the graphic image nor the verbal was accorded precedence: "Straight away, the obverse and the reverse reserved the thickness of the medal as the field of oscillation in which glances could wander freely."

Like "the choice of register," the choice of titles was dictated by concern for establishing a *"terrain de rencontre"*—common ground on which the two artists could meet. First of all, titles had to be debated. "It sufficed then to go on to their double analogical interpretation (which was done simultaneously; Bounoure writing, Camacho drawing, facing one another)."

It is as though two players whom one would expect to find on opposing teams were playing instead on the same side. The rules of the game having been modified to dispose of the competitive spirit, we can expect an outcome notably different from usual. "The score," comment the authors of *Talismans*, "is the solicitation of influences, the infusion, at first provoked [presumably by the choices made during the selection of topics deemed suitable for treatment, chosen with a view to establishing a *terrain de rencontre*], of the aromas in visible things, then the coming and going of the radiance emanating from a crown of ice laid on fruit blushing under devotion." More than this, though, the participants discovered little by little that "inner Babylons" existed and that these had an "objective certainty": "The self triumphs in its empire of dust and measures the extent of its victory without laughing."

Clearly, working in collaboration in this way, Bounoure and Camacho were attempting something more complex and ambitious than Radovan Ivsic and Toyen were doing at about the same time in a 1967 volume where Ivsic's texts *Le Puits dans la tour* and Toyen's

collages *Débris de rêves* occupy alternating pages but never really become one. All the same, references to the self, occurring at the end of "Passe-boule," still requires some clarification. We find enlightenment in the very first edition of Breton's *Le Surréalisme et la peinture:* "The sensorial verbs: to see, hear, touch, feel, demand to be conjugated differently from the others. To this necessity respond surprising participles: already seen, already heard, never seen, etc. Seeing, hearing, this is nothing. Recognizing (or not recognizing) is everything. Between what I recognize and what I do not recognize there is I" (p. 11). Measuring the thickness of the medal on which a Camacho drawing decorates the obverse side and a Bounoure poem the reverse (or vice versa), examining the connection between the writer's contribution and the graphic artist's, we find ourselves, just as they themselves have done, recognizing or not recognizing through our desires, focused by erotic association, and so measuring too our knowledge of ourselves.

The point made by Breton so very soon in *Le Surréalisme et la peinture* is exceedingly important for anyone asking how surrealist painting and writing are to be assessed. Surrealism is truly creative only so long as it evokes an inner model which the oppressive conditions of everyday living set at variance with common experience. Hence this model can be imaged faithfully only at the expense of generally accepted esthetic modes and rationalist principles. Hence, too, an account in words of a surrealist pictorial image promises to be impossible while we continue to treat the use of language as governed forever by the rules of verbal exchange habitually regarded as normal and perfectly well adapted to communicating anything that needs and deserves to be shared with others.

We cannot go any farther unless we bear in mind that the surrealist pictorial image is really self-sufficient. It does not have to rely on translation into words to render it communicable. Listening, as we have been doing, to painters as different from one another as Gorky, Masson, and Svanberg speak about their own work furnishes proof enough of the inadequacy of verbal means to describe what pictures can show. Indeed, statements of the kind we have heard these artists make illustrate over and over again the superiority of the picture over verbal language, wherever words are used reasonably with the purpose of capturing something the pictorial image has succeeded in showing. The disadvantage plainly lies with the spoken or written word.

Those surrealists whose preferred medium is verbal face a predicament. They understand perfectly well what the dangers are. They must beware of tarnishing the graphic image, of reducing its intensity, or limiting its suggestive power, possibly even distorting it. The language of critical analysis is of a nature to bring about these very results, when utilized for evaluating surrealist visual imagery. Luckily, however, the benefits claimed for analytical techniques of this sort appear quite irrelevant to the surrealist. He sees no point in trying to compensate somehow for their inherent weaknesses or in trying to make an effort to improve upon critical language as he finds it practiced by others. Literary commentary and art criticism being equally impertinent exercises in the surrealist's eyes, we should be wasting our time looking for a surrealist version of the one or the other.[4] Evidently, surrealists have found a solution to their predicament in the direction of verbal imagery explored by Benjamin Péret. Certainly, this is what Paul Colinet did in a text called "Ici commence le domaine enchanté," accompanying several reproductions of paintings in Waldberg's book on René Magritte.

Colinet went well beyond itemization of the formal constituents of each picture and reached out tentatively toward identification of their poetic interaction. He saw a burning musical instrument as a bombardon freeing its bouquet of flames, a tree stump with the handle of an ax imprisoned beneath one of its roots as clutching at its own disaster, wallpaper through which patches of blue and white sky are visible as a paper with holes gathering pieces of sky.[5] We find something comparable in Eluard's texts published with photographs of Bellmer's doll in *Les Jeux de la poupée* (1949), or in the poems Eluard wrote to pay tribute, in *Les Mains libres,* to drawings by Man Ray ("Man Ray's drawings, always desire, never need!"). Reading texts of this caliber, we are not dealing with critical commentary, as it is commonly understood, any more than we would have done as visitors to the 1967 exhibition entitled HARR: a homage to Raymond Roussel in

[4] The failure of Frederick Brown's essay "Creation versus Literature: Breton and the Surrealist Movement," in John K. Simon, ed., *Modern French Criticism,* 127–47, proves this well enough.

[5] Magritte's work has proved to be a particularly fruitful source of inspiration for commentary of this kind. See *Le Garde-Fou* (texts by Colinet, Mariën, Nougé, and Scutenaire), Brussels: Les Lèvres Nues, 'Le Fait accompli,' No. 76 (December 1972) and Jacques Wargifosse, *Les Sensations dépaysées: rêverie illustrant des objets de René Magritte,* No. 104 (January 1974) in the same series. See also Paul Nougé, *Histoire de ne pas rire,* "René Magritte ou la révélation objective," pp. 294–300.

Jorge Camacho, *"The Dance of Death" Opus 18. Self-Portrait.* 1976. Oil on canvas. Collection of the artist. Photo Marc Lannoy.

Joseph Jablonski, *The Shores of Umor.* Collage-Painting.

which Jorge Camacho, instead of attempting merely to illustrate Roussel's novels *Impressions d'Afrique* and *Locus Solus,* offered a visual counterpart to the Rousselian technique of word play, using plastic forms in place of linguistic elements.

In these and other equally characteristic surrealist verbal tributes, the language of critical judgment has been set aside, outlawed one might say. The essence of surrealist imagery being poetic transposition, response to the image develops in the surrealist sensibility quite naturally and therefore most authentically on the poetic plane. Here a corresponding language of images captures something that experience quickly proves to be too elusive for us to track down with the limited assistance of the habitual formulas of critical writing, consecrated by traditional modes of expression and conventional ambitions.

It is understood, of course, that evidencing his love for Roussel's work in a language of pictorial imagery peculiarly his own, Jorge Camacho does not necessarily teach us more about Roussel than, shall we say, the critic Michel Foucault has done. But it cannot be denied that the painter teaches us something quite different. And the really important point is this. What his methods enable Camacho to show impresses surrealists as far more enlightening than either the objective approach of Foucault or the self-serving commentary on Roussel's work offered by Alain Robbe-Grillet.

If the surrealist appears to fail, by the standards critics apply and the public accepts, it is because these standards leave him convinced of one thing above all. The criteria underlying them cannot guide him right to the center of the poetic universe that he believes a truly creative artist affords us the opportunity to enter. Disregarding such criteria, the surrealist is not simply indulging in obscurantist circumlocution or in a self-conscious inventory of identifiable forms. He has other ends in view when writing as André Breton does in a text from *Yves Tanguy,* dated March 1938:

> FOXGLOVES—We have opened on the slopes a fabulous glove shop to serve him and the people in his escort. These are gloves for putting whatever one sees to sleep, for touching what one does not see. As they come near, dust-sheets slip over the furniture, which slips in its turn over moss. It is from our color that he makes his liqueur, the one that makes the heart beat in what has never been and is preparing fully to live for him. (pp. 14–15)

Breton and the other surrealist writers who want to set down their impressions of this or that painter's work gladly dispense with the

language of critical appraisal because they consider it inadequate to the task of taking us beneath the surface of a surrealist canvas, into the world conjured up by the image fixed by pictorial means. Significantly, their primary ambition is not to transpose in words whatever the picture shows—a distinctly foolish ambition, they contend, and one doomed to failure. In the presence of a creation by a painter who has drawn from an inner model, caught up in wonder at the image depicted, the surrealist finds within himself corresponding wondrous images. Thus the maxim laid down in the first edition of *Le Surréalisme et la peinture* turns out to be neither as trite nor as pedestrian as it might seem: Breton did indeed consider a painting as a window, not because he sought evasion through pictorial imagery but because it permits us to *"look out upon"* our inner selves.

Because they avail themselves of verbal images so as to communicate their reaction to pictorial imagery, surrealists do not have to make any of the distinctions others must establish between painting with figurative elements and nonfigurative art. Turning from a Tanguy, with its forms concretely rendered though often of ambiguous shape, to a canvas by E. F. Granell does not require the surrealist to adjust his focus or to modify his language, even though Granell sometimes banishes outlines recognizable from familiar reality:

> Come from all directions, untamed and proud, and, for the very security of his mind, seeming to demand of the bold rambler that he be equipped with a safe conduct of carbonic snow or that he benefit from immunities proclaimed by loud vegetal solicitations and from the occult protection of rare minerals, these animals still dripping with a rain tinted by the pollen of carnivorous flowers hasten toward an undertow of happiness, at a distance from the burning forest.
>
> Animals of ebony, princely flashes, pelages on which the embers of so many gestures have left impalpable ash, quivering wild beasts and scintillating play (the yellow amber of the eyes' pupils is magnetized by the furs that *charge* it)—animals of sand and other dresses, their bearing testifying to the pleasure taken by a whole world in creating them—as well as to its determination not to let itself be told stories less tall on the pretext of usefulness.

Someone unfamiliar with the graphics accompanying Claude Tarnaud's text *Braises pour E. F. Granell,* from which these words come, is not going to find this passage helpful, when visualizing Granell's painting. It is not Tarnaud's intention to catalog identifiable

elements that will allow those not yet acquainted with Granell's work to recognize it, in the way that description of a typical Dalí canvas would make Dalí's painting recognizable to anyone curious to seek out more examples of it. As a matter of fact, those features Tarnaud appears to describe most exactly are not pictorial elements universally identifiable—ebony or sand animals are not a regular feature of Granell's painting by any means, in the way that a blazing giraffe is a typical motif in Dalí's. Every spectator can pick out for himself Dalí's limp watches, just as he learns to look out for the crutch motif. Far fewer would be able to detect in Granell's work the animal forms to which Tarnaud refers. For Claude Tarnaud is not merely recording what everyone else can see. He is setting down a running account of his own imaginative activity, released by contact with pictorial evidence of a surrealist painter's imaginative experience. The writer's modest ambition is to be an intermediary between painter and reader. At no time, though, does he claim or wish to suggest that his own verbal interpretation of what the former has made him see exhausts the meaning of the picture or even enjoys some special privilege other spectators must respect. The surrealist writer does not aim to confine the reader's awareness of the painter's work, but to share his own excitement before it. For this reason, the painting or drawing provides a starting point for poetic meditation:

> Each picture is a touchstone Chalcedon that permits us the worst liberties with the splendid epidermis of space—golden fleeces nailed to every branch, torn underwear on the labyrinths of the intimate pelages—and the eye loses itself in the windings of marten under the threatening calm of midday: a hand taking flight in the long fringe of the scarlet curtain.

Under the title *Constellations* appeared in 1959 a deluxe edition of twenty-two color-plates executed by Joan Miró between January 21, 1940, and September 12, 1941. These graphics, André Breton declared in an introduction to the collection, constitute "a *series* in the most privileged sense of the term," being "an intentional succession of works of the same dimensions, using the same material means of execution":

> They participate in and differ from one another after the fashion of bodies in the aromatic or cyclic series of chemistry: considered at the

E. F. Granell, *Teresa de Avila Wonders whether to Return to Toledo.* 1961. Oil on canvas. Collection Mr. and Mrs. A. Coquillat, Madrid. Photo John D. Schiff.

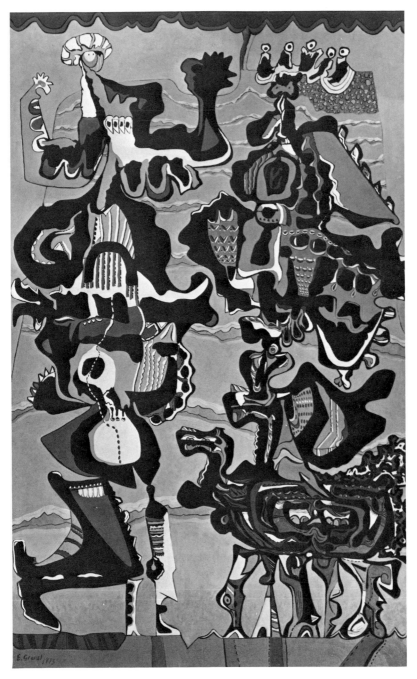

E. F. Granell, *The Riding Master Congratulates the Young Horsewoman*. 1973. Oil on canvas. Collection of the artist. Photo D. Weiss.

same time in their progression and their totality, each of them takes on also the necessity and value of each component in a mathematical series; finally the feeling of an uninterrupted exemplary success that they afford us, here, retains, for the word *série* [break], the force it has in games of skill and chance.

Miró's *Constellations* were published in a volume where they appeared with twenty-two *"proses parallèles"* by André Breton, for which Gérard Legrand argues, in *Poésie et autre,* that the term "series" is just as appropriate.

Breton's parallel texts, modestly termed *prose,* make up a poetic meditation on themes explored by Miró. In every phase, they take their focus from the imagery furnished by the graphic artist.[6] They reflect a poetic reverie, faithful to the pictorial images passing one after the other before the writer, yet never limited in scope to the ambition of providing merely a reading of those images, aimed at transposing them verbally. The full range of Breton's undertaking is not yet conveyed in the following passage, which occurs early in the series. Already, though, with its allusion to Gérard de Nerval, Xavier Forneret, and Arthur Rimbaud, this text advises us about the kind of inspiration Breton will draw from Miró's work and about the orientation of his response before it:

> *Characters in the night guided by*
> *the phosphorescent trail of snails*
>
> Rare are those who have not experienced the need for such help in broad daylight—that broad daylight in which the common herd have the agreable pretension of seeing their way. They are called Gérard, Xavier, Arthur. . . the ones who have known that, in comparison with what could be reached, the beaten tracks, so proud of their signposts and leaving nothing to be desired by way of tangible foot-support good, lead strictly nowhere. I say that the others, who flatter themselves they have their eyes wide open, are without knowing it lost in the woods. Upon awakening, everything hangs on denying fallacious clarity the sacrifice of this Labrador stone glimmer which takes away from us so fast and so much in vain the premonitions and the incite-

[6] This observation in no way contradicts Anna Balakian's assertion that *Constellations* testifies to Breton's indebtedness to Mallarmé and Rimbaud. It is certainly compatible with her analysis of the recurrent motifs of *Constellations.* See Anna Balakian, "From *Poisson soluble* to *Constellations:* Breton's Trajectory for Surrealism," pp. 48–58, especially pp. 53–57.

ments of night dream when it is all we possess in our own right to guide us without striking a blow through the labyrinth of the street.

Prompted by what Miró shows him, Breton celebrates privileged moments like the one of which we read in "Femme et oiseau":

Woman and Bird

The cat dreams and purrs in the brown stringed-instrument trade. He scrutinizes the bottom of ebony and from a distance laps the living mahogany tree in a roundabout way. It is the hour when the sphinx of madder releases his horn by the thousands around the Vaucluse fountain and when everywhere woman is no longer anything other than a calix overflowing with vowels in liaison with the illimitable magnolia of the night.

As we read further through Breton's *proses parallèles*, all written between October and December, 1958, we find them fulfilling little by little the prophecy he makes in "Danseuses acrobates": "Nothing, either, will be governed in the mind without a distracted person's trait at the expiration of which the highest period of suppling commands abandonment to the radar that infallibly sets encounter on track and, doubt rejected, from tropism to giration, must always permit us to *grasp once again by the hand*." The result is a succession of arresting verbal images, just as much in revolt against the visible world and its customary order as the *Constellations* themselves:

The key to the earth bestrides the moon. The crioceris sets in a bezel the point of the sword of consecration. A sailing ship borne by the trade winds opens up a pass in the woods. And the twelve drops from the philter extravasate in a wave of sap that emparadises hearts and pretends to bring out that marvel (it can be glimpsed only) which, on the side of happiness, would counterbalance sobbing.

"Le Réveil au petit jour" mentions a flying bonnet belonging to a miller's wife, a plow with the head of a lark, and a flame that throws out its chest on an unmade bed. These are surrealist objects such as we are more accustomed to meeting in the writings of Péret than in Breton's. Looking at the accompanying pictures, we cannot say that Breton simply is itemizing motifs easily recognizable as being of Miró's inven-

tion. Formal ambiguity reigns in the painter's work and does not permit identifications by any means as clear as Breton's words might give us to understand. Instead, Miró's ambiguous forms evidently have given impetus to imaginative play in the writer. Breton thus makes one important thing plain. Paying respect to the imagery employed by a surrealist in one medium may well take on, in another, a character totally different from an attempt at transliteration. In his tribute to Miró, André Breton demonstrates his firm conviction that only in a language dedicated to breaking down the categories of rational thinking can one expect to do justice to pictorial forms like Miró's, rebellious against categorization.

Like the pictures from which he draws inspiration, Breton's texts stimulate imaginative exploration beyond the commonsense bounds imposed upon the possible by reason. Against reason, his reference in "Vers l'arc-en-ciel" to "the strong scent of slipping-away and feinting" associates the art of fencing with venery or cooking. Making us witnesses to the operation of analogical thought, Breton's writing for *Constellations* justifies Legrand's claim that his texts constitute "one of the most revelatory moments, in every respect, of the poetry, in fact of the thought, of André Breton."

In "Femmes encerclées par le vol d'un oiseau" Breton asks, "Where have I seen before that feather of slingshot in maidenhair fern spin vermilion in the lightning of a fencing doll?" Naturally, no answer follows. As surrealists speak of it, the poetic experience—verbal and pictorial—is more characteristically revelatory anticipation than recreation of past events. If we reject the thought, in "Femmes encerclées par le vol d'un oiseau," of a nightjar working as a switchman, then, going beyond reproof of Breton's text, our objection stands between us and appreciation of Miró's picture; or so it must seem to the surrealist, even while he acknowledges that no nightjar, working or unemployed, is visible at a glance in the accompanying illustration.

This does not mean that the surrealist writer arrogantly seeks to impose upon others an interpretation strictly his own. Breton's discretion remains exemplary throughout the texts for *Constellations*. The closest he comes to commenting on his own poetic reverie is to speak in "Femmes au bord d'un lac à la surface irisée par le passage d'un cygne" of a reverie that "takes on the velvety appearance of the flesh of a thought proportioned to the dimensions of the Cyclopean eye opened by lakes." His explanation, if one may go so far as to call it so, remains adamantly nonexplicative, quite impervious to reason. It suggests, therefore, that one enters the pictorial universe of Joan Miró, as

Joan Miró, *Person, Birds, Stars*. 1965. Oil on canvas. Galerie Maeght, Paris. Photo Claude Gaspari.

Joan Miró, Untitled. 1970. Oil and watercolor on newspaper. Galerie Maeght, Paris.

André Breton himself has done, "on the marvelous cloud of incogniz-ance." And this, there is no need to emphasize, is a means of trans-portation all the more suitable, to surrealist thinking, for appearing to the reasoning mind incapable of taking us anywhere worth going.

Like the little naked man sitting on his stone in "L'Oiseau migrateur," holding "the key to riddles" and teaching the language of birds, Breton has placed his trust in language: "Whoever encounters this truth about letters, words and so on can never, expressing himself, fall short of his conception." Reading his texts for Miró's *Constella-tions* and those he brought together in *Yves Tanguy,* we find it easy at first to believe André Breton is ridiculing our honest endeavor to understand Miró and Tanguy better. In the end, however, we have to acknowledge that we are not facing obscurantism at all. The dis-satisfaction some may continue to feel, nevertheless, their unrelieved puzzlement, provides accurate measurement of the distance they still have to travel in order to attain complete understanding of the func-tion of imagery in surrealism.

CONCLUSION

IN A BOOK OF ESSAYS belligerently subtitled *Batailles pour le sur-réalisme*, Jean Schuster presents surrealism as being, from a certain angle, "an intellectual effort to dissipate the fog carried within by the *confusion* of minds that claim to open with a single key the world of which they fear, above everything else, the *complexity*" (p. 36). Even without knowing exactly what that key is, we find Schuster's definition helpful in clarifying the distinction between poetry and prose in José Pierre's *Le Surréalisme, aujourd'hui*. Here prose is understood as "the exercise of writing or painting having no link with any metaphysical perspective," that is to say, "beyond recourse to the sacred significance of art and poetry" (p. 11). Not surprisingly, introducing Pierre's *Le Surréalisme* and commenting on those movements that have sought to take the place of surrealism in painting, Schuster contends that the latter necessarily condemn themselves to failure because their ambitions do not extend outside the framework of "a plastic revolution." Such movements, in his view, remain schools, "in the sense that each one of them does no more than propose a technique, a style, a mode of expression, their common denominator being the absence of general ideas." In contrast, declares Schuster, surrealism assigns pictorial imagination the same aim as verbal poetry: "let the curtain rise on the space where man, freed of the constraints of external reality, triumphs over his phantasms and changes his life." The message is appropriately the same in *Le Surréalisme, aujourd'hui*, a lecture delivered by José Pierre at the French Institute in Naples, on April 2, 1973: "I should not want to conclude however without having warned my listeners against the illusion that the Surrealism of today like that of yesterday is limited to what is painted, sculpted or written. The motivating force

of Surrealism was and remains revolt and if this force were to fail, one could speak of Surrealism no more" (p. 41).

So long as we wish to come close to understanding the true nature of the surrealist revolt against widespread intellectual confusion, we cannot ignore the following. In *La Clé des champs* Breton speaks of surrealism as "opening certain doors that rationalist thought flattered itself it had condemned for good and all" (pp. 88–89). In other words, surrealists see perfection of thought as proportionate to its freedom from the confinement they associate with reason. Since, logically, thought thus becomes most perfect when least submissive to rationalist thinking, communicating thought must entail in surrealism a new mode of perception and response. It is the latter that the imagery of surrealism is intended to inculcate.

In an article published early in 1944, Pierre Mabille testified unequivocally:

> The main value of surrealism seems to me to have been the reintroduction of the marvelous into daily experience. It has taught that if reality appeared deadly dull, this is because man did not know how to see, his glance being limited by an education deliberately designed to blind him and by an esthetic censorship handed down from time past. It has taught that if man was deaf in a mute world, this is because he was deafened by the hubbub of the most silly kind of society, by the soporific leitmotifs repeated ad nauseam by our teachers. It has taught us to listen to the inner voice which, every minute, is capable of dictating the poem.[1]

Whether surrealists refer to an inner model or to an inner voice, they bow to the inner necessity to which Mabille's text alludes. Their attention goes in the same direction, and does so with least distraction when they have freed themselves of burdensome estheticism and of respect for rationality. This explains why Alain Jouffroy speaks in his *Une Révolution du regard* of the "Copernican character" of the revolution effected by surrealism, a revolution that replaces human reason with "the unknown" as the spiritual centre of the universe (p. 29).

The surrealist refuses to grant objective reality anything better than a subservient role in projecting what he sees and hears within. For him, poetry is not resident in the known but in the as yet unknown. In consequence, he draws a firm line to separate art from

[1] Pierre Mabille, "Le Paradis," *VVV*, No. 4 (February 1944), p. 36.

Leonora Carrington, *Lepidoptera*. 1969. Oil on canvas. Collection of the artist. Photo Crispin Vazquez.

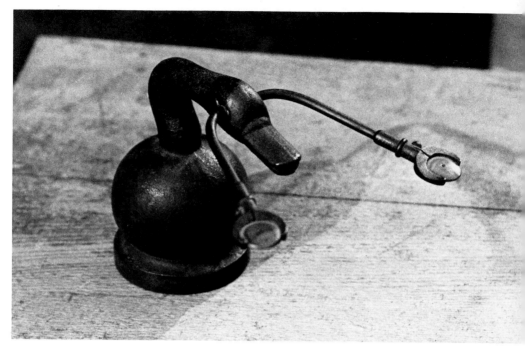

Jacques Brunius, Found Object.

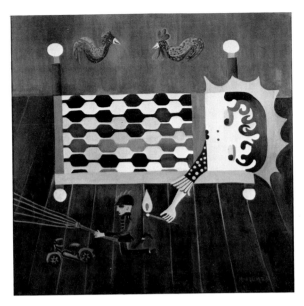

Marianne van Hirtum, *Lost Cat and Dog*. 1975. Oil on canvas. Collection of the artist.

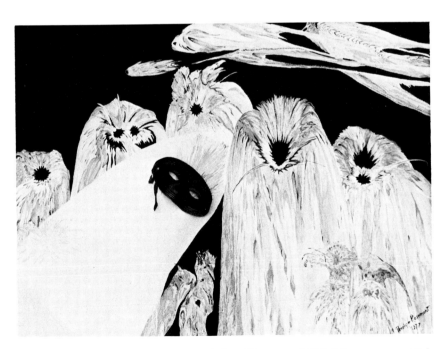

Penelope Rosemont, *The Voyage of the Albatross*. 1977. Oil on canvas. Collection of the artist.

nature, looking upon the former as providing a richly rewarding experience such as nature always denies us and for which it is incapable of supplying the model.

All surrealists agree with André Breton in treating familiar reality as valuable only when and where it can be seen helping point the way, through the unwonted, to the unknown. And even then they ask us to bear in mind, as Schuster does in his *Développements sur l'infra-réalisme de Matta*, that "Imagination prolongs physical perception beyond the latter's limits." In other words, a working principle of surrealism is that imagined reality does not depend upon perceived reality (p. 19). Hence surrealists start out from the conviction that it is up to man to decide upon which level he will attempt to communicate with others. They recognize that the decision he reaches on this matter will govern his evaluation of objective reality and of the part it can be expected to play in the communicative process.

Actual appearance is not poetic reality to the surrealists. All the same, they share the belief that reality can be approached in such a way as to make it serve as a pathway to poetic experience. Indeed, creativity manifests itself in surrealism wherever reality is annexed by surreality. In linking two or more elements to be found in the visible world, the surrealist image is illuminative. It transcends their familiar significance by effecting a novel conjunction between them. From this results a vision that eludes the limitations of the habitual.

Surrealist imagery takes impetus from the welcome spectacle of failure, identified in surrealism with any form of artistic expression based on purely realist principles. Thus surrealism is fully capable of ironically turning aspects of habitual reality to account. We see this happen wherever *trompe l'œil* techniques in painting or meticulous verbal precision can promote confusion in minds that customarily look upon reason as the key for opening the world. Technical considerations, then, tend to enter into a surrealist's assessment of art only so long as they assist him in gauging how little or how much it takes to subvert objective reality, where the relationship of technique to creativity is established and maintained by inner necessity alone. Breton's allusion in the 1924 surrealist manifesto to the compensatory role of poetry is not to be interpreted as an admission that he thought of poetry as a mere substitute or consolation. Practice of surrealist poetry means transcending concerns of a purely technical nature. Poetry for the surrealist embraces all exploratory investigation likely to hasten fulfillment of needs to which his primary ambitions give prominence. This is why Breton ascribes poetry a capital role, in his *Entretiens:*

"to move ceaselessly forward to explore the field of possibilities in every direction, to show itself always—whatever happens—an *emancipatory* and *anticipatory* power" (p. 233). Full possession of the self through surrealist poetry brings the poet the attendant benefit of being able to dominate ambient reality, then, or at least to liberate himself from its oppressive influence. Now centralized in the imagination of man, the world ceases to appear hostile or indifferent. Thanks to imagery evidencing the imagination's assimilative capacity, man no longer feels alienated from his physical environment.

Predicting a return to the purely inner model in *Le Surréalisme et la peinture*, Breton looked forward to success in meeting "the necessity for total revision of real values." Finding its origins in the conflict between the outer necessity of objective reality and the inner necessity of subjective desire, the imagery of surrealism invariably resolves that conflict to the latter's advantage. When we are interpreting surrealist images, therefore, the touchstone is not habitual experience but increased comprehension, the enlarged cognition that comes from looking through the image upon the world it is able to reveal. To the extent that surrealism is, in Breton's words, "a general revision of the modes of cognition," surrealist poetry characteristically is "not creation, but unveiling."

As a means of enlarging cognitive powers, surrealism demands revision of our ideas about the things of which we should take cognizance. For this very reason its imagery testifies to the surrealist's abiding belief that images are revelatory and that their revelations are liberative. It is in this sense that Benjamin Péret spoke forcefully of poetry as correcting external reality: the surrealist image corrects objective reality by way of projected desire and in the interest of increased awareness. Stress upon cognition takes imagery of this kind out of the realm of pictorial and literary tradition, so bringing it much closer to that of the esoteric tradition in its functionality. For cognition can "take a step forward," as Breton put it, only if one is able and willing to meet the standards laid down by surrealism, when pursuing a knowledge of the self that evades rational limitations. By such standards, the poet finds himself engaged in an activity confidently described by Péret as helping man obtain "a forever perfectible knowledge of himself and of the universe." So it is not until we have progressed beyond preoccupation with strictly technical ques-

tions that we can hope to see the following. Fundamentally, surrealism takes its drive from an original conception of what Jean-Louis Bédouin has called "the relationship of the individual to his own thought."[2] This means that the creative artist not only enjoys new rights but also has new obligations which cannot be ignored.

As Eluard described it when prefacing Gisèle Prassinos' *La Sauterelle arthritique*, surrealism is "an ethic of dissolution, of suppression, of negation, of revolt, the ethic of children, of poets who refuse to be acquisitive and who still remain freaks so long as they have not rekindled in all men the desire to face squarely what separates them from themselves." As a result, the mechanism of the emancipatory, anticipatory surrealist image is activated when mental representation is released from physical perception during an act of cognition allowing representation to displace perception and, in some cases, to discredit it entirely. Thus surrealist imagery sets up its own order of priorities. The external world is placed at the service of the reality of human consciousness. This comes about in ways to which the reality principle has failed to accustom us, yet to which the pleasure principle makes surrealists readily responsive. Now the idea of surrealism as a mode of cognition takes on fuller and deeper implications. The image helps surrealists know more about the inner world than about the outer world, often at the price of thoroughly confusing people preoccupied only with the latter.

Speaking in *Les Vases communicants* of the communicating vessels of waking and sleeping, Breton notes that desire fastens onto whatever is useful to serve its satisfaction. Hence his hypothesis that "everything *is an image*" while every object can stand for anything at all: "The mind is marvelously prompt to grasp the slightest relationship that can exist between two objects taken up by chance and poets know they can always, without fear of being mistaken, say of the one that it is *like* the other: the only hierarchy that may be established among poets can rest only on the greater or lesser freedom they have shown in this respect. Desire, if it is really vital, denies itself nothing" (pp. 148–49).

Regularly and inexorably giving representation precedence over perception, the inner over the outer, surrealist imagery releases the artist from dependence upon the external world of physical reality. Of necessity, then, evaluation of creative achievement in surrealism must dispense with the criteria of outer resemblance, set against familiar reality. All that separates the real from the imagined, in these

[2] Jean-Louis Bédouin, *Benjamin Péret,* p. 69.

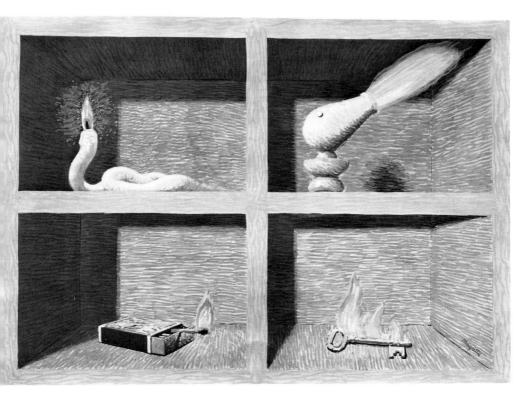

René Magritte, *Les Vases communicants*. 1946. Gouache. Galerie Isy Brachot, Brussels.

circumstances, is the individual's consciousness of the former, more exactly, perhaps, his willingness to accept it as true and incontrovertible. In surrealism, the confidently anticipated submission of the real to the imagination can be projected with all the more assurance because, in the surrealist's mind at least, it already has taken place. One article of faith set forth in Breton's prefatory essay in a collection of his poems, *Le Revolver à cheveux blancs* is that "the imaginary is that which tends to become real." It promises eventual invasion of reality by the imaginary, ultimate absorption of the real in the imagination. And it occurs in a text called "Il y aura une fois," significantly situating in the future the "once upon a time" of fairy tales. In other words, it is imagination, surrealists are confident, that will resolve the antinomies with which André Breton was so concerned, thanks to its capacity for bridging the gap separating inner reality from the outer world.

Eluard's description of the poet as inspiring rather than evoking plainly shows where this view of imagination is leading. If the imagination may be supposed to have supplied the energy from which the image has come, it may well require a corresponding and responsive creative reaction in the reader, listener, or spectator. This explains why Svanberg has deemed it appropriate to call the image the "liberator of the imagination." The surrealist artist and his audience actively share in a creative experience that must remain abortive until reception has responded to emission in a fruitfully collaborative effort. Thus the only limitations weighing upon surrealist imagery are those that define man's sensibility. Dalí granted as much, by implication anyway, when he spoke of the mind's degree of paranoiac activity. Ernst did so too, when speaking of the mind's capacity for hallucination. As for Breton, he specified hallucination of a very definite kind, when asserting in *Point du jour* that everything depends, in the end, on our "power of voluntary hallucination." As pinpointed in Breton's statement, voluntary hallucination emerges as the signal benefit surrealists enjoy, when exercising the "power of enunciation" mentioned in the *Introduction au discours sur le peu de réalité*.

It is easy enough to see where Breton is taking us. Hallucination follows upon enunciation. The latter proves to be poetically fruitful when disarticulation of rational thought results from an exciting reorientation of thinking. Aligning Breton's declaration and Svanberg's, we escape the fallacious conclusion that producing valid surrealist images cannot result except from disregard for all rules and from complete surrender of self-control.

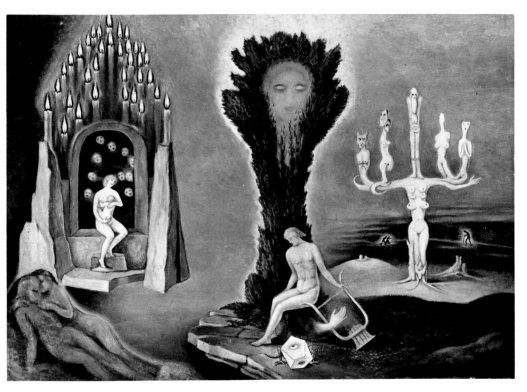

Alberto Martini, *The Three Altars*. 1936. Oil on canvas. Courtesy of Bruno Grossetti, Centro Italiano d'Arte Annunciata, Milan.

As reflected in the image, the mystery of artistic creation in surrealism has to do very largely with the following. The inner model is not always clearly visible in the imagination. Its manifestation may not take place at all, except as a consequence of a felicitous combination of circumstances. And not all of the latter are subject to the artist's conscious, voluntary control. Among the methods to which surrealists incline very gladly, use of means of forcing inspiration and direct appeal to chance revelation clearly are indicative of the elusive nature of the model these artists are dedicated to capturing, one way or another. Where the image reflects a world of the creator's own invention or discovery, then, the criteria allowing art to be judged by reference to observable concrete reality lose their persuasiveness and actually become serious obstacles to appreciation. This follows naturally from the surrealists' unwavering dedication to fostering an art of creation that will invalidate the art of imitation once and for all. In surrealism, worthwhile human activity is thought to rest on the elevated plane of imagination, well above that of observation. And so, equipped only with the traditional evaluative standards in which surrealists have no faith, we risk losing our way among representative surrealist works. The surrealist object, the painted and verbal image all tug imperiously at the mind. They entice it along paths reason has found impassable and lead where esthetic values can neither take us nor permit us to follow.

All in all, it is fair to say that emission and reception can come together only on the same wavelength in surrealism. The world where the surrealist feels most at ease is a world of latencies. Here the sensibility is free to respond without consideration for reason or the utilitarian principle, because it has been brought into contact with latencies that promise fulfillment under guidance from desire alone. "Reality is the manifestation of desire," runs a phrase of Vincent Bounoure's with which no genuine surrealist could quarrel.[3]

Obviously, we have to distinguish once and for all between the "practically controllable" image demanded by Hans Bellmer and unacceptable confinement of surrealist expression through imagery under the influence of rigorously controlled techniques. Especially instructive, then, is Bellmer's argument that an object is real not because taken from nature, but for what it represents to desire. Surrealist imagery, which marshals such objects and disposes them in defiance of natural order, is nothing if not the enlightening precipitate of de-

[3] Vincent Bounoure, "Conclusion et feedback," *La Brèche: action surréaliste*, No. 8 (November 1965), p. 118.

sire. For this reason, both to the creator himself and to his audience, its validity may stand in inverse proportion to the careful application of acquired technique—of mere contrivance, as surrealists would see it. A surrealist is convinced an image is of small value—of little practical utility—unless it denotes the illuminating passage of dreams into reality. Like the use of verbal language, the methods employed in painting or in creating surrealist objects are invested with meaning solely by their identifiable capacity for facilitating that passage. Without this, they could have no justification. That is why surrealist imagery frequently takes us through the experience of witnessing depreciation of accepted values, brought about by manipulation of elements drawn from a world where, above criticism and beyond debate, values are set by social usage, habit, and routine. In a sense, therefore, the surrealists' imagery testifies to their abiding belief that fulfillment of human desire has to be an antisocial act, to the extent that society's viewpoint is strictly antipoetic.

Surrealist negativity is really but a first step, though. It is intended to initiate positive discoveries. From depreciation to revaluation, this is the optimistic movement characteristic of all surrealist poetic activity. Only those who persist in looking upon the images of surrealism as ends, and not as means, can misinterpret surrealist motives. At best, they stop on the threshold of an experience that surrealism has the primary function of sharing with us all. And then they complain. . . .

The hostility with which certain critics of painting and literature greet manifestations of the surrealist *insolite*, for example, shows them to be quite content with the familiar, and for this very reason denied the chance to join in celebrating the unwonted. Meanwhile, as time has familiarized them with some of the forms of the *insolite* and also with the methods by which it is brought to our attention, they have come to refer disparagingly to the "commonplaces" of surrealist art and to argue with every confidence that surrealism has lost its power to shock. What really has happened is that they have merely progressed from bewilderment to boredom, without, in most cases, having experienced wonder even for an instant. Hence surrealists would deny most energetically that this evolution in critical judgment is a token of surrealism's lack of success. They see it, instead, as the inevitable consequence of the limited range of estheticism.

In surrealism, estheticism is dismissed as a simply diversionary force, intervening between poetic expression and full attainment of

its prime purpose, revelation. The reason for this is clear. Surrealists are sure the functional nature of art is ruled out wherever esthetic values command respect. The surrealists' unrelenting opposition to estheticism is neither a trick to gain attention nor an eye-catching paradox. On the contrary, it is profoundly significant, resulting from a firm belief voiced by Jouffroy, among others, in the preamble to his *Une Révolution du regard:* "Moreover, esthetics, in the rules of which I do not believe, is since Baudelaire a superstructure of extreme fragility, subject to continual variations, and with no roots in reality" (p. 10). The parallel drawn by Breton between surrealist objects and mathematical objects indicates what is really at issue here. The layman's interest in certain mathematical objects is necessarily different from the mathematician's. So, too, the public educated in certain concepts of beauty may feel drawn to this or that surrealist object for reasons having nothing to do with its true role in surrealism's revolt against the conditioned reflexes of esthetic response. Hence, much of the puzzlement many members of the public at large feel when faced with surrealist imagery results from their inability to accept and react to surrealist art on its own terms. They find themselves unable to bridge imaginatively the distance separating the image in its surrealist function from the interpretation estheticism tends to place on anything to which utilitarian values cannot be ascribed without delay. By the same token, assessed according to the standards of surrealism, works that meet with some measure of public approval are not always among the most important or lasting of those surrealism has inspired. For instance, Eluard's wide reputation as the best of the surrealist poets stands in marked contrast with his own evaluation, "Péret is a greater poet than I."[4] This is not to say that we must consider surrealist principles to have been compromised dangerously in the writing done by Paul Eluard during his period of association with Breton. All the same, we must acknowledge that, even then, his poems reflected esthetic preoccupations which, in the long run, would make his work far more accessible to a nonsurrealist audience than ever would be the case with the writings of Benjamin Péret, a surrealist poet first and last.

Attentive to the inner voice, to something becoming articulate within, the surrealist must eliminate from consciousness any and every concern that could have the effect of distorting this voice. A feeling of being led by forces he has no need to presume to control is among his most prized gifts. Executing drawings with his eyes closed, Victor

[4] Quoted by Jehan Mayoux, "Benjamin Péret, la fourchette coupante," *Le Surréalisme, même,* No. 2 (Spring 1957), p. 156.

Brauner reduced to its simplest terms the surrealist artist's willing reliance upon inner resources, so demonstrating his conviction that the outer world can inspire only mimetism of the most unproductive kind. As Eluard affirmed, the art of imitation is capable of attracting only artists who do not hunger after themselves, whose needs can be met adequately in the outside world, and who do not feel impelled to search within for the substance of their work.

In the surrealist Eden, the role of the tempting serpent falls to the critical mind of rationalist inclination. When Breton set obscurity up against lucidity, presenting the latter as the enemy of revelation, he was simply availing himself of the vocabulary of reasonable discourse to stress the very close relationship between surrealist purpose and method. Nora Mitrani expressed herself somewhat differently, yet had the same point to emphasize: "But to the French knight Descartes we prefer the Percevals who, with heart full of anguish, plunge into the dark wood, searching for the impossible."[5]

It is entirely in keeping with the surrealists' outlook that they always find themselves particularly impressed by artists not only naturally inclined to relinquish conscious control during the creative act, but actually endowed with special gifts for doing so. In his *Développements sur l'infra-réalisme de Matta* Schuster speaks of "the inner guerillero," that is, of "the automatic voice pronouncing the discourse of the instincts" (p. 17). Breton, for his part, represented automatism as a diving bell, because he looked to automatic methods to take man to unexplored depths, under circumstances that protect him during his conquest of the irrational from the deleterious effects that may come from intentionality. Surrealists acknowledge that automatism may be seconded by deliberation, only so long, though, as the latter is not permitted to inhibit the former, to confine its activities or channel its explorations.

As a call for a general revision of modes of cognition, surrealism represents concentration of attention upon knowledge of a certain kind. And this often means opening the door upon sights in which rationality can detect no virtue. All surrealists share the deep conviction that man's sensibility may respond, and his mind may apprehend, without recourse to reason. In these circumstances, the artist's primary obligation is to place himself at the disposal of forces which could only be badly served, he feels sure, by any attempt on his part to guide or supervise their expression. As surrealists speak of and apply them, means of forcing inspiration are not methods used to guarantee

[5] Nora Mitrani, "Le Congrès s'amuse," *Médium: communication surréaliste,* Nouvelle Série, No. 1 (November 1954), p. 16.

anticipated or even foreseeable results. Quite the opposite, they are means by which inspiration is stimulated to an activity the full extent and attractiveness of which cannot be estimated by someone who supposes its benefits measurable in advance. Excitement comes, here, from an experience that has taken the creative surrealist farther than he hoped to go.

Surrealists believe that only when we reach out beyond the limits of habitual experience, circumscribed by reason, can we fulfill ourselves and hence truly know ourselves. This explains why, in the main, the creative methods favored in surrealism are designed to facilitate escape from the confinement of reasoned understanding. Surprise, for example, signposts the road to revelation, as it offers incontrovertible proof of the collapse of the utilitarian principle. The various procedures employed by surrealists—all with the purpose of bringing about revelation—find unification in inner necessity, operating through human consciousness, not through material or social law, and taking its strength from desire.

Now, the surrealist does not identify desire exclusively with a conscious need to which he can put a name without hesitation. In fact, he looks upon desire as a compelling force that sometimes eludes identification altogether. And so dealing with the imagery of surrealism poses a special problem.

In whom is the right of arbitration vested, and how is that right to be exercised judiciously? If we find accusations of obscurity, negative in effect, easily taking shape in our minds, this is because they reflect the very overestimation of one of the characteristics of language—"its power of immediate exchange"—against which Breton protested. In these circumstances, we must admit to being out of sympathy with the surrealists' dedication to the cause of establishing "a means of elective exchange between men," in which "immediate exchange" is no longer the goal. Surrealists stand behind this declaration from Breton's *Légitime Défense*: "Once again, all we have is that we are endowed to a certain degree with the word and that, by it, something great and obscure tends imperiously to find expression through us, that each of us has been chosen and designated to himself from among a thousand to formulate that which, in our lifetime, has to be formulated." And just as surely they prize the poetic discovery to which Breton and Schuster refer in their "Art poétique" when announcing proudly, "This path has chosen me."

The attitude made explicit in *Légitime Défense*, when Breton alludes to a distinctive surrealist language, is reflected just as faithfully in nonverbal modes of surrealist expression. Whether he communicates what he has to share with us in words or pictures, the surrealist aims to extend an invitation in the name of liberative imaginative experience. When André Breton likened painting to a window valuable for what it looks out upon, he delimited the medium of artistic presentation once and for all, clearly defining its value in surrealism. He indicated that whatever form it takes, the image has meaning only for what it enables us to see, literally or in the mind's eye. Making a window is the work of an artisan, surrealist theory implies, not that of a true artist. The latter proves his worth when he succeeds in locating his window where it will look out upon and reveal something excitingly new. In other words, the vitality of surrealist poetry escapes us, unless we find our attention engaged and held by the following question: Why does the artist express himself as he does?

It is only when posing this fundamentally important question that we really can expect to come to terms with Marcel Mariën's *étrécissements*, for example. *Etrécissements* are photographs taken from commercial magazines which the artist has modified—or corrected, as Péret would have said—by cutting away parts of the original image with scissors (as *étrécissement* results from *rétrécissement* when the first letter is lopped off). This is the appeal of Mariën's technique. It expands visible reality by a process that, in anticipation, seems destined to reduce its import. Set against surrealist ambitions on the broadest scale, such a method of addition by subtraction speaks for itself. After experimenting with *étrécissements* as early as the summer of 1964, Mariën exhibited several examples during a show running between April and May of 1967. Remarks on *étrécissements* in the show's catalog conclude with this aggressive statement:

> It remains only for me to declare that any *étrécissement* other than those listed in the present catalog (to which are to be added the five illustrations for the numbered copies of the latter), that any other *étrécissement* would constitute a forgery, a kind of swindle, even and above all if, extraordinarily, the person speaking to you were to be, under pressure from circumstances he cannot imagine, their unpardonable author.[6]

[6] Marcel Mariën, in the catalog *Marcel Mariën: Rétrospective et Nouveautés 1937–1967*, Brussels: Galerie Defacqz, 1967.

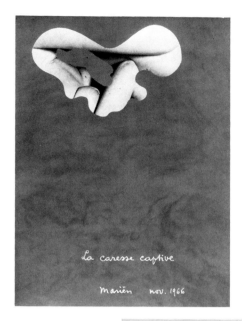

La caresse captive

Mariën nov. 1966

Marcel Mariën, *The Captive
Caress.* 1966. Etrécissement.
Collection J. H. and Jeanne
Matthews.

Roland Penrose, *Taeco-Mene.*
1929. Pencil and colored crayons.
Courtesy of Timothy Baum, New
York. Photo Nathan Rabin.

Like Marcel Duchamp, who asked himself whether he should limit the number of *ready-mades* he signed in a given year,[7] Mariën is wary of facility, which he evidently believes can lead only to the kind of self-kleptomania against which Breton protested. Moreover, he is just as determined to refrain from exploiting technique for its own sake, beyond the point where he still expects it to yield new discoveries and thus has become, in consequence, no more than a mechanical device, better suited to the hands of an artisan than to those of an inquiring artist.

The great benefit surrealists associate with chance—the kind of chance Mariën allowed to guide his scissors when making *étrécisse-ments*—is this. From where they choose to stand, the revelation of chance appears anything but fortuitous. Seen in surrealism as expressive of inner necessity in conflict with rational sense, such revelations shed their false appearance of being merely accidental. Surrealists treat them as the exciting projection of desire, exemplifying the philosophy of immanence in which the surrealist attitude toward external reality has its roots. And so when Ernst claimed the strength of the surrealist image to be proportionate to the degree of arbitrariness it displays, he actually was measuring the distance between surrealist imagery and rational comprehension. Breton did exactly the same, writing under the entry "Image," in the *Dictionnaire abrégé du Surréalisme:*

[7] "Limiter le nbre de rdymades par année?" runs a notation reproduced in Michel Sanouillet, ed., *Marchand du Sel: écrits de Marcel Duchamp*, p. 45. Duchamp was to explain to Alain Jouffroy in December 1961, "But the danger is that anything at all can become very beautiful after a short time if you repeat the operation too often, and I had, for this reason, to limit the number of *ready-mades! . . .* If I produced too many of them, this would be the end of the *ready-made* and its condemnation, because everything becomes pretty or ugly in the sense of esthetic delectation one way or another, in spite of all precautions." See "Conversations avec Marcel Duchamp," in Jouffroy's *Une Révolution du regard,* p. 119. Asked what determined the choice of *ready-mades,* Duchamp told Pierre Cabanne, "That depended on the objects: in general one had to defend oneself against the 'look.' It is very difficult to choose an object because after a couple of weeks you come to like it or to detest it. You have to achieve something so indifferent to you that you have no esthetic emotion. The choice of ready-mades is always based on visual indifference as well as on the complete absence of good or bad taste." Urged to define taste, Duchamp called it habit, "The repetition of a thing already accepted." See Pierre Cabanne, *Entretiens avec Marcel Duchamp,* pp. 83–84.

The strongest surrealist image is the one that presents the highest degree of arbitrariness, the one it takes longest to translate into practical language, whether because it has in it an enormous dose of apparent contradiction, or whether one of its terms is curiously hidden from sight, or whether, promising to be sensational, it seems to end weakly (suddenly closing the angle of its compass), or whether it draws out of itself a ridiculous *formal* justification, or whether it is of a hallucinatory order, or whether it very naturally lends to the abstract the mask of the concrete, or conversely, or whether it implies the negation of some elementary physical property, or whether it sets us laughing. (p. 14)

The surrealist poetic sense transcends reason's impression of opposition and inconsistency, which stand up as valid conceptions only in a rationally ordered system. This is to say that the encounter arranged by the image appears fortuitous only from the other side of a point left far behind during poetic exploration.

To a significant degree, the wonder the surrealist experiences when contemplating the effects of inspiration comes from observing how simple are some of the means from which creativity takes its impetus—means like folding paper in *cadavre exquis,* for example. The surrealist advances to optimistic conclusions, in the assurance that it takes very little to set desire free. It still may be difficult, of course, to say for sure who the exquisite corpse is. But it is clear enough to surrealists that he will drink, and that the wine he will enjoy will be *new.*

What are the advantages of going once again where we have been before, seeing once more what we have seen already, or witnessing something we have no trouble anticipating seeing? Upon the surrealists' negative answer to this question rests the true explanation for the existence of significant surrealist imagery and for the varied forms it can take. When the surrealist extols analogical thought, it is to rescue thinking from the jurisdiction of reason. It is to offer in place of reasonable associations the intuitive linkage that sets the universe—or, what really counts more, our awareness of it—on a new footing. Analogical thought, the metaphorical principle, here plays its part in holding the critical mind in abeyance until—so the optimistic philosophy of surrealism confidently teaches—it is obliged to surrender its claim to dictate our responses to the world where we must live. Inner necessity, meanwhile, is not simply the egotistical expression of private feeling. As surrealists see it, exploration of the universe of obsession

is a more authentic means than any other of grasping that necessity. And to be truly fruitful, surrealists would have us believe, such an exploration has to be compulsive in nature rather than merely exhibitionist. So the deeper the artist probes within himself, the greater will be his chances of speaking to and for other men. Surrealists realize only too well that working gladly in the dark would grant them but a dubious claim to attention, unless there were some hope of finding illumination in darkness. Surrealism offers the prospect of detecting a light that can be approached only after extinction of all the lamps set up by reason to guide man through the rationally ordered universe.

When Paul Eluard ascribed poets the essential role of inspiring rather than evoking, he relocated poetry with reference to past experience as well as habitual reality. Henceforth, he implied, the artist's achievement is not to be measured by the scale of the familiar, but according to what his imagery will have enabled us to see for the first time, "always for the first time." In these circumstances, reduction of the role of deliberate conscious control is assumed to guarantee the poet certain valuable attendant privileges, that of augmented creative power notably. For controlled effect is suspect to all surrealists, to the extent that it risks defeating the purposes of true creativity as these are understood in surrealism. The less the artist knows of the operation of the creative sensibility, apparently, the more acute and productive that sensibility will be. The image becomes divinatory, provided the response it elicits takes us where we have never been before, opening up unexpected vistas of unforeseeable promise. Here the conflict that, according to reason, keeps lucidity on one side and intuited revelation on the other can be dismissed as unworthy of serious attention. Scorning rational lucidity, the surrealists dedicate themselves to the eager pursuit of revelation. To them, transgressing the laws of customary logic, for instance, means transcending these and attaining a vision that will bring most welcome release from the confinement of day-to-day routine experience.

In surrealism transgressing reasonable logic means seeking to uncover new and stimulating relationships. These do not have to depend for credibility on the reality acknowledged by common sense. As testimony to this kind of productive transgression, the representative surrealist image becomes, in Magritte's phrase, "a call to order" of a distinctly extrarational nature. The image points to a new order, developed with the logic of the antireasonable. Freed from respect for reason, liberated by an imaginative energy quite unrestricted by

commonsense projection, the poetic statement creates for itself the "margins of silence" of which Eluard spoke eloquently in *Donner à voir*. So it leaves the image free to capture the inner model. This way, the image becomes "the only *evidence* in the world," resulting, Breton's *La Clé des champs* tells us, from "the spontaneous, extralucid, insolent relationship" established under surrealist inspiration in defiance of common sense.

In the final analysis, interpreting the everyday world is never enough for the dedicated surrealist. He feels impelled to go beyond mere interpretation and to aim at real transformation. The consequences for surrealist imagery are not hard to project. Breton brings them into clear focus when commenting on surrealism in his second manifesto: "One would not wish it to be at the mercy of the moods of this man or that: if it declares itself able, by its own methods, to wrench thought from an increasingly harsh bondage, to place it once more on the road to total comprehension, to return it to its original purity, this is enough for it to be judged only on what it has done and on what it still has to do to keep its promise" (pp. 154–55).

WORKS CITED

U NLESS OTHERWISE INDICATED, the place of publication is Paris. For works other than first editions to which parenthetical page references appear in the text, the original publication date is noted after the title.

BOOKS

Alexandrian, Sarane, *Les Dessins magiques de Victor Brauner,* Denoël, 1965.

Alexandrian, Sarane, *Surrealist Art* (French edition: 1969), New York & Washington: Praeger, 1970.

Alquié, Ferdinand, ed., *Entretiens sur le surréalisme,* Paris & The Hague, n.d. (1968).

Alquié, Ferdinand, *La Philosophie du surréalisme,* Flammarion, 1955.

Angélique, Pierre (pseudonym of Georges Bataille), *Madame Edwarda,* Editions Georges Visat, 1965.

Aragon, Louis, *La Grande Gaîte,* Gallimard, 1929.

Aragon, Louis, *Le Mouvement perpétuel,* Gallimard, 1925.

Aragon, Louis, *La Peinture au défi* (1930), reprinted in his *Les Collages,* Hermann, 1965.

Aragon, Louis, *Persécuté Persécuteur,* Editions surréalistes, 1931.

Arp, Jean, *Jours effeuillés,* Gallimard, 1966.

Arp, Jean, *On My Way,* New York: Wittenborn, Schultz, 1948.

Arp, Jean, *Poèmes sans prénoms,* Grasse: privately printed, 1941.

Arp, Jean, *Le Siège de l'air*, Vrille, 1946.

Arp, Jean, *Unsern täglichen Traum*, Zurich: Arche, 1955.

Arp, Jean, *Le Voilier dans la forêt*, Louis Broder, 1957.

Bataille, Georges, *Histoire de l'œil*, K éditeur, 1944.

Bataille, Georges (under the pseudonym Pierre Angélique), *Madame Edwarda*, Editions Georges Visat, 1965.

Bédouin, Jean-Louis, *Benjamin Péret*, Seghers, 1961.

Bédouin, Jean-Louis, *Les Masques*, Presses Universitaires de France, 1961.

Bédouin, Jean-Louis, *La Poésie surréaliste*, Seghers, 1964.

Bellmer, Hans, *Mode d'emploi*, see *3 tableaux, 7 dessins, 1 texte*.

Bellmer, Hans, *Petite Anatomie de l'inconscient physique ou l'Anatomie de l'image*, Le Terrain Vague, n.d. (1957).

Bellmer, Hans, *Die Puppe*, Carlsruhe: privately printed, 1934.

Bellmer, Hans, *3 tableaux, 7 dessins, 1 texte,* Revel: no publisher's name, 1944.

Bellmer, Hans, *25 Reproductions*, no publisher's name, 1950.

Bellmer, Hans, and Eluard, Paul, *Les Jeux de la poupée*, Editions Premières, 1949.

Bonnet, Marguerite, *André Breton: naissance de l'aventure surréaliste*, José Corti, 1975.

Bounoure, Vincent, ed., *La Civilisation surréaliste*, Payot, 1976.

Bounoure, Vincent, and Camacho, Jorge, *Talismans*, Editions surréalistes, n.d. (1967).

Breton, André, *L'Air de l'eau*, Editions des Cahiers d'Art, 1934.

Breton, André, *L'Amour fou*, Gallimard, 1937.

Breton, André, *Anthologie de l'Humour noir* (definitive edition), Jean-Jacques Pauvert, 1966.

Breton, André, *Le Cadavre exquis, son exaltation*, Milan: Galleria Schwarz, n.d. (1975).

Breton, André, *Clair de terre*, Collection "Littérature," 1923.

Breton, André, *La Clé des champs*, Sagittaire, 1953.

Breton, André, *Entretiens*, Gallimard, 1952.

Breton, André, *Fata Morgana*, Buenos Aires: Editions des Lettres françaises, 1942.

Breton, André, *Introduction au discours sur le peu de réalité*, Gallimard, 1927.

Breton, André, *La Lampe dans l'horloge*, Robert Marin, 1948.

Breton, André, *Légitime Défense*, Editions surréalistes, 1926.

Breton, André, *Manifestes du surréalisme*, Jean-Jacques Pauvert, n.d. (1962).

Breton, André, *Nadja*, Gallimard, 1928.

Breton, André, *Les Pas perdus* (1924), Gallimard, 1949.

Breton, André, *Perspective cavalière*, Gallimard, 1970.

Breton, André, *Poésie et autre*, Le Club du Meilleur Livre, 1960.

Breton, André, *Point du jour*, Gallimard, 1934.

Breton, André, *Le Revolver à cheveux blancs*, Editions des Cahiers libres, 1932.

Breton, André, *Le Surréalisme et la peinture* (definitive edition), Gallimard, 1965.

Breton, André, *L'Un dans l'autre*, Eric Losfeld, 1970.

Breton, André, *L'Union libre*, Editions surréalistes, 1931.

Breton, André, *Les Vases communicants* (1932), Gallimard, 1955.

Breton, André, *Yves Tanguy*, New York: Pierre Matisse Editions, 1946.

Breton, André, Char, René, and Eluard, Paul, *Ralentir Travaux*, Editions surréalistes, 1930.

Breton, André, and Eluard, Paul, *L'Immaculée Conception*, Editions surréalistes (chez José Corti), 1930.

Breton, André, and Legrand, Gérard, *L'Art magique*, Formes et Reflets, 1957.

Breton, André, and Soupault, Philippe, *Les Champs magnétiques* (1920), Gallimard, 1967.

Brion, Marcel, *Art fantastique*, Albin Michel, 1961.

Cabanel, Guy, *A l'Animal noir* (St Lizier): privately printed, 1958.

Cabanel, Guy, *Maliduse* (St Lizier): privately printed, 1961.

Cabanne, Pierre, *Entretiens avec Marcel Duchamp*, Pierre Belfond, 1967.

Calas, Nicolas, *Art in the Age of Risk*, New York: Dutton, 1968.

Calas, Nicolas, *Confound the Wise*, New York: Arrow Editions, 1942.

Camacho, Jorge, and Bounoure, Vincent, *Talismans*, Editions surréalistes, n.d. (1967).

Carelman, Jacques, *Saroka la géante*, Le Terrain Vague, 1965.

Char, René, *L'Action de la justice est éteinte*, Editions surréalistes, 1931.

Char, René, *Poèmes militants* in his *Le Marteau sans maître*, Editions surréalistes (chez José Corti), 1934.

Char, René, Breton, André, and Eluard, Paul, *Ralentir Travaux*, Editions surréalistes, 1930.

Chavée, Achille, *Le Cendrier de chair*, La Louvière: Cahiers de Rupture, 1936.

Chazal, Malcolm de, *Sens-Plastique*, Mauritius: Esclapon, 1947.

Corvin, Michel, *Petite Folie collective*, Tchou, 1966.

Crevel, René, *L'Esprit contre la raison*, Cahiers du Sud, 1928.

Dalí, Salvador, *The Secret Life of Salvador Dali*, New York: Dial Press, 1942.

Desnos, Robert, *Langage cuit* (1923) in his *Corps et Biens*, NRF, 1930.

Desnos, Robert, *Rrose Sélavy* (1922–23) in his *Corps et Biens*, NRF, 1930.

Dhainaut, Pierre, *Mon Sommeil est un verger d'embruns*, Ussel: Editions Peralta, 1961.

Ducasse, Isidore (under the pseudonym Comte de Lautréamont), *Les Chants de Maldoror* (1869), GLM, 1938.

Dupin, Jacques, *Miró*, London: Thames & Hudson, 1962.

Eluard, Paul, *L'Amour la poésie*, Editions surréalistes, 1930.

Eluard, Paul, *A Toute Epreuve*, Editions surréalistes, 1930.

Eluard, Paul, *Cours naturel*, Editions du Sagittaire, 1938.

Eluard, Paul, *Donner à voir*, Editions de la N. R. F., 1939.

Eluard, Paul, *La Vie immédiate*, Editions des Cahiers libres, 1932.

Eluard, Paul, and Bellmer, Hans, *Les Jeux de la poupée*, Editions Premières, 1949.

Eluard, Paul, and Breton, André, *L'Immaculée Conception*, Editions sur-réalistes (chez José Corti), 1930.

Eluard, Paul, Breton, André, and Char, René, *Ralentir Travaux*, Editions surréalistes, 1930.

Eluard, Paul, and Ernst, Max, *Les Malheurs des immortels*, Librairie Six, 1922.

Eluard, Paul, and Péret, Benjamin, *152 Proverbes mis au goût du jour,* La Révolution surréaliste, 1925.

Eluard, Paul, and Ray, Man, *Les Mains libres,* Jeanne Bucher, n.d. (1937).

Ernst, Max, *Beyond Painting,* New York: Wittenborn, Schultz, 1948.

Ernst, Max, *La Femme 100 têtes,* Editions du Carrefour, 1929.

Ernst, Max, *Histoire naturelle,* Jeanne Bucher, 1926.

Ernst, Max, *Le Poème de la Femme 100 têtes,* Jean Hughes, 1959.

Ernst, Max, *Propos et présence,* Editions d'Art Gonthiers-Seghers, 1959.

Ernst, Max, *Rêve d'une Petite Fille qui voulut entrer au Carmel,* Editions du Carrefour, 1930.

Ernst, Max, *Une Semaine de Bonté ou Les Sept Elements capitaux,* Jeanne Bucher, 1934.

Ernst, Max, and Eluard, Paul, *Les Malheurs des Immortels,* Librairie Six, 1922.

Giedion-Welcker, Carola, *Jean Arp,* New York: Abrams, n.d. (1957).

Henein, Georges, *Déraisons d'être,* Editions surréalistes (chez José Corti), 1938.

Henein, Georges, *Un Temps de petite fille,* Editions de Minuit, 1947.

Henry, Maurice, *Les Paupières de verre,* Fontaine, 1945.

Hugnet, Georges, *40 poésies de Stanislas Boutemer,* Théophile Briant, 1928.

Hugnet, Georges, and Seligmann, Kurt, *Une Ecriture lisible,* Editions des Chroniques du jour, 1938.

Ivsic, Radovan, *Toyen,* Filipacchi, n.d. (1974).

Ivsic, Radovan, *Le Puits dans la tour,* and Toyen, *Débris de rêves,* Editions surréalistes, 1967.

Jarry, Alfred, *L'Amour absolu,* Mercure de France, 1899.

Jean, Marcel, *Histoire de la peinture surréaliste,* Editions du Seuil, 1959.

Jelenski, Constantin, *Les Dessins de Hans Bellmer,* Denoël, 1966.

Jouffroy, Alain, *Aube à l'antipode,* Le Soleil noir, 1966.

Jouffroy, Alain, *Brauner,* Le Musée de Poche, 1959.

Jouffroy, Alain, *Une Révolution du regard,* Gallimard, 1964.

Juranville, Clarisse (pseudonym of Paul Nougé), *Quelques Ecrits et quelques dessins,* Brussels: Robert Henriquez, 1927.

Kupka, Karel, *Un Art à l'état brut,* Lausanne: Editions Clairefontaine, 1962.

Lautréamont, Comte de (pseudonym of Isidore Ducasse), *Les Chants de Maldoror* (1869), GLM, 1938.

Legrand, Gérard, and Breton, André, *L'Art magique,* Formes et Reflets, 1957.

Leiris, Michel, *L'Afrique fantôme,* Gallimard, 1934.

Leiris, Michel, *Aurora,* Gallimard, 1946.

Leiris, Michel, *Glossaire: j'y serre mes gloses,* Editions de la Galerie Simon, 1939.

Leiris, Michel, *Haut Mal,* Gallimard, 1943.

Lippard, Lucy, ed., *Surrealists on Art,* Englewood Cliffs, N.J.: Prentice-Hall, 1970.

Mabille, Pierre, *Le Miroir du Merveilleux,* Les Editions de Minuit, 1962.

Magritte, René, *Manifestes et autres écrits* (Brussels): Les Lèvres Nues, n.d. (1973).

Mansour, Joyce, *Jules César,* Pierre Seghers, n.d. (1955).

Mansour, Joyce, *Rapaces,* Seghers, 1960.

Mariën, Marcel, *La Chaise de sable,* Brussels: L'Invention collective, 1940.

Mariën, Marcel, *Crystal Blinkers,* Harpford, Sidmouth: TransformaCtion, n.d. (1973).

Markale, Jean, *Les Grands Bardes gallois,* G. Fall, 1956.

Masson, André, *Anatomy of My Universe,* New York: Curt Valentin, 1943.

Matthews, J. H., *Surrealist Poetry in France,* Syracuse, N.Y.: Syracuse University Press, 1969.

Matthews, J. H., *Toward the Poetics of Surrealism,* Syracuse, N.Y.: Syracuse University Press, 1976.

Mayoux, Jehan, *Au Crible de la nuit,* GLM, 1948.

Mayoux, Jehan, *Ma Tête à couper,* GLM, 1939.

Mayoux, Jehan, *Traînoir,* Dunkerque: privately printed, 1935.

Mesens, E. L. T., *Alphabet sourd aveugle,* Brussels: Editions Nicolas Flamel, 1933.

Miró, Joan, *Constellations,* New York: Pierre Matisse, 1959.

Monnerot, Jules, *La Poésie moderne et le sacré,* Gallimard, 1945.

Munis, G., and Péret, Benjamin, *Pour un Second Manifeste communiste,* Le Terrain Vague, 1965.

Nougé, Paul, *Clarisse Juranville: Quelques Ecrits et quelques dessins,* Brussels: Robert Henriquez, 1927.

Nougé, Paul, *Histoire de ne pas rire,* Brussels: Editions de la revue *Les Lèvres Nues,* 1956.

Nougé, Paul, *Le Jeu des mots et du hasard,* Brussels: Les Lèvres Nues, 1955.

Paz, Octavio, *The Bow and the Lyre* (*El arco y la lira* [1956]), New York: McGraw-Hill, 1975.

Péret, Benjamin, *Air mexicain,* Librairie Arcanes, 1952.

Péret, Benjamin, *Anthologie des Mythes, légendes et contes populaires d'Amérique,* Albin Michel, 1959.

Péret, Benjamin, *A Tâtons,* in his *Feu central,* K éditeur, 1947.

Péret, Benjamin, *De derrière les fagots,* Editions surréalistes (chez José Corti), 1934.

Péret, Benjamin, *Le Déshonneur des poètes,* México: Poésie et Révolution, 1943.

Péret, Benjamin, *Dormir, dormir dans les pierres,* Editions surréalistes, 1927.

Péret, Benjamin, *Le Gigot, sa vie et son œuvre,* Le Terrain Vague, 1957.

Péret, Benjamin, *Le Grand Jeu,* Gallimard, 1928.

Péret, Benjamin, *Histoire naturelle,* Ussel: privately printed, 1958.

Péret, Benjamin, *Main forte,* Editions de la revue Fontaine, 1946.

Péret, Benjamin, *La Parole est à Péret,* New York: Editions surréalistes, 1943.

Péret, Benjamin (under the pseudonym Satyremont), *Les Rouilles encagées* (*Les Couilles enragées*), Eric Losfeld, 1954.

Péret, Benjamin, *Je sublime,* Editions surréalistes, 1936.

Péret, Benjamin, and Eluard, Paul, *152 Proverbes mis au goût du jour,* La Révolution surréaliste, 1925.

Péret, Benjamin, and Munis, G., *Pour un Second Manifeste communiste,* Le Terrain Vague, 1965.

Péret, Benjamin, et al., *Toyen,* Editions Sokolova, 1952.

Pierre, José, *Max Walter Svanberg et le règne féminin,* Le Musée de Poche, n.d. (1975).

Pierre, José, *Position politique de la peinture surréaliste,* Le Musée de Poche, n.d. (1975).

Pierre, José, *Le Surréalisme,* Lausanne: Editions Rencontre, 1966.

Pierre, José, *Le Surréalisme, aujourd'hui,* La Quinzaine littéraire, 1973.

Pieyre de Mandiargues, André, *Les Incongruités monumentales,* Robert Laffont, 1948.

Prassinos, Gisèle, *La Sauterelle arthritique,* GLM, 1935.

Ray, Man, *Les Mannequins—Résurrection des Mannequins,* Jean Petithory, 1966.

Ray, Man, and Eluard, Paul, *Les Mains libres,* Jeanne Bucher, n.d. (1937).

Richter, Hans, *Dada: Art and Anti-Art,* London: Thames & Hudson, 1965.

Roussel, Raymond, *Impressions d'Afrique* (1910), Jean-Jacques Pauvert, 1963.

Roussel, Raymond, *Locus Solus* (1914), Jean-Jacques Pauvert, 1965.

Rubin, William S., *Dada and Surrealist Art,* New York: Abrams, n.d.

Russell, John, *Max Ernst* (1966), London: Thames & Hudson, 1967.

Sanouillet, Michel, *Dada à Paris,* Jean-Jacques Pauvert, 1965.

Sanouillet, Michel, ed., *Marchand du Sel: écrits de Marcel Duchamp,* Le Terrain Vague, 1958.

Satyremont (pseudonym of Benjamin Péret), *Les Rouilles encagées (Les Couilles enragées),* Eric Losfeld, 1954.

Schehadé, Georges, *Poésies III,* GLM, 1949.

Schehadé, Georges, *Rodogune Sinne,* GLM, 1947.

Schuster, Jean, *Archives 57/68: batailles pour le surréalisme,* Eric Losfeld, 1969.

Schuster, Jean, *Développements sur l'infra-réalisme de Matta,* Eric Losfeld, 1970.

Seligmann, Kurt, and Hugnet, Georges, *Une Ecriture lisible,* Editions des Chroniques du jour, 1938.

Simon, John K., ed., *Modern French Criticism,* Chicago & London: The University of Chicago Press, 1972.

Šmejkal, František, *Surrealist Drawings,* London: Octopus Books, 1974.

Soby, James Thrall, *Arp,* New York: The Museum of Modern Art, 1958.

Soby, James Thrall, *Joan Miró,* New York: The Museum of Modern Art, 1959.

Soby, James Thrall, *Yves Tanguy*, New York: The Museum of Modern Art, 1955.

Soupault, Philippe, *Essai sur la poésie*, Eynard, n.d. (1950).

Soupault, Philippe, *Profils perdus*, Mercure de France, 1963.

Soupault, Philippe, and Breton, André, *Les Champs magnétiques* (1920), Gallimard, 1967.

Svanberg, Max Walter, *Grafik*, Malmö: Lilla Antikvariatet, n.d. (1967).

Tarnaud, Claude, *Braises pour E. F. Granell*, Paris & New York: Editions Phases, 1964.

Toyen, *Débris de rêves*, and Ivsic, Radovan, *Le Puits dans la tour*, Editions surréalistes, 1967.

Vitrac, Roger, *Le Faune noir*, Lhen, 1919.

Vitrac, Roger, *La Lanterne noire*, in his *Dés-Lyre*, Gallimard, 1964.

Vitrac, Roger, *Peau-Asie* (originally in *La Révolution surréaliste*), in his *Dés-Lyre*, Gallimard, 1964.

Waldberg, Patrick, *Max Ernst*, Jean-Jacques Pauvert, 1958.

Waldberg, Patrick, *René Magritte*, Brussels: André De Rache, n.d. (1965).

SURREALIST MAGAZINES

L'Archibras, No. 1 (April 1967)—No. 7 (March 1969).

BIEF: jonction surréaliste, No. 1 (November 1958)—No. 12 (April 1960).

La Brèche: action surréaliste, No. 1 (October 1961)—No. 8 (November 1965).

Dyn (México), No. 1 (April–May 1942)—No. 2 (July–August 1942).

London Bulletin (London), No. 1 (April 1938, called *London Gallery Bulletin*)—Nos. 18–20 (June 1940).

Médium: communication surréaliste, Nouvelle Série, No. 1 (November 1953)—No. 4 (January 1955).

Minotaure, No. 1 (January 1933)—No. 13 (October 1938).

La Révolution surréaliste, No. 1 (December 1924)—No. 12 (December 1929).

Le Surréalisme, même, No. 1 (September 1956)—No. 5 (Spring 1959).

VVV (New York), No. 1 (June 1942)—Nos. 3 and 4 (February 1944).

CATALOGS OF GROUP SHOWS

Dictionnaire abrégé du surréalisme, Galerie des Beaux-Arts, 1938.

Princip Slasti (Brno, Prague, Bratislava), January–May 1968.

Le Surréalisme en 1947, Editions Pierre à Feu, 1947.

Surrealist Intrusion in the Enchanters' Domain, New York: D'Arcy Galleries, 1960.

INDEX

Action de la justice est éteinte, L'
(Char), 48

Aesop, 109

Afrique fantôme, L' (Leiris), 14

Air de l'eau, L' (Breton), 87

Air mexicain (Péret), 17

A l'Animal noir (Cabanel), 113, 211

Alice in Wonderland (Carroll), 109

Alphabet sourd aveugle (Mesens), 150

Alquié, Ferdinand, *Philosophie du surréalisme, La,* 58

Amour absolu, L' (Jarry), 99

Amour fou, L' (Breton), 90, 125

Amour la poésie, L' (Eluard), 7

Anatomy of My Universe (Masson), 59

Anthologie de l'Humour noir (Breton), 69, 131, 218, 230–31, 233

Anthologie des Mythes, légendes et contes populaires d'Amérique (Péret), 14–15

Arcimbaldo, xx

Apollinaire, Guillaume, 72, 76

Aragon, Louis: xiii, 16, 72, 173; *Peinture au défi, La,* 28, 66, 75, 83, 90, 91, 92, 105; *Persécuté Persécuteur,* 10

Arp, Jean (Hans), 42, 55, 158, 170, 178; *Jours effeuillés,* xiv, 66, 112, 134, 149, 176; *On My Way,* 125; *Poèmes sans prénoms,* 9; *Siège de l'air, Le,* xvii, 9–10, 69; *Unsern täglichen Traum,* 158; *Voilier dans la forêt, Le,* 108

Art à l'état brut, Un (Kupka), 58

Artaud, Antonin, 14–15, 48, 163, 181

Art belge, L', 218

Art magique, L' (Breton and Legrand), 149

A Tâtons (Péret), 70

A Toute Epreuve (Eluard), 10

Assommoir, L' (Zola), 98

Aube à l'antipode (Jouffroy), 226–27

Au Crible de la nuit (Mayoux), 7

Audoin, Philippe, 127, 130–31

Aurora (Leiris), 95

Baj, Enrico, 46

Balakian, Anna, 130

Baldung, H., xx

Bataille, Georges, *Histoire de l'œil,* 208, 210; *Madame Edwarda,* 210

Batailles pour le surréalisme (Schuster), 255

Baudelaire, Charles, 164

Bédouin, Jean-Louis, 4, 60, 235; *Masques, Les,* 14; *Poésie Surréaliste, La,* 69

Bellmer, Hans: 59–60, 64, 199–211, 266; *Jeux de la poupée, Les* (co-author), 202–203, 243; *Mode d'emploi,* 209–10; *Petite Anatomie de l'inconscient physique ou l'Anatomie de l'image,* 60, 199, 203–205, 208, 210; *Puppe, Die,* 199–203; *3 Tableaux, 7 dessins, 1 texte,* 162; *25 Reproductions,* 205

Beyond Painting (Ernst), 42, 71–72, 76–77, 92, 117, 118–19, 122, 126, 143, 240
Blake, William, xx
Boiffard, J.-A., 173
Bonnet, Marguerite, 7
Bosch, H., xx
Bounoure, Vincent, 141, 179, 266; *Civilisation surréaliste, La* (co-editor), 15–16; *Talismans* (co-author), 241–42
Braises pour E. F. Granell (Tarnaud), 246–47
Braque, Georges, 42, 66
Brauner (Jouffroy), 28
Brauner, Victor, 75, 145–46, 190, 199, 269
Breton, André: xiii, xv, xvii, xx, 16, 19–20, 23, 25, 34, 38–40, 48, 68, 72, 76, 101, 103–104, 118–19, 122, 127, 130, 134, 146, 150, 153, 158, 167–69, 173, 178, 182, 189, 215, 225, 228, 234, 237–38, 247, 260, 268–69, 273; *Air de l'eau, L'*, 87; *Amour fou, L'*, 90, 125; *Anthologie de l'Humour noir*, 69, 131, 218, 230–31, 233; *Air magique, L'* (co-author), 149; *Champs magnétiques, Les* (co-author), xxiii, 1–11, 142; *Clair de terre*, 196; *Clé des champs, La*, 29–30, 57–58, 60, 83–84, 88–89, 129, 184, 217, 256, 276; *Entretiens*, 1, 11, 260–61; *Fata Morgana*, 69; *Immaculée Conception, L'* (co-author), 114; *Introduction au discours sur le peu de réalité*, 38; *Lampe dans l'horloge, La*, 115; *Légitime Défense*, 270–71; *Manifeste du surréalisme, Le*, xiii, 11–13, 30, 37–38, 42, 46–47, 55, 60, 65, 78–81, 90, 123, 129, 140, 157, 161; *Nadja*, 55, 63, 121; *Pas perdus, Les*, 58, 72, 121; *Perspective cavalière*, 32, 88, 181; *Point du jour*, 7, 135, 264; *Poisson soluble*, 30–32, 63; *Poésie et Autre*, 250; *Ralentir Travaux* (co-author), 141; *Revolver à cheveux blancs, Le*, 46, 70, 264; *Second Manifeste du surréalisme*, 13–14, 106; *Surréalisme et la peinture, Le*, xiii, xxii, 20–21, 26, 39, 42–48, 51, 54–55, 87, 132–33, 135, 137, 143, 169–70, 176, 179, 184, 188, 195, 212, 216, 235, 242, 246, 261; *Un dans l'autre, L'*, 87, 153–56; *Union libre, L'*, 196; *Vases com-*

municants, Les, 47, 262; *Yves Tanguy*, 176, 235–37, 245
Brion, Marcel, 169, 218
Brisset, Jean-Pierre, 163, 230
Brunius, Jacques, 68–69, 75–76, 83, 104
Buddha, 15
Buffon, G., 72

Cabanel, Guy, *A l'Animal noir*, 113, 211
Cahiers d'Art, 129
Cahiers du Mois, 226
Calas, Nicolas, 150; *Confound the Wise*, 57
Camacho, Jorge: 245; *Talismans* (co-author), 241–42
Carelman, Jacques, *Saroka la géante*, 100
Carroll, Lewis, 108; *Alice in Wonderland*, 109; *Through the Looking-Glass*, 108
Cendrier de chair, Le (Chavée), 70
152 Proverbes mis au goût du jour (Eluard and Péret), 109–13, 115
120 Journées de Sodome, Les (Sade), 210
Cézanne, Paul, 189
Chaise de sable, La (Mariën), 70
Chamberlain, Neville, 174
Champs magnétiques, Les (Breton and Soupault), xxiii, 1–11, 142
Chants de Maldoror, Les (Lautréamont), xx, 75
Char, René: *Action de la justice est éteinte, L'*, 48; *Poèmes militants*, 4, 11; *Ralentir Travaux* (co-author), 141
Chavée, Achille, *Cendrier de chair, Le*, 70
Chazal, Malcolm de, *Sens-Plastique*, 43
Cheval, The mailman, 170
Civilisation surréaliste, La (Bounoure and Effenberger), 15–16
Clair de Terre (Breton), 196
Clarisse Juranville: Quelques Ecrits et quelques dessins (Nougé), 161
Clé des champs, La (Breton), 29, 30, 57–58, 60, 83–84, 88–90, 129, 184, 217, 256, 276
Colinet, Paul, 243
Confound the Wise (Calas), 57
Constellations (Miró), xv, 247–54

Corvin, Michel, 108
Couilles enragées, Les, (Péret), 108
Cours naturel (Eluard), 4
Crevel, René, *Esprit contre la raison, L',* 63
Crimes de l'amour, Les (Sade), 208
Crystal Blinkers (Mariën), 70
Cubism, 42, 68, 117

Dada, 38–40, 42, 71, 83, 174–76, 178
Dalai Lama, The, 15
Dalí, Salvador, 27, 51–55, 182–84, 188–89, 247, 264
da Vinci, Leonardo, 91, 137, 146
Dax, Adrien, 32, 131, 134, 140
Débris de rêves (Toyen), 242
de Chirico, Giorgio, 34, 38, 42, 46, 216–17
De derrière les fagots (Péret), 4, 17
Degottex, 26, 48
Déraisons d'être (Henein), 106
Déshonneur des poètes, Le (Péret), 15
Desnos, Robert, 38, 72, 163, 226; *Langage cuit,* 48, 113, 233; *Rrose Sélavy,* 106, 115
Développements sur l'infra-réalisme de Matta (Schuster), 260, 269
Dhainaut, Pierre, *Mon Sommeil est un verger d'embruns,* 69
Dictionnaire abrégé du surréalisme, 141, 202, 273–74
Domingues, Oscar, 75, 137, 140, 145
Donner à voir (Eluard), xxii, 2, 25, 37, 47, 51, 57, 87–88, 91, 137, 185, 208
Dormir, dormir dans les pierres (Péret), 16
Duchamp, Marcel, 72, 92, 106, 163, 273
Dumur, Guy, 228
Dupin, Jacques, xiv–xv, 87
Dyn, 137

Ecriture lisible, Une (Hugnet and Seligman), 240–41
Effenberger, Vratislav, *Civilisation sur-réaliste, La* (co-editor), 15–16
Eluard, Paul: xiii, 4, 16, 19, 26, 34, 39, 70, 72, 101, 170, 173, 205, 217, 227, 262, 264, 268, 269, 275, 276; *Amour la poésie, L',* 7; *A Toute*

Epreuve, 10; *152 Proverbes mis au goût du jour* (co-author), 109–13, 115; *Cours naturel,* 4; *Donner à voir,* xxii, 2, 25, 37, 47, 51, 57, 87–88, 91, 137, 185, 208; *Et Suivant Votre Cas* (co-author) 240; *Immaculée Conception, L'* (co-author), 114; *Jeux de la poupée, Les* (co-author), 202–203, 243; *Mains libres, Les* (co-author), 243; *Malheurs des Immortels, Les* (co-author), 240; *Ralentir Travaux* (co-author), 141; *Vie immédiate, La,* 114
Entretiens (Breton), 1, 11, 260–61
Ernst, Max, xiv, xv, 28–29, 34, 38–40, 66, 68, 72, 75–76, 80–84, 87, 91, 104, 108, 112, 121, 123, 130, 134, 142, 146, 149, 158, 216, 233; *Beyond Painting,* 42, 71–72, 76–77, 92, 117, 118–19, 122, 126, 143, 240; *Et Suivant Votre Cas* (co-author), 240; *Femme 100 têtes, La,* 90, 92, 94–99, 103, 105; *Histoire naturelle,* 119, 126–27; *Malheurs des Immortels, Les* (co-author), 240; *Poème de la Femme 100 têtes,* 94; *Semaine de Bonté, Une,* 99–100
Espinoza, 75
Esprit contre la raison, L' (Crevel), 63
Essai sur la poésie (Soupault), 1
Estienne, Chales, 149
Et Suivant Votre Cas (Eluard and Ernst), 240

Fata Morgana (Breton), 69
Faune noir, Le (Vitrac), 47
Femme 100 têtes, La (Ernst), 90, 92, 94–99, 103, 105
Figaro littéraire, Le, 237
Finnegans Wake (Joyce), 108–109
Ford, Charles-Henri, 135
Forneret, Xavier, 250
Foucault, Michel, 245
Frances, Esteban, 158
Freud, Sigmund, 231
Futurism, 208

Gaudi, 170
Giacometti, Alberto, 125, 170, 176
Gide, André, 121
Giedion-Welcker, Carola, xiv

Gigot, sa vie et son œuvre, Le (Péret)
16–17
Glossaire, j'y serre mes gloses (Leiris),
14–15, 163–64
Goldfayn, Georges, xx, 155
Gorky, Arshile, 185, 189, 242
Goya, F., xx
Grand Jeu, Le (Péret), 70
Granell, E. F., 246–47

Haut Mal (Leiris), 14
Heisler, Jindrich, 101
Henein, Georges, *Déraisons d'être*, 106;
Temps de petite fille, Un, 69
Henry, Maurice, 212; *Paupières de
verre, Les*, 69
Hérold, Jacques, 43, 46–47
Histoire de l'œil (Bataille), 208, 210
Histoire de ne pas rire (Nougé), 27,
87, 91, 103–104, 165–66, 181, 189,
228
Histoire naturelle (Ernst), 119, 126–
27
Histoire naturelle (Péret), 126–27, 129,
142, 154
Homo Ludens (Huizinga), 153
Hubert, Renée Riese, 99–100, 143
Hugnet, Georges, 141; *Ecriture lisible,
Une* (co-author), 240–41; *40 poé-
sies de Stanislas Boutemer*, 10
Huizinga, Johan, *Homo Ludens*, 153

Immaculée Conception, L' (Breton and
Eluard), 114
Impressions d'Afrique (Roussel), 245
*Introduction au discours sur le peu de
réalité* (Breton), 38
Incongruités monumentales, Les (Pieyre
de Mandiargues), 212
Ivsic, Radovan, *Puits dans la tour, Le*,
241–42

Jaguer, Edouard, 68, 80, 104
Jarry, Alfred, *Amour absolu, L'*, 99
Jean, Marcel, xvii, 59, 84, 91
Je sublime (Péret), 17

Jeu des mots et du hasard, Le (Nou-
gé), 106
Jeux de la poupée, Les (Bellmer and
Eluard), 202–203, 243
Jouffroy, Alain, 29; *Aube à l'antipode*,
226–27; *Brauner*, 28; *Révolution du
regard, Une*, xvii, 256, 268
Jours effeuillés (Arp), xiv, 66, 112,
134, 149, 176
Joyce, James, *Finnegans Wake*, 108–109
Jules César (Mansour), 205

Kahlo de Rivera, Frida, 47
Klapheck, Konrad, 190–92, 195
Klee, Paul, 38, 42
Kupka, Karel, *Art à l'etat brut, Un*, 58

Lampe dans l'horloge, La (Breton),
115
Langage cuit (Desnos), 48, 113, 233
Lanterne noire, La (Vitrac), 47–48
Laurens, Henri, 66
Lautréamont, Comte de, 21–23, 40, 43,
48, 58, 63, 71–75, 94, 131, 161, 179,
192; *Chants de Maldoror, Les*, xx,
75
Legrand, Gérard, 28, 72–76, 78, 162,
250; *Art magique, L'* (co-author),
149
Légitime Défense (Breton), 270–71
Leiris, Michel, 167; *Afrique fantôme,
L'*, 14; *Aurora*, 95; *Glossaire, j'y
serre mes gloses*, 14–15, 163–64;
Haut Mal, 14
Lely, Gilbert, 94
Libertaire, Le, 17
Lichtenberg, Georg Christoph, 113
Littérature, 1
Locus Solus (Roussel), 245
Lolita (Nabokov), 109
London Bulletin, 34, 55, 173, 240

Mabille, Pierre, 256; *Miroir du Mer-
veilleux, Le*, 101
Madame Edwarda (Bataille), 210
Maddox, Conroy, 190

Magritte, René, XIV, 21, 26–27, 34, 55, 75, 87, 165–69, 181, 185–89, 212–24, 227–28, 243, 275; *Manifestes et autres écrits*, 214–15
Main forte (Péret), 17
Mains libres, Les (Eluard and Ray), 243
Malheurs des Immortels, Les (Eluard and Ernst), 240
Mallarmé, Stéphane, 1, 25, 72, 250
Manifeste des exégètes (Péret), 17
Manifestes et autres écrits (Magritte), 214–15
Manifeste du surréalisme (Breton), xiii, 11–13, 30, 37–38, 42, 46–47, 55, 60, 65, 78–81, 90, 123, 129, 140, 157, 161
Mansour, Joyce, *Jules César*, 205; *Rapaces*, 11
Marcuse, Herbert, 21
Mariën, Marcel, 271–73; *Chaise de Sable, La*, 70; *Crystal Blinkers*, 70
Masques, Les (Bèdouin), 14
Masson, André, XIV, 38, 42–43, 75, 132–33, 143, 149, 195, 242; *Anatomy of My Universe*, 59
Ma Tête à couper (Mayoux), 10, 48, 63
Matta Echaurren, Sebastian, 75, 84, 140, 188–90
Mayoux, Jehan, 79, 170, 212; *Au Crible de le nuit*, 7; *Ma Tête à couper*, 10, 48, 63; *Traînoir*, 114
Médium: communication surréaliste, 5, 137, 153
Meryon, C., xx
Mesens, E. L. T., 66, 68, 75–76, 83, 87, 101; *Alphabet sourd aveugle*, 150
Minotaure, 57, 137
Miró, Joan, xiv–xv, 27, 34, 39, 42–43, 75, 87, 104, 133–34, 146; *Constellations*, xv, 247–54
Miroir du Merveilleux, Le (Mabille), 101
Mitrani, Nora, 59–60, 205–208, 210–11, 269
Mode d'emploi (Bellmer), 209–10
Monnerot, Jules, 91
Mon Sommeil est un verger d'embruns (Dhainaut), 69
Morise, Max, 38, 40
Mouvement perpétuel, Le (Aragon), 7
Munis, G. (co-author), *Pour un Second Manifeste Communiste*, 16

Nabokov, Vladimir, *Lolita*, 109
Nadja (Breton), 55, 63, 121
Naville, Pierre, 38, 40–42
Nerval, Gérard de, 211, 250
Nord-Sud, 40
Nougé, Paul, 185, 195, 215, 217, 221, 224; *Clarisse Juranville: Quelques Ecrits et quelques dessins*, 161; *Histoire de ne pas rire*, 27, 87, 91, 103–104, 165–66, 181, 189, 228; *Jeu de mots et du hasard, Le*, 106; *Pour illustrer Magritte*, 219–20
Nouvelles littéraires, Les, 228
Nouvel Observateur, Le, 228
Novalis, V., 129

On My Way (Arp), 125
Oppenheim, Meret, 192, 212

Paalen, Wolfgang, 55, 75, 137, 173, 184
Paulhaun (Jean), 72
Parole est à Péret, La (Péret), 15
Pas perdus, Les (Breton), 58, 72, 121
Paupières de verre, Les (Henry), 69
Paz, Octavio, 25, 27, 98, 129, 176, 234
Peau-Asie (Vitrac), 106
Peinture au défi, La (Aragon), 28, 66, 75, 83, 90–92, 105
Péret, Benjamin, 2, 16, 34, 39, 42, 46, 51, 65, 100–101, 105, 133, 135, 137, 153, 155, 164, 197–98, 212, 218, 243, 250, 261, 268, 271; *Air mexicain*, 17; *Anthologie des Mythes, légendes et contes populaires d'Amérique*, 14–15; *A Tâtons*, 70; *152 Proverbes mis au goût du jour* (co-author), 109–13, 115; *Couilles enragées, Les*, 108; *De derrière les fagots*, 4, 17; *Déshonneur des poètes, Le*, 15; *Dormir, dormir dans les pierres*, 16; *Gigot, sa vie et son œuvre, Le*, 16–17; *Grand Jeu, Le*, 70; *Histoire naturelle*, 126–27, 129, 142, 154; *Je sublime*, 17; *Main forte*, 17; *Manifeste des exégètes*, 17; *Parole est à Péret, La*, 15; *Pour au Second Manifeste Communiste* (co-author), 16
Persécuté Persécuteur (Aragon), 10

Perspective cavalière (Breton), 32, 88, 181
Petite Anatomie de l'inconscient physique ou l'Anatomie de l'image (Bellmer), 60, 199, 203–205, 208, 210
Philosophie dans le boudoir, La (Sade), 210
Philosophie du surréalisme, La (Alquié), 58
Pierre, José, 27, 80, 131, 149, 227; *Position politique de la peinture surréaliste,* 20–21, 54, 132–33, 140; *Surréalisme, Le,* xiii, xvii, 29, 34, 40, 133, 178–79, 219, 255; *Surréalisme, aujourd'hui, Le,* 255
Picabia, Francis, 42–43, 69, 72, 92
Picasso, Pablo, 38–39, 42, 66
Pieyre de Mandiargues, André, *Incongruités monumentales, Les,* 212
Poème de la Femme 100 têtes, Le (Ernst) 94
Poèmes sans prénoms (Arp), 9
Poèmes militants (Char), 4, 11
Poésie et autre (Breton), 250
Poésie surréaliste, La (Bedouin), 69
Poésies III (Schehadé), 69
Point du jour (Breton), 7, 135, 264
Poisson soluble (Breton), 30–32, 63
Pop Art, 192
Position politique de la peinture surréaliste (Pierre), 20–21, 54, 132–33, 140
Pour illustrer Magritte (Nougé), 219–20
Pour un Second Manifeste Communiste (Munis and Péret), 16
Prassinos, Gisèle, *Sauterelle arthritique, La,* 262
Profils perdus (Soupault), 1
Puits dans la tour, Le (Ivsic), 241–42
Puppe, Die (Bellmer), 199–203

40 poésies de Stanislas Boutemer (Hugnet), 10

Ralentir Travaux (Breton, Char, and Eluard), 141
Rapaces (Mansour), 11

Ray, Man, 38–39, 42, 75, 176; *Mains libres, Les* (co-author), 243
Read, Herbert, 34
Redon, O., xx
Reich, 21
Reverdy, Pierre, 40, 60, 66, 130, 196
Révolution du regard, Une (Jouffroy), xvii, 256, 268
Révolution surréaliste, La, 13, 15, 38–39, 40, 42, 46, 48, 141, 163, 173, 196, 221
Revolver à cheveux blancs, Le (Breton), 46, 70, 264
Rhétorique, 221
Rimbaud, Arthur, 48, 58, 72, 176, 179, 238, 250
Robbe-Grillet, Alain, 245
Rodogune Sinne (Schehadé), 9, 112
Rosenberg, Harold, 72
Rosey, Gui, 224
Rouilles encagées, Les (Péret), See *Couilles enragées, Les*
Rousseau, Henri, xx, 217
Roussel, Raymond, 157, 243; *Impressions d'Afrique,* 245; *Locus Solus,* 245
Roy, Pierre, 42
Rrose Sélavy (Desnos), 106, 115
Rubin, William S., 185
Russell, John, xv, 92, 103

Sade, D. A. F., 205; *120 Journées de Sodome, Les,* 210; *Crimes de l'amour, Les,* 208; *Philosophie dans le boudoir, La,* 210
Saint-Pol-Roux, 179, 228, 234
Sanouillet, Michel, 174
Saroka la géante (Carelman), 100
Sauterelle arthritique, La (Prassinos), 262
Schehadé, Georges, *Poésies III,* 69; *Rodogune Sinne,* 9, 112
Schuster, Jean, xiii–xiv, 54, 57, 91, 115, 134, 227–30, 270; *Batailles pour le surréalisme,* 255; *Développements sur l'infraréalisme de Matta,* 260, 269
Scutenaire, Louis, 55, 221, 224
Second Manifeste du surréalisme (Breton), 13–14, 106
Seghers, Anne, 156
Seligman, Kurt, 75; *Ecriture lisible, Une* (co-author), 240–41

Semaine de Bonté, Une (Ernst), 99–100
Sens-Plastique (Chagal), 43
Seven, 28
Siège de l'air, Le (Arp), xvii, 9–10, 69
Silbermann, Jean-Claude, 162, 184
Šmejkal, Frantisek, 188
Soby, James Thrall, xv–xvi, 27, 34, 149
Soupault, Philippe, 39; *Champs magnétiques, Les* (co-author), xxiii, 1–11, 142; *Essai sur la poésie*, 1; *Profils perdus*, 1
Styrsky, Jindrich, 80
Surréalism, Le (Pierre), xiii, xvii, 29, 34, 40, 133, 178–79, 219, 255
Surréalisme, aujourd'hui, Le (Pierre), 255
Surréalisme et la peinture, Le (Breton), xiii, xxii, 20–21, 26, 39, 42–48, 51, 54–55, 87, 132–33, 135, 137, 143, 169–70, 176, 179, 184, 188, 195, 212, 216, 235, 242, 246, 261
Svanberg, Max Walter, 26, 27, 149, 198–99, 242, 264

Talismans (Bounoure and Camacho), 241–42
Tanguy, Yves, xvi–xvii, 34, 42, 75, 122, 149, 176, 192–95, 197–98
Tarnaud, Claude, *Braises pour E. F. Granell*, 246–47
Temps de petite fille, Un (Henein), 70
Tenniel, J., 108
Thomas, Dylan, 28
Through the Looking-Glass (Carroll), 108
Tillim, Sidney, 26
Traînoir (Mayoux), 114
3 tableux, 7 dessins, 1 texte (Bellmer), 162
Toyen, 55, 80, 154; *Débris de rêves*, 242

Treece, Henry, 28
Trotsky, L., 16
Tzara, Tristan, 142

Uccello, P., xx
Un dans l'autre, L' (Breton), 87, 153–56
Unik, Pierre, 16
Union libre, L' (Breton), 196
Unsern täglichen Traum (Arp), 158

Valéry, Paul, 234
Vases communicants, Les (Breton), 47, 262
Verlaine, Paul, 155
Vie immédiate, La (Eluard), 114
View, 135
25 Reproductions (Bellmer), 205
XX^e Siècle, 51
Vitrac, Roger: 173; *Faune noir, Le*, 47; *Lanterne noire, La*, 47–48; *Peau-Asie*, 106
Voilier dans la forêt, Le (Arp), 108

Waldberg, Patrick, xiv–xv, 94, 167, 218

Yves Tanguy (Breton), 176, 235–37, 245

Zervos, Christian, 133
Zinoviev, G., 16
Zola, Emile, *Assommoir, L'*, 98
Zürn, Unica, 205

THE IMAGERY OF SURREALISM

was composed in 10-point Linotype Caledonia and leaded two points
with display type in handset Deepdene by Joe Mann Associates, Inc.;
printed on 80-lb. Warren Lustro Offset Enamel, dull,
Smyth-sewn and bound over boards in Columbia Bayside Vellum
by Vail-Ballou Press, Inc.;
and published by

SYRACUSE UNIVERSITY PRESS
SYRACUSE, NEW YORK 13210